Images of the Corpse

A RAY AND PAT BROWNE BOOK

Series Editors
Ray B. Browne and Pat Browne

Images of the Corpse

From the Renaissance to Cyberspace

Edited by

E L I Z A B E T H K L A V E R

THE UNIVERSITY OF WISCONSIN PRESS / POPULAR PRESS

The University of Wisconsin Press
1930 Monroe Street
Madison, Wisconsin 53711

www.wisc.edu/wisconsinpress/

3 Henrietta Street
London WC2E 8LU, England

1 3 5 4 2

Printed in the United States of America

Library of Congress Cataloging-in-Publication Data

Images of the corpse: from the Renaissance to cyberspace /
edited by Elizabeth Klaver.
p. cm.
"A Ray and Pat Browne book."
Includes bibliographical references and index.
ISBN 0-299-19790-5 (cloth: alk. paper)—
ISBN 0-299-19794-8 (pbk.: alk. paper)
1. Dead in art. 2. Dead in literature. 3. Arts, European.
I. Klaver, Elizabeth.
NX650.D4I46 2004
760′.04493069—dc22
2003020575

Contents

Illustrations

Acknowledgments

I would like to express my appreciation to Southern Illinois University, Carbondale and the English department for supporting this project. I have many friends and colleagues to thank, just a few of whom I name here: John Haller, Richard Falvo, Kevin J. H. Dettmar, Mary Lamb, A. J. Morey, Cammie Sublette, and Paula Arnold. I am especially grateful to Michael L. Humphries, whose help and advice were invaluable.

Permissions

My sincere thanks for the following permissions:

The Anatomy Theatre at the Worshipful Company of Barber-Surgeons, London, cross-section of the interior, from Isaac Ware's *Designs of Inigo Jones and others* (ca. 1731), reproduced by kind permission of the provost and fellows of Worcester College, Oxford

"The visceral lecture Delivered by Barber-Surgeon Master John Banister Aged 48, Anno Domini 1581" (MS Hunter 364), reproduced by kind permission of Glasgow University Library, Department of Special Collections

Tote (Dead Woman) 2, from the series *18 Oktober 1977*, 1988, Gerhard Richter, oil on canvas, 62 × 62 cm, permission of the artist

Confrontation (Gegenüberstellung) 1, 2 and 3, 1998, Gerhard Richter, The Museum of Modern Art, New York

Out of my head, 1999, Lorraine Webb, permission of the artist

Chromosome Choice, 2000, Lorraine Webb, permission of the artist

Aorta, 1999, Lorraine Webb, permission of the artist

Under the Skin, 1998, Lorraine Webb, permission of the artist

Waterbody 2, 1998, Lorraine Webb, permission of the artist

Body Flow, 1998, Lorraine Webb, permission of the artist

Introduction

ELIZABETH KLAVER

At the beginning of a book entitled *Images of the Corpse,* a reader might wonder, and rightly so, why anyone would wish to link literary and artistic endeavor with the dead body. And, moreover, why anyone, apart from a small gang of Frankensteins operating out of the dark corners of academe, would wish to spend many a satisfying hour casting a critical gaze upon it. But that is exactly what the twelve authors of this book represent: a growing community of humanities scholars, artists, and medical practitioners who are interested in recognizing and interrogating the link between the medical sciences and the arts and humanities. One broad school of thought attempts to incorporate literary training into medical settings with the aim of achieving "ethical criticism"—the sense that literature has important application to the health care of a community. In this type of interdisciplinary crossover, scholars like William Monroe advocate drawing on narrative, rhetorical, and performative theory in interpreting the body as a cultural artifact. Susan Sontag is perhaps the best known representative of this sort of body criticism in her work on the metaphorical discourse of disease (Monroe 29).

But this does not mean that scholars in the field ignore the darker and more unsettling side of the history of Western culture and its relation to the body dead or alive, indeed to the very attempt to observe and study it. Critics have delved into the "pathologization" of the live body in the Western health-care system and the problematic objectification of the patient in the doctor/patient relationship. As for the dead body, it has always occupied a special place in Western culture, at times even being debased to a public spectacle—something Judge Ito was not willing to

tolerate in the O. J. Simpson murder trial of 1995.[1] Today, we can detect the popular edge of this fascination with the corpse simply by surfing the television channels at prime time, noting the number of programs that make the dead—sometimes mutilated—body the target of prying eyes, from depictions of autopsies on ABC's *CSI* to crime scenes on the Discovery channel.

Public obsession with the forensic analysis of the dead body has made Patricia Cornwell's Kay Scarpetta novels just the most recent literary representation of popular depictions of human dissection, a tradition that, in fact, extends back to the Renaissance, when famous physicians like Andreas Vesalius commanded large audiences of the learned and curious alike for his public human anatomies. A scene similar to the sort one would find at the playhouse occurred in the early anatomy theaters, with the cadaver at center stage, cut open and on display, its organs held up in triumph for public viewing. Indeed, John Ford's seventeenth-century play, *'Tis Pity She's a Whore,* ends with the character Giovanni running onstage with the dripping heart of his sister impaled on the business end of a bloody dagger, a violent bond between the anatomy theater and the Renaissance stage.

Rembrandt's stunning painting of 1632, *The Anatomy Lecture of Dr. Nicolaes Tulp,* actually records this rather unsavory fascination with the dead body in Western art, medicine, and humanism. I recall walking into a room at the Mauritshuis in the Netherlands and coming unexpectedly upon the painting. Its sheer size was astonishing enough (seven by five feet). But the public, performative, indeed voyeuristic, nature of the setting—a semicircle of bourgeois gentlemen eagerly watching the venerable anatomist cut into a cadaver—is what I found most unsettling: that is, until I turned around and found myself part of a large semicircle of spectators who were, as I, fascinated by the whole dark and grisly thing.

Historically, the dead body in the West has always been fraught with all sorts of cultural vexations about spectacle, taboo, violence, and, perhaps surprisingly, research. As wave after wave of disease swept Europe, there was good reason for ordinary folk to shun the dead body and to fear the new anatomically based medical research. Perhaps, intuitively, it seemed unwise to delve into the interior of the dead body. One of the most horrible episodes in the history of medicine was an epidemic of fatal puerperal fever that swept the teaching hospitals of Europe in the nineteenth century, which was finally linked to the cadavers in the basement. Doctors were in the habit of delivering babies with unclean hands and instruments

after performing autopsies on women who had died of puerperal fever (Glasser 10–11).

Certainly by the early Renaissance in Europe, anxieties were being generated not only about the social taboo of the dead body and the prospect of its violent desecration, but also as Jonathan Sawday points out in *The Body Emblazoned,* about a "culture of dissection" that enabled a reciprocity of particularization among the social, aesthetic, and scientific spheres. What Foucault describes as an *episteme* of resemblance allowed the intrusive fragmentation of the dead body in an anatomy lecture to correlate with the social and intellectual imperative to objectify and partition the world (Sawday 2–3) and to create taxonomies of nature.[2] At the same time, the practice of anatomy began its lengthy association with criminality, not only because subject bodies were supplied by the executioner but also due to the law of supply and demand that soon gave rise to a lucrative trade in grave robbing, a nasty business portrayed in Mary Shelley's *Frankenstein.* Once anatomy was established as essential to pedagogy, several thousand cadavers were required by the medical schools each year, a demand the gallows could not hope to supply (Marshall 21). By the nineteenth century, it was not uncommon for surgeons to bribe undertakers and dissect bodies against the wishes of the deceased and their families. The problem was to a certain extent remedied by social reconfigurations such as England's Anatomy Act of 1832, although that piece of legislation simply transferred the burden of providing cadavers from the criminal class to the poor (Marshall 21–23). It did, however, enable research and pedagogical human dissection to gain some respectability and begin its retreat behind closed doors, where it remains to this day.[3]

As Rembrandt's painting also indicates, though, the dead body has been crucial to the advancement of knowledge in the modern West, certainly going back to the early rise of anatomy in thirteenth- and fourteenth-century Europe. While the state had already begun to sanction autopsy for medicolegal purposes, the decade of 1310 introduced the dissection of human cadavers into the university curriculum, with the first recorded pedagogical anatomy by Mondino de' Liuzzi in Bologna about 1315 (*Western Medical Tradition* 177). Interestingly, artists, not physicians, were among the first to study dissected human remains and were instrumental in helping anatomy obtain an initial degree of legitimacy, at least among the more learned (*Western Medical Tradition* 265).[4] Many of us are familiar with the stories of midnight dissections performed by Michelangelo and Leonardo da Vinci. Less well known is the formalized art theory based

on anatomy that was burgeoning at the time. *On Painting* by Leon Battista Alberti challenged the painter to study anatomy, to draw the body from the inside out. Alberti writes that after the artist sketches in the bones, he may "add the sinews and muscles, and finally clothe the bones and muscles with flesh and skin" (qtd. in Schultz 30). Indeed, a hundred years later Vincenzo Danti would conduct eighty-three human dissections in preparation for his treatise on art and its relationship to anatomy, *Trattato delle perfette proporzioni* (Schultz 43). And since the Renaissance, human anatomy has remained foundational to much artistic practice. Art schools today regularly require attendance at human dissection, and many contemporary artists work with magnetic scanning and X-rays.

At the beginning of this historical narrative, medical science and art conjoin most clearly in the exquisite representations of the dissected human body published in 1543 by Andreas Vesalius, *De Humani Corporis Fabrica.* The unknown artist of Vesalius's treatise on anatomy is clearly demonstrating how the bones and muscles articulate in the living human being by depicting the body in various stages of un-flesh, dead but enlivened in naturalized positions (figure 1). And for medicine, as it had for art, anatomy was rapidly becoming the foundation of knowledge, an epistemology that elevated the importance of observation and categorization, a sensualist and empiricist philosophy greatly enhanced by inventions such as the microscope in the late sixteenth century. Eventually, research-oriented autopsies would lead William Harvey to determine the circulation of the blood in the seventeenth century; based on some seven hundred postmortem dissections, Giovanni Battista Morgangi at the turn of the eighteenth century would read the pathological signs of disease in the corpse and seal the significance of anatomy to medicine; Marie François Xavier Bichat, claiming that "Several autopsies will give you more light than twenty years of observation of symptoms" (in Ackerknecht 148), would found a new clinical medicine in the early nineteenth century based on lesions seen in the cadaver ("the birth of the clinic," as Foucault calls it). This medical gaze would give rise to the laboratory medicine of today, vastly enriched by a pantheon of powerful "all-seeing" machines. But, as Jacalyn Duffin reminds us, observing the dissected body remains, at the beginning of the twenty-first century as it did to the early moderns, the best challenge to medical knowledge and diagnosis (66).

What is the status of the dead body today as we look back at its medical and cultural history in the modern West? Body criticism, as Duffin puts it, recognizes that the body has always undergone fabrication by

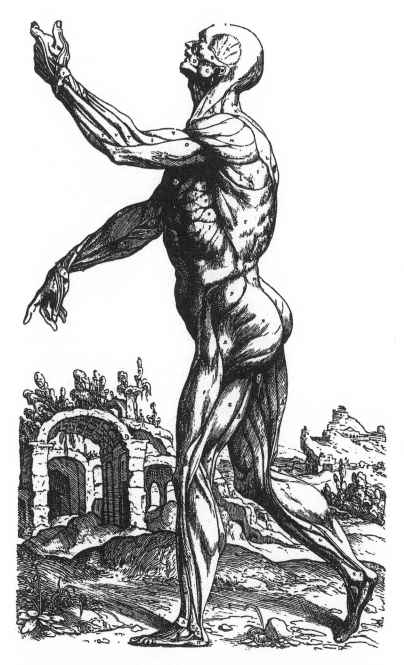

Figure 1. The Second Plate of the Muscles, Andreas Vesalius, *De Humani Corporis Fabrica,* 1543.

enculturation and socialization throughout history and has never been simply a human continent "waiting to be discovered and explored" (35). From this vantage, the title of Vesalius's *Fabrica,* for instance, begins to ring with additional significance, for it may be understood as naming a project that, in taking the body apart, put it back together not as an *original,* but as a *different,* empirically based morphology, indeed one that corrected the outgoing, "wrong" Galenic model. Criticism of the dead body, perhaps even more so than of the live body, apprehends the Western imperative to "do something" (in this case) about the corpse. Arguably the most powerful object in our lives, the dead body absent its cultural manifestations becomes a Kristevan abject too horrific to tolerate. As Philippe Ariès's monumental work, *The Hour of our Death,* so profoundly demonstrates, the chronicle of the dead body has always been one of proper categorization and placement in a culturally acceptable zone, whether laboratory, funerary, or aesthetic.

Certainly for Western epistemology, today we can detect in the history of the dead body the trace of a Foucauldian "residence of truth in the dark centre of things" (*Clinic* xiii), a "truth" that cutting up and representing the dead body has attempted to reveal. Once the Cartesian division of the soul and the body had occurred, the dead body in both the medical and aesthetic arenas could become the landscape of a quest for meaning, with the trope of an enlightening gaze navigating the discourses of the sciences, arts, and humanities. Even death becomes exposed as culturally constructed, an agency laden with the significance of social legibility and utility for the living. Essentially a postmodernist perspective, this view of death and the dead body constitutes the subject position spanning the twelve authors in this book, a wide-ranging group of two medical doctors, an artist, two art historians, a philosopher, a political scientist, a film scholar, and five literature scholars. Rather than aiming at a sweeping historical narrative, the essays provide a series of snapshots of the way the dead have been represented at particularly crucial moments from the public anatomies of the seventeenth-century London barber-surgeons to the cyberspace anatomy theater of today. The very title of the collection— *Images of the Corpse*—articulates the approach as an awareness that the dead body has always been subject to fabrication, albeit encoded in different ways at different times. Whether in the discourses of medicine or the arts and humanities, the dead body is viewed as a textual, semiotic, discursive entity. Cumulatively, the essays consider the impact constructions of the dead have on individual and social subjectivity.

The Essays

We begin with a descriptive essay by Dr. Eugene Arnold, a pathologist and medical examiner of long standing. In "Autopsy: The Final Diagnosis," Dr. Arnold draws on his deep professional experience to describe the current medical practice of autopsy. Beginning with his training in medical school, Dr. Arnold provides a privileged glimpse inside the autopsy room, at times allowing the reader to look over his shoulder as he performs a series of postmortem dissections. Demonstrating perhaps the purest expression of Western epistemology at work, Dr. Arnold explains how he "listens" to the dead body.

In the next essay, Maria Angel develops the notion that textual interpretation models forensic pathology as a dissection of the corpus. "Physiology and Fabrication: The Art of Making Visible" links the dead body with the book "as a series of laminated surfaces that are unfolded, refolded, and discovered in acts of research." Deploying a wide range of theorists from Michel Foucault to Gilles Deleuze, Angel argues that the (dead) body becomes legible through a navigation of "making visible" functions. In this remarkable essay, Angel turns her own critical gaze first on illustrations of pre- and Renaissance anatomy and then on descriptions of modern surgical practice, particularly plastic surgery.

Focusing on attitudes toward the dead body in the Renaissance, "Blood and Circuses" by Kate Cregan examines the theatrical, discursive character of the public anatomy in seventeenth-century London by the Worshipful Company of Barber-Surgeons. Comparing illustrations of the anatomy lecture with the playhouse, Cregan shows how the performance (costumes, properties, setting, and audience) was key to the generation of knowledge on the anatomical stage. At the center of Cregan's discussion is a marvelous case study of Canberry Besse, a woman who was executed at Tyburn and subsequently anatomized publicly. Canberry Besse exemplifies how the dead body is determined by a "discursive construction of meaning," and especially for the female, embodied as an eroticized subject formed at the headwaters of gender, criminality, death, and spectacle.

Dr. Robert April, a medical neurologist and amateur scholar of nineteenth-century French literature and history, writes the next essay, "Representation of the Dead Body in Literature and Medical Writings during the Restoration in France." Exercising a medical doctor's expert knowledge of clinical medicine, Dr. April offers a masterful analysis of the paradigm shift taking place in medical thought and practice during

post-Revolutionary France. Turning away from the earlier system of nos-
ology, Dr. April shows how physicians began to develop the lesion-based
concept of disease and pathological anatomy. He then reads three famous
deathbed or postmortem scenes from Gustave Flaubert's *Madam Bovary*
and Honoré de Balzac's *Le Père Goriot* and *La Peau de Chagrin* against the
medical theories and practices of the day.

Reading Brazilian literature from the late nineteenth and twentieth
centuries, Robert Moser considers the eerie phenomenon of the *revenant,*
"that which returns" from the dead in the form of a corporeal materiality.
Grounding his approach in the death culture and history of Brazil, Moser
demonstrates how an ongoing dialogue between the living and the dead
helps construct social relations and identities, including a carnivalesque
upside-down social order. His essay "The Carnivalesque *Defunto:* Death
and the Dead in Modern Brazilian Literature" pays particular attention to
the intriguing novel by Joaquim Maria Machado de Assis, *The Posthumous
Memoirs of Brás Cubas.* Here, Moser expertly unpacks the vantage point of
the narrator, who poses not as "a writer who is dead but a dead man who
is a writer."

In the next essay, "Watching Over the Wounded Eyes of Georges
Bataille and Andres Serrano," Kylie Rachel Message skillfully mobilizes
the theories of Jacques Lacan, Jean Baudrillard, and Roland Barthes to
demonstrate how the spectator's self-identity becomes problematized
through an interchange of gazes with the dead. Allowing the *Morgue* series
of photographs by Serrano to operate on Bataille's *Story of the Eye,* Message
pinpoints an attraction-repulsion mechanism of the corpse that seduces the
subject, blinds the eye, and produces signage in reference only to death.
In Message's intriguing model, desire unfolds in the subject as a masochis-
tic imperative.

By examining the art of Gerhard Richter, Andrew McNamara considers
the linkage of death and art in such works as *18 Oktober 1977,* which de-
picts members of the German terrorist group known as Baader-Meinhof.
McNamara argues in "Optative Death: Gerhard Richter in the wake of
the Vanguard" that such meditations on death broach the limits of art and
wrack the contemporary artist with the ghost of modernist provisionality.
In staging another "funeral" for the Baader-Meinhof gang in this suite of
paintings, which includes *Tote (Dead Woman),* Richter engages the ques-
tion of art's memorializing function in the "wake of the avant-garde."

"[A]s a feminist, is it 'wrong' to enjoy a film which lingers over images
of women's violated bodies?" This is a paradox pondered by Deborah

Jermyn in her courageous essay, "You Can't Keep a Dead Woman Down: The Female Corpse and Textual Disruption in Contemporary Cinema." Analyzing three recent mainstream films, *Reversal of Fortune, The Silence of the Lambs,* and *Copycat,* Jermyn considers whether the female murder victim, being doubly abject as a dead woman, acts as a site of disruption in the filmic text. Jermyn suggests that it may be possible to reconcile feminism with representations of the female corpse.

Interestingly, the reconciliation Eugene Thacker tackles in the next essay is between the real-world body and cyberspace. "Database/Body: Digital Anatomy and the Precession of Medical Simulation" describes the fascinating Visible Human Project, initiated by the National Library of Medicine and the National Institutes of Health, in which male and female cadavers were sliced, scanned, and uploaded onto an online database. In exploring the status of the body as information and the relations among the cadaver, the virtual body, and referential human subjects, Thacker identifies a paradigm shift from an empirical to a digital epistemology.

Michael Mendelson's philosophic essay "The Body in the Next Room: 'Death' as Differend" poses the question haunting all of the essays in this collection: Do representations of death ultimately fail because death is something unrepresentable? The dead body is simply a vestige, the silent relic of a *not*-place and a *not*-being we cannot even begin to discern. Yet, in this beautifully conceived reflection, Mendelson describes a moral topography that includes death as part of a figural, pictorial, and cartographical construct. Although we cannot actually see or conceive of death that is truly "death," we cannot doubt its presence and actuality.

We end the book with a splendid collaboration between a scholar and an artist, Jennifer Webb and Lorraine Webb, which explores the relation of death to the subject, particularly the artist-subject, and to the construction of meaning. Based on a series of sketches Lorraine Webb made at the Museum of Anatomy in Australia, "Dead or Alive" suggests that painting the dead body profoundly opens up the relation of the self to the body and the primary rifts in identity. Recalling the significatory power of autopsy in Dr. Arnold's descriptive essay (the first chapter), "Dead or Alive" persuasively links the artist with the pathologist as agents enabling the dead body to represent.

NOTES

1. Judge Ito denied the media's request to show the autopsy photographs of murder victims Nicole Brown Simpson and Ronald Goldman.

2. See Foucault, *The Order of Things*, 17–45.

3. In England, the Murder Act of 1752 made compulsory the execution and public dissection of all murderers. The Anatomy Act of 1832 gave the medical schools access to the unclaimed bodies of the poor, a practice that began to die out by World War II. Today, most cadavers are acquired by donation.

4. Contrary to popular belief, by the early modern period the Catholic church was sanctioning the dissection of human bodies. It was the college of physicians who lagged behind in recognizing the importance of anatomy.

WORKS CITED

Ackerknecht, Erwin H., M.D. *A Short History of Medicine*. New York: Ronald Press Company, 1968.

Duffin, Jacalyn. *History of Medicine: A Scandalously Short Introduction*. Toronto: University of Toronto Press, 1999.

Foucault, Michel. *The Birth of the Clinic: An Archaeology of Medical Perception*. Trans. A. M. Sheridan Smith. New York: Vintage, 1994.

———. *The Order of Things: An Archaeology of the Human Sciences*. New York: Vintage, 1994.

Glasser, Ronald, M.D. *The Light in the Skull: An Odyssey of Medical Discovery*. Boston: Faber & Faber, 1997.

Marshall, Tim. *Murdering to Dissect: Grave-robbing,* Frankenstein *and the Anatomy Literature*. Manchester: Manchester University Press, 1995.

Monroe, William. "Performing Persons: A Locus of Connection for Medicine and Literature." *The Body and the Text: Comparative Essays in Literature and Medicine*. Ed. Bruce Clarke and Wendell Aycock. Lubbock: Texas Tech University Press, 1990. 25–40.

Sawday, Jonathan. *The Body Emblazoned: Dissection and the Human Body in Renaissance Culture*. London: Routledge, 1995.

Schultz, Bernard. *Art and Anatomy in Renaissance Italy*. Ann Arbor: UMI Research Press, 1985.

The Western Medical Tradition: 800 BC to AD 1800. Cambridge: Cambridge University Press, 1995.

Images of the Corpse

Autopsy

The Final Diagnosis

EUGENE A. ARNOLD

L et me speak frankly. Over the years I have performed, observed, or reviewed many autopsies. To me there is little that is noble or romantic about the cadaver on the dissecting table. In many instances the dead body provides graphic evidence of the ravages of disease or the brutality of violence to which the person was subjected prior to death. Distress, pain, and anguish are sometimes indelibly etched in facial expressions or body distortions. In other instances the person appears serene. Whatever the presentation may be, there is a neutrality about the deceased that does not justify a judgment about emotion. The proper setting for this type of judgment would seem to be the manner in which the individual faced the terminal stages of life. So, dying may be handled in a noble manner or the circumstances of dying may have romantic overtones, but the dead are silent in this regard.

An autopsy is a procedure that must be performed without emotions of dismay, distaste, or sentimentality. The dead body on the table is many things: a testimonial to a failure of the healing arts; a testimonial to the violence humans inflict upon one another or upon themselves; and concrete evidence of our mortality. For the pathologist, however, the deceased person on that table is something more. Within that dead husk there are answers to the events and circumstances that led to his or her demise. There are answers to explain the failure of therapeutic efforts to prolong life. There may be factors suggesting that there is a new or previously unknown disease process present in this person that might lead to expansion of our knowledge of disease. The deceased, mute though they may be, have valuable things to tell us. The translator for these messages is the

3

pathologist and the interpretation requires an attitude of objectivity, a systematic approach, and the knowledge and experience to decipher the information presented.

Acquisition of these attributes is a long and sometimes difficult process. One of the most onerous of the problems to be faced is mastery of your own feelings about violation of the body of a dead person. Different people handle this in different ways, so I can speak only for myself in this regard. Religious preference or philosophical attitudes do not seem to play a role since pathologists come from all backgrounds in regard to theological creed and outlook on life and its values. The basic tenet for me is respect for the deceased and the knowledge that the deceased and I are working together to solve a problem. I do not intend to trivialize or minimize the situation, but for me autopsies are intellectual exercises in reverse problem solving: I am presented with the end result of the interaction of a number of factors that I must identify and correlate in terms of temporal sequence and significance.

So how did I acquire this mind-set? When I first went to medical school I had had little personal experience with the dead or the dying. The only family member who died in the period between my childhood and matriculation was a great-grandmother who died when I was ten years old. I have only vague memories of her funeral and I didn't even know that she had a terminal illness. My first real encounter with a dead body was in the anatomy laboratory in medical school. First-year students were divided into groups of five and assigned to a cadaver for dissection. My group worked on a man who had died in prison. We never knew why he had died. Even here the experience seemed to have little relation to the process of dying or of the dead. The room had a strong odor of formaldehyde and the cadaver was gray, stiff, and hard. It didn't seem to be a real person. I don't remember any of the students being in distress at our systematic dissection of this body.

The next encounter with the dead occurred in the second year of medical school. It was a requirement of the pathology department that all students participate in six autopsies during the course. The sixth autopsy was to be performed by the students under direct faculty or house staff supervision. Each group of four students was placed on a rotating call schedule for autopsies performed during the pathology course instructional time. My group was third in the rotation, and by the time we were called for our first autopsy we had heard tales of students in the preceding groups vomiting, leaving the autopsy room in distress, or fainting. Our anxiety

level was high when we gathered in the corridor outside the autopsy suite, and we engaged in nervous banter about who in our group would be the one to pass out. The resident performing the autopsy called us in. There were two autopsy tables in the room, which was large, well lighted and immaculately clean. The air had a slightly sweet smell mixed with the pungent aroma of disinfectant. No dead body was present. We sat in a small office and the resident outlined the clinical findings for the patient, the diagnosis, and the course of events in the hospital prior to the patient's death. The patient had been a fifty-four-year-old white male cigarette smoker who had presented with a complaint of progressively severe head-aches that did not respond to analgesics. He had had a twenty-two-pound weight loss over a three-month period and had a dry, hacking cough and a low-grade fever. Chest X-rays showed a mass in the main-stem bronchus on the left, skull X-rays showed a mass in the left parietal lobe of the brain with a shift of the midline of the brain to the right, and examination revealed edema around the head of the optic nerve on ophthalmoscopic examination. The clinical diagnosis had been bronchogenic carcinoma with metastasis to the parietal lobe of the brain and increased intracranial pressure.

We put on plastic aprons and surgical gloves and went into the autopsy room. The resident reminded us that we were to show the same respect for the deceased that we would for a living patient and tried to reassure us that, while the procedure was not a pleasant one, neither was it grue-some. He told us that if we found it beyond our tolerance we were free to leave the room. The diener (who is the autopsy assistant) brought the body from the refrigerator, and he and the resident placed it on a table. They confirmed the identity of the deceased and began the procedure. At each stage of the dissection the resident explained what he was doing and the reason for doing it in a particular manner. Each step was done in a systematic manner so that there would be no inadvertent omission of findings. Organs were weighed, measured, and dissected. Samples of each tissue were placed into bottles of fixative for later microscopic examina-tion. Body fluid samples were obtained and placed into appropriate tubes for biochemical, bacteriologic, or immunologic testing.

As the procedure continued, I found myself becoming engrossed in the task of making correlations of the physical findings and how they explained what this person had experienced during his illness and why his physician had ordered different tests and prescribed different therapies as his disease evolved. There was the emaciated body, the malignant tumor

partially obstructing the main-stem bronchus with the gross pathological presence of bronchopneumonia and the presence of a rounded mass at the gray-white cortical junction in the parietal lobe. The increased intra-cranial pressure had led to herniation and compression of the midbrain as the cause of death. A final finding, which had not been detected clinically, was the presence of metastases to the adrenal glands. On later microscopic examination, the primary tumor was found to be a small-cell carcinoma, explaining why the patient had not been operated on for his lung tumor since this type of malignancy is virtually incurable by surgery.

As the autopsy progressed, I also found my anxiety and emotional distress fading. I became engrossed in the way the autopsy was providing a visual explanation for the events that had occurred in this man. This patient was providing me an exposition of human frailty that transformed the printed words in the pathology textbook. William Osler was right! To practice medicine without a textbook is to go to sea without a chart; to practice medicine without a patient is not to go to sea at all. My subsequent autopsy experience has reinforced my appreciation of the validity of Osler's concept. The intellectual constructs of the medical literature come alive only when you listen to and understand the lessons of the patient. Incidentally, none of the students in my group fainted, got sick, or left the room.

The Practice of Autopsy

A systematic approach is of great importance in the autopsy procedure. The methods that have been developed over the years are intended to minimize the chance of overlooking relevant findings. If the deceased died in the hospital the initial step is a review of the findings documented in the patient's chart. You read the admission workup, the provisional diagnoses, the laboratory data, the nurses' notes, and the progress notes recorded during the patient's hospital stay. If there were surgical procedures or biopsies performed, you review the operative notes and the tissue diagnoses obtained from these procedures. The intent is to become familiar with the events that led to the patient's admission; the physical findings and symptoms present at the time of admission and their evolution during his stay; the family and social background that is relevant to the illness as diagnosed; the laboratory findings that support or rule out different diagnoses; and the therapeutic measures utilized along with the responses to therapy.

The second step in the autopsy is thorough examination of the appearance of the individual. Is this the person on whom the autopsy is to be performed? You compare his wristband identification and his toe tag against the chart data. His height is measured and recorded. Body weight is usually obtained from the hospital chart although the body may be weighed in the autopsy suite. For his stature and sex was this person thin, emaciated, well nourished or obese? Does he appear to be normally developed physically and sexually for his stated age? Are there scars or recent incisions either from surgery or trauma? How do these correlate with the data from the patient's present or past medical history? Are skin lesions present? If so, what are their size, distribution, color, and characteristics? If the patient has been burned, what percentage of the body surface is involved and are the burns partial- or full-thickness burns? Is there evidence of infection of the burned areas? You look for evidence of injection sites. You assess the degree of rigor mortis and look for postmortem lividity, which is due to the pooling of blood in dependent areas of the body after death. You examine the oral cavity, the eyes, the nose, and the ears and look for edema or swelling of the extremities. In some cases edema may be severe with involvement of the trunk as well as the lower extremities, a condition known as anasarca. All abnormalities are measured, anatomically mapped, and recorded.

The examination of the internal organs is the next step. One of two approaches is generally used. One procedure is attributed to Rudolf Virchow, the "father" of modern pathology, the other to Karl Rokitansky, an eminent Austrian pathologist practicing in the nineteenth century. In the Virchow procedure the internal organs are removed in one block of tissue, maintaining their anatomical relationships after removal from the body. In the Rokitansky method the organs are removed individually for dissection. In the vast majority of cases the dissection of the organs is performed in the same sequence, although an occasional situation may be encountered where the tissue changes produced by the disease make this impossible and the dissection technique has to be modified. The primary concern is to evaluate the changes occurring in each organ and to assess alterations in the anatomical relations of abnormal organs to neighboring structures or to distant organs. Tissue samples are taken from each organ in the body and placed in fixatives for processing for microscopy or placed in appropriate dishes or tubes for studies in microbiology, biochemistry, immunology, or toxicology. Each organ is weighed and measured and all abnormalities of appearance are recorded in the autopsy notes. A standard

procedure is to remove the brain and the meningeal membranes intact and suspend the brain in a gauze bag in a large crock of fixative for later dissection and sampling. For voluntary autopsies it should be remembered, however, that restrictions may be placed upon the extent of the dissection by the next of kin. These restrictions are legally binding and may alter the entire procedure.

Now comes a critical point: how do you recognize abnormality? Even more importantly, how do you recognize a pattern of abnormalities that lead to a firm, accurate evaluation of what developed in this individual? For this exercise a set of criteria must be at hand that allows you to distinguish the alterations produced by one disease entity from those produced by every other disease entity. These markers have been developed, formulated, tested, and retested over the centuries by workers in all disciplines of biomedical science. Pathology is an eclectic discipline with no unique methodology. The pathologist builds his diagnosis using the bricks provided by all fields of biological science. In this regard, pathology has often been described as a "bridging discipline," allowing the flow of knowledge and information between basic and clinical sciences to come together for the solution of medical problems as they occur in the individual and in populations. The acquisition of this knowledge comes from undergraduate training in chemistry, biology, physics, and mathematics followed by medical school training in all aspects of basic and clinical science. Then there is the daily application of this material to the autopsy, to autopsy conferences, to surgical pathology, to cytology, to laboratory medicine.

When I was in training in pathology we (the pathology house staff) performed an average of three autopsies a week and went to six autopsy conferences a week, where the previous day's autopsies were reviewed in detail by the senior faculty. All autopsies that we performed were reviewed at completion by a senior faculty member, and we were examined in detail at that time about our evaluation of the findings. I will never forget one particular autopsy during this period of my training. This was the forty-first autopsy I had performed. I started the autopsy at 5:00 P.M. and finished at about 8:30 P.M. I called the senior faculty member to let him know that the procedure was over and that I was ready for his review. He questioned me about the clinical aspects and asked me to summarize my findings, which I did. He then said, "Gene, I don't believe I have to come to review the tissues. I think you know what you're doing. I'll see you in the morning at the conference."

And the conference went well. At my case presentation to the pathology faculty and staff I was able to demonstrate the correlations between the anatomical findings and the clinical abnormalities the patient had shown during the course of his illness. The variations in the natural course of the disease that had been produced by therapy were demonstrable, as was the cause of death. The gross anatomical findings at postmortem examination were sufficient to establish the final diagnosis, and the later microscopic findings and laboratory data became simple confirmatory evidence for the provisional autopsy findings. In many instances the gross anatomical findings are found to be correct in establishing diagnoses, while in other cases the gross findings provide an imprecise diagnosis that must be amplified and modulated by further studies. For example, a diagnosis of bronchogenic carcinoma can be established with a high degree of certainty at autopsy, but a diagnosis of squamous cell carcinoma of the lung requires microscopic examination to separate this particular type of malignancy from other forms of cancer involving the bronchial tree.

My forty-first autopsy had brought me to a stage that all pathologists must achieve: the synthesis of informed observation and the clinical database into an intellectual whole that is precise and that has little or no ambiguity. After the years of study in university and medical school there is a continual educational process in the postgraduate years in which hundreds of cases are studied on an individual basis and the correlations between the clinical data and the pathological findings are constantly being established. In surgical pathology, autopsy pathology, and cytopathology, hundreds of microscopic slides are studied and the changes seen here are related to the gross anatomical findings in the surgical specimens or the postmortem examination as well as to the clinical data for each case. The characteristic features of each disease are then mentally catalogued so that unique aspects of each can be identified.

One disease may present clinical and anatomical features that closely resemble other forms of disease, so that overlap or mimicry occurs. In this case, the fact that mimicry may be present must be recognized and the overlap taken into consideration, necessitating the search for those features or combination of features of each disease that are seen only in that particular entity: the practice of differential diagnosis. Another problem that must be recognized and taken into consideration is that variations in the manifestations of abnormalities may occur, so a spectrum of alterations may be seen in a single particular disease entity, a theme with variations, so to speak. It is the repetitive case study of many

examples of disease in many individuals that defines the limits of mimicry and variation.

The conceptual framework utilized in the medical autopsy (as opposed to the forensic autopsy) is that disease is initiated and progresses in a series of four steps. The first of these involves a specific interaction between an injurious agent (an etiological agent) and a cell system. The injurious agent may be from either the external or internal environment of the affected cells. The second phase arises from the alterations of cellular function that are the result of this specific interaction. This cascade of altered metabolic pathways produces morphological changes within the cell that are related to the etiological agent, the specific initial interaction, the cell population at risk, and the duration and severity of exposure of the cells to injury. These structural changes may be at any or all levels of anatomical organization: subcellular, cellular, organ, multiple organs, or total body. The final step is the clinical presentation of these changes, which now appear as symptoms, signs, anatomical abnormality and/or abnormalities in body fluids and physiologic function, and the appearance of tissue changes with imaging techniques. Clinicians develop the database from the final phase as the basis for diagnosis and treatment, and the pathologist utilizes this information to develop an understanding of the preceding steps. In many instances, of course, there is considerable overlap of the functions of the clinician and the pathologist in the development and understanding of the implications of the data presented by the patient, with the primary difference being in the methods by which the data is obtained.

The Performance of Autopsy

Let's go through a medical autopsy briefly to illustrate this process of observation and correlation. The diener calls to tell you that an autopsy is scheduled for a Mr. Jones, who died this morning in the intensive care unit. When you arrive in the autopsy suite the diener tells you that the body was placed in the refrigerator an hour ago, indicating that there has been a short postmortem interval and that tissue integrity should be of good quality. The chart indicates that Mr. Jones was admitted through the emergency room, where he complained of severe epigastric abdominal pain that radiated to his upper back. The pain was constant and intense and was accompanied by abdominal tenderness with guarding. Initial diagnostic considerations were perforated peptic ulcer, acute hemorrhagic

pancreatitis, ruptured acute appendicitis, mesenteric artery occlusion with ischemia of the bowel, or rupture of a gangrenous gall bladder with acute cholecystitis. He was a forty-two-year-old chronic alcoholic of the "spree" drinking pattern, who had been drinking heavily just prior to the onset of the abdominal pain. Initial blood studies showed an elevated serum amylase of the pancreatic type and hypocalcemia. He was admitted with a diagnosis of acute hemorrhagic pancreatitis on the basis of the history of drinking, the character of the pain, and the blood findings.

In the hospital he was placed on supportive therapy since there is no specific treatment for pancreatitis. His vital signs were normal. Blood studies on the third day of hospitalization showed elevated serum lipase levels with continuing low calcium levels. Clinically, the lipase elevation confirmed the diagnosis of acute pancreatitis. He then rapidly developed marked decreases in blood pressure followed by rapidly developing short-ness of breath, increased heart rate and respiratory rate, and X-ray evidence of pulmonary edema. His urine output decreased with an accompanying elevation of blood urea and creatinine levels. The diagnosis was adult respiratory distress syndrome and acute renal failure secondary to shock. He died the next day in stage three shock.

Together with the diener, you place the body of Mr. Jones on the autopsy table. You measure his height and note that he has needle puncture marks on the dorsum of his left hand and an indwelling catheter inserted through his penis into the urinary bladder. He is normally developed, pale, and shows some wasting of the extremities. There is no evidence of jaundice. Rigor mortis has not developed and there is minimal postmortem lividity of the back and the buttocks. Examination of the oral cavity, ears, and nasal passages show no abnormalities. You confirm his identity by his wrist band and the toe tag placed there after his death. You remove the indwelling catheter. The permission for autopsy restricts the procedure to the thorax and abdomen, with no brain examination to be done.

The initial incision is Y-shaped and extends from the clavicles down the midline to the symphysis pubis. You dissect the pectoral muscles and skin from the rib cage and separate the diaphragm from its thoracic attachment. With a large pair of shears, you cut through the costochon-dral junctions bilaterally and cut through the tissue at the sternal notch. The sternum can now be removed and the organs can be examined in situ. The lungs are red and firm, but there is no fluid in the thoracic cavity. Several abnormalities can be seen in the abdominal organs. The mesenteric

and omental fatty tissue shows multiple small focal areas of yellowish white masses and the liver appears large and yellow. Anatomical relationships of all organs is normal and there is no excess fluid in the peritoneal space. You now cut through the trachea and then dissect the remainder of the diaphragm from its attachments. The rectum and urethra are severed deep within the pelvis and all of the organs are removed as a single block of tissue and placed on the table for dissection. You have just utilized the Virchow procedure.

The criteria that are used to evaluate gross anatomical abnormalities are alterations in size, shape, color, and consistency of each organ. First you ligate the small intestine at the ligament of Treitz and then remove the entire intestinal tract from its mesenteric attachments. The bowel is set aside for later examination. Opening the aorta posteriorly you note that there is moderate atherosclerosis, particularly of the abdominal aorta. No thrombi are present and the aorta appears otherwise normal. The pericardial sac is opened and the heart is removed. The surfaces are smooth and glistening and there is no excess pericardial fluid. The heart weighs 378 grams, which is within the normal range for an adult male. Dissection shows only moderate atherosclerosis of the coronary arteries, with no lesions found in the myocardium, endocardium, or pericardium. The heart is firm and no changes in color are present. The valves and ventricular walls are measured and are within normal limits.

The lungs are increased in consistency, with loss of normal aeration, and ooze a frothy fluid from their cut surfaces. Fluid of this type is also found within the bronchial tree. The color is beefy red, a marked departure from the normal tannish pink. The lungs are very heavy and do not float when placed in a water bath. The other abnormalities are confined to the pancreas and liver. There is marked enlargement of the head of the pancreas, and multiple areas show an irregular deep red discoloration. This type of discoloration is also present to a lesser degree in the body and tail of the pancreas. The normal lobulated architecture shows distortion by areas of fibrosis, and sectioning reveals calcification of the parenchyma in some areas. The surface fat reveals the same small yellowish foci that were seen on the omental and mesenteric surfaces. The common bile duct and gall bladder are opened and show no gall stones or evidence of inflammation. The liver weighs 2,357 grams, which is well above the normal range, and has a greasy yellow surface. There is no gastric or duodenal ulceration and the appendix is normal. The wall and mucosal surfaces of the intestinal tract are normal. The kidneys appear normal grossly. Multiple tissue

samples are taken from each organ and placed in two different types of fixative for histological processing.

A brief anatomical diagnosis of the major findings related to this person's terminal illness would be: acute hemorrhagic pancreatitis with fat necrosis of omentum, mesenteric, and pancreatic fat; chronic pancreatitis; adult respiratory distress syndrome (diffuse alveolar injury); fatty liver; and moderate atherosclerosis of aorta and coronary arteries. Microscopic examination of the kidneys later showed necrosis of the tubular epithelium as the anatomical basis for the acute renal failure.

The Epistemology of Autopsy

What does the autopsy tell us about the clinical findings? Acute pancreatitis is usually caused by alcohol intake or obstruction due to gall stones. Usually the acute process occurs in a person with preexisting chronic pancreatitis. This patient had no gall stones, and the type of fatty liver seen here is extremely frequent in the alcoholic. The low blood levels of calcium are due to sequestration in the multiple areas of fat necrosis, and the presence of pancreatic enzymes in the blood is due to destruction of tissue with leakage of active enzymes into the bloodstream. The loss of normal pancreatic function frequently produces profound shock, which led to the lung injury with massive pulmonary edema and the kidney damage resulting in failure. The third stage of shock does not respond to treatment and is almost always fatal. The clinical diagnosis was correct in this case, and the autopsy provided confirmation for the progression of events following the acute pancreatic damage. In some cases there is a discordance between the autopsy findings and the clinical impressions, in which case the autopsy becomes a teaching tool for the practitioner.

The autopsy also helps to expand medical knowledge. At least eighty diseases have been discovered or clarified by autopsy data since 1950. Two small examples of this happened in my own experience. One case involved a young man who had an extra Y chromosome: the XYY syndrome. He committed suicide by jumping off a bridge into a rocky riverbed. Death was due to several severe traumatic lesions. A routine examination of his testicles as part of the postmortem revealed a marked abnormality in the normal development of testicular cells into mature sperm: maturation arrest. Was this an isolated finding peculiar to this individual or might it be a part of the XYY syndrome generally? In collaboration with endocrinologists, we studied the prison population in a maximum security facility,

since the incidence of XYY males is higher in prisoners than the general population. Study of testicular biopsies from these prisoners showed a high number with maturation arrest, all of whom had the XYY genotype. From this and subsequent studies we now know that one of the causes of male infertility is the XYY syndrome.

In the second instance we routinely made lung smears from all patients who came to autopsy with pneumonia. In a few of these patients the causative organism was *Pneumocystis carinii.* Positive smears for this agent occurred only in patients who had hematopoetic malignancies such as leukemias or lymphomas or who were otherwise severely immunosuppressed. The faculty member who was conducting this study reported it in the 1960s, anticipating the later emergence of *Pneumocystis* as the most common infection occurring in the AIDS population.

The forensic autopsy is conducted when a person dies for unknown reasons. This might be a death where the individual was not under a physician's care or where the police have made a determination that death due to accident, suicide, or homicide must be established. In this type of autopsy there rarely is a clinical history available, and the starting data consists of a police report. Documentation of all findings is critical, and specialized approaches in ballistic injury, toxicology, traumatic injury characteristics, and causes of sudden death are used. The chain of evidence must be maintained and extensive imaging and tissue sampling are more commonly used than in the medical autopsy.

Of the forensic cases I have done, one was particularly gratifying because of the fortunate outcome for the family of the deceased. The coroner called to say that the dead man had recently been dishonorably discharged from the Air Force for insubordination, failure to perform his duties, and assault and battery. He was visiting his sister who lived in our jurisdiction, and he had collapsed in her bathroom. He was dead when the ambulance crew arrived fifteen minutes later. There had been a discharge physical performed where he had been found to be in "good health." The military were sending observers for the autopsy, and duplicate tissue samples and slides were to be provided to the appropriate federal agency for confirmation of our findings.

At autopsy the man appeared to be perfectly normal on external examination except for a small scalp laceration where he had struck his head on the tile floor of the bathroom. Examination of the thoracic and abdominal organs also revealed nothing abnormal. When we removed the brain, however, it was markedly swollen with congestion of the meningeal vessels

and showed compression ridges bilaterally on the lobes of the cerebellum. These findings were consistent with cerebral edema, increased intracranial pressure, and tonsillar herniation of the brain into the foramen magnum. I dissected the brain in the fresh state in this instance and found a large tumor mass arising in the right cerebral hemisphere that had invaded the corpus callosum and spread to the left cerebral hemisphere. The tumor showed areas of hemorrhage and some cystic regions. The cerebellum and medulla showed areas of infarction due to compression of the vascular supply. Medullary infarcts are rapidly fatal. The most unusual aspect of this case was the tonsillar herniation with a supratentorial mass since tonsillar herniation usually is seen with masses in the posterior fossa. The findings at autopsy and confirmation of the presence of a glioblastoma multiforme by microscopy provided the explanation for the abnormal behavior patterns and raised questions about why it had been missed by the medical personnel at the air base. The sergeant was reinstated post-humously, and his family was able to receive the benefits to which they were legally entitled.

The word *autopsy* comes from the Greek *autoa* (self) and *opsis* (to see), which is usually rendered as "to see with one's own eyes." This is a limited translation, since the autopsy is really informed observation with deductions based upon the accumulated knowledge of our antecedents. In many ways we are the beneficiaries of this interaction between the deceased and the observer and will continue to be in the future, if we will only listen.

Physiology and Fabrication

The Art of Making Visible

MARIA ANGEL

[F]or did we not pray once in a way to wrap up in a book something so hard, so rare, one could swear it was life's meaning?

—Virginia Woolf, *Orlando*

The relationship between the dead body and text is reflected in the etymological connection between corpse and corpus. Both are derived from the Latin *corpus* meaning body, and both these kinds of bodies are the sites for investigative and critical procedures that rely upon certain kinds of visibility. Gilles Deleuze argues that for the philosopher Michel Foucault forms of knowledge and the specification of its objects has involved relations between "seeing and speaking," that is, between "bands of visibility and fields of readability," that alter in different historical periods (47). I argue that the history of the body as an object of knowledge is entwined with the history of the book and its function in the service of the anthropologies of "man." Describing the interpretive work of a "human" science and the birth of modern medicine, the historian Michel de Certeau writes of the body becoming a "*legible* picture that can in turn be translated into that which can be *written* within a space of language." For Certeau, the cadaver of modern medicine is a book, a "cipher that awaits deciphering." He argues that between the seventeenth and eighteenth centuries what allowed the seen body to be converted into the known body was "the transformation of the body into extension, into open interiority, like a book, or like a silent corpse placed under our eyes" (3). The dead body, like the book, takes shape as both a visibility and a repository of knowledge.

Within the field of medical anatomy, the corpse has had to bear the empirical responsibility for demonstrating and revealing the functions and

constitution of the human body (life itself) through the detailing of organs and systems rendered visible by the anatomical procedure. The textual corpus, on the other hand, is a body of work whose contours and systems are rendered perceptible and authenticated by what Michel Foucault has termed an "author function." Tracing the historical emergence of this function, Foucault argues that during the Middle Ages scientific texts dealing with cosmology, medicine, and natural science were "only considered truthful . . . if the name of the author was indicated" (*Language* 125–26). Truth was rendered in the image of the authorizing word drawn from the holy and canonical texts of knowledge and applied to the world of things. In more contemporary times, the concept of authorship, figured in Roland Barthes's famous concept of "the death of the author," has intensified rather than negated the relationship between the corpus and corpse. For textual criticism, the text is taken as the author's excremental remains, a body of "dead" letters. The predominant paradigm for textual studies has been that of forensic pathology and its modus operandi, the critical autopsy. Like the corpse, the text is something to be opened up, secularized, and dissected in order to find out how it works, how "life" works. It isn't hard to find pathological metaphors in the bodies of textual criticism. Barthes's "The Death of the Author" abounds in histological references. "The text," he writes, "is a tissue of quotations drawn from the innumerable centers of culture," and, of the corpus functioning as a site for the investigation of vital functions, he states that "life never does more than imitate the book, and the book itself is only a tissue of signs" (*Image* 147).

Using the concept of physiological texture to frame my analysis, I look at how the body has become "textualized," that is, written into an anatomical corpus through a process of saying and seeing. I propose that the folding together of text and image, language and visibility, produce particular forms of knowledge applicable to our perception of both the book and the body. Drawing on the diverse work of Andreas Vesalius, Michel Foucault, Gilles Deleuze, and Jacques Derrida as well as Stefan Hirschauer's work on the manufacture of bodies in surgery, I develop a model of the dead body and book as a series of laminated surfaces that are unfolded, refolded, and discovered in acts of research. Using examples drawn from the fields of anatomy, physiology, philosophy, and literature, I argue that processes of authorization are material discursive practices; they construct authority through the production and exhibition of material documentation that functions as a body of evidence. In fact, the body and its images

are the sites used in the discovery and exposition of knowledge and truth about the human subject in both physiological and ontological senses.

Fabrication and Discovery

To write the body.
Neither the skin, nor the muscles, nor the bones,
nor the nerves, but the rest: an awkward, fibrous,
shaggy, raveled thing, a clown's coat.

 —*Roland Barthes by Roland Barthes*

Contesting the distinction between fact and fiction by exposing the "weave of difference" at work in these apparently epistemologically and ontologically distinct categories, Derrida's work on fabrication and the function of veiling in the structuring of truth exposes the seams and makeup of truth, that is, its textuality.[1] In "Le Facteur de la Vérité" he argues, "In attempting to distinguish science from fiction, one finally will resort to the criterion of truth" and that in asking the question "what is truth?" one will be drawn "beyond the waystations of adequation or of homoiosis, to the notion of unveiling, of revelation, of laying bare" (419). In other words, he proposes that the staging of "truth" within the domain of "science" proceeds by two moments. The first of these is adequation, or correspondence, where an example is chosen because it corresponds in some way to the truth. Second, through the masterly act of demonstration and interpretation (analysis), the example "starting from its original content, is to be co-ordinated with its naked truth, but also with truth as nakedness" (415).

"Le Facteur de la Vérité" begins by calling into question the status of truth through the analysis of a textual example, a body of evidence. Derrida asks, "What happens—and about what—when a text, for example a so-called literary fiction, . . . stages truth?" (417). The body *of* evidence he chooses as his example has the body *in* evidence as its theme: Hans Andersen's tale of "The Emperor's New Clothes." In this fable, two impostor tailors weave an Emperor an invisible garment that they maintain will be visible to his good and loyal subjects. The Emperor parades publicly in his invisible garments, and his loyal subjects, "intimidated by the fabric's power to act as touchstone," (417) pretend not to notice until a young child loudly proclaims the Emperor's nakedness. As Derrida notes, the tale presents us with both an invisible nakedness and invisible garments, a visibility at once hidden and exposed. It also thematizes the

production of "truth" by prescribing in advance the postures of analysis, particularly through the naïveté of the child who exposes the emperor's nakedness and who can be seen as a metaphorical equivalent of the analyst. An important question can be raised here about the modality of analysis itself: to what extent does the production of truth require the naïveté of the child in order to expose it, and further, to what extent does naïveté allow truth to be found in the exposed object rather than in the fictions of the fabricating subjects represented by the tailors who weave the garments that are both visible and invisible? In Andersen's version of the tale, the visibility of the fabric woven by the two impostors is conditional upon a prior question of judgment. The tailors tell everybody that "the cloth had the strange quality of being invisible to anyone who was unfit for his office, or unforgivably stupid" (1). Fabricating the conditions of visibility in this manner, the impostors play upon the "blind spot" of self-conscious knowledge—neither the Emperor nor his subjects want to bear (bare) the risk of not seeing the fabric. In Andersen's version, the tailors are primarily referred to as weavers of the most marvelous cloth. They can be seen as making (textualizing) "truth" and situating it on the side of the seductive power of fabrication and make-believe (fiction). Truth, in this instance, is a matter of "tailoring" facts to suit one's purpose, where only the innocence of the child escapes the play of fabrication.

Derrida's comments about "The Emperor's New Clothes" are made with specific reference to Sigmund Freud's use of the tale within the analytic scene of psychoanalysis.[2] Using psychoanalysis as an example of a discourse with scientific value as opposed to the "fictive" value of a literary work, Derrida's interest lies in the way that the "scientific" analytic text of psychoanalysis "finds" itself in the literary fiction of the fairy tale. Arguing that their "co-implication is more contorted than one would believe" (418), he shows how Freud's analysis needs an example, a literary illustration, in order to explicate itself. Derrida picks up on Freud's reference to the illustrative tale as "an interesting piece of evidence" that "seems to crop up just at the right moment" (416). This mode of the discovery of the example-as-evidence corresponds to the naive exclamation of the child in Andersen's tale. The wondrous proclamation of the Emperor's nakedness corresponds to, and can be found in, the analytic moment described by Derrida as "illustrative jubilation that treats the very elements of its "scientific" discourse as *there to be found*, happily available for the instructing discourse. And most often in the form of a fable, a story, a tale" (416). As Derrida argues, the tale (text) gives in advance the "truth" of Freud's

analysis, distributing "the position of the analyst, the forms of his dis-
course, the metaphorico conceptual structures of what he seeks and what
he finds." In other words, "One text finds itself, is found in the other"
(418). Freud's truth is found in the body of a literary text, revealed in the
figure of the Emperor's unveiled body.

Found in the relationship between master discourse and example, the
doubling structure of co-implication, the location of one text *in* the other,
is brought down to a matter of sight. Seeing takes the form of the per-
ceptual mode most befitting truth as something immediately apparent to
the innocent eye. In "The Emperor's New Clothes" the exposure of the
Emperor's nakedness is a wondrous insight on the part of the child who
points and proclaims the "truth" as an analyst would in the analysis of
dream work. Luce Irigaray argues that wonder is played out through a
particular predication of subject and object based on a perceptible rela-
tionship between self and other. It is "the moment of illumination—
already and still contemplative—between the subject and the world" (77)
that assumes "a directly speculative access to the object, to the other" (79).
Through the immediacy in which the object supposedly presents itself to
a naive and artless eye, the subject can assume a form of mastery over the
world of objects by speaking the "truth," repressing the process of fabri-
cation, the relational and fabricated texture of "empirical evidence" exem-
plified in "The Emperor's New Clothes" by the coalescence of both an
invisible nakedness and invisible garments.

The process of the artful fabrication of empirical evidence, making it
"there to be found" as Derrida might say, is clearly demonstrated in the
work of the historian of science, Londa Schiebinger, on the gendering of
skeletons in the eighteenth and nineteenth centuries. Schiebinger analyzes
how medical science, in striving to uncover hard evidence for theories of
sexual difference, was involved in the manufacture of its empirical object
of study. Writing of the first illustrations of female skeletons that appeared
in the years between 1730 and 1790, Schiebinger argues that "the materi-
alism of the age led anatomists to look first to the skeleton, as the hardest
part of the body, to provide a "ground plan" for the body and give a
"certain and natural" direction to the muscles and other parts of the body
attached to it" (191). Prior to the eighteenth century, anatomical discourses
on sexual difference had been physiologically anchored in the analysis
of reproductive organs and tissue. Schiebinger argues that the Enlighten-
ment saw a revolution of scientific views on sexuality where anatomists
called for finer distinctions of sexual difference, moving away from the

ancient idea that sexual identity depended on the differing degrees of body heat and the Vesalian view that sexual organs were appended to a neutral skeletal form. This process of extensive sexual taxonomy involved a corresponding intensive colonization of the body in order to expose its hidden and sexualized morphology.

The impetus for the penetrating scientific view that moved beyond the "fabric of the flesh" to the "bones" of the matter in its search for the unveiling of the secrets of gender was the idea that "sexuality could be seen as penetrating every muscle, vein, and organ attached to and molded by the skeleton" (191). As evidence, Schiebinger cites the French physician Pierre Roussel, who in 1775 reproached his colleagues for believing that women were similar to men except for their reproductive organs. "[T]he essence of sex," Roussel explains, "is not confined to a single organ but extends, through more or less perceptible nuances, into every part" (189). This reference to the "more or less" perceptible differences of sex returns us to the analytic of a visually ambivalent scene: to an invisible visibility and to the task of revealing this hitherto invisible evidence. Literally embodied as a scientific logic of discovery, this perceptual/perceptive inventiveness requires that something, as yet unseen, be made visible, that the secret of sexual difference be uncovered, revealed, and brought to light through the speculative inquiry into the interior spaces of the body. The art historian Barbara Stafford describes eighteenth-century anatomy as the "science of subcutaneous parts." Citing P. N. Gerdy's *Anatomie des formes extérieurs* (1829), she argues that anatomy functioned "like an enlargening glass." Penetrating beyond the veiling skin, it was seen to have the ability to "magnif[y] the smallest detail, rendering distinct hidden morphologies" (54).[3] It thus exposed more than could usually be seen. Transparency, Stafford writes, "was achieved by the mind's travelling downward and 'scooping' out interiors" (55). She makes an interesting connection between this expositional function of anatomy and processes of graphic reproduction, such as engraving and Intaglio printing, that, she argues, were "resolutely manual" in their reliance on burning and scraping surfaces with needles and corrosive acids in order to produce "burnished surfaces and varnished depths" (54).

As the result of a process that sought to colonize and reveal the truth of the human form, the work done on the sexing of skeletons needs to be seen in this light of rendering perceptible the formerly imperceptible. Representing the body in its minimalist physiological form, pared down to its defabricated "bare bones," so to speak, the skeleton was given the

function of revealing the architecture of sexual difference. The theme of the skeleton as exposed and dis/covered material evidence (unveiled *stoff*) is evident in anatomical illustrations from the post-Renaissance period. For example, revealing an analytic teleology that progressively works its way inward, the sequence of illustrative plates from the second book of Vesalius's famous *Fabrica* begins with images of the flayed body and proceeds through the differentiated layers of muscle to the plates of the bones beneath. Revealing a similar movement of unveiling, Schiebinger refers to an illustration of the definitive human skeleton of the eighteenth century, from Bernard Albinus's *Tabulae sceleti et musculorum corporis humani,* published in 1747. Standing in an abundant garden (Eden perhaps, which would signify the purity of form before the fall into self-consciousness and deception), this skeleton is pictured in the process of being disrobed by a cherub removing a veil or cloak, drawing a metaphorical relation to the removal of the texture/fabric of flesh. In other words, flayed skin and tissue can be seen as a kind of wrapping removed from the body, uncovering it so as to discover its essential structure. Cued by the analytic function of the child in Andersen's fable, we could also extend this metaphor of unveiling to include the cherub as anatomist, reinforcing the act of discovery as an innocent disclosure—likewise, the *putti* (cherubs) that adorn the seals and cartouches displaying the anatomists' names and the text titles in post-Renaissance anatomy texts can be seen in this light of precocious analysis.

As Schiebinger graphically demonstrates in her book, the work done on the sexing of skeletons revealed the gross distortions that corresponded to ideologies about the different sexes. Rather than working with complete skeletons, anatomists worked with composite ones, collecting bones that matched "ideal" function and stitching them together to produce ideal skeletons. Needless to say, the perfect female skeleton had a small head (for fewer brains) and a large pelvis (suited to her perceived maternal reproductive role). In fact, as Schiebinger argues, women have a relatively larger head size in relation to body size than do men. A further example of the way that scientific discovery is tailored to suit particular views can be seen in the manner in which this fact was finally accepted. Schiebinger argues that rather than concluding that women's large skulls "were loaded with heavy and high powered brains" the medical fraternity used the empirically verified fact of women's proportionally larger skulls as "evidence that women physiologically resemble children, whose skulls are also large relative to body size" (207). In other words, by making comparisons

between women and children, and by finding empirical evidence and illustrating particular ideas about female physiology, anatomists were able to translate hegemonic views of women into the language and materialism of modern science. Rather than portraying a scrutinizing, "objective" teleological movement that sought to discover the "natural" mysteries of sexual difference as they infused the perceptible and imperceptible structures of the human body, biological science should be seen as a tailor fabricating its visions, weaving its illustrated empiricities from the strands of hegemonic and heterogeneous social discourses and texts.

Visibilities: Displaying the Dead Body

In this section I analyze the relation of the exposed and displayed body to the production of forms of material evidence. As we will see in relation to the history of the anatomy theater, the visible provides a condition and support for what can be said or illustrated, forming what Deleuze calls an "enunciative base" (54). Although, as Deleuze writes, "visibilities are never hidden, they are none the less not immediately seen or visible." Like the Emperor's robes in Andersen's tale, they can be visible or invisible "so long as we consider only objects, things or perceptible qualities, and not the conditions which open them up" (57). The examples I use in this section demonstrate that self-evidence is revealed in a gesture that would appeal to the *sight* and *site* of an exemplary body. I examine how the visible and sayable are folded together in a seemingly reversible relationship so that what is seen is clearly evidenced by what is said and vice versa. Developing a working rule for the analysis of the immediacy of the visible image, Stephen Heath argues that "where a discourse appeals directly to an image, to an immediacy of seeing as a point of its argument or demonstration, one can be sure that all difference is being elided, that the unity of some accepted vision is being reproduced" (53). Heath's critique aims at the deconstruction of an evidentiary mode of representation that occludes the constructedness of processes of specular composition, in this case the elliptical folding together of book and body.

This process of revealing the truth through an appeal to what appears before one's eyes in acts of discovery can be usefully examined through Michel Foucault's proposition that forms of knowledge involve a relationship between saying and seeing. Using this idea, that the articulation of the visible and the sayable provides the basis for forms of thought, I propose that processes of authorization involve making something appear

that conforms to what is being said. If we accept that authorization con-
sists in the demonstration of a power of right or priority through some-
thing, then the exemplary text is a body of evidence in evidence. In the
case of the legal legitimation of authority, evidence consists in the produc-
tion of statutes—legal principles or laws "set out" in formal documents
that can be produced to substantiate a claim. Likewise, authorship, in the
literary sense, can be seen as a set of institutionally sanctioned rights over,
and responsibilities for, a written work attributed to what David Saunders
and Ian Hunter call a legal personality. In the case of demonstrating con-
ceptual authority, an author or writer (or anatomist) may refer to a set
of written texts, a corpus, as foundation or precedence for an argument.
For example, "Clip out an example," writes Derrida, "since you cannot
and should not undertake the infinite commentary that at every moment
seems necessarily to engage and immediately to annul itself" (*Dissemina-
tion* 300). Here Derrida refers to the necessity for the production of exte-
riority (in this case, the examples of the dead body and book) in order to
substantiate the authorizing commentary. Inaugurated by the incision, the
cut, which severs the subject from the object, the represented from the act
of representing, the production of the exterior reference instantiates and
grounds the "truth" that resides out there in the objective world and not
with the fabrication of the subject—or so a naive empiricism would have
us believe. In this section I want look at how the corpse and dead body
become folded together through the masterful acts of saying and seeing,
which require the "innocent" disclosure of material evidence.

Deleuze, in his book on Foucault, works with the proposition that dif-
ferent relations of the visible and the sayable produce different forms of
knowledge, and he argues that Foucault's major philosophical achieve-
ment was analyzing the conversion of visibilities into the domain of dis-
course (109). Deleuze qualifies this statement by arguing that Foucault
issues a double challenge, because the problem of knowledge is irreducibly
split as it involves an essential nonrelation between speaking and seeing,
language and light. In other words, we do not see what we speak about,
nor do we speak about what we see because, paradoxically, the relation-
ship between the two forms, their reversibility, emerges from an essential
disjunction (109). Arguing that this discontinuity characterizes the differ-
ence between the thought of Foucault, on the one hand, and Martin Hei-
degger and Maurice Merleau-Ponty, on the other, Deleuze proposes that
for Heidegger and Merleau-Ponty "[l]ight opens up a speaking no less than
a seeing, as if signification haunted the visible which in turn murmured

meaning" (111). For Foucault, he states, this isn't the case as "light-Being refers only to visibilities, and language-Being to statements." However, the historical and discursive folding together of these two elements produces a paradoxical form of "intentionality" within the discursive domains of knowledge. On the one hand, Deleuze asks, if knowledge is constituted by two forms, making it discontinuous with itself, how could a subject display any intentionality toward an object? On the other hand, "it must be able to ascribe a relation to the two forms which emerges from their 'non-relation'" (111). The possibility of saying what one sees constitutes the conditions of analytic wonder and discovery, the revelation of something not yet seen or perceived. Before investigating how discovery depends upon the fold or crevice between speaking and seeing in relation to the fabrication of bodies, I want to turn to an historical account of forms of modern visibility as a way of mapping the constructed discursive nature of "what is seen."

Recalling his image of the word from *The Order of Things,* where once deposited on the whiteness of the page, having no sound and nothing to say for itself, it "can do nothing but shine in the brightness of its being" (300), Foucault gives us a blind language combined with a mute luminous spectacle as the essential conditions for representation. These two "strata," the visible and the sayable, are variously composed and combined (distributed) in different historical periods or epistemes. Deleuze goes on to say that this "interlacing" between the two disjunctive forms produces a kind of reversibility so that what is seen is said, and this reversibility can be multiplied "in both directions" to "become infinitesimal or microscopic" (112). He refers here to an optical teleoscopy of knowledge, the direction of vision or, rather, the reversal of its vectors, producing an "inside" and an "outside" of its objects.

In *The Order of Things,* Foucault argues that the epistemological difference between classicism and modernity, between "our prehistory and what is still contemporary," is based on different perceptions of the relationship of words and things. For the classical age he identifies two apparently antagonistic but indissoluble forms. There is first "a non-distinction between what is seen and what is read, between observation and relation which results in the constitution of a single, unbroken surface in which language and observation intersect to infinity" (39). Foucault presents a version of classical language and knowledge developed in accordance with the idea of "the great book of nature," where the forms of nature constitute a form of primary text, in other words, the names of things resided in the things

they designated (36). The second form that Foucault identifies as belonging to classicism is the inverse of the first, where there is "an immediate dissociation of all language, duplicated, without any assignable term, by the constant reiteration of commentary" (39). Knowledge in this case consisted in bringing one form of language to bear on another, so that the "great unbroken surface of words and things" is restored. Classical epistemology, according to Foucault, functioned in the space between a primal (written) text and the infinity of interpretation: "One speaks upon the basis of a writing that is part of the fabric of the world; one speaks about it to infinity, and each of its signs becomes in turn written matter for further discourse; but each of these stages of discourse is addressed to that primal written word whose return it simultaneously promises and postpones" (41). This primacy of the written word is literally in operation within the theater of pre-Renaissance anatomy, where the anatomist seated in an elevated podium, physically separated from the corpse, would read from a medical text while the "assistant" demonstrator cut open the body, and his helper, the ostensor, with his wand pointed to its relevant parts.

Analyzing the woodcut frontispiece of Johannes de Kentham from *Fasciculus Medicinae* (1495), Jonathan Sawday writes than within the pre-Vesalian scene the corpse "is the passive recipient of textual authority which emanates from the elevated anatomist" (118). Citing Luke Wilson, Sawday argues that the de Kentham woodcut clearly illustrates a hierarchy of functions. Here the professor anatomist is elaborately framed in a podium standing or sitting above the horizontally laid out corpse that functions passively by receiving and exemplifying the authorial word bestowed from on high. The function of the anatomist is to speak from the book of knowledge and to deliver the procedure from a primary text. As Sawday notes, the corpse remains unopened, with the demonstrator poised at the point of executing a primary incision. This suggests that the contents of the corpse's interior, the not yet visible internal organs, have little significance to the primary production of meaning that resides within the anatomist's book. The invisible internal organs of the body are important only insofar as they may provide visible evidence of the anatomist's text. Knowledge, in this scenario, is produced through the correspondence between the text and the body—or in Foucault's terms, in the "non-distinction between what is seen and read," the unbroken surface of words and things signified by the, as yet, unopened surface of the body.

With the emergence of modernity, Foucault argues, words cease "to intersect with representations and to provide a spontaneous grid for the

knowledge of things" and once detached from representation language exists only in a dispersed manner (*Order* 304). Modernity ushers in the opening up of things in order to find a lost unity. The rupture between words and things must be sutured back together through epistemological endeavors that seek to restore meaning to the world. But how is this to be achieved now, given the fragmentation and separation of "language" and "visibilities" that characterize modern interpretive activity? With respect to the function of analysis, Foucault argues that the process involves the construction of something similar to a palimpsest, where the distance between image and word, body and text, is conflated. Within modernity the analysis of the dissociated word is made to uncover (in)visibility. Foucault writes that "if one's intent is to interpret, then words become a text to be broken down, so as to allow that other meaning hidden in them to emerge and become clearly visible" (304). This is evident within the post-Renaissance anatomy theater, for example in the work of the "father" of modern anatomy, Andreas Vesalius.

Comparing the frontispiece of Vesalius's *Fabrica* with de Kentham's woodcut reveals some interesting differences that can be thought of in terms of the distinction that Foucault draws between the classical and the modern (figure 2). The Vesalian scene is radically different, depicting the performance of knowledgeable authority as a movement away from the elevated pronouncement of resemblance toward the procedure of anatomy itself, which involves the opening out of the body. In the Vesalian theater the anatomist has descended from his elevated position and stands next to the corpse, replacing the demonstrators and ostensors. They are banished from the anatomical scene and are depicted as squabbling underneath the operating table. Making the point that in antiquity and medieval times there was very little human dissection and no anatomical illustration, Thomas Laqueur argues that the Vesalian frontispiece stands as a rebuke to those who, in earlier times, merely read from ancient texts while assistants did the dissection. In an analysis of Mondino de Luzzi's *Anathomia* (1493), a counterexample to Vesalius, he points to the depiction of the anatomist sitting above the corpse with an opened text on his lap, gazing at the cadaver's face rather than on the exposed viscera. Laqueur writes that "[t]he body seems almost an afterthought" and that the attention given the cadaver's face is evidence that "its humanity, not its value as dead material to be studied, demands attention" (70–71).

Within the Vesalian scene, the distance between the anatomist in his podium and the corpse has vanished, the relation now becoming one of

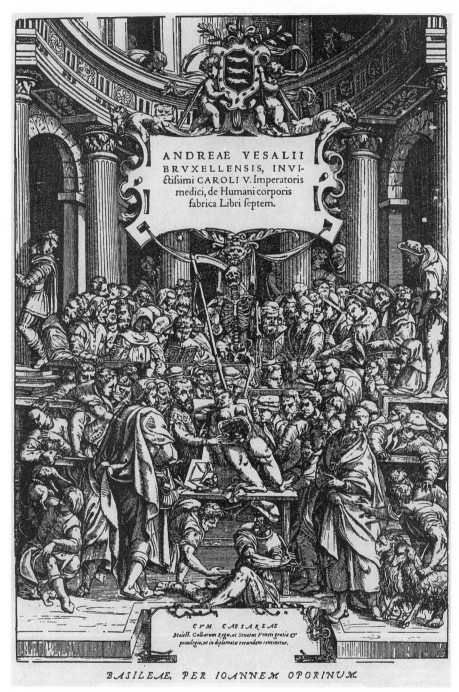

Figure 2. Title Page to the Second Edition, Andreas Vesalius, *De Humani Corporis Fabrica*, 1555.

reader to corporeal text. Vesalius himself probes the gaping abdominal hole that has displaced the cadaver's face as the focus of attention; the opened body replaces the opened book as the source of anatomical knowledge, suggesting that responsibility for knowledge now lies within its exposed interiority. Correspondence between text and image, words and things, has been transcribed by an elusive system of exposure that reorganizes the pre-Renaissance relationship between the body and the "text" of knowledge. As Laqueur notes, in a context where the anatomist's authority is primarily invoked through his proximity to the corpse and his ability to reveal its interiority, the body becomes the source of illustrations and text; they in turn become the "graphic substitute for actually seeing the structures in question and thereby vouchsafing the anatomist's words" (75). Already we can begin to see the elliptical play of self-evidence based on the repression of textual mediation and fabrication in the production of truth. Laqueur writes that Vesalian and subsequent anatomies "continued to evoke the authority, first, of a dramatically opened, exposed body and then derivatively, of naturalistic representation itself" (75). In other words, in these scenarios the canonical text is produced through the "secondary" function of recording the visibilities dictated by the anatomist's demonstrations.

This representational aspect of the text can be seen in the frontispiece of Renaldus Columbus's *De re anatomica* (1559), where an illustrator sits subserviently beneath the opened corpse, his gaze directed at the abdominal cavity and the manipulations of the chief anatomist (whose gaze appears, in turn, to be focused on the illustrator). Several figures stand around the dissecting table holding opened texts, consulting or making comparisons. Rather than interpreting these figures as complying with an older model of visibility derived from a classical canonical textual authority, I suggest that the text has assumed a different referencing function relative to the primary status of the corpse. In comparison to the elevated position of the text in de Kentham's frontispiece, the proximity of these texts to the corpse is symptomatic of a movement whereby the cadaver and the primary anatomical text eventually become elided or folded together, to be separated out only in the play of discovery and recovery of knowledge.

This is already evident in the Vesalian scene where the primary text has disappeared into the depths of the corpse to be discovered by the anatomist's illustrative activities. The materials of representation—the parchment and inkpot—lie on the dissecting table, close to Vesalius's right

hand, amongst the scalpels and in close proximity to the flayed and incised abdomen (suggesting that it is the anatomist who both operates and illustrates according to what he sees and discovers). At the cadaver's feet lies a discarded cloth, again signaling the association between parchment, skin, and screen that have been separated out from the "stuff" to be analyzed. This can be seen as the movement toward the secularization of knowledge, which involves the devolution of authorization from canonical knowledge to rational empiricism, where evidence is there to be found by the speculative eye that unwraps and unveils the body and dictates to the transcribing hand. Like the child revealing the naked "truth" in Andersen's tale of "The Emperor's New Clothes," the Vesalian anatomist maintains a distinction between the textual space of representation and materiality, discarding fabrication from the analytic scene. This is what makes Vesalius truly modern. Further, with a small stretch of the imagination, it is possible to see in the spatial relationship between the cartouches and the opened corpse the terms of a transubstantiation of the organs and insides of the body into the "written word." Here in these theaters we could say that the word is to be found (discovered) in the body and then folded out (displayed) and screened.[4]

The Corp(u)se

The plasticity of the relationship between seeing and saying, book and body, is intensified in the contemporary surgical theater, which has inherited the conflation of these elements. The only difference is that the docile body is no longer "dead" but instead rendered pliable through the anaesthetic procedure. In this final section I detail the final transformation, or rather superimposition, of corpse and corpus. I argue that the contemporary patient body is colonized and composed according to the logics of lamination and articulation that it inherits from the older forms detailed above.

Stefan Hirschauer in "The Manufacture of Bodies in Surgery" refers to the scientific processes of digging into flesh so as to uncover and make visible the organs and systems of the human body. Supported by optical instruments such as lamps, magnifying glasses, microscopes, and reflecting instruments such as forehead mirrors, operating, according to Hirschauer, becomes a "sequence of looking and cutting," where "[l]ayers of skin and tissue obstructing the view are cut through and spread apart." The general rule of this process is that "[o]ne must see to cut, and one cuts in order to

see more" (299). Hirschauer goes on to argue that while dissection consists in making objects visible it is at the same time classifying work that consists in an "exposition" of the body "as it is known from the anatomy book" (301). He describes the process thus:

> [T]he flesh is dense and compact, stuck together and impenetrable. First, one has to identify something in a crevice opening up, in the depths of a wound or on a bloody surface. During the search for a spermatic duct, someone utters "I don't see anything," and an assistant is told, "now, this is the transversus perinei profundus."
>
> In the case of microsurgery, this identifying work can take hours, in which whitish and red cords are identified as particular nerves and vessels and lifted out of their bloody surroundings by slings and numbered clamps. (300)

In this description, opening up the body in order to find and classify its functioning parts relies upon making visible particular organs and structures by breaking into the density of the body by cutting it apart. Through reference to the "crevice," Hirschauer draws attention to the primary analytic movement as a parting or rupture of a horizontal surface in order to gain access to, or rather to produce, an "interior." This "crack" in the surface produced in the form of the wound or incision is what opens up the possibility of bringing something forth into vision, allowing the birth of the dark interior into the light of existence—"First, one has to identify something in a crevice opening up." Through its liminal function, the crevice transforms the imperceptible, embodied in the utterance "I don't see anything," into the visible "birth" of an organ (an assistant is told "this is . . ."). What was hidden is made visible *and* known.

Here I want to take up Hirschauer's reference to the manufacture of visibility from the latter part of the citation above where he describes the slings and numbered clamps that keep the "wound" (crevice) open and assist in the classification of nerves and vessels. Hirschauer operates a model where evidence is produced and constructed according to an interpretive system tooled with instruments that allow the surgical body to see, through the construction of particular fields of visibility. He argues that apart from these instruments "the hands remain the most important instruments for viewing" (300). There is a resonance established in his paper between surgery (from the Greek *cheirourgia,* literally meaning "handiwork") and a poetics of manufacture (manus referring to "hand").

Earlier he refers to the surgeon-body (the surgical team) as a rhythmic hand "machine" where "instruments slide into hands snapping shut" (297).

As a machine, the surgeon-body is involved in the manufactured fabrication of the patient body. Concerning the importance of the hands, Hirschauer argues that as instruments for viewing they are involved in palpating ("making something out"), stretching tissue "to make it more transparent," and identifying nerves "by way of their tensile strength." During "blunt dissection" the hands are involved in "stretching, tearing or shifting tissue" and during "sharp dissection" they hold and use scalpels (which are "held like a pencil"), scissors, or electric cauterizers. In fact the body is treated as a fabric of different textures. "Vessels, skin, tissue, and bones are tackled differently depending on the way in which they resist: the skin is treated with the scalpel, the yellow layer of fat and peritoneum with the scissors, muscles with the cauterizer" (300).

Hirschauer refers to the "craft" of surgery as resembling building or carpentry, in relation to the sawing, drilling, and screwing together of bones, and, more importantly for my purposes, the practice of tailoring, where "the skin and tissue of different consistency are cut apart and sewn together." This crafted, or rather, textured, fabrication/manufacture of the body, its woven and pliable consistency, is aptly demonstrated in the case of plastic surgery and in what Hirschauer calls anatomical exposition.

In plastic surgery—the example Hirschauer uses is that of autogenous transplantation on transsexuals—the patient body is described as a "stock of material," some of which is "useful," other parts considered as waste and "amputated" (302). There is an analogy to be made here between this description and the work of a tailor cutting a pattern from a length of fabric. The surgeon-tailor goes to work shifting pieces of skin and transforming organs:

> The skin of the penis is used for a vagina and the skin of a vagina is used for a penis, the scrotum for labia and vice versa. Parts of the labia might become nipples, pieces from the intestines may be used for a vagina, skin from the back of the foot and forearm as well as costal cartilage is taken for a penis. In the course of such operations, the organs dealt with undergo . . . an instrumental dissolution. So, a scrotum is transformed into a trapezium; a penis turned inside out and divided into skin and shaft; the shaft is split into urethra and spongy bodies; they are "mobilized" (that is, separated from the body), whereas the skin is used for an emerging neovagina. (302)

In this description the body emerges as the product of a refolding of its pliable material surfaces in order to produce pockets and protrusions conforming to a gendered identity. Organs are turned inside out; skin folded, refolded, and stitched; and interiorities manufactured or flattened out. Given the numerous references to the creation of a vaginal cavity or else its rebirth into a penis, its refolding as something other, this process could be taken as a literal working of the body in terms of Derrida's concept of invagination (*Dissemination*). However, my interest lies in unpicking/unraveling the interior depth of the pocket or cavity, and in taking the vagina literally as a crack in the surface of the body, a rent in the face of the fabric produced either through the "e-volutionary" ("developmental") folding out of the body or else, as in the case of plastic surgery, through the "in-volutionary" incision—the refolding of the body.

Associated with the generative function of the vagina and the surgical incision, the crevice, or crack, as liminal rim, can be seen as a "stretching" of a hole into a gap big enough for something to emerge (a crack of light, perhaps) or else a darkness to see into, depending on what side of the Enlightenment threshold one occupies. Relations to the crevice are reversible. For example, the incision allows the surgeon to peer inquisitively into the body searching for knowledge—that glimmer of light—or else to knowledgeably subtract or add parts to it. Passage through the threshold, the penetration into an interiority, as I have already argued, does not result in total discovery but rather in a form of recovery: the dialectical play of fabricated surface according to what Gilles Deleuze and Felix Guattari call a white wall/black hole system (167–71). The white wall can be thought of as an illuminated surface, a skin or screen, which develops rents or cracks when stretched, or as pitted with little black holes (eruptions or cavities), providing some form of "break in" or "break through" into a space apparently behind the white wall. In other words, penetration involves moving through a black hole until one reaches a white wall, a screen or surface that is used to discover or recover an object, potentially producing yet another white wall/black hole system to pursue.

The optical illusion of exploration and discovery is produced through the process of discovering and recovering laminated surfaces, or, in other words, working one's way through a series of translucent veils and through the reversibility of the incision-suture operation.[5] This applies both to the human body and the anatomy book, where in the modern theater the latter is superimposed on the former. Hirschauer describes the preparatory

process, whereby the body is made ready for operating and incising, as primarily a covering one. The area around the planned incision is painted with disinfectant, turning it a "strange orange-brown." Paper towels are placed strategically around the targeted area, and blue linen is spread all over the body except the area to be operated (288). Hirschauer also notes that the covering of the face is a formal part of this transformational process. He writes that it "creates anonymity and functions like a reverse folding screen covering the naked face instead of the naked body" (306). The play of recovery in discovery is extended to the site of the incision itself, which is covered with translucent plastic film, a sterile second skin that makes the body "look like the dull surface of a plastic doll" (288). As reference to this toy replica suggests, the body is in the process of being transformed into a model or "artificial" copy drawn from the anatomy book.

Through anatomical exposition, the patient literally becomes a surface upon which an inscription will be projected. Hirschauer states that sometimes the incision "is drawn on the body, so the scalpel must follow only the indicated path" (299). The process preceding the first cut involves the inscription of knowledge through the process of lamination. "The body of the anatomy atlas," as Hirschauer states, "covers not only surgical practice but its object" (311). Once the primary incision is made, a surgeon "learns to use the anatomy atlas in the broken ground of the flesh." Exemplifying perfectly the proposition that knowledge involves making something perceptible, he argues that the knowledge of the body that grows out of an anatomical view "combines the anatomical *knowing that* of the visible and the anatomical *knowing how* of making something visible" (310). Hirschauer's metaphors are particularly interesting at this point in his description of surgical exposition, where he describes how perception in surgery is a continuous superimposition of the "concrete" patient-body and the "abstract body" of the atlas. He argues that "the working conditions of dissection are forced on the patient-body, when its signs of life are reduced and its movements and leaks are ligatured. It becomes obedient and manageable like a corpse" (311). The transformation of knowledge from abstract to concrete involves the conscription of "dead" matter into the process: a corpse is transformed into a corpus.

Finally, Hirschauer invokes the body of the book as a way of articulating the relation between docile matter and knowledge. What he calls the "imaginary anatomical body," at the outset not yet visible in the patient-body, is "constructed in the course of the constant attempts to produce *its* visibility" (312). The model he uses is that of the body *as* book: "One "leafs

through" the three-dimensional patient-body to find the two-dimensional structure of anatomical pictures. Section after section, the proper anatomy of the ideal body is engraved on these layers" (312). The body, then, comprises a set of folded surfaces that can be opened like a book, and the process of inscription or engraving retheorized in terms of a process similar to flaying—the description of the incision *drawn* on the body in this case can refer to a process of writing as unsheathing. Writing of the master engraver William Hogarth in her analysis of dissection, Stafford argues that he "conceived of opaque and solid bodies as made up of thin shells or removable peels" and he developed a design tool, the serpentine line, for bringing out their "muscular twistings and winding concavities and convexities." However, the engraved trace itself was just an empty vein waiting to be filled with ink (55).

In opposition to the pre-Renaissance principle of correspondence between the canonical primary text and the structures of the body, this modern fascination with the contortions and folds of things, their hidden depths and structures, corresponds to an epistemological obsession with hidden interiors in which knowledge is sought and *from* which knowledge can be withdrawn. Like the exposed interiority of body in the Vesalian anatomy theater that becomes the anatomist's text for the discovery of the workings of the human body, this view of knowledge conforms to Foucault's contention that "order" is "at one and the same time, that which is given things as their inner law, the hidden network that determines the way they confront one another, and also that which has no existence except in the grid created by a glance, an examination, a language" (*Order* xx).

In this description of the hidden but expositive nature of knowledge, we can trace the disappearance of the canonical text, found in the classical order to reside with the elevated podium and separation of words and things, into what Hirschauer describes as the broken ground of the flesh. In other words, as the primary canonical text disappears into the flesh, word made is made "thing." The classical extension (outward relation) between words and "visibilities" becomes folded together, giving the illusion of hidden depth (a concept repeatedly found in Foucault), of the image in or beneath the word that maps representation back onto being. As we have seen in relation to the pre-Renaissance theaters, the anatomist's book determined the visibility of the organs and the organization of the exposed body. The spoken canonical text had a superordinate function, its structures superimposed on the undifferentiated body. However, with

the Vesalian scene, the instruments of representation are separated out from the primary text residing within the interior of the corpse. Interiority is revealed by the anatomist's more proximate activities that extract knowledge from this empirical site and then represent it in the books of knowledge that are then reapplied (refolded in) to the body. Inheriting and intensifying these elements of lamination and articulation, the contemporary body is a pliable one, a text that can be tailored to suit one's desires. Within our contemporary theaters, the body has become a model without an original blueprint (the figure of the doll is perhaps most appropriate, particularly in the theater of plastic surgery). Its shape belongs to the dialectic between the possibilities inherent within its structures and what the anatomist says about it. As Deleuze and Guattari note, "enunciation does not speak 'of' things; it speaks on the same level as states of things and states of content" (87). What we know of the body, then, is born of visionary language, the interplay of its empirical and transcendent quality.

NOTES

1. Both "text" and "textile" share the Latin root *texte,* extending to the former the sense of a woven artifact, something that is made by weaving together strands of words and meaning. With respect to the concept of fabrication, a parallel can be drawn here with the concept of fabric, which is derived from the Latin *facere* (to make).

2. For Freud, "The Emperor's New Clothes," like the story of Oedipus, functions as an illustration containing allegories and figures that explicate and illustrate his "science." The story is referred to in his analysis of embarrassing dreams of being naked from *The Interpretation of Dreams.* The tale exemplifies the function of secondary revision and latent content in dream work. Veiling and exposing the desire to return to the "unashamed period of childhood," a "Paradise" that we can "regain every night in our dreams," the tale, like the dream, disguises or veils a "truth" in the form of infantile wishes that have fallen victim to repression. Freud writes: "The impostor is the dream and the Emperor is the dreamer himself; the moralizing purpose of the dream reveals an obscure knowledge of the fact that the latent dream content is concerned with forbidden wishes that have fallen victim to repression. For the context in which dreams of this sort appear . . . leaves no doubt that they are based upon memories from earliest childhood. It is only in our childhood that we are seen in inadequate clothing both by members of our family and by strangers, nurses, maid-servants, and visitors; and it is only then that we feel no shame at our nakedness." As Derrida notes, Freud appends a note to the last sentence: A child plays a part in the fairytale as well; for it was a small child who suddenly exclaimed: "But he has nothing on!" (*Interpretation* 342).

3. This process is reflected in the title of Stafford's book: *Body Criticism: Imaging the Unseen in Enlightenment Art and Medicine.*

4. "Display" literally refers to a movement of folding out (Latin *dis-*, apart, and *plicare,* to fold).

5. The opening up of surfaces is reversed in what Hirschauer calls "the retreat from the patient-body" as the surgeon-body "moves up through more shallow layers towards the skin." Hirschauer describes the process of withdrawal as one where "the body is put back together again with sutures; one layer after the other is closed, the plastic film removed and suddenly one can recognize the wound again: the belly for example, reappears, and with it the boundaries of the wound. The disfigured part of the body comes to light again when the sheets are pulled away" (302–3).

WORKS CITED

Albinus, Bernard. *Table of the Skeleton and Muscles of the Human Body.* London 1749.

Andersen, Hans Christian. *The Emperor's New Clothes and Other Stories.* London: Penguin, 1995.

Barthes, Roland. *Image-Music-Text.* Trans. S. Heath. London: Fontana, 1977.

———. *Roland Barthes by Roland Barthes.* Trans. S. Heath. London: Macmillan, 1977.

Certeau, Michel de. *The Writing of History.* Trans. T. Conley. New York: Columbia University Press, 1988.

Columbus, Renaldus. *De re anatomica.* Venice, 1559.

Deleuze, Gilles. *Foucault.* Trans. Sean Hand. Minneapolis: University of Minnesota Press, 1988.

Deleuze, Gilles & Guattari, Felix. *A Thousand Plateaus: Capitalism & Schizophrenia.* Trans. B. Massumi. Minneapolis: University of Minnesota Press, 1987.

Derrida, Jacques. *Spurs: Neitzsche's Styles.* Trans. B. Harlow. Chicago: University of Chicago Press, 1979.

———. *Dissemination.* Trans. B. Johnson. London: Athlone Press, 1981.

———. "Le facteur de la vérité." *The Post Card: From Socrates to Freud and Beyond.* Trans. A. Bass. Chicago: University of Chicago Press, 1987. 411–96.

Foucault, Michel. *The Order of Things: An Archaeology of the Human Sciences.* Trans. A. M. Sheridan. London: Tavistock Publications, 1970.

———. *The Birth of the Clinic: An Archaeology of Medical Perception.* Trans. A. M. Sheridan, London: Tavistock Publications, 1973.

———. *Language, Counter-Memory, Practice: Selected Essays and Interviews.* Trans. F. Bouchard and S. Simon. Ithaca, N.Y.: Cornell University Press, 1977.

Freud, Sigmund. *The Interpretation of Dreams.* Trans. J. Strachey. Pelican Freud Library, vol. 4. Harmondsworth, Middlesex: Penguin, 1978.

Heath, Stephen. "Difference." *Screen* 19.3 (1978): 51–112.

Hirschauer, Stefan. "The Manufacture of Bodies in Surgery." *Social Studies of Science* 21 (1991): 279–319.

Irigaray, Luce. *An Ethics of Sexual Difference.* Trans. C. Burke and G. C. Gill. Ithaca, N.Y.: Cornell University Press, 1993.

Kentham, de Johannes. *Fasciculo de Medicina.* Venice, 1550.

Laqueur, Thomas. *Making Sex: Body and Gender from the Greeks to Freud.* Cambridge, Mass.: Harvard University Press, 1990.

Mondino, de Luzzi. *Anathomia.* 1493.

Saunders, David and Ian Hunter. "Lessons from the 'Literary': How to Historicise Authorship." *Critical Inquiry* 17 (1991): 479–511.

Sawday, Jonathan. "The Fate of Marsyias: Dissecting the Renaissance Body." *Renaissance Bodies: The Human Figure in English Culture.* Ed. L. Gent and N. Llewellyn. London: Reaktion Books, 1990. 111–135.

Schiebinger, Londa. *The Mind Has No Sex? Women in the Origins of Modern Science.* Cambridge, Mass.: Harvard University Press, 1991.

Stafford, Barbara Maria. *Body Criticism: Imaging the Unseen in Enlightenment Art and Medicine.* Cambridge, Mass.: MIT Press, 1991.

Vesalius, Andreas. *De humani corporis Fabrica.* Basel 1543.

Woolf, Virginia. *Orlando: A Biography.* New York: Harcourt Brace Jovanovich, 1973.

Blood and Circuses

KATE CREGAN

Representations of the dead circulated at many levels within early modern English culture. Death was a public and socially performed process, whether as a sacrament or as a punishment: and in the Anatomy Theater of the Worshipful Company of Barber-Surgeons the deceased human form was both ritualistically, and publicly, explored and explained. In an overtly theatrical pedagogic process barber-surgeons in early seventeenth-century London acted as authorities of delimitation over the discursive construction of the anatomized human body. Bodies were lectured over by "readers" who referred to illustrated anatomical manuals, outlining in words, with the aid of visual stimuli, what the audience was to see and understand from the lesson laid before them. It was a lesson that formed the final act in the tragedy of the anatomical subject, frequently a grim product of the public gallows.

The performance of anatomical dissection differentiated and delimited embodiment, utilizing the remains of executed felons to create and propound a gendered ontology. When the classical, scribal authority that characterized earlier models of "scholastic" education receded before the "empirical" evidence of Vesalian anatomical practice and illustration, as Jonathon Sawday argues, spectators were no longer limited to seeing what the written word told them to see; they were subjected to the new authority of a protoscientist: the anatomist. "The confrontation between the body and the anatomist came to replace the tripartite division of textual authority, living authority and the passive authority of the body" (*Body Emblazoned* 64–65). To this I would add, a new authority came into being in this dynamic, as powerful as classical textual authority had been: the

39

visual authority of the anatomical illustration. Within the context of a theatrical space, post-Vesalian anatomical illustrations showed the anatomist and his audience what to see. The incorporation of the company in London in 1540 was virtually synchronous with the creation in Italy of Vesalius's richly iconographic pictorial representations of the anatomized human body, which were to have an overwhelming influence on European anatomy for nearly two centuries to come.[1] At the Barber-Surgeons' lectures, conceptions of masculinity and femininity were disseminated, exhorted in pedagogic rhetoric, visually framed by the illustrations embedded in anatomical texts, and mediated through the example on the table.

"Worse then dead bodies"

What are whores?
They are those flattering bels have all one tune
At weddings, and at funerals: your ritch whores
Are only treasuries by extortion fild,
And empt[i]ed by curs'd riot. They are worse,
Worse then dead bodies, which are beg'd at gallowes
And wrought upon by surgeons, to teach man
Wherin hee is imperfect.
 —Webster 3.ii.95–102

Cardinal Monticelso abuses Vittoria Corombona in these terms in the trial scene at the center of *The White Devil* (ca. 1612). Vittoria has been arraigned for infidelity and on suspicion of being an accessory to the murder of her husband. In the cardinal's biblically inspired rhetoric, whores, and by extension potentially all women, are corrupt and corrupting in the most literal of senses. The allusions to the gallows, anatomical pedagogy, whoredom, and the law contained within this one speech have a direct connection to, and draw together, all the concerns of this chapter. Webster is referring directly to the practices of the Worshipful Company of Barber-Surgeons of London, who retrieved from the gallows at Tyburn, and publicly anatomized, up to four executed felons a year—all within easy walking distance of the Red Bull, where this play was first staged.

The history of one woman is iconic of the nexus of sex, criminality, death, and display at work here. Elizabeth Evans, known as Canberry or Canonbury Besse, and her confederate in life and crime, Countrey Tom (Thomas Sherwood) were hanged in April 1635 for the murder of three

men. Tom had bludgeoned the men so they could be robbed, and Besse had assisted him by drawing these "gulls" in and fleecing them once they had been attacked. H.G.'s (Henry Goodcole's) reporting of the confession and penitence of Countrey Tom demonstrates the kind of submission before God that was considered appropriate behavior at the gallows.[2] Tom confesses all his crimes, including the murder of one victim for whose death he had not been indicted, and is brought to salvation in his final hours. Even though Goodcole reports that Tom was the one to wield the blows that killed each of the men, the bulk of the moral disapprobation in *Heavens Speedie Hue and Cry* falls to his partner, Besse.[3]

Besse was a disgrace to her "very good parentage" in Shropshire, because when she was sent into service in London for her improvement, she "grew acquainted with a young man in London, who tempted her unto folly, and by that ungodly act her suddain ruine insued" (H.G. A.4.v). Her "ungodly act" was stereotypically lustful: she was sexually incontinent and was a prostitute for the four years before she met Tom. From that time on she was his constant companion until they were apprehended a year later. As a prostitute Besse acted as the "decoy Ducke" (A.v), using her sexual availability to tempt each of the victims from the main road, at which point Tom could attack them.

Besse's temptation and fall into a lustful life and death is caste in the mold of an Eve tempted by the devil, and in Tom's gallows confession Besse, like Eve, is represented as the source of her partner's downfall. Tom's confession lays the blame for the criminal turn his life took and his imminent execution, squarely at Besse's door: "admonishing all that did see him that day, to beware of Whores, for they were the worst Company in the World, wishing all to beware by his fall, and not to be seduced, or blind-fold led, as hee was by such bewitching creatures, to irrevocable ruine" (B.4.v). Between the narrative of Tom's confession to the murders and Besse's gallows speech, there are a further two pages, supposedly imparted to Goodcole by Tom, warning both of the ways in which "lewd" women may approach one, and the places where one can find such women at work.

In her gallows speech, Besse in turn is reported to have expressed "a perfect hate, and exclamation against all Theeves, which caused her destruction" (C.2.v). In the report of her contrition before her demise, however, Besse is not allowed either the degree of dignity or the detailed reporting accorded Tom. Further, at the moment when she is allowed to express herself, in a very public manner, her words do not form just a confession

or a warning, they become a shrewish railing of "perfect hate." Like Eve, Vittoria Corombona, and all representations of exorbitant women of her time, Besse is as free with her mouth as she is with her body. Sinfulness, criminality and corruption are gendered, and Grandmother Eve is at the heart of Besse's, and consequently Tom's, fall. Though she died "very penitent," she was not spared the fate of many a victim of the Tyburn Tree: she was "after her execution conveied to Barber Surgions Hal" (C.3.r).

Anatomy Theaters

At their incorporation in 1540, Henry VIII granted the Barber-Surgeons of London a perpetual right to the bodies of four executed felons per annum, to be used at their discretion, as anatomical subjects, "to make incision of the same deade bodies or otherwyse to order the same after their said discresions at their pleasure for their futher and better knowlage instruction in sight learnyng and experience in the sayd scyence or facultie or surgery" (32 Henry VIII, cap. 12, cited in Beck 18). The barber-surgeons were sanctioned by the sovereign as the "authorities" who "delimited, designated, named and established" (Foucault 42) the human subject as an anatomical object.[4] They did this through a process of practical anatomical pedagogy that was carried out, unlike the few anatomical lectures that were held by their rivals the physicians, in English. While these felons were not their only anatomical subjects—private anatomies and postmortem were also undertaken (with permission) at the expense of individual anatomers (Young 119–120, 180, 331)—these criminal "persons" were used for their public anatomies: that is, the regular series of lectures held for the benefit of barber-surgical apprentices and their masters, to which curious "members of the general public were occasionally admitted" (Pepys 59–60).

Initially regular public anatomies were held in the common hall of the company, with temporary scaffolding erected for the accommodation of the crowd of spectators (Young 315). The court records of the company give an early case of the specifications for such a structure:

> 1st February, 1568. Also yt ys ordayned and agreed by this Courte That there shalbe buyldyngs don and made aboute the hall for Seates for the Companye that cometh unto every publyque anathomy, ffor by cawse that every prsone comyng to se the same maye have good prspect over the same and that one sholde not cover the syght thereof one frome another as here to

fore the Company have much cõplayned on the same. . . . And also ther
shalbe pyllers and Rods of Iron made to beare and drawe Courteynes upon
& aboute the frame where wthin the Anathomy doth lye and is wrought
upon, for bycawse that no prsone or prsones shall beholde the desections
or incysyngs of the body, but that all maye be made cleane and covered wth
fayer clothes untyll the Docter shall com and take his place to reade and
declare upon the partes desected. (Young 315)

The theatrical implications of this structure, and the participants and
properties appertaining to it, are clear. The scaffolding and seats were
arranged to allow the optimum view for the audience. They were invited
to gaze into the body, even as they were regulated into taking up that posi-
tion. Once seated their line of sight was drawn, but not restricted, to what
was placed on the centrally located dissecting table.

The temporary scaffold structure was superseded by a purpose-built
Anatomy Theater, designed by Inigo Jones and built between 1636 and
1638 (figure 3). In the plans of this theater one can see a repetition of
the attempted regularization of the audience's attention inherent in the
design. The seats all face the central platform upon which the body was
dissected. The risers ensure that in the crush of a capacity crowd of around
two hundred people (Cregan 123–24) those on the higher levels can see
over the heads of those below them. The windows that are indicated
would have facilitated ample natural light, a factor that was not a feature
of most of the continental Anatomy Theaters. It was decorated, like the
Leiden Anatomy Theater and museum, with admonitory examples, flayed
skins and prepared skeletons of the bodies of felons. The walls were also
painted with "the figures of seven liberal sciences and the twelve signs of
the zodiac" (Dobson and Milnes Walker 81), a decorative effect that had
its counterpart in playhouses like the Globe. A female skeleton was placed
"on the Corbell stone of the Signe Libra," punning on blind justice and
her scales, while her male counterpart was set above Taurus: both had "the
planett Venus governeing those twoe signes underneath" (Young 337).

The plans of the Barber-Surgeons' Anatomy Theater, and the written
description of the temporary scaffold theaters that preceded it, reveal a
direct homology between their design and those of the playhouses. This
is logical enough, the inspiration for their architecture came from a
common source—both were designed under the influence of classical and
neoclassical architectural principles. They each had areas equivalent to the
orchestra or auditorium, the proscaenium, and the arena in their *theatra*.

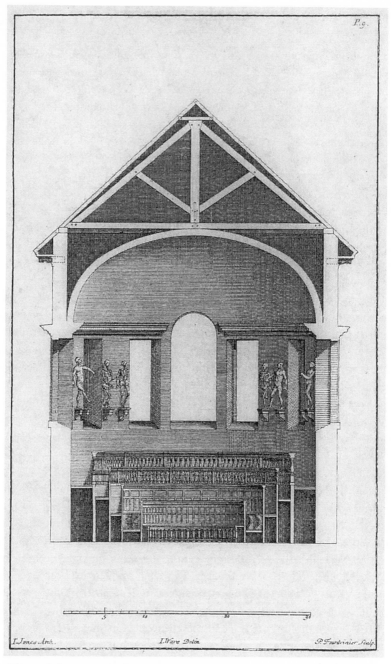

P.9.

I. Jones Arch. I. Ware Delin. P. Fourdrinier Sculp.

Figure 3. The Anatomy Theatre at the Worshipful Company of Barber-Surgeons, London, cross-section of the interior, from Isaac Ware's *Designs of Inigo Jones and others* (ca. 1731), reproduced by kind permission of the Provost and Fellows of Worcester College, Oxford.

Raked seating around the margins of each building surrounded a raised central area upon which a formalized scene was enacted on the bodies of subjects scrutinized by an audience prepared to be confronted by a gory spectacle, familiar in the Jacobean playhouses. People went to the public and private theaters to see and be seen. The barber-surgeons went to their theater to see and to learn a fundamental aspect of their trade. In the ceremonial way in which these anatomies were performed there was also a sense in which the participants were there to be seen. Anatomies were pedagogic apparatuses, but they also functioned as self-legitimating spectacles by which the company asserted and reinforced its position as the sanctioned arbiter of the anatomical subject.

In the early years of the seventeenth century, London was littered with playhouses, from class-inclusive or admixed converted inn yards and baiting houses to the new "round" public playhouses and the socially segregated private theaters (Gurr 14). Just as in London today one person might be equally at ease in a football stadium, a cinema, or an opera house, an individual theater patron in the early seventeenth century might frequent all or only one of the Red Bull, the Globe, and the Blackfriars.[5] There are several main features common to the design of all these playhouses. Theaters were first and foremost venues at which the overwhelming imperative was to enable *mass viewing* of the action in play, both on the stage and in the social "performances" in the galleries and the pit. Auditory considerations work in tandem with this, of course: an actor needs to be seen and heard, particularly in such an aural culture. The construction of the theaters centered, therefore, upon enabling the largest number of people to see the action in progress, with varying degrees of ease and comfort, dependent upon the size of a patron's purse or choice of theater. In both the public and the private theaters, people were stratified in their physical relation to the stage by their ability to pay, which was also a fair indication of their social rank. A certain measure of attentive behavior was hoped for if playwright's prefaces are any indication, but, by the same evidence, it was also frequently lacking, with members of the audience taking an active part in voicing their approval or disapproval of what was put before them.

Like the audience of the seventeenth-century public theaters, in the Anatomy Theater proximity to the "stage" was determined by professional and/or financial standing, although entry was by invitation rather than payment: high status ensured the best view. In Holland and Italy, where people did pay to attend anatomies, the seats closest to the anatomist were reserved for those who were able to pay for the costlier tickets.[6] In the early

seventeenth century the cost of the Barber-Surgeons' anatomies was borne by the company from their general funds, but one's position within the company still regulated one's position within the stands. Apprentices and plebeian visitors were relegated to the stands farthest from the corpse and, like the spectators throwing apple cores or walnut shells onto the playhouse stage from the pit, they could be unruly and call out during the proceedings (Young 366). The more powerful members of the company, like those who took boxes or lords' rooms or sat on the stage in the private theaters, sat closest to the corpse and those who acted upon it.

Performing Anatomy

Regimens and monetary concerns extended beyond the regulation of behavior in the theaters. The body at the center of the theater was also the product of a series of controlled acts and financial transactions. For at least a century gratuities and regular payments associated with the performance of anatomies formed a significant part of the framework of the company's audit books. The anatomical subject was at the center of a set of commodifying relations, within which s/he was a consumable object. There were regulations regarding the payment of the beadle and porter for their assistance in collecting the bodies from Tyburn (Young 299, 301, 382).[7] Once the company's right had been claimed, each of the main players had a set fee for taking part in the proceedings.[8] Other payments were also involved in retrieving and eventually disposing of the body. Although the corpse itself was gifted to the company by the sovereign, there were conflicting and competing rights associated with it: for example, the hangman had the right to the clothes of the felon and required recompense if they were not left with him when the body was transported back from Tyburn to Monkwell Square. There were also subsequent costs associated with cleaning up after the anatomy and paying for the burial of the remains. In 1606 the combined burden of these costs led to the suspension of the anatomies for three years because of the poverty of the hall's coffers (Young 327).

The lectures followed a set procedure over three days, given in an order determined by the natural process of decay, with a day devoted to each of the visceral, muscular, and osteological lectures. The public anatomies held on the continent were usually held in the winter months (Ferrari 64–66), which prevented the body from becoming too noisome over the three days' proceedings. Public anatomies at the Barber-Surgeon's Hall followed

the same pattern, with lectures given in morning and afternoon sessions (Young 362), but they were held up to four times a year.[9] They fell quarterly, undoubtedly to take advantage of the availability of bodies at the quarterly assizes (Cregan 272).

These performances also had regulations setting out the proper accoutrements for the members of the company and for the linen to be afforded the central players—reader, masters, and stewards. Costume, properties, and setting were manipulated to effect and enhance the pedagogical intent. The terms of these regulations were initially set down in a court minute of "5th March 1555" and were reiterated in 1635 (Young 309, 355). The 1581 portrait of John Banister's anatomy lecture shows the required form of dress in use. (Figure 4) The title pages of Crooke's ΜΙΚΡΟΚΟΣΜΟΓΡΑΦΙΑ (1631) and Alexander Read's *The Manuall of the Anatomy or dissection of the body of Man . . .* (1638) also depict ceremonially dressed groups of men in attendance at anatomies.[10]

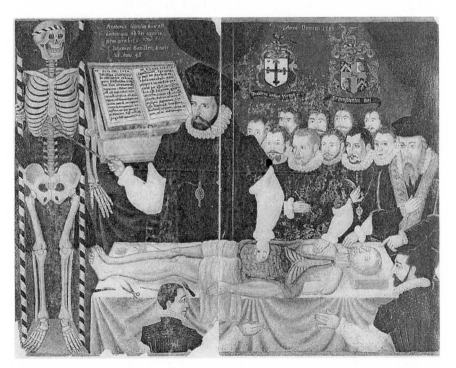

Figure 4. *The visceral lecture Delivered by Barber-Surgeon Master John Banister Aged 48, Anno Domini 1581* (MS Hunter 364, Glasgow University Library), reproduced by kind permission of Glasgow University Department of Special Collections.

From the terms of these minutes, the partitioning of anatomical actor from his appreciative audience is clear. Each player in this bloody circus was supposed to behave in an agreed manner and to wear a particular costume that distinguished him in his allotted role.[11] The main performers were not only centrally located within the theater but their position is also marked out by the "matte about the harthe in the hall" (Young 309) upon which they stood. The "ij fyne white rodds appointed for the Docter to touche the body where it shall please him" (Young 309) at once gave the reader the power to point out and describe the body parts being interpreted and allowed him to maintain a distance between himself and the deceased criminal form. Those who dealt with the body had linen "aprons and sleves every daye bothe white and cleane" (Young 309) that could be changed to avoid begriming their clothes. The barber-surgeons in the audience were supposed to wear caps, hats and/or gowns signifying their position within the company, just as the populace at large was regulated by wider sumptuary laws. The final character was laid in front of them on a table, upon which the "business" of the performance was enacted. Even the cadaver had a curtain—later an embroidered pall—in which it was "clothed" (Young 214). In the raked galleries the "comon people" observed the spectacle enacted before them. Neglect of these rules attracted fines (Young 335), suggesting a failure to comply with, and an anxiety to ensure, strict adherence to this ritualistic regime.

A small cast of actors played their allotted parts. The reader or doctor, like Prospero in *The Tempest,* governed proceedings, directing the action by declaiming classical authorities on anatomy and appealing to the new authority of the post-Vesalian illustrations that supported them. His attendants, the barber-surgical master and stewards, provided the "business," laying hands on the body and performing the dissection. The working of this theater not only shared its layout with the dramatic theater, it also used analogous spectacular devices to impress its audience. The stewards took care to prepare the body and keep it behind a curtain, confining it to this "discovery space" until the moment appropriate for its disclosure, when the reader was ready to enter and pronounce over it. In this theater, however, death was not a ruse. The corpse of the executed criminal, the final actor, was eviscerated, flayed, and the flesh systematically removed from his or her bones.

The material conditions of the Anatomy Theater at the Barber-Surgeon's hall regulated and disciplined all of the bodies that attended its performances, not just the body of the corpse. They were all subject to a

pedagogical regimen, effected through the ritual of the performances that took place in this theater. Anatomical dissections were sites of discipline: both the body and the audience were subject to the authoritative discourse of the anatomy text as pronounced and enacted in this bloody circus. The audience gazed upon the body, which was represented to them by, and mediated through, the word of classical textual authority, declaimed by a lecturer.

The body was framed and represented, defined, monitored, and controlled. The audience who came to view the spectacle of the opened corpse was disciplined within the same dynamic. The anatomical imperative *nosce te ipsum*—"know thyself"—was a literal as well as a metaphoric injunction. The body was not only a reminder of the transience of the flesh; under the anatomical gaze it was also a mirror of the observer, the discursive construction of the corpse reflecting back upon the spectator. As sites that drew spectators, as spaces in which rituals of embodiment were held, the anatomy theaters were also locations where the construction of sex and gender was demarcated as it was in the playhouses. The performance of anatomies was part of the matrix that brought the body into being, under the authority of anatomical illustrations.

"The Figure Explained"

The painting that commemorates the anatomy lectures given by John Banister in 1581 represents this process of "authorized" framing in progress. A group portrait, it shows Banister reading a lecture on the viscera, one hand resting on the gut of the opened cadaver, the other holding a "rod" with which he indicates where those organs would sit in relation to the skeleton, suspended to Banister's right. It stands in the "case of weynscot made wth paynters worke yr upon," ordered in 1568 (Young 315). To Banister's left, crammed into the upper right quadrant of the painting, are eleven men. One of these figures, by his robes, dignity, and proximity to the body, would appear to be the master of the company. He motions sagely toward the cadaver's head, in a gesture of benediction. Four men, two to Banister's immediate left and two opposite him, are carrying out the actual work of the dissection in the clean white sleeves mandatory for the masters and stewards. The man immediately to Banister's left holds a probe, the man next to him holds a dissecting knife, their apparel suggesting they are the masters of anatomy. Both rest a proprietorial hand upon the body. The two men on the opposite side of the cadaver appear

to be the stewards, who were partially responsible for the procurement and disposal of the body.

The painting shows, on the table at the feet of the corpse, the sort of mess that was complained of as a nuisance to the kitchen: "hitherto the bodies have been a great annoyance to the tables, dresser boards and utensils of the upper kitchen by reason of the blood, filth and entrails of these anatomies" (Young 334). Shears, knives, and what appears to be adipose tissue taken from the body litter the lower part of the table. This painting also gives some indication of the kinds of anatomical texts that were in use in this particular Anatomy Theater. The book that sits on a lectern over Banister's right shoulder is given a dominant position in the painting, higher than the reader himself, and second only in prominence to the skeleton. In this image Banister touches the body and indicates the skeleton, but the text transcribed onto the painting, both in the depiction of the book and the words transposed onto the corpse, makes clear that he has been referring to the book.[12]

Across the opened gut of the cadaver three words appear denoting the upper intestine, the stomach, and the liver. Although the text depicted is unillustrated, apart from its frontispiece, the painter has made the cadaver the anatomical illustration to the text.[13] And in the hierarchy of the participants' scale, which mimics the place of each in the hierarchy of authority (also implicit in the relation between text, skeleton, and reader), Banister is the only character larger than the body of the cadaver. There is a correspondence, too, between the text and the body: what one reads in the book will become clear in and through the form on the table. This painting illustrates how the organs came into being for the audience through the mediating hand of the reader, reinforced by an appeal to the authority of the text. But it goes further by offering the anatomical subject as illustrative evidence, both within the logic of the painting, as the subject before the assembled audience, and external to the painting, as an illustration to the book on the lectern to the observer of the painting. It is iconic of the shift in the power relation between the anatomist, the body, and the text that was subsequent to the rise of Vesalian illustration.

Anatomy books brought back or imported from the continent, and anglicized for the local classically illiterate market, were illustrated with images infused with the aesthetic mores and theories of Renaissance Italy. Sander Gilman has said, "[I]t is the culturally determined reading of any text or image in its historical (and, indeed, national) context which determines its particular meaning; and one basic aspect of this culturally

determined reading of a text is the image of disease which dominates any given culture" (Gilman 155). Gilman's use of the term "disease" can just as easily be replaced with "the body." One of the effects of the migration and multiplication of these continental woodcuts and plates was that some of the factors that influenced their production, such as religious and artistic aesthetics, while not perhaps obtaining directly, were implicit in the dominant discursive representations of the body in England: and they were deeply, stereotypically gendered.

When the patrons of the anatomy theaters of England followed the texts imported from European centers of learning they were taking part in a relatively recent revision of classical anatomical precepts, which saw a shift in authority from the declamatory scholastic tradition to an increasing reliance on empirical observation. Many of the books that were designed to be used at English anatomies as dissection manuals originated in Italy or were based in the practices of educational anatomy as revivified there. Those Englishmen who went on to become the eminent anatomists of the sixteenth and seventeenth centuries had often studied at one or other of the continental universities or had at least visited their Anatomy Theaters (Cook 50–52). Through their aegis, the practice of surgeons, physicians, and anatomists in Padua, Bologna, Paris, and Leiden influenced the practice of surgery and "physic" in seventeenth-century England.[14] The practice and experience of anatomy in England was infused with both classical anatomical and artistic traditions that had had their rebirth in quattrocento Italy. These drawings were, in turn, permeated by stereotypical assumptions about the "nature" of "sex," of sexuality, and of gender: "*Anatomia* operated according to a rigidly gendered set of rules and prohibitions. To those rules and prohibitions, the art, literature, and science of the body were subservient" (Sawday, *Body Emblazoned* 229).

Consider the two figures that appear in the frontispiece and reappear in the body of Helkiah Crooke's ΜΙΚΡΟΚΟΣΜΟΓΡΑΦΙΑ: *A Description of the Body of Man* (1631): the female gravida figure on the verso and the male *écorché* on the recto. This book is one of the few of which it can be said with certainty that it was in the possession of the Barber-Surgeons: Crooke dedicated it to them and "donated" a copy of the first edition to the company in 1616 and was granted five pounds for his generosity. It is in English, and it is also known to have been a popular text.[15] These figures are reengraved from illustrations in Juan Valverde de Hamusco's *Historia de la composición del cuerpo humano. . . .* (1556). The female figure originally appeared on the recto of the frontispiece in the first edition as

well as in "The Fourth Booke: Of the Naturall Parts belonging to genera-
tion, as well in Man as in Women" (Crooke, *Description* [1615] 197). It
shows a pregnant woman with her abdomen partly resected to display a
gravid uterus. This illustration had already been reused in Andreas Lau-
rentius's *De anatomice* (1595). Crooke acknowledges his debt to Laurentius
and has quite obviously used his reengraving of the gravid figure rather
than Valverde's original. If one compares the three illustrations, Laurentius's
and Crooke's are virtually identical, although the engraving in Crooke is
a little cruder. That Crooke chose to use Laurentius's version when he
obviously knew Valverde's (Crooke 10) is pertinent when one observes
their differences. Gesturally, Valverde's original owes much to the penitent
nonparous Eve that appears in Vesalius's *Fabrica* and to artistic represen-
tations of a newborn, untouched Venus rising from the sea. Valverde's
pregnant yet modest Eve covers her right breast and her genitals. There
is economy and restraint in the disposition of her limbs. Her expression
is solemn, her eyes properly downcast in shame as she gazes absently to
her left.

The reproduction found in Crooke substantially alters the portrayal of
the female figure, first and most obviously by reversing her. Other alter-
ations suggest that this is an unrepentant fallen Eve or a lustful Venus.
The fingers on the hand that cover the genitals have been splayed further
open. This gesture at once suggests concealment and invitation, signifying
the characteristic potential for openness or incontinence of even the most
chaste woman's body. The left hand covers the left breast, but in straight-
ening the fingers of the hand and moving the point at which the tips of
the fingers touch the sternum further across onto the right breast, the
figure is made to appear to be erotically presenting her breast to her (male)
viewer, much as one presents a nipple to a hungry infant. Not only are
the gestures that signify modesty altered, so too are this figure's gaze and
expression. When one combines the gestural codes with her direct smiling
gaze looking out of the plane of the picture at the viewer, we see another
version of Eve or Venus: the seductress. And she is soon to undergo the
fulfillment of God's curse: "I will greatly multiply your pain in childbear-
ing; in pain you shall bring forth children" (Gen. 3:16).

The majority of illustrations used in Crooke's text show little sign of
emendation. Where they are adapted they portray the female figures as
sexually available and reinforce the casting of male figures as pitiable mar-
tyrs. The central male figure of the frontispiece appears in the body of the
text in the first edition but is brought to prominence on the title page of

this, the second. It shows a man who has seemingly obliged his audience and his anatomist by flaying himself.[16] It is generally accepted that the depiction of this figure has been influenced by representations of the Ethiopian Christian martyr, Saint Bartholomew. Samuel Edgerton has noted the striking similarity between the flayed skin that Valverde's figure holds and that held by Michelangelo's depiction of Saint Bartholomew in the *Last Judgment* (215–19). This obliging fellow is, like the female figure, adapted from Valverde by Crooke's engraver, but in this case only by the introduction of some crude changes to his musculature. His expression and stance portray the nobility of bearing and saintly forbearance that characterizes the original and which is typical of the depiction of the vast majority of male anatomical figures. The only discernible difference is in the ghostly visage of the flayed skin. In Crooke's version it appears to be looking out at the reader, and its expression is more pitiable than the fiercer-looking original. One could take this as a shift in emphasis from the stance of a proud Christian martyr to the resignation of a secularly punished criminal, like Tom.

The choice of these two figures as the opening illustration to the book is appropriate. Like the Adam and Eve given as examples of surface anatomy adapted by Thomas Geminus directly from Vesalius, the male/masculine body is portrayed as repentant, thoughtful, and forbearing; the female/feminine body as sexual. There was in fact some controversy surrounding Crooke's first edition, over the explanation of generation and the illustrations used in this book, on the grounds that they were lewd. Crooke, rightly, argued that the illustrations had been in use for decades, that "they are no other then those which were among our selves dedicated to three famous Princes, the last a Mayden-Queene" (Crooke 10). Crooke's politically motivated detractors, who alluded to "Aretine's" postures, had a point, however: the representations of the female form in anatomical illustrations are, like the sexual figures that accompanied Pietro Aretino's sonnets, highly eroticized.

Crooke's text was large and expensive and most probably intended to be the reader's reference on the lectern. This would seem to limit the influence of these illustrations to the privileged few close enough to the center of the theater to see them clearly. But these illustrations were more accessible in a vernacular pocket edition, specifically designed for use by barber-surgical apprentices crowded into the raked standings.[17] Alexander Read's *Description of the Body of Man* was an epitome of Crooke's text, which contained the same illustrations and was directly indexed to it,

making it a valuable pedagogic tool.[18] The volume is much smaller than
Crooke's and designed to be portable and affordable. It is the pedagogical
function of Read's text more than the illustrations that appear in it that
warrant some comment. The page on which each of Read's figures appears
in Crooke's book is given for all the plates, with directions to seek them in
"the History of this Booke at large." Read's illustrations follow Crooke's
in all essential points. The text is severely pared down, however, contain-
ing only brief explanatory information on the indicated structures.

In Read's preface he justifies his distillation of Crooke's compilation
of the work of others by pointing out some of the disadvantages of large
anatomies and the advantages of his own:

> [I]n the aforesaid Authors, the descriptions of the parts being interposed
> betweene the Figures, distract the minde, and defraud the store house of
> memory; besides this the volumes are not portable: Whereas by the con-
> trarie, this small volume presenting all the partes of the body of man by
> continuation to the eie, impresseth the Figures firmly in the mind, and
> being portable may be carried without trouble to the places appointed for
> dissection: where the collation of the Figures, with the Descriptions, cannot
> but affoord greate contentment to the minde. The Printer therefore of the
> former great volume, hath published this small Manuell, hoping it will
> proove profitable and delightfull to such as are not able to buy or have no
> time to peruse the other (Read, *Description* A3r–A3v)

Read's lauding of the lack of complex written explanation and disputation
is intriguingly empiricist. Read privileges the "Figures" or illustrations,
over the learned text, in essence because the written text is unnecessary.
Written descriptions "distract the minde" from the images that are clearly
understandable to the observing eye. An illustration impresses the "Fig-
ures more firmly in the mind," it aids in committing them to memory
more forcefully: an anatomical picture is worth a thousand words. This
privileging of the visual image over the written word is also inherent in
the title of Read's *The Manuall of the Anatomy or dissection of the body of
Man* (1638): the "Anatomy or dissection" is not explained, it is "shewed"
so that it can be "methodically digested" and thereby reconstructed.

Read merely states explicitly what is already implicit in the whole pro-
cess of theatrically displayed anatomies: that the evidence of the eyes and
the comparison of figure in the book with figure on the table, or the figure
on the corbel stone, will yield up the truth of embodiment itself. That

"truth" comes tied to a wealth of cultural presuppositions. The anato-mized female is always seen in terms of her gender, her culture, and her sexual availability. The male form is predominantly shown as an *écorché*, flayed to varying degrees, like a martyred Saint Bartholomew or Marsyas. The female body is *never* shown without some drapery of skin. The mus-cular, skeletal, and nervous systems are almost exclusively depicted on the male body, as are all the organs common to both males and females. The female body is depicted in these anatomical texts, together with the pro-liferation of small pamphlets that were indebted to them, solely in terms of its generative function. The effect, then, is to propagate the idea that all the gendered, cultural, gestural, and aesthetic codings that are present in these representations of the bodies of women are in fact true and *essential*.[19]

Sawday argues that the trope of presenting the anatomical subjects as seemingly live creates the effect that the cadaver is complicit in the act of dissection. He argues that the cadaver in the frontispiece of Vesalius's *Fabrica*, a female subject, looks toward Vesalius compliantly, yielding to the act, as if she "*desires* dissection" ("Fate of Marsyas" 123) (figure 2). To which I would add she is also positioned with her genitals facing the reader, her legs parted, breasts bared, and in a position that invites entry. Laqueur states "she comes out at us from the plane of the picture" (172) and argues that the rhetorical strategy of this frontispiece may be read as "an assertion of male power to know the female body and hence to know and control feminine Nature." (73) I would argue that it is not so much that the corpse desires dissection but that even in death the feminine body is sexually charged. How could a Renaissance man conceive of a naked woman who does not express her sexual desires, those irresistible forces by which he believed she was ruled?

As the body is dissected it both becomes an "anatomy" and reveals anatomy. The title page from Read's *Manuall* exemplifies the slippage between these two terms. Anatomy and dissection are interchangeable, but the act of anatomization is part of the production of anatomy. The body is, then, both the site of a corpus of knowledge and also names and gives meaning to the corpus of knowledge itself. The body, the gendered body, is the product of a set of attributions, properties, and appearances, which are decided upon and shaped by the authority of delimitation that is viewing and describing it. The "passive authority" of the body is depen-dent on the discursive construction of meaning within which it is itself constructed. Anatomical illustration forms a part of that discursive con-stitution of the ontological.

"Beg'd at gallowes"

Canberry Besse came to form an integral part of that ontology in the
Barber-Surgeons' Anatomy Theater. Unlike the majority of felons anato-
mized by the company, Besse was never accorded the final dignity of being
interred. She is, however, mentioned in the Barber-Surgeons' court min-
utes for 29 March 1638: "It is ordered that Edward Arris and Hen: Boone
shall have libertie to sett up in or Theater a Sceleton by them wrought
on when they were Masters Anatomysts on the body of Cañbury besse to
be placed on the Corbell stone of the Signe of Libra" (Young 337). The
notoriety of her crimes undoubtedly influenced her anatomists to make
her a permanent exhibit. Convicted, condemned, and executed, Besse was
dissected at the Barber-Surgeons and mounted as a permanent display
above their regular public anatomical lectures. The gibbeted remains of
her confederate, Countrey Tom—"martyred" at a public crossroads in a
manner that made his anatomization, like Saint Bartholomew, virtually
redundant—were retrieved at some later date for exhibition opposite her.

Partners in life, crime, and death, Besse and Tom became the two skele-
tal figures set upon the corbel stones adorned with the symbols of Libra
and Taurus, respectively, "the planett Venus governeing those twoe signes
underneath" (Young 337). In death, as in life, Besse was represented as an
icon of feminine corruption. When one takes into account her crimes, as
relayed in the "gallows confession" pamphlet, the punning significance
of placing her anatomized remains above the Libran scales of justice and
her partner in life and in crime above Taurus become clearer. It reinforces
the logical end of their physical and criminal partnership. The way in
which the Barber-Surgeons chose to display their remains casts them as
eternally portraying the lust and corruption that they penitently regretted
at the gallows.

Eve was set above Libra, Adam above Taurus. Their skeletal remains, like
the cadaver in the Banister painting, were an adjunct to the pedagogical
workings of the theater, a pair of three-dimensional anatomical illustra-
tions. In anatomical illustrations, as on the early modern stage, explicit
connections are frequently made between the corrupting nature of a
woman's sexual organs, death, and anatomy. Besse became a desiccated
exemplar of the dangers of the pleasures of the flesh, reinforcing the ped-
agogic message that was proffered in the anatomical illustrations before
the apprentices. She was such a perfect example of corrupt femininity one
assumes she was still there in 1666 and was one of the skeletons whose safe

return to the Anatomy Theater was compensated for after the confusion of the Great Fire (Young 414).

Besse is the only readily traceable body anatomized by the Barber-Surgeons prior to the Restoration, and it is significant that she is a female and a felon. Her criminality, sinfulness, and sexuality are inextricable from her representation both within the Anatomy Theater and in the reporting of her demise. Hers is also the only body in the surviving records of felons who were anatomized whose ultimate fate is also recorded with the narrative of her crimes and her execution. The rhetoric surrounding her death and her anatomization casts her fate as a just end to a sinful career. Is it any wonder that, though she "died very penitent," she was "after her execution conveied to Barber Surgions Hal for a Skeleton having her bones reserved in a perfect forme of her body which is to beseene and now remaines in the aforesaid Hall" (H.G. C.3.r). And this is applauded, at least by Goodcole.

The anatomization of an individual person in such obvious and direct connection with the workings of justice does not reappear until well into the eighteenth century with the passing of the Murder Act (1752), which made anatomization a legal adjunct to a sentence of death. Legal justice is not particularly important to Besse's narrative. The judicial process through which she and Tom passed, their imprisonment in Newgate and trial at the Sessions House, is dealt with and disposed of in little more than a paragraph. Rather, she is receiving God's judgment and his punishment for a sinful life. It is a just punishment upon an aberrant, exorbitant woman. Not only is her grisly fate relayed along with the reporting of her confession, it is repeated, with less sympathy and more relish, at the end of the pamphlet: "the Coy-duck, or divellish allurer to sinne and confusion, was dissected and her dryed Carkase or Sceleton of Bones and Gristles is reserv'd, in proportion to be seene in Barber Surgeons Hall" (H.G. C.4.r). This rider is, in effect, an advertisement for the admonitory exhibition she became, set up "to teach man, / Wherein hee is imperfect."

Sawday allies the venally explicit representation of the female body to a preoccupation with categorization and control: the illustrations in anatomy manuals that were used as guides to the body bear this out. But Sawday conflates a socially diffuse preoccupation with female sexuality with an apparently heightened enactment of that preoccupation. That the *only* way that the female form was "seen" was in relation to its sexual availability and venal propensities does not mean that the bodies of women need then have been particularly common as anatomical subjects. It just means

that when a woman *was* anatomized the motivating factor for doing so was to examine the organs of generation. The same can be said of the allying of femininity, criminality, and the subject of dissection. Amongst those convicted of serious crimes, men grossly outnumbered women: even on the most extravagant estimate women could not have accounted for more than 20 percent of those who underwent capital punishment in the seventeenth century (Cregan 247–51).

Certainly the idiosyncratic manner in which William Shepherd, the humorist clerk of the Parish of Saint Olaves, consistently recorded the unnamed burials of publicly dissected persons seems to display a fascination with the anatomization of females, through a decided feminization of the anatomical subject's remains (Register of Baptisms). In the variable orthography characteristic of the period, An or Ann Athomy[20] was buried approximately eighteen times in the space of four and a half years between 1644/5 and 1649/50. The facetious use of this pseudonym for the remains of a dissection suggests at once a desire to conceal the fact of the burial of anatomies within the churchyard, scattering them through the register amongst the other Anns late of this parish, and a feminization of the generic subject of the slab. It also hints at a wider fascination, at least for this clerk, with the female subject of the Anatomy Theater: for him, the splayed and eviscerated female body was seemingly indissociable from the general act of anatomy.

William Shepherd, like the barber-surgeons, anatomists, illustrators, and playwrights of his day, knew the "truth" of embodiment. Even in the unity of death, at which point logically all bodies suffer the same fate, it is differentiated, and in that difference it is erotically and morally weighted.

NOTES

This chapter is a distillation of the first part of my dissertation. The section titled "The Figure Explained" is taken from an illustration of a female gravida figure in Jane Sharp's *The Midwives Book* (1671). Here I have to confine my analysis to a single example of the gendering at work in anatomical illustrations, but in my doctoral thesis I have given detailed analysis of over fifty illustrations and surveyed hundreds printed between 1400 and 1700. I would like to thank Jonathan Carter, Denise Cuthbert, and Paul James for their generosity in reading an earlier draft of this work and for their acute insights, comments, and suggestions.

1. See Cushing for a bibliography of the books in which Vesalius's work appears.
2. See Sharpe on the rhetoric of the penitent "good death" at the gallows.
3. In this respect, as Langbein argues, it is a fairly representative example of its genre (46).

4. Foucault uses madness as an example of an object constructed through and by an authorized discourse, namely medicine: "(as an institution possessing its own rules, as a group of individuals constituting the medical profession, as a body of knowledge and practice, as an authority recognized by public opinion, the law, and government) [it] became the major authority in society that delimited, designated, named and established madness as an object" (42).

5. These three theaters, respectively a converted inn yard, a public playhouse, and a private theater, are rough equivalents of the sports stadium, cinema, and opera house. The ability to enter these different arenas was, of course, also governed by price: admission varied from one pence to six pence in the public playhouses, but seats in the private theaters were rated in shillings (Gurr 26).

6. See Heckscher (42–43) for Holland and Ferrari (82–84) for Italy.

7. From 1715 this was no easy matter as there were many riots at Tyburn over the removal of bodies, and beadles often found themselves injured in the affray. It is often erroneously assumed that this was always the case, usually by mis-citing Peter Linebaugh's seminal article on eighteenth-century anatomy, "The Tyburn Riots Against the Surgeons," in Hay et al. Linebaugh is perfectly correct in his argument, but as I have demonstrated in "Microcosmographia," the same case does not obtain before the eighteenth century.

8. Between 1604 and 1620 the master and stewards received six pounds for performing their duties (*Audit Book*).

9. I have demonstrated conclusively that unlike the continental pre-Lenten public anatomies, the Barber-Surgeons performed their public anatomies virtually all year around, although far fewer were performed in the summer months (Cregan 256–72).

10. Both these books were dedicated to the company so it is fair to assume that these illustrations are intended to reflect their intended recipients to some degree, although in the case of Crooke's work the scene displayed on the verso to the frontispiece does not show the scaffolding used at public anatomies, which by the company's accounts were definitely in use when this reprint of his 1615 *magnum opus* was published (Cregan, appendix 5). It may, however, depict a private anatomical lecture.

11. While there were females who paid their quarterage to the company and female apprentices who may have attended, none were ever office bearers and therefore would not have taken an active role in the public anatomies, much as women did not tread the boards in this period.

12. This has been identified as an octavo edition of Realdus Columbus's *De re anatomica* (Paris, 1572), opened at the section on the viscera (Power 77–78).

13. The imposition of text onto a painting, particularly free-floating banderoles, mottoes, or dates, was far from unusual in English art at this period. The fact that it is imposed on a body is unusual: this is the sort of labeling reserved for maps, like John Speede's, or the adaptation of Saxton's Atlas on which Queen Elizabeth I stands in the "Ditchley" portrait (Strong 134–36). It is more typical of older (fourteenth- and fifteenth-century) traditions of European anatomical illustration, of "wound men" and "frog posture" fugitive sheets.

14. For a brief (if a little jumbled) account of the interrelationship of the practices of Anatomy Theaters in Italy, Holland, England, and France, see van Rupp.

15. I have chosen to be conservative in my choice of texts and selected those I thought were the most accessible and/or the most prolific publications, for the following reasons. Just because an image is striking and rich in metaphor or iconography does not mean that the message being transmitted by it was a widely received or a commonly accepted one. For example, whilst the images in *De dissectione* that Laqueur sets such store by are rich and remarkable, the book was expensive, and I would argue that any implied message in its images reached far fewer people on the continent than would have been the case for those published by Read or Crooke in England. A "king may go a progress through the guts of a beggar" (*Hamlet* 4.3.30–31), but a lavishly produced, illustrated anatomical text by a physician, who from 1546 was also the printer to King Francis I, would not necessarily reach and influence the perceptions of a beggar, or a barber-surgeon.

16. Sawday reads this figure as Marsyas, flayed by Apollo ("Fate of Marsyas" 126).

17. "Pocket" editions and fugitive sheets available to the apprentice allowed him or her the agency to observe and interpret the image within the pedagogical process, but the interpretation of those images was directed by the reader, and they also carried with them stereotypical assumptions about gendered attributes.

18. Crooke's full-format book went through six issues and two editions as well as being abridged by Read as his *Description* and further adapted as *The Manuall of the Anatomy or dissection of the body of Man* (London 1638), both of which went through multiple print runs (Russell xxiii, 161–63).

19. This is not the same as saying they are biologically determined; it is more an affirmation of the "nature of woman" as taught by the Church.

20. The (female) name An or Ann appears in Shepherd's hand with proper surnames throughout the period he kept the register.

WORKS CITED

Audit Book 1659–1674. MS D/2/2 Barber-Surgeon's Hall, Monkwell Square, London.

Beattie, J. M. *Crime and the Courts in England, 1660–1800.* Oxford: Clarendon Press, 1986.

Beck, R. Theodore. *The Cutting Edge: Early History of the Surgeons of London.* London: Lund Humphries, 1974.

Cook, Harold J. *The Decline of the Old Medical Regime in Stuart London.* Ithaca, N.Y.: Cornell University Press, 1986.

Cregan, Kate A. "Microcosmographia: Seventeenth-Century Theatres of Blood and the Construction of the Sexed Body." Diss. Monash University, 1999.

Crooke, Helkiah. ΜΙΚΡΟΚΟΣΜΟΓΡΑΦΙΑ: *a Description of the Body of Man.* London: William Jaggard, 1615.

———. ΜΙΚΡΟΚΟΣΜΟΓΡΑΦΙΑ: *A Description of the Body of Man.* London, 1631.

Cushing, Harvey W. *A Bio-Bibliography of Andreas Vesalius.* London: Archon Books, 1962.

Dobson, Jessie, and R. Milnes Walker. *Barbers and Barber-Surgeons of London: A History of the Barber's and Barber-Surgeon's Companies.* Oxford: Blackwell Scientific, 1979.

Edgerton, Samuel Y., Jr. *Pictures and Punishment: Art and Criminal Prosecution During the Florentine Renaissance.* Ithaca, N.Y.: Cornell University Press, 1985.

Ferrari, Giovanna. "Public Anatomy Lessons and the Carnival in Bologna." *Past and Present* 117 (1987): 57–107.

Foucault, Michel. *The Archaeology of Knowledge.* London: Routledge, 1994.

Geminus, Thomas. *Compendiosa Totius Anatomie Delineatio* Trans. Nicholas Udal. London: 1553.

Gilman, Sander L. *Disease and Representation: Images of Illness from Madness to AIDS.* Ithaca, N.Y.: Cornell University Press, 1988.

G[oodcole]., H[enry]. *Heavens Speedie Hue and Cry Sent After Lust and Murder.* London: N. and I. Nokes, 1635.

Gurr, Andrew. *Playgoing in Shakespeare's London.* Cambridge: Cambridge University Press, 1991.

Heckscher, William S. *Rembrandt's Anatomy of Dr. Nicolaas Tulp: An Iconological Study.* New York: New York University Press, 1958.

Langbein, John H. *Prosecuting Crime in the Renaissance: England, Germany, France.* Cambridge, Mass.: Harvard University Press, 1974.

Laqueur, Thomas. *Making Sex: Body and Gender from the Greeks to Freud.* Cambridge, Mass.: Harvard University Press, 1992.

Laurentius, Andreas. *De Anatomice* Paris: 1595.

Linebaugh, Peter. "The Tyburn Riots Against the Surgeons." *Albion's Fatal Tree: Crime and Society in Eighteenth Century England.* Ed. D. Hay, et al. London: Allen Lane, 1975. 65–118.

Pepys, Samuel. *The Diary of Samuel Pepys.* Ed. R. C. Latham and W. Matthews. Vol. 4. London: G. Bell and Sons, 1971.

Power, Sir D'Arcy. *Selected Writings 1877–1930.* Oxford: Clarendon Press, 1931.

Read, Alexander. *cor a Description of the Body of Man.* London: William Jaggard, 1616.

———. *The Manuall of the Anatomy or dissection of the body of Man. . . .* London, 1638.

Register of Baptisms, Marriages and Burials, Parish of St. Olaves Silver Street 1561–1770. MSS 6534 and 6534A Guildhall Library, Aldermanbury, London.

Roberts, K. B., and J. D. W. Tomlinson. *The Fabric of the Body: European Traditions of Anatomical Illustration.* Oxford: Clarendon Press, 1992.

Russell, K. F. *British Anatomy 1525–1800: A Bibliography of Works Published in Britain, America and on the Continent.* Winchester, Hamps.: St. Paul's Bibliographies, 1987.

Sawday, Jonathan. *The Body Emblazoned: Dissection and the Human Body in Renaissance Culture.* London: Routledge, 1995.

———. "The Fate of Marsyas: Dissecting the Renaissance Body." *Renaissance Bodies: The Human Figure in English Society C.1540–1660.* Ed. Lucy Gent and Nigel Llewellyn. London: Reaktion Books; 1990. 111–35.

Shakespeare, William. *The Complete Works.* Ed. S. Wells and G. Taylor. Oxford: Oxford University Press, 1986.

Sharpe, J. A. "'Last Dying Speeches': Religion, Ideology and Public Execution in Seventeenth Century England." *Past and Present* 107 (1985): 144–67.

Strong, Roy. *Gloriana: The Portraits of Queen Elizabeth I.* London: Thames and Hudson, 1987.

Valverde de Hamusco, Juan. *Historia de la composición del cuerpo humano* Rome: Antonio de Salamanca, 1556.

van Rupp, Jan C. C. "Michel Foucault, Body Politics and the Rise and Expansion of Modern Anatomy." *Journal of Historical Sociology* 5.1 (1992): 31–60.

Webster, John. *The Complete Works of John Webster.* 1927. Ed. F. L. Lucas. 4 vols. London: Chatto and Windus, 1966.

Young, Sidney. *The Annals of the Barber Surgeons of London.* London: Blades, East and Blades, 1890.

Representation of the Dead Body in Literature and Medical Writing during the Restoration in France (1799–1848)

ROBERT S. APRIL

The purpose of this essay is to look at writings about the dead body in post-Revolutionary French medical teaching and at representation of the dead body in literary passages of the period. During these years from Napoleon Bonaparte to the Republican Revolution (1799–1848), a critical change in thinking about death and disease took place, which separates the thinking of this period from earlier times. I would like to propose the thesis that this change in thinking led, on the one hand, to the emphasis on pathological anatomy and the lesion concept in disease and, on the other, to the relative weakening of vitalism and other, non-materialist philosophies in medicine. Furthermore, this change provided an intellectual basis for the evolution of the physician into the modern scientist-healer that we know today.

This evolution in medical thinking was the reflection of a fundamental change in the consideration of nature and natural science, which was founded on the principles of earlier thinkers (Descartes, Spinoza, Liebniz) but evolved into a new mindset that characterized the Enlightenment (Cassirer 37–92). This change led to a new relationship between the objects of the senses (concrete and particular) and a flight of the mind into areas of universal order and law. It was this evolution in the history of ideas, and not the advent of technological innovations, that led to the new medicine and representation of the dead body.

Literary concern with dying and the dead body is evident in all periods of history. These are subjects that interest authors because they show how people think about the reality of the human condition. In this sense, literature shares the strategy of pathological anatomy—namely, to use the

dead body to understand the living process, or simply stated, a looking at what was to see its influence on what is now. Literary depiction of doctors at work gives another image of some historical figures described in this essay; literary depiction of the dead reveals the nature of the society in which these changes in medical thinking were evolving.

I am a medical neurologist, trained in the historical tradition of Western medicine. I am also an educated amateur of French literature. I have chosen this topic because of my reading of nineteenth century medical history and also the works of known writers of the period. The political, philosophical, and scientific spirit of the times is reflected in both domains. By looking at these readings more closely, it might be possible to shed some light on the question of why this break in the history of ideas took place between the eighteenth and nineteenth centuries.

Sociopolitical Background

The turbulent political events of the 1790s swept away the old society (*ancien régime*) and eliminated the social reference points and intellectual dogmas that had characterized life under absolute monarchy. The restoration of imperial and then monarchical authoritarianism that began in 1799, as France fought off external military threats and reestablished the internal organization of life at home, produced a new age for a new nation. The new society combined the ideals and science of the Enlightenment and the libertarian thrust of the Revolution with the resurgence of the old religion and central political authority. Society moved cautiously, on tiptoes, making false steps, stumbles, and falls, as it first walked on this uncharted terrain.

The rise of empirical thinking that characterized the Enlightenment produced more interest in observation and experimentation and a materialistic determinism to explain natural phenomena in biology as well as chemistry and physics (Cassirer 65). In France, at least, this produced concern with anatomy, dissection, and description of disease, both in the living and the dead body. Physicians moved away from the scholastic approach called nosology. Nosology was a diagnostic system based only on classifications of symptoms. It acknowledged diseases to be (memorized) lists of symptoms—a taxonomy based on similar classifications in botany, zoology, and other natural sciences. The new physician of the Enlightenment began to consider the structural changes that constitute what is now called morbid anatomy—that is, the nature of local alterations in the

structure of vital organs by disease processes. He began to look at these events in a positivist fashion.

In pathological anatomy, attention was turned to the local change in the organ—the lesion. Thus, the lesion was to be considered the disease itself. It followed from this approach that one could begin to think about causes for lesions and also work backward to correlate them with the signs of change in the living body. Even if causes were not easily forthcoming, thinking about cause and effect was put into motion and stimulated those workers whose attention turned from structure alone to ideas of abnormal function (physiology).

Medical historians have defined different philosophical positions during this epoch. These include the pathological anatomists, the organicists, the vitalists, the physiologists, and the positivists. Ultimately, positivism became the foundation of experimental, empirical approaches to biological science and medicine in the nineteenth century. August Comte, its champion, denigrated the vitalist, spiritual approaches of the past, stating rather harshly that its proponents were simply wrong. It was an earnest reaction to all the traces of scholastic metaphysics that still permeated Western thinking.

But why at this time were all medical approaches able to look at dead organs with new eyes and see meaning in them that had not been appreciated before? Each approach added variations to the theme. Each was incomplete and none was totally correct. Our question is why such ferment was generated then and not before. Was it because of the development of new technical tools? Or, as I believe, was it a change in thinking rather than technology that permitted the new look at the dead body?

The development of technical tools to assist the human sensory apparatus did open new areas of observation in the larger physical world and in the smaller medical one. The telescope allowed precise statements about planetary motion and position. The microscope opened a new vista for the observation of small biological phenomena. The stethoscope provided an extension of the ear in order to render a "new eye" (Duffin, *To See* 121–50) on the vital processes of health and disease in living human organs. René Théophile Hyacinthe Laennec, the inventor of the stethoscope, and others developed systematic methods to explore physically the signs of disease in living organs and to compare them with the lesions in the body of the dead patient.

Was the change related only to the turbulent politics and the revolutionary social changes from 1789 to 1815, the fall of the First Empire? I do

not think so. The change in thinking that characterized the Enlighten-ment, whether directly or indirectly related to the French Revolution, was the forebear of the medical progress of the period this essay describes. It is thinking about dead organs as objects of nature with their intrinsic laws to be revealed by observation, measurement, and experimentation that led to the new concepts of disease and diagnosis. Medical thinking in this period of history led to the idea that one disease had one cause. Such a system of thought was reinforced during the microbial era, in which a specific organism became the cause of a specific disease. A change in this thinking to multiple factors in disease causation has occurred only with the advent of the genetic-microbiological era of contemporary medicine.

In the medical world, the new way of seeing disease went along with a new concept of medical instruction. Michel Foucault describes this new teaching at the bedside in his work on the birth of *la clinique.* His term translates to the English words "clinical," "bedside," "inspection," "palpa-tion," "auscultation" and "percussion"–in brief, the hands-on approach to the signs and symptoms of disease in a living, suffering patient. Fou-cault calls this a change of *le gaze médical,* which allows one's perception to expand in order to ask new questions. New observations and more interaction with the sick patient and, ultimately, exploration of the dark recesses of his dead body—the organs themselves—produced a new way of conceptualizing the process of disease and the making of a more accu-rate diagnosis in the living patient (Foucault 1–20).

The change in medical organization (Weiner 21–76) that led to *la cli-nique* was brought about by the reforming energy of certain figures such as Jacques Tenon, Michel Augustin Thouret, le duc de la Rouchefoucauld-Liancourt, Jean Colombier, and Félix Vicq d'Azyr. Public hygiene was developed via public baths, improvement of water, and waste control. Hospital reform was stimulated by aristocrats and citizen-reformers such as Liancourt and Prince Tallyrand. A new system of medical teaching arose out of the *ancien régime* institutions that had been closed by the Revolu-tion. The new medical charter (1794) established a more closely defined cadre of educated practitioners of medicine, pharmacy, and midwifery. It concerned itself also with distributing health care to the provincial, rural populations. It produced a regulated curriculum that would ensure med-ical education and sufficient clinical experience for the new practitioners. The public dangers of unregulated practice by untrained charlatans, as well as the death of many military doctors in the imperial wars, led to the need

for a replenished, but educated, medical cadre. Hence, the idea of *officier de santé,* a more rapidly trained but also more limited practitioner than the full *docteur en médecine,* satisfied a particular, temporary social need.[1] The proviso that the new republic was responsible for the health care of all citizens provided a plethora of clinical subjects for observation, description, and treatment (Duffin, *To See* 111–17).

The new medical school that arose out of the ashes of the *ancien régime* provided a breeding ground for the new ideas, the new medicine, and the new look at the dead body. A sociopolitical revolution, followed quickly by the beginnings of an industrial revolution, shook the very foundations of daily life at all levels of society. Jacques Léonard details the changes that could not have been imagined a few years before (*Archives du Corps* 11–52). All citizens had to adapt their ways to look at their individual lives and deaths. This was indeed a "future shock" as great as any we have experienced in our own lives.

The Dead Body, Pathological Anatomy, and Positivism

It was in the setting of this new medical school that the ancient Hippocratic method was supplanted by the new "science." The approach was different because it was based on opening the cadaver and performing a systematic examination of the internal organs and fluids. This led to the definition of the *lesion* as the local disease. From this point, one could correlate the lesion to the premorbid signs of the disease in the living patient. This sequence became the basis for clinical-pathological correlation, which is the hallmark of accurate medical diagnosis. The school of pathological anatomy concentrated on the lesion and tended to make the lesion itself both cause and effect of the disease.

Yet a conflict arose within the new medical thinking. It was seen as a struggle between "scientific" and "metaphysical" medicine, oversimplified by some historians into a dichotomous controversy between religious (vitalistic) thinking, on the one hand, and atheistic, liberal (positivistic) thinking on the other. By examining these differences, we must understand our medical forebears' thinking about problems that we, as doctors, still see today but, because our contemporary *gaze médical* is so unlike theirs, understand in very different terms.

Why would one raise the cry of "metaphysics" against Laennec's position that there exist vital forces in living (and dead) tissues to explain fatal disease that had not produced lesions in the organs at postmortem

examination? Laennec championed this position because his experience with thousands of corpses had shown him that there were such examples—and among them he included epilepsy, chorea, asthma, and fever. Realizing that available knowledge did not provide for the determination of cause in such cases, he postulated lesions in the impalpable vital forces that, he argued, could in turn produce lesions in solid organs. Whether this was a retreat to a mystical idea of God in matter, a return to Hippocratic thinking, or a humble expression of honest ignorance in an otherwise empirically oriented scientist is a matter for discussion (Duffin, "Cadavers" 139–55). Although Broussais, Laennec's scientific opponent, argued that metaphysics had no place in pathological anatomy, he himself postulated physiological and pathological forces that could not be seen, measured, or further defined empirically. Referring to the physiological works of Albert von Haller (142–86), Broussais was excessive in his emphasis on "irritation" (tissue excitability), particularly from the gastrointestinal mucosa, as the cause of generalized diseases, even in organs as distant as the brain (258–59). Using another nonobservable function—the "sympathies"—he postulated that mental and neurological aberrations could be caused by irritation from the gut, disseminating themselves far and wide through the sympathies of the central nervous system (119).

What emerges from the cited readings is a change in the history of ideas concerning observation of biological events. Even so, interpretation varied about the same observations. The movement from rationalism to empiricism in medical thinking was based on a philosophic change in the observation of living nature itself. The difficulty for the modern reader is that there was no scientific definition of terms. Moreover, there persisted in the minds of biologists the idea that living matter could not be explained through the laws of chemistry and physics. The dichotomy of organic and inorganic chemistry originally implied that organic processes included a vital force. This was debunked completely only in modern times, in the age of molecular biology (Watson 32–70).

The change in thinking leading to new observations on the dead body is described in the philosophical works of Auguste Comte, whose basic, early writings covered the years 1830–42. Comte espoused the philosophy called positivism, which had great importance for biological scientific thinking. His book is a call to scientific observation of natural phenomena by the senses and the application of *a posteriori* reasoning based on these observations. He sees reality only in the phenomenon itself and is foe to all forms of rationalism (160–209):

Biology began to have a scientific character from the time, almost our own, when living phenomena were subjected to the general laws of nature, of which they present only simple modifications. Their independence from these general laws is upheld today only by metaphysicists [vitalists]. Nonetheless, the growing sentiment of this truly speculative point of view, from which living things should be studied, has been up till now not force-ful enough to change the old cultural system of biology. This operation must not only extract biology from the various metaphysical influences but also must preserve it from the exaggerated trespasses of inorganic phi-losophy. Thus for about one hundred years, biology has been volleyed about between metaphysics, trying to retain it, and physics, trying to absorb it. (160)[2]

Comte's ideas are far in advance of his time; they are evolutionist and dynamic. He presages Claude Bernard and biophysics when he says, "From a doctrinary point of view, one cannot analyze any physiological phe-nomenon without applying the laws of one or another branch of physics, the basic universal science" (260).

An admirer of Marie-François-Xavier Bichat, Comte systematizes the approach to disease through the lesion, which is localizing in a particular organ, has a measurable and describable nature, and can be used to recon-struct a history of what took place in its evolution (165). This will be the lesion-based natural history of disease, which will no longer relate to some unseen, undescribable essential quality (life force, vital force, essence), but will be confined to that describable domain of the lesion itself. Here is where the dead body, pathological anatomy, and positivism come together to give meaning to the history of post-Revolution medical thinking and what followed. It is clear that this did not lead to an effective medicine at the time. That would await therapeutics, microbiology, physiology, anes-thesia, and antisepsis.[3]

Literary Representation of Death and the Dead Body

Given this brief survey of the medical writings about the dead body and how they influenced the representation of living processes, let us see what was done by the literary writers of the day. The examples I have chosen depict social, religious, and scientific thinking in early- and mid-nineteenth-century French life. In them one can appreciate the conflict between the new, scientific way of seeing the dead body and the old,

religious way. The explanations of disease, death, and the hereafter were fundamentally irreconcilable. Even with the scientific points of view being expounded in the academies, the populace read a romantic literature permeated with Christian thinking. Therefore, God as first cause was not so distantly removed from the events as he might have been in the minds of some scientists and doctors. This conflict played an important role in the different representations of the dead body.

According to Philippe Ariès, concepts of death changed greatly during the early modern period of European history into a state that was not as tame as it had been in earlier times (602–14). People now began to fear death. The unknown aspect of the hereafter became a reason for apprehension. To counter this darker side of death-thinking, a Christian beatification of death evolved. The death notebooks of certain nineteenth-century families (the French family La Ferronys and the British Brontës), written during the years that tuberculosis was overrunning Europe, are an example of the beatification of death, its softening, and its transition to a state that could be celebrated blissfully in the privacy of the home and the intimacy of the family (409–68).

Death would be made to arrive when all those important to the dying person were present and when needs could be tended and concerns expressed in an orderly, loving fashion by those in his or her life—family, friends, servants, and clergy. The sobering medical reality, however, was that, despite growth in the understanding of the lesions of tuberculosis, there was no effective therapy. The doctor, although more learned, was no more helpful in curing than he had been earlier (Davila 10–15). The relation to the science of the time was the fact that death was an inevitable consequence of the diagnosis of tuberculosis. The diagnosis was made by a combination of symptomatic analysis and physical examination, including Laennec's new method, mediate auscultation (stethoscope). But since infectious theory did not exist, counterirritant treatment especially blood-letting by leeching was the accepted method as well as putative therapies related to diet, fresh air, and rest. The existence of tuberculous lesions in affected lungs was recognized, but not a causal relationship with a microscopic infectious agent. Another step in the evolution of *le gaze médical* would be necessary.

The scourge of tuberculosis often affected the younger members of a family. Thus, families adapted to the inescapability of death by creating a conception of death as a blessed, anticipated event. It was awaited eagerly because it was, for the living, something characterized as liberating, giving

the heretofore afflicted victim a release from pain and a liberty from the constraints of the earthly existence. He or she was to be transported, according to this system of ideas, to a higher level, one suffused by love in its highest, spiritual form. This psychological reaction to a cruel, impersonal, painful death created a romantic ideal—what Ariès calls "*la belle mort*" (310–12). In relation to the present thesis, one can see that religious thinking was the basis for the concepts of the afterlife as well as immaterial forces in nature and in disease—vitalism. In this way, vitalism appeared to have religious overtones. The vital force was a manifestation of the first cause, or God. This kind of thinking would have no place in the scope of the new positivistic medical science.

François-René de Chateaubriand, the aristocratic author of *Le Génie du Christianisme,* gave post-Revolutionary France a text that placed Christian thinking about death squarely in the literary mainstream of the period. *Atala,* a romantic novel that treats the beauty of life in the wilderness among New World Indians, gives us an exquisite description of the "*belle mort*" of Atala herself. The passage cited here is a beautiful example of the representation of this kind of death and the dead body. The antithesis of the scientific description posited by my thesis, it is full of nonempirical ideas based wholly on religious concepts of the soul, immortality, paradise, and the baseness of the senses—all contrary to the thinking that came out of the Enlightenment and post-Revolutionary French science.

After much expiation, expression of despair, frustration in her inability to consummate her incestuous love of Chactas, Atala dies in a literary description full of Christian myth and ritual. What is important for this essay, however, is the description of the dead body, which I quote at length:

Atala lay on a bed of mountain mimosas, with her feet, her head, her shoulders, and part of her breasts uncovered. In her hair one saw a faded magnolia flower—the exact one I had placed on the virgin's bed as a fertility symbol. Her lips, like a rose button picked only two mornings ago, seemed to carry on, with a smile. A striking pallor of her cheeks was varied only by a few blue veins. Her beautiful eyes were closed, her modest feet joined together, and her alabaster white hands were folded on her heart, holding an ebony crucifix; the beads of her vows were around her neck. She seemed to be enchanted by the angel of melancholy and by the double sleep of innocence and the grave. I have never seen anything more heavenly. Whoever might have been unaware of this girl's having achieved the holy light would have taken her to be a statue of sleeping virginity. (152)

Although this is the beautiful romantic death, Chateaubriand injects into it much frankly Christian verse, with snippets of Job, Ecclesiastes, and personal sentiment about the precariousness of life.

Flaubert

However, the romantic literary genre coexisted with a realistic one. If we turn to Flaubert's gruesome description of Emma Bovary's death by poisoning, we read a detailed, almost clinically precise description of the physical process of the dying person and the corpse.[4] It brings us into contact with medical writing of the day, something that affected Flaubert directly, since his family constituted a network of doctors (indeed, his father, professor of surgery at the Medical School Rouen, was a reputed leader in his field) (Ackerknecht 118). All of the detailed clinical descriptions in *Madame Bovary* are reminiscent of the empirical, carefully documented note taking in the clinic and morgue that had become part of the new medical teaching and research in Paris and elsewhere (Epstein 54; Duffin, *To See* 4). Flaubert's textual description of Emma Bovary's terminal illness, if not completely a positivistic description of natural events, is certainly closer to the new empirical medicine of its day than to earlier, rationalistic nosology.

Let us concentrate on those passages that introduce the doctors and the clergy—the dispassionate men of science and the sympathetic men of the cloth to whom society had given the special task of seeing to the everyday problem of caring for the sick and dying. Through the detailed dialogue, one can hear the words of these men, who are representative of the period and who share their thoughts about terminal illness, death, and dying. It will be understood that these descriptions should not be interpreted as historically factual data because they are filtered through the novelist's pen. Nonetheless, they are, in my opinion, a literary "dissection," correlating to what we find in the scientific textbooks of the day. Moreover, they allow us to appreciate the social importance of the players in the death scene of the times. Instead of the romantic death of Chateaubriand's Atala, we find ourselves confronting a painful death, a disturbing death, and an ugly death without romantic qualities. When Flaubert holds up the mirror of death to reflect his perception of the vanity, pettiness, and cruelty of his time, he narrates a sequence of clinical signs and symptoms. Flaubert's detailed clinical description of the acutely arsenic-toxic patient, Emma Bovary, contains all the facts that would be presented in a textbook description available to medical students of the day.

A contemporary textbook description of poisoning by arsenic, an element used to treat epilepsy and syphilis in the nineteenth century, is the following. Acute toxicity manifests itself: (1) in the gastrointestinal tract—burning in the throat, difficulty swallowing, nausea, vomiting, diarrhea, abdominal pain, and a garlic odor on the breath; (2) in the cardiovascular system—cyanosis, difficulty breathing, and hypotension with heart failure and arrhythmia; (3) in the central nervous system—delirium, coma, and seizures (Isselbacher 2461–62).

Now let us read Flaubert's description of Emma Bovary's case. At the onset, just after taking the fatal dose, Emma comforts herself by believing in the romantic myth about death as peaceful sleep. She thinks to herself, "Ah, this is not so bad, death! I am going to sleep and all will be over!" (459). But shortly after this passage, she is overcome by a disturbing inky taste in her mouth and then a brisk thirst, which causes her to shout to Charles to open the window. First she has a wave of nausea, and a bit later, a feeling of a mounting chill, followed by the return of vomiting. The details of the physical signs are given in such phrases as "Charles noted that there was, at the bottom of the basin, a kind of whitish gravel that was attached to the porcelain lining" (460). And, ever the son of a doctor, he describes the abdominal tenderness that is well known clinically. The case report becomes more and more specific, painting for us a clinical presentation of the signs and symptoms in a way that is more graphic than the lines in a textbook.

When at this point in the evolution of symptoms Charles learns that Emma has been poisoned, he becomes hysterical and loses self-control. Amid this chaos, Charles, looking through his medical manual, finds he is unable to see the print clearly. Now Homais, the pharmacist, the man of science insistent on explaining natural events according to cause and effect but without human empathy or insight, comes on the scene. For Flaubert, he is a figure to mock and scorn since he represents the mediocre, unintelligent rule follower and self-interested social climber, who, dogmatically substituting the received wisdom of science for that of religion, goes his way flaunting the clergy with his secular explanations of everything. Learning from Charles that the poison is supposedly arsenic, Homais responds that a (chemical) analysis is in order.

Soon after the arrival of the first doctor, Monsieur Canivet, one hears the commotion from the second doctor's carriage, the very important Dr. Larivière, who has been called in from the Medical Faculty of Rouen. Flaubert now paints for us the glorious consultant in this passage. Of

Dr. Larivière, whose name connotes something powerful and natural (compared to Dr. Canivet, whose names suggests a canine, domesticated element) we are told, "The appearance of a god would have not caused more emotion" (464). We are told next that Larivière was trained under Bichat.[5] Taking a step into the arena of historical fact, Flaubert describes what is essentially an image of Bichat in the following laudatory passage about the fictional Larivière. He was of "a new, now extinct, generation of philosopher-practitioners who, cherishing their art fanatically, practiced it with wisdom and appreciation! He did not seek titles and ribbons, and was liberal, hospitable, and paternalistic to the poor. He practiced virtue without believing in it and would have been remembered as a saint if his sharp mind did not make itself feared, as if he were a demon" (464).

Emma's bedroom has no hint of that in a *belle mort,* the beautiful, romantic death scene. It is depicted in a matter-of-fact manner, in which the ugly presence of agonal pain, blood, and vomit is not hidden. The priest arrives to carry out his mission, actually hailed by Larivière, another sign of medical resignation in the face of intractable deterioration. Flaubert, ever mixing images of the holy rite with the realistic aspect of the dying body—the gross and unpleasant images the beautiful death tries to obscure—shows how the priest attempts to put a holy candle in Emma's hand to symbolize the imminence of the celestial glory, but, "too weak to hold it, her hand opened and the candle, without the priest there to sustain it, fell to the ground" (470).

With an ever-increasing crescendo of realism, the death throes come upon Emma, and we are witnesses of this last scene, so clinically correct in its detailed precision:

> She was like someone waking from a dream, and asking for her mirror she remained, staring at herself in it for some time, until tears began to drop from her eyes. At that moment her head fell backwards, she sighed, fell back onto the pillow. Her chest rose and fell rapidly and her tongue fell from her mouth. Her eyes rolled back, pale like lamp bulbs going out, one would have thought her dead but for the frightening acceleration of the movements of her breathing, accompanied by a noisy breathing, as if her soul were leaping up in order to detach itself from her body. (471)

In the last sentences of the death scene, when the blind beggar appears in the street singing his fateful poem with sounds recalling the springtime of youth, Emma makes a final rally: "Emma sat up from the bed like a corpse

being shocked back to life, her loose hair hanging down, her eyes staring straight away, mouth hanging open, . . . and she started to laugh, an atrocious laugh it was, frenetic in nature, desperate, believing that she could see the hideous face of the miserable beggar standing there in the eternal shadows like an unexpected terror, . . . when a convulsive seizure threw her back onto the mattress. Everyone in the room came over to her. She existed no longer" (472).

All is over. Some involuntary movements of her body, an agonal laughter, and silence. Nothing more. There are no angels, no visions, no mystical light, nothing: "Elle n'existait plus." She existed no longer. What, Flaubert seems to ask, could be more banal and meaningless than this individual death and this dead body? How different a description of the dead body, the corpse, from that of Atala: "Emma's head hung over her right shoulder. The corner of her mouth, opened, made a black hole in her face; her two thumbs were flexed in the palms of her hands; a sort of white dust was sprinkled over her lids and her eyes were beginning to disappear in a viscous pallor that resembled a fine web made by spiders. The sheet formed a depression over her bosom to her knees, then rose up to cover the points of her toes" (477).

We are now in the postmortem scene, that of the remains and the description of the body itself. Although Homais (whose name recalls *homo,* something human, not godly) is vocally irreligious, he feels moved to participate in the wake, seated next to the body with two candles burning at the bedside. When Bournissien, the priest, comes into the room, there follows a controversial argument about the value of prayer, the place of the soul, and other issues relating to Christianity, about which M. Homais is quite skeptical. He questions the authenticity of Jesuit history, and the debate goes on.

When Homais returns to the room of mourners, he brings aromatic herbs. Flaubert, unlike the romantics, does not protect the senses of the reader. The unseemly aspects of terminal illness and the dead body are not spared us. It is clear that the miasmas in the death room are not pleasant and that deodorants, such as they were, lessened the often sickening aspects of body secretions and the odor of putrefaction. No detail is spared by the author who tells us that "un flôt de liquides noirs, comme un vomissement" (478) came out of Emma's mouth as the ladies lifted the head to place the crown on it. One of the ladies warns the others to take care not to soil the dress and notes that M. Homais appears to be a bit squeamish, at which point there is a discussion relating to the dead body:

"Oh, yes, goodness knows! I saw others of them when I was at Hôtel-Dieu studying pharmacy! We used to drink punch in the dissecting amphitheaters! Nonexistence does not frighten a philosopher; and furthermore, I often remind others that I am going to will my body to the hospitals in order to serve science later" (479–80).

Perhaps the two opposing considerations of the dead body in *Madame Bovary* are best symbolized and summarized in the simple actions of the two protagonists—Homais, the skeptical but mediocre man of science, and Bournissien, the believing, but mediocre, man of the cloth (482–83). The priest sprinkles holy water; the pharmacist, hypochloric acid (*un peu de chlore*). Each reflects a way of looking at the dead body—one as the remains after the departure of the soul, the other as a potentially infectious source of disease. As morning comes they take leave of each other, and the priest, hand on the pharmacist's shoulder, says, "Nous finirons par nous entendre" (484). And that is the way it is to Flaubert's realistic mind. Life goes on; the two points of view—metaphysical/Christian and empirical/scientific—live with each other, each expressing in its own way a different human perception, neither correct, both incapable of solving the human problem. Nevertheless, the traditional, metaphysical Christian thinking is displaced progressively by the newer empirical, positivist, cause-and-effect thinking that will ultimately characterize all of later nineteenth-century medicine and, by the twentieth century, take over the entire system of ideas regarding biology and medicine. In the literary description, death and the dead body, formerly the unique province of the priest, slowly become the province of medicine.

Flaubert's description of the death of Emma, as well as his detailed description of her personality from girlhood, through marriage, through her quest for sensuality and tenderness in love, her wasteful life, her suicide and death, has been called a true literary dissection. His working technique of drafting and redrafting many manuscripts through detailed minute points, with growing numbers of pages, notes, sketches, resumés, and outlines is well known to students of literature. Figure 5 is a caricature of Flaubert in the pose of a pathologist in the morgue, dissecting the bloody corpse of a female body with his tools, which include a pen, ink, and mirror (Flaubert 504).

From the point of view of the representation of the dead body, we have a brief sentence about what happens to Charles after his death at the discretion of M. Homais: "Thirty-six hours later, upon the request of the apothecary, M. Canivet came down. He opened him up and found

Figure 5. *Flaubert disséquant Madame Bovary.*

nothing!" (501). This is a textual indication that postmortem examina-
tion was acceptable in the medicine of the period. It is not clear how
and where the autopsy was performed, but since there was no hospital
in Yonville, and Canivet was not from Rouen, it seems to have been per-
formed locally, perhaps in someone's yard or shed. Perhaps, even, in
M. Homais's laboratory! From her research on Laennec's letters, Duffin
learned that autopsy was not reserved for those dying only in the hospital.
She bases this on a case report of Thérèse Guillemin, a thirteen-year-old
mentally ill girl whose brain and body were studied postmortem (Duffin,
To See 87, 353).

Balzac

We turn now to the last pages of Balzac's novel, *Le Père Goriot*, which is
part of *La Comédie Humaine*, his attempt to describe the social life of the
human species in a naturalistic genre. Père Goriot is the widower father
of two adult daughters, both married into high society, while he, who has
worked and saved to protect them from the harsh realities of life, is now
dying, impecunious. The protagonist of the novel, Eugène Rastignac, a
student, making his way in Parisian society, asks one of the daughters,
Delphine, with whom he is close, to visit her father, who is dying in his
tawdry rooming house.

Caring for the old man is Dr. Bianchon, Balzac's fictive doctor who
figures importantly throughout *La Comédie Humaine*. Ackerknecht's his-
torical text informs us that Bianchon is the literary creation for Balzac's
personal friend, Dr. Jean Bouillaud (1796–1881) (108–9, 110). Bianchon be-
longed to the eclectic school and, although a disciple of François Broussais's
pathological anatomy, never upheld the monomaniacal position that gas-
trointestinal irritation was the principal cause of disease. He upheld micro-
scopy and numerical analysis in medicine and is remembered as a great
teacher of the medical faculty.

When Eugène returns to the boardinghouse to give the news of Del-
phine's imminent arrival, he finds "le père Goriot being cared for by
Bianchon and operated on by the hospital surgeon, while the physician
watched and assisted. Cupping burns were seen on his back, a sign of the
latest medical remedy, one that was totally useless" (232). When the doctors
leave, hopeless, Eugène is instructed to change the sheets and keep Goriot
comfortable. There is opium for pain. We are shocked by the pathos
of this scene—a dying old man in his last moments, abandoned by his

self-interested daughters but holding desperately to any shred of their presence and memory.

Balzac's representation of the death of Goriot is an exclamation of the highest emotion exalted for the last time by the most natural of lies. His daughters, angels to him, were certainly of this earthly stuff and had, in reality, abandoned him for many years. Balzac's description of the human machine struggling in its last moments has nothing sublime about it: "His physiognomy preserved the painful imprint of the combat taking place between life and death in a machine that no longer contained this kind of cerebral consciousness for which a human being can experience pain and pleasure" (248). With "le cerveau envahi," Goriot is in a state of agonal coma, unable to perceive the late arrival of his daughter. It is noteworthy that Balzac's analysis of terminal brain function in this passage relates to the widely held notions of cerebral localization that were prevalent in his time.

This concept of functional localization in the brain was popularized in the last half of the nineteenth century. It was the scientific outgrowth of phrenology, which posited that one could diagnose personality and character traits by the presence of local prominences (bossing) of the cranial vault. Cerebral localization of function was the hallmark of classical clinical neurology and has survived well into our own time. This concept upholds a functional specialization in different regions of the cerebral cortex—for example, vision in the occipital lobes, hearing in the superior temporal lobes, and motor function around the central fissure of Rolando. An extension of this thinking would fix each cognitive and moral faculty discretely in one local brain center. In this way, the brain was conceived of as a mosaic of functional centers in spatial juxtaposition, but functionally discrete and different one from the next. Thus, speech in one part, sight in another, and the "feeling of pleasure and pain in another" (Ajuriaguerra and Hécaen 1–21).[6]

Goriot's death is starkly unromantic. His body lies unattended in a simple sheet in an empty rented room on a mattress in a Parisian boardinghouse! No family, no friends; only a hired priest to say the required prayers. Eugène and Bianchon, the two characters who knew Père Goriot and his daughters, are chilled by the dehumanized quality of this passing. The description of the body is certainly one without frills: "The body was placed on a strapped bed, between two mourning candles in this bare room, where a priest had come to sit next to it" (251).

Balzac's depiction of the dead body evokes sadness from the reader for

the life Goriot lived, the pain he felt, and for his ultimate abandonment. Here is our fundamental sadness—the final destiny that awaits us at the end of our days. We cannot escape it; we can only deny it and dupe ourselves through alcohol, material goods, power, and desire. In the end we are caught in the web of fate like the fly in the spider's web so often mentioned by Victor Hugo, particularly in *Notre-Dame de Paris* (19, 326). This physical description of death, and the dead body as a material remnant of a living organism, is in keeping with the empirical, realistic view of the dead body in the medical dissecting room. Death is no longer a transcendental, spiritual issue, attended by religious rites, but a physical state that allows analysis and reconstruction of living processes by examination of the lesions in the dead organs.

This is also the ultimate message in Balzac's work, *La Peau de Chagrin*, the magical tale of Rafael de Valentin. His pact with a satanic creature ensures that his earthly desires will be realized, but only at the expense of a donkey skin that, with each satisfied desire, shrinks a bit more as Rafael gets progressively sicker. When he dies, it disappears. A victim of his own fate, Raphael is, indeed, caught like a fly in a spider's web. And so it is in the new medical point of view of the dead body—the disease process that leads to the lesion is an inexorable march of events leading, unidirectionally, to death. The progression of lesion to death does bear resemblance to pessimistic fatalism, on the one hand, but ultimately to the hope for effective remedy when more is known about the mechanism of disease. In Balzac's novel, the shrinking of the *peau de chagrin* to a critical mass leads to Raphael's wasting illness. In these scenes, Balzac represents the dying body.

Raphael chooses to seek medical consultation for this illness, which sounds like tuberculosis. Following is an interesting consultation with three reputable physicians, a caricature of three historical physicians of the time (Broussais, Giovanni Morgagni, and Joseph Recamier), and the final death scene with its description of Rafael's dead body. Rafael's moribund appearance just prior to the consultation sets the scene. His friend Pauline is so distraught that at first glimpse, "She hid her face in her hands because she saw the hideous skeletal appearance of death. Raphael's head was pale white and hollow like a skull that had been dug up from the depths of the cemetery to serve as study material for some scientist" (284).

The consultation with the "oracles" of contemporary nineteenth-century medical science throws light on the role of the doctor in the representation of the dying body and death itself. They are the judges: "These

supreme judges were going to pronounce the sentence of life or death"
(284). Balzac gives us the impression that doctors are social judges as well
as men of science, but the scene shows us that the best medical consulta-
tion, even when ineffective, is always available to those who can pay for it.

We have the description of the consultation itself, the nature of the
physical examination, and the diagnostic formulation given by each of the
three figures who represent the School of Paris, clearly the leaders of med-
icine at the time of the Restoration, probably about the time of the Rev-
olution of 1830. Each represents a particular philosophical approach to
disease as it was understood at the time. There is no mention of labora-
tory diagnosis, the chemical analysis of body fluids, or microscopic exam-
ination of body excretions. Physiological thinking in medicine was just
beginning. Balzac says, in a somewhat pejorative manner, that in these
three doctors—Broussais, Morgagni and Recamier—we see the battle of
the three philosophies of medicine. Balzac pays tribute to his personal
doctor, Bouillaud, in the character of Bianchon, for whom he had great
affection and admiration. Balzac tells us that Bianchon is "a man of the
future and of science. He is a wise and modest representative of the kind
of studious medical students who are being prepared to inherit the trea-
sures that have amassed in the last fifty years of the École de Paris. Perhaps
he will be one who will build the monument for which the preceding cen-
turies have brought so much different material" (285).

The haughtiness of the demeanor of the three consultants is very un-
familiar to those of us who practice contemporary American medicine.
Balzac's figures are above criticism and give their opinions in a fashion
that defies any rebuttal. The first doctor, Brissais, points out that excessive
use of Raphael's thinking functions (he was working on an encyclopedic
philosophical treatise) has rendered him susceptible to pulmonary tuber-
culosis. François Joseph Victor Broussais (1772–1838) (Ackerknecht 61–68),
represented by Brissais, was one of the undisputed leaders of the Paris
School of the 1820s. Broussais's writings explain how he regards excessive
thinking and its relationship to the causation of disease through excessive
irritation (136).

Balzac explains that his Brissais was heir to the positivistic, materialis-
tic philosophy of Pierre Jean Georges Cabanis and Bichat (Ackerknecht
3–8, 21, 51). Brissais, says Balzac, believed that each human being is a
finished unit subject uniquely to the laws of its own organization, whose
normal and disordered states are explained by observable causes (285). In
contrast to Brissais's materialism, Balzac presents Dr. Cameristus, who is

Dr. Joseph Claude Anthelme Recamier. The third doctor is Maugredie, a reference to Dr. Giovanni Batista Morgagni (1783–1855), the skeptical experimentalist-phenomenologist, who accepted no theory exclusively but believed in each one's possible truth (Ackerknecht 124). Maugredie is a great believer of fact alone, skeptical of all revealed truths. He relates the shrinkage of the donkey skin to the unavoidable keratinization of the skin with aging and proposes that that particular phenomenon is as yet inexplicable (286).

At this point Balzac criticizes the indifference shown in the expressions of the three consultants. They appear to us to be concerned only with the details of their explanations, not the fate or the comfort of the patient. Only Bianchon shows that he cares. Bianchon is a truly lovable figure, perhaps like Bouillaud, Balzac's friend and doctor for whom, it is said, Balzac called when on his own death bed (Ackerknecht 110).

The manner in which the three consultants ultimately conclude their diagnosis, their certainty, their a priori conclusions, is grist for Balzac's satiric mill. He berates them because they make a mockery of sensualist, Enlightenment thinking applied to medicine and because they have no effective therapy to offer. Notwithstanding the lack of effective therapies in tuberculosis (described poignantly by Jean-Claude Davila in his dissertation on Chopin's tuberculosis), the consultants' opinions were taken to be the last word and the effective judgment of the patient's survival. They were truly the arbiters of life and death. A modern-day reader finds himself truly amazed at the ignorance and arrogance of their formulations. Brissais claims that the patient is "exhausted by too much brain work. Violent exertion of body and mind has weakened his whole body" (288). This formulation about overwork, diet, and stress as etiologies fails to include any discussion of infectious causes, which were not understood at the time.

Brissais brings in his monomaniacal belief in the causation of irritation and inflammation in all disease, the primary site being in the gastrointestinal tract. Although he was a strong proponent of pathological anatomy, Broussais's fundamental explanation was that gastrointestinal irritation was the etiology of all illness, in all organs. It was not based on experimental verification but on a rational method of inquiry that followed his observations on the prevalence of gastrointestinal pathologies in an era of rampant enteritic conditions. Brissais explains in the text that "the brain is atrophied because there has been progressive deterioration of the stomach, the center of living force, which has weakened the entire system. From the

stomach, constant and intense radiations pass through the nervous plexus to the brain, causing excessive irritation of that organ" (288). He belittles Raphael, who persistently asks questions about the donkey skin, calls it monomania (a term used for madness in the nineteenth century), and suggests treatment by bleeding. In brief, to Brissais the stomach is at the origin of all disease, which migrates from it to the other organs and invalidates them. Even a disorder of thinking has an inflammatory origin in the stomach, and this is subject to bleeding, as is most other illness. It was the insistence on the therapeutic value of bleeding, upheld by Broussais, which was responsible for the thriving leech trade at the time (Weiner 229).

Brissais concludes that the prognosis is good if the patient follows his advice, which includes putting leeches on the abdomen: "You might still be able to save your friend easily" (288–89). Looking at this passage from our perspective of twenty-first-century medicine, it is outrightly preposterous. Brissais simply expresses a myth about pathological processes, one that is not based on observation and experiment. This thinking, lacking any observable, or experimental, basis is expressed in a language of fantasy, just as is the story of the *peau de chagrin* itself.

How can it be, we ask ourselves, that such an intelligent person as Broussais, an undisputed leader of the Faculté de Science, could expound such poppycock? This is the problem of being unable to understand the perception of a medical thinker of the past or to understand that his "regard" (*gaze médical*), to use the words of Foucault, was qualitatively different from ours. We must be able to understand, if we are to put ourselves as best we can in the shoes of the time, that Broussais and his colleagues conceptualized, even visualized, the body and its organs very differently from the way we do today.

I do not support the position that this difference in thinking between the nineteenth and twenty-first centuries is a silent configuration based on support of language structures, which differ today from what they were then, rather than a difference in objectifiable reality (Epstein 57–75). On the contrary, the change in the history of ideas was beginning to open medical thinking to a new empiricism that would ultimately generate general concepts about the cause of illness. The change in thinking led to the change in language, not vice versa. In a world like ours, where electronic sensory extensions of the examiner permit viewing, hearing, and feeling the structures and functions of the inner passages, the bloody linings and the circulating fluids, can we be tolerant and accepting of those colleagues from the past who could only imagine the stretched and twisted nerves,

the hardened or burnt organs, and the "overwhelming gastric irritation, the great sympathetic neurosis, the dynamic sensitivity of the epigastrium, and the tightening of the hypochondral areas" (Balzac 288)? I think so, but only if we can understand the change in the ideas about disease.

Balzac's rebuttal of Brissais comes in the words of Cameristus, who claims that the brain affects the stomach, not the other way around. He belittles Brissais's suggestions that the patient is only a stomach in the form of a man. He makes a plea to respect the unique vital force affecting the organs in each of us. And last, Maugredie denies the certainty of each theoretical position and consents to the pragmatic—which is bleeding and hygienic water from a sanitarium in the mountains—to combat the undisputed symptoms of irritation. "If it is tuberculosis," he adds, "then we can hardly expect to save him" (291).

The final scene of death of *La Peau de Chagrin* is a gothic, romantic one, full of passion and violence. By returning to Raphael's death chamber, Pauline, devoted to, and in love with, Raphael, provides the last elements of desire that will shrink the fateful skin to nothingness. But Raphael, consumed by the last bursts of passion and desire, runs after Pauline who, realizing what she has done, tries desperately to kill herself to save Raphael. There, in disarray, half-naked, Pauline is sensually sprawled out before Raphael, whose passionate appetites are aroused and drive him to a final love scene, in which the characters are drunk with passion and inflamed to a frenzied, lustful behavior: "The dying Raphael sought words to express the desire that was devouring all his physical force; but he could find only the strangled sounds of his breathing, whose râles seemed to originate deep in his entrails. Finally, soon unable even to form sounds, he suddenly bit Pauline on her breast. Jonathas, the servant, entered, terrified by the cries he had heard, and tried to pull away from the young woman the corpse over which she was bent in a corner of the room" (324–25).

Conclusion

I have attempted to explain why an evolution in medical thinking, centered on the representation of the dead body and its organs as the nature of disease, developed at this turbulent time in the history of France. My thesis is that this change in thinking was related directly to that which characterized the Enlightenment. The abandonment of rationalistic thinking that had evolved from the Middle Ages led to a new relationship between empirical observation of natural events (including disease in bodily organs)

and the nature of human thought. This new harmony expressed itself in mathematical language for physicists, but not yet for doctors. There was not thus far a universal biological law that had been conceived by the human mind out of the observation of human senses. The numerical method based on the *esprit systématique* of the Enlightenment was only beginning to make inroads in medicine and biology.

Although the period was associated with a total perturbation in the society at large, I do not believe that the ridding of the old dogma, despotism, and religion was the direct cause. It provided a sociopolitical setting in which the new ideas of the Enlightenment, already in existence, could play themselves out. It was the change in ideas that made possible a new empirical pragmatism in medicine and was responsible for this broadening of *le gaze médical* and a new way of conceptualizing disease in the clinical patient. It may be that a general correlation exists between creative bursts in human thinking and particular historical moments, when old systems are abolished radically by political change and general growth of the economy. Under these circumstances intellectual talent from all classes may be stimulated, along with intellectual controversy and the emergence of new ideas that bring progress in scientific thinking. I would submit that it is the change of thinking and the sociopolitical factors that precede the development of the new technology, rather than the reverse. In post-Revolutionary France it might be that Napoleon's administration was the spark that ignited the fires of sociopolitical action, putting into effect the ideas that had marked the Enlightenment and the Revolution.

Although there are many excellent books and essays written about the period, some of which I have tried to cite in this essay, perhaps the future will have to turn to the literary descriptions, of which those cited here are but a few, to remember these great and interesting medical men, their observations, their systems of thought, their methods and their sociopolitical positions.[7] As Ackerknecht says so well in his work on the Paris Hospital and its doctors, "It is quite possible that these contemporary descriptions of Paris medicine will never be equaled by historians' attempts to create the medical past—and that these descriptions will still live on when medicine has developed so far beyond the Paris model that, without them, the latter would be completely forgotten" (199).

NOTES

1. *The officier de santé* was a lesser category of medical practitioner. Charles Bovary was one, and his education is well described in Gustave Flaubert's *Madame Bovary* (64). His activities and skills were significantly less than those of the *docteur en méde- cine,* which explains in part his inferior self-image next to the prestigious consultants as well as his incompetence in the treatment of Hippolyte's clubfoot.

2. All citations from Comte, Chateaubriand, Flaubert, and Balzac are translations by the author.

3. For a discussion of vitalism and its persistence in modern times, see Duffin's "Cadavers." I would submit that psychoanalytic thinking might be today's important remnant of vitalism. This is a field that holds the existence of nonmaterial forces (ego, id, unconscious, preconscious) to be instrumental in the production of symptoms of mental illness. Until the neural substrate for these functions is understood in quanti- tative terms, the usefulness of such concepts will be unquestioned (Kandel 467).

4. This description of the body, from which the soul was departing, was extremely distasteful to those who prosecuted Flaubert during the 1852 trial for indecent writ- ing. To them, it was an insult to public taste, certainly compared to Chateaubriand's wholly accepted description of a body after *la belle mort.*

5. Marie-François-Xavier Bichat's (1771–1802) charismatic personality and his con- tributions to the opposing camps of pathological anatomy and vitalism in medical diagnosis account for his importance in French medicine long after his premature death. Pierre Jean Georges Cabanis (1757–1808) was a physician, teacher, and philoso- pher. He promoted research into the relationship between psychic fears and physio- logical conditions. Joseph Claude Anthelme Recamier (1774–1852) was a vitalist who upheld the principle of a vital force in living creatures, which can be present in dying bodies and absent in living ones. The vital force was a higher, immaterial secret that played games with lancets, confused surgeons, and evaded the effects of pharmaceu- ticals. It was subject to divine law and its absence or presence was the basis for health or disease. Recamier was, in real life, one of Laennec's close associates, involved in local- ization and lesion observations, but also holding to the principles of vitalism. François Magendie (1783–1855) was a physiologist who was considered skeptical because he did not believe in general principles but concerned himself only with specific phenomena and their local causes. In that sense he laid the groundwork for the development of experimental medicine.

6. The key historical event for localizationist neurology was Pierre Paul Broca's famous presentation in 1861 to the Société d'Anthropologie de Paris. He demonstrated from pathological anatomy that a lesion in the third left frontal convolution of the brain was related to the loss of language in a patient. He called this loss of language *aphasia.* This empirical demonstration showed, unequivocally, that a specific intellectual faculty was localized to a determined point in the hemispheres and put to rest the doctrine of unity of function in the central nervous system (Ajuriaguerra and Hécaen 1–17).

7. Ackerknecht cites the following authors who wrote about doctors and their activities: Honore de Balzac, Jules Sandeau, Eugene Sue, Jules Janin, Alfred de Vigny, Claude Tillier, Maxime du Camp, Gustave Flaubert, Émile Zola, and Edmond de Goncourt. He notes that Eusèbe de Salles published a derogatory portrait of Laennec (Dr. Lasinec).

WORKS CITED

Ackerknecht, Erwin H. *Medicine at the Paris Hospital 1794–1848*. Baltimore: Johns Hopkins, 1967.
Ajuriaguerra de, J., and H. Hécaen. *Le Cortex Cérébral*. Paris: Masson et Cie., 1964.
Ariès, Philippe. *The Hour of Our Death*. New York: Oxford University Press, 1981.
Balzac, Honore de. *La Peau de Chagrin*. Ed. Nadine Satiat. Paris: Flammarion, 1996.
———. *Le Père Goriot*. Ed. Pierre Citron. Paris: Garnier-Flammarion, 1996.
Broussais, F. J. V. *De l'Irritation et de La Folie*. Paris: Chez Mlle. Delaunay, Librairie, 1828.
Cassirer, Ernst. *The Philosophy of the Enlightenment*. New Jersey: Princeton University Press, 1951.
Chateaubriand, François-René de. *Atala, Réné. Les Aventures du Dernier Abencénage*. Paris: Flammarion, 1996.
Comte, Auguste. *La Philosophie Positive*. Paris: Flammarion, [1876]. 1830–42
Davila, Jean-Claude. "Étude de la Maladie de Chopin à Travers sa Corréspondance." Thèse pour Docteur en Médecine. Université Paul-Sabatier Toulouse III Faculté de Médecine, 1995.
Duffin, Jacalyn. "Cadavers and Patients: Laennec's Vital Principle and the Historical Diagnosis of Vitalism." Ed. G. Cimino and F. Duchesneaus. *Vitalisms from Haller to the Cell Theory*. Firenze: Leo S. Olschki, 1997. 139-55.
———. *To See with a Better Eye: A Life of R. T. H. Laennec*. New Jersey: Princeton University Press, 1998.
Epstein, Julia. *Altered Conditions: Disease, Medicine and Storytelling*. New York: Routledge, 1995.
Flaubert, Gustave. *Madame Bovary*. Ed. Jacques Neefs. Paris: Librairie Générale Française, 1999.
Foucault, Michel. *The Birth of the Clinic: An Archaeology of Medical Perception*. New York: Vintage Books, 1973.
Hugo, Victor. *Notre-Dame de Paris*. Paris: Pocket, 1998.
Isselbacher, K., et al. *Harrison's Principles of Internal Medicine*. Thirteenth Edition. New York: McGraw-Hill, 1994.
Kandel, Eric. "A New Intellectual Framework for Psychiatry." *American Journal of Psychiatry* 155 (1998): 457-69.
LaGarde, Andre, and Laurent Michard. *Le XIXe Siècle. Les Grands Auteurs Français du Programme*. Paris: Les Editions Bordas, 1966.
Léonard, Jacques. *Archives du Corps: La santé au XIXe Siècle*. Paris: Ouest-France, 1986.
———. *La Vie Quotidienne du Médecin de Province au XIXe Siècle*. Paris: Hachette, 1977.
Von Haller, Albert. *First Lines of Physiology*. Troy, Mich.: Obadiah Penniman and Co., 1803.
Watson, J. D. *Molecular Biology of the Gene*. New York: W. A. Benjamin, 1965.
Weiner, Dora B. *The Citizen-Patient in Revolutionary and Imperial Paris*. Baltimore: Johns Hopkins University Press, 1993.

The Carnivalesque *Defunto*

Death and the Dead in Modern Brazilian Literature

ROBERT H. MOSER

Each culture discovers its own way of representing the dead through language. This partly explains why finding an English equivalent for *defunto*, the most frequently used word to describe a dead person in Portuguese, presents a rather formidable challenge. In English *defunto* has a counterpart in the word *corpse;* however, there remains a distinct connotative gap between the two words (and worlds), one that ultimately provides fertile ground for cultural comparisons. Unlike corpse, defunto contains both body *and* spirit; the two concepts are not semantically divorced in Portuguese. Moreover, defunto possesses none of the starkness of corpse, a word stripped of any personal, intimate, or spiritual qualities. Whereas corpse connotes a cold, impersonal, anonymous, and exposed body being prepared for autopsy or embalming, defunto is rarely divested of its spiritual core, its intransient personality. It is, in this sense, closer to the English *deceased* or *beloved*, without, however, the same degree of emotional abstraction of these words. It is also very much the dead body and, in this respect, shares the corpse's tangible materiality. Indeed, for more traditional segments of the Brazilian population, particularly widows and other (primarily female) family members, its application extends beyond physical death. In this context the immediate family refers to the defunto in lieu of the deceased individual's name, the utterance of which could beckon their unwanted return.

One could argue that the expressive range of defunto in contemporary Brazil suggests traces of a premodern connection with the dead, a kind of colonial specter roaming in the dark semantic recesses of the word. The purpose of this study is to probe similar, yet broader, traces of this

connection between the living and the dead through several key works of modern Brazilian literature. Special attention is given to the late-nineteenth-century novel *The Posthumous Memoirs of Brás Cubas,* written by Joaquim Maria Machado de Assis who, despite his relative obscurity outside of Brazil, is described by Susan Sontag as "the greatest author ever produced in Latin America" (107).

Though circuitously referring to the body, my essay more precisely explores that which survives bodily death and whose spirit is cloaked, however fleetingly, in corporal materiality—ghosts, specters, phantoms, the spirits. To label the Brazilian fiction analyzed here as merely ghost stories, however, would be to ignore the extent to which these narratives defy such a categorization and, in so doing, create their own unique brand of the living-dead. Rather, the term *revenant,* which in French literally means "that which returns," lies closer to the study's object of analysis and central questions: Why do they return? In what form do they return? How is their return understood in the broader context of Brazilian cultural history?

"Death Is a Festa"

Before answering these questions, and in order to better appreciate the social implications of the selected texts, a brief historical overview of death culture in Brazil is necessary. The finality of death, argues anthropologist Robert Hertz in his seminal work, *Death and the Right Hand,* is offset by society's desire to view it as a period of momentary separation: "For the collective consciousness death is in normal circumstances a temporary exclusion of the individual from human society. This exclusion effects his passage from the visible society of the living into the invisible society of the dead" (86). A basic premise of this paper is that the invisible society of the dead has historically played a key role in the construction of both social relations and collective identities in Brazilian society. The cultural currency and sustaining popularity of Spiritism in Brazil today, alongside popular Catholicism and the syncretic Afro-Brazilian religious traditions of Candomblé and Umbanda, is one facet of what American anthropologist David Hess calls Brazil's underlying "spirit idiom."[1] The term "idiom" aptly describes Brazilian society's profound connection with the spirit world, because it reiterates both the structural and communicative nature of this relationship. Similarly, focus is cast on the particular dialogue that interlinks this world with the afterworld.

Moreover, the epistemology of a spirit idiom in Brazil makes sense only in light of the country's own sociohistorical origins and development. The profound and enduring impact of Portugal's social model on its former colony is well documented.[2] Long before Pedro Álvares Cabral encountered the Brazilian coastline in 1500, popular Catholicism in Portugal had established a tradition of revering both saints and the dead. The cult of the dead forged a degree of intimacy between the living and the dead in Iberian popular Catholicism, creating a proximity that was officially discouraged by church authorities and Catholic dogma.[3]

The capacity of popular Catholicism to take hold in colonial Brazil was enhanced by the prominence and relative autonomy of the plantation system, emblematized by the *casa grande* or slave master's house.[4] Far from official bureaucratic and ecclesiastical control, each plantation constituted a self-sustaining socioeconomic and spiritual unit. Furthermore, close proximity between the *casa grande* and the *senzala* (slave quarters) allowed popular Catholicism's divinization of the dead to intersect with the spirit-based belief systems of the African slaves who continued to practice, incognito, Yoruba religions, in which spirit mediumship and ancestral worship were central components. Moreover, the fusion of Catholicism and Afro-Brazilian religions with indigenous culture is exemplified by the presence of *caboclos* (Amerindians) in Umbanda's pantheon of spirits.[5]

Although urban areas in colonial Brazil enjoyed relatively less autonomy from Portugal's administrative and ecclesiastical control than the surrounding plantations, certain institutions and rituals did emerge within the sociopolitical and religious order that helped promote the development of a spirit idiom within the cities. To begin with, the large concentration of African slaves in cities such as Salvador, Recife, and Rio de Janeiro ensured the constant presence of religious syncretism. The most important advocates in the transition between life and death, however, were the religious brotherhoods or *irmandades*. Representing the interests of diverse sectors of colonial Brazilian society, from the aristocracy to the slaves, and attentive to many aspects of social welfare, the most important function of the brotherhoods was the safeguarding of a dignified death for their members. By ensuring that their deceased members were given a proper burial and funeral procession, and then conducting masses for their souls thereafter, the brotherhoods acted as the guardians of those rituals that, if observed, led to salvation. Similarly, direct appeal to the dead, in the form of masses or alms, was very often conducted with the assistance

of the brotherhoods. Gatekeepers between the world of the living and the world of the dead, they helped shape the particular grammar and nuance of Brazil's spirit idiom.

The confluence of the multiple historical forces described above endowed Brazil's spirit idiom with a unique expression that may be said to possess the following five essential characteristics:

1. Historically, interaction between the living and the dead has been one in which *a relationship of close proximity is highly valued.* According to Gilberto Freyre, the dead occupied an intermediary and extremely familiar space within the family dynamic of the *casa grande* during colonial times: "Beneath the saints and above the living in the patriarchal hierarchy were the dead, who in so far as possible ruled and kept watch over the lives of their children, grandchildren, and great-grandchildren. In many a Big House their portraits were preserved in the sanctuary among the images of the saints, with a right to the same votive lamp and the same flowers" (xxxi).

2. Inherent in Freyre's observation is the idea that this relationship was not only close but *active.* The dead not only "watched over" the living, they "governed" their lives to a certain degree. João José Reis, in his study *Morte é uma Festa* (Death is a Festivity), describes the numerous contexts during nineteenth-century Brazil in which *the dead were expected to intervene on behalf of the living* (and vice versa), both during this life and in the afterlife: "In the religion of the brotherhoods . . . the living, the dead and the saints all formed part of a ritual family whose members were permanently tied to one another. . . . In the brotherhood's chapel one prayed as much *through* the dead as *for* the dead. The dead contributed to the resolution of the problems of the living, along with God and the saints, although to a different degree" (317). As we shall see, the capacity of the dead to act as celestial advocates in both the life and death of the living is an important concept because it points to one possible justification for the presence of the revenant in Brazilian literature.

3. Both Freyre and Reis suggest that historically there has existed *an ongoing dialogue between the living and the dead,* through religious rituals such as mass and funeral processions as well as in the course of daily activities. This dialogue not only contributed to the unity of the "ritual family" made up of the living, the dead, and the saints, but also provided a sense of continuity and coherence among the

living. Indeed, it may be said that the well-being of the community depended upon the preservation of good relations with the dead. It is, therefore, no coincidence that the dead are called upon to intervene particularly in moments of either personal or social crisis.[6]

4. Anthropologists and historians studying the culture of death have observed that in most societies there exists an important *distinction between a "good death" and a "bad death."*[7] As in Portuguese society, a good death in Brazil has traditionally been, above all, a matter of timing. To die unexpectedly, away from loved ones, and without the opportunity to bring closure to one's affairs in this world epitomizes a bad death. Thus, dying well in Brazil traditionally involved the assistance of family and friends to perform those rituals meant to insure both a proper send-off to the next world and the maintenance of ties to this world. The consequences of a bad death, for both the individual and the community, were highly undesirable, for they generally resulted in the deceased becoming a "wandering soul" that haunted the community until some resolution was found.

5. The burials and funeral processions of colonial Brazil were undoubtedly solemn occasions; however, historical documents indicate that these events were anything but sober. Rather they acquired many of the *forms normally associated with carnivalesque festivities.* By all accounts, the funerals of the colonial aristocracy, wealthy merchants, and upper clergy were sumptuous affairs involving a vast procession of lamenters from diverse segments of Brazilian society. Funerary pomp was added by musical accompaniment, the clanging of church bells, ornamental carriages, and the lighting of countless candles. On the other end of colonial Brazil's social spectrum, the early-nineteenth-century illustrations and commentary of Jean Baptiste Debret provide us with a portrait of African slave funerals that are, in their own way, equally as festive. In one such illustration Debret depicts the funeral procession of an African "prince" in which the body, carried in a hammock and shrouded in hearse cloth, is surrounded by what appear to be carnival revelers consisting of percussion players, a master of ceremonies, acrobats and curious onlookers.[8] The carnivalesque revelry of Afro-Brazilian funerals did not escape the attention of the Portuguese authorities, who viewed the syncretic rituals and apparent disorderliness of these events as a threat to the social order (Reis 162). Ultimately, however, the carnivalized religious and funerary commemorations of the Portuguese themselves demonstrated that the

colonizers shared their slaves' belief in the importance of ritualized festivals as a form of investing in the spirit world.

"The feeling is in the color black."

To what extent these characteristics of the relationship between the living and the dead have persisted into the twentieth century in Brazil is open to debate. Undoubtedly, many aspects of this relationship have been dramatically altered by broad modernizing trends and the gradual influx of foreign value systems, such as positivism and notions of social hygiene, all factors that have changed the way people in Brazil (particularly in urban settings) view death and the dead. It would be misleading, however, to assume that the "traditional" relationship described above has been simply substituted by a more modern one. Rather, it may be said that these value systems have, at least since the arrival of the Portuguese court to Rio de Janeiro in 1808, existed in a state of conflict and ongoing negotiation. Brazilian anthropologist Roberto DaMatta argues in his comparative essay on death in Brazil and the United States that, in contrast to North American society, Brazilians today continue to emphasize strong, personal relations with the dead, whereas they tend to reject death as an abstract or purely scientific concept: "Long before being aware that death means nonbeing or nothingness, I think that the majority of Brazilians become aware of the dead of their family, house, neighborhood, community, nation, and century" (119). Mediators between this world and the next, the dead maintain as well as create social ties within modern Brazilian society. According to DaMatta, dealings between the two realms are conducted by way of warnings, omens, signs, mourning practices, and of course, memory.

One also discovers the specter of a premodern connection with the dead in the memoirs of Brazil's greatest playwright, Nelson Rodrigues. On December 26, 1929, Nelson witnessed his brother's murder when a disgruntled reader of the family's newspaper shot Roberto point-blank at the journal's office in Rio de Janeiro. In his memoirs Nelson tells how he, along with his family, mourned his brother's loss intensely. His family did not cry, they "howled." The value that Nelson personally placed on mourning rituals may be most clearly seen in the following quote from his *Memoirs,* in which he describes his scorn for modern society's failure to recognize such rituals: "Today, the pain of losing a loved one doesn't even merit a black tie. No one puts on mourning garments anymore. Just

the other day, I overheard a young woman say: 'The feeling isn't in the color.' It surely is. Yes, the feeling is in the dye of the black suit. And in the black dress. In 1929, my family dressed profoundly in black. My father, my mother, all of my siblings. I began to think that I would never again dress in clothing that wasn't black" (144).

The Rodrigues family's strong affirmation here of the mourning tradition, in contrast to the comment by the young woman—"the feeling isn't in the color"—exposes the widening gulf in Brazilian society between traditional and modern value systems, especially as these systems relate to death. The woman's comment reflects a typically modern sentiment, that one's response to death is best expressed individually and internally. However, for Nelson, "the feeling" resides precisely in the black tones of the mourner's suit or dress, that is, in those external manifestations of grief that are part of the elaborate rituals designed to observe the death of a loved one. When divorced of such rituals, according to Nelson, both the deceased and death lose that dignity that is so intrinsic to them.

There was, in fact, ample occasion for deathwatches in Rio de Janeiro while Rodrigues was a boy living in the "The North Zone." In October of 1918, *cariocas* (residents of Rio de Janeiro) started dying in large numbers from the influenza epidemic, which spread from Europe to port cities around the world after World War I. In a span of two weeks approximately fifteen thousand people in Rio de Janeiro had died from the disease, that is, at a rate of about one thousand per day. The epidemic disappeared almost as suddenly as it had appeared, however, only after a large percentage of the population was already wearing black. As Ruy Castro points out in his biography of Nelson Rodrigues, Rio de Janeiro responded to the catastrophe with the "carnival of resurrection" of 1919, the most erotic and uninhibited carnival Brazil had ever seen (25–26). Considering this social climate, it is no wonder that one of Rodrigues's first essays as a boy in school was a story about a case of adultery, that had as its primary themes sex and death.

The prevalence of funeral processions, wakes, and other mourning rituals during the late nineteenth and early twentieth century suggests that death culture formed an integral part of daily life in modern Brazilian society. Indeed, as late as 1872 the life expectation for free Brazilians was only twenty-seven years and for slaves a dismal eighteen years (Martins 71–72). One can only imagine what the life expectation was for an indigenous population already devastated by epidemics and social upheaval. Prior to 1900, 30 percent of newborns died within a year and only a half of those

who survived lived to be twenty. By all accounts the funeral of infants was a celebrated occasion, in which the baptized child's purity and immediate transformation into an angel was understood to be a given. Northern European visitors to Brazil in the nineteenth century who witnessed these *festas* for an *anjinho* were invariably shocked by the music, food, drink, gunshots, fireworks, and overall jovial attitude of the participants that characterized infant funerals (Reis 138–40).

These documents strongly suggest that death and *festa* were by no means conceptualized as mutually exclusive in nineteenth-century Brazil and that religious festivals such as Our Lady of Good Death and Christ's ritual burial on Good Friday, infant funerals celebrating the deceased "little angels," and animated funeral processions in general formed the carnivalesque elements of a pervasive cultural response to the social disorder brought about by death. As Reis sees it: "Funerals traditionally were experienced as a kind of ritual of social decompression in which the greater the production of signs, ritual gestures and symbolic objects the more effective was the ritual" (138). Thus, the funerary "spectacle," on one level, served to distract the living from their loss and, by allowing mourners to experience their grief collectively, it helped reestablish the social equilibrium jeopardized by the arrival of death. In short, the festivities surrounding death in Brazil enjoyed a distinct social function, one that resonates in unique and complex ways in the Brazilian fiction to which we now turn.

The Work of a Dead Man

In 1880 when Joaquim Maria Machado de Assis wrote his fifth novel, *The Posthumous Memoirs of Brás Cubas*,[9] Brazil was, to borrow Gayatri Spivak's words, "learning to live at the seam of the past and the present"(78). The transition to a republican form of government, following nearly sixty years of a constitutional monarchy, loomed close on the horizon. Six years earlier, the Brazilian Emperor Pedro II had dictated the first message by telegraph from Brazil to Europe. This achievement constituted a kind of technological manifestation of the symbolic connection that existed between Brazil's capital city Rio de Janeiro and the cultural centers of Europe. It was a time when pianos were being imported in great numbers from France and England for the enjoyment of the *carioca* elite. Yet it was this same social class that clung stubbornly to a slave-based economy, the last of its kind in the Western hemisphere. The disjointedness of a society that professed the ideals of enlightenment and liberalism but whose way

of life depended largely upon slave labor was not lost upon Machado de Assis. Perhaps more so than any author of his era Machado de Assis delved deeply into the underlying incongruities of a Brazilian elite caught in the liminal state of a developing modern nation with an unresolved colonial past.

While nearly all of Machado's bourgeois characters, to some degree, germinate from the disjointedness of this particular social milieu, none more so than Brás Cubas. A dilettante if there ever was one, Brás Cubas embraces the privileges bestowed upon a slave-holding class accustomed to a maximum of social advancement with the minimum of actual effort expended, as well as the moral pitfalls of an elite whose ideological bearings were determined by its desire for cultural ornamentation and social recognition. As many of Machado's critics have pointed out, but none so forcefully as Brazilian literary critic Roberto Schwarz, Brás Cubas's narrative tone is steeped in the impertinence of the class from which he springs, and even more so because he has had the audacity to return from the grave to compose his memoirs.[10] For the reader discovers at the onset of the novel that Brás Cubas's memoirs are *posthumous* in the literal sense of the word. The narrator is indeed dead, but rather than laying his soul to rest, Brás Cubas appears to us as a restless soul anxious to reconstruct his life's story.

The short chapters that comprise *Posthumous Memoirs* were published originally by *Revista Brasileira* in 1880 as a series of individual vignettes. A year later it was published as a novel in its entirety. For his contemporaries, however, the work was radically unnovelesque. Although the staccato chapters were a trademark of Machado's style, the level of digression and circuitous narration broke down all conventions of common literary sensibility in Brazil. Alternating between memorialist reflections and philosophical excursions, the story meanders in a seemingly purposeless way that may best be described as "anti-narrative" (Teixeira 93). Caught between the ebb of his autobiography and the flow of his witticisms, the reader finds precious little narrative footing. It is no wonder that *Posthumous Memoirs* has been described as the watershed between plot driven fiction and poetic fiction in Brazilian literature (Teixeira 93).

The story begins at the end with Brás Cubas satirically narrating his own funeral, attended by only eleven friends on a drizzly afternoon. He can hardly conceal his amusement when a "friend" eulogizes that "nature appears to be weeping over the irreparable loss of one of the finest characters humanity has been honored with" (7). Shortly after, we learn how

he died. Obsessed with the idea of inventing an antihypochondriacal poultice aimed at curing humanity of its melancholy and driven by a final quest for personal glory, Brás Cubas, ironically, neglects his own health and dies after a bout with pneumonia brought on by a "strong draft." If his death seems pointless, so is the "remedy" that caused it. As we soon discover, both are reflections of a life remarkable for its futility. During the course of his narrative, we gradually learn of his amorous escapades during adolescence, his life as a "bachelor" while attending university in Portugal, an ill-fated maneuver by his father to simultaneously furnish his son with a bride and a prestigious political appointment, a brief stint into oppositional journalism, and a long, drawn-out love affair with a married woman named Virgília. By the time Brás Cubas dies, so have most of the people who exerted some influence on his life.

Ultimately, *Posthumous Memoirs* derives its poetic force and psychological insights not from the content of its narrative but rather from the fecundity of its narration. As Brás Cubas makes clear from the very beginning: "I am not exactly a writer who is dead but a dead man who is a writer, for whom the grave was a second cradle" (7). Death offers distinct advantages, particularly for a narrator inclined to expose and then dissect the moral and psychological inconsistencies of his countrymen (as well as his own). In the following passage he explains in a typically garrulous fashion why this is so:

Perhaps I'm startling the reader, with the frankness with which I'm exposing and emphasizing my mediocrity. Be aware that frankness is the prime virtue of a dead man. In life the gaze of public opinion, the contrast of interests, the struggle of greed all oblige people to keep quiet about their dirty linen, to disguise the rips and stitches, not to extend to the world the revelations they make to their conscience. And the best part of the obligation comes when, by deceiving others, a man deceives himself, because in such a case he saves himself vexation, which is a painful feeling, and hypocrisy, which is a vile vice. But in death, what a difference! What a release! What freedom! Oh, how people can shake off their coverings, leave their spangles in the gutter, unbutton themselves, unpaint themselves, undecorate themselves, confess flatly what they were and what they've stopped being! Because, in short, there aren't any more neighbors or friends or enemies or acquaintances or strangers. There's no more audience. The gaze of public opinion, that sharp and judgmental gaze, loses its virtue the moment we tread the territory of death. I'm not saying that it doesn't reach here and

examine and judge us, but we don't care about the examination or the judgement. My dear living gentlemen and ladies, there's nothing as incommensurable as the disdain of the deceased. (52)

Like Menippus in Lucian's *Dialogues of the Dead*, Brás Cubas finds in death a unique vantage point from which to ridicule the living. The relevance of deceased authorship as a narrative strategy in *Posthumous Memoirs*, and, correspondingly, the specific motivation behind this narrator's markedly irreverent tone has been the subject of diverse interpretations by Machado's critics. Helen Caldwell, in her study *Machado de Assis: The Brazilian Master and His Novels*, suggests that the root of the novel's melancholic tone lies in the specter of "self-love" dwelling in the heart of its narrator and in the hearts of the majority of its characters. Brás Cubas proves himself incapable of love and, therefore, constitutes the living dead (Caldwell 110–11). Even in life, his was a "dead soul." Caldwell's conceptualization of deceased authorship as a metaphor for Brás Cubas's "dead soul," condemned to perpetual egotism, however, does not extend beyond the universal symbolism of life/death, love/self-love, good/evil. These are universal themes that undoubtedly are essential to Machado's work but which ultimately tell us very little about how the dead, or for that matter, "dead souls," were viewed in late-nineteenth-century Brazil, or why Machado, who was a product of that specific culture, might be compelled to tell his story from a posthumous perspective.

A radically different kind of symbolic reading of deceased authorship in *Posthumous Memoirs* is offered by Roberto Schwarz in his study *Um Mestre na Periferia do Capitalismo: Machado de Assis*. According to Schwarz, "the posthumous voice automatically makes a parody of everything it says," by which he means the very improbability of deceased authorship sabotages the narrator's credibility (20). Thus, Brás Cubas's personal claim to intoxicating freedom and unaccountability in the "undiscovered country," far from the gaze of public opinion, is, Schwarz proposes, merely a portrait of the ideological recklessness and *social* unaccountability enjoyed by the ruling class in Brazil. In other words, his worldly ambitions continue to be precisely that—of this world rather than otherworldly.

The improbability of deceased authorship, Schwarz argues, "is contrived to deprive fiction and its readers of an easy relation to one another" (*Misplaced Ideas* 88). While I would agree that Brás Cubas's parodic tone is a central feature of his narrative, one that we shall see has multiple ramifications for the reader's relationship to the text, I would contend that

the voice of the dead was anything but improbable to Machado's reader-
ship one hundred years ago. Though never easy, this relationship between
the living and the dead was a highly familiar one in the day-to-day lives
of most Brazilians then. The particular resonance of Brás Cubas's post-
humous voice and its impact upon nineteenth-century Brazilian readers
takes on new meaning when examined within the sociohistorical parame-
ters of Brazilian death culture.

Written with "a playful pen and melancholy ink"

What sort of revenant is Brás Cubas? To begin with, he is curiously unin-
terested in the spirit world to which he belongs. No mention is given of
his fellow deceased, nor for that matter of God, angels, or saints. Rather,
his attention is focused almost exclusively on the affairs of the living, their
ambitions, hypocrisies, and idiosyncrasies. Brás Cubas does not enjoy any
particular clout in the afterworld, nor does he exhibit any interest in form-
ing a reciprocal relationship with the living. In this sense, he is more spec-
tral than spiritual, and as such, his involvement with *this* world comes at
the expense of the living. Throughout the novel the reader is addressed in
a tone ranging from playful indifference to outright mockery. Brás's dedi-
cation is brazenly sarcastic and sets the tone for the rest of the book: "To
the Worm Who Gnawed the Cold Flesh of My Corpse I Dedicate these
Posthumous Memoirs as a Nostalgic Remembrance" (2). If we understand
"corpse" to mean the "body" of his memoirs, the implication is that we the
readers are the worms gnawing through the chilly remnants of his life.

Interspersed through his meandering narrative are pauses in which Brás
Cubas addresses the reader directly. These narrative intrusions are notable
because they remind us that he is not merely an omniscient narrator, but
rather a voice speaking directly from the beyond. They are often confes-
sional and suggest a level of intimacy that is, nevertheless, later violated
when the narrator's relentless sarcasm becomes apparent. Such otherworldly
interventions constitute heightened narrative moments in the novel that
serve to either uphold or undermine the relationship between narrator
and reader. Halfway through, Brás Cubas takes the liberty of undermin-
ing his own narrative, which he now finds tedious, all the while blaming
the reader for any defects it might possess:

> I'm beginning to regret this book. Not that it bores me, I have nothing to
> do and, really, putting together a few meager chapters for that other world

is always a task that distracts me from eternity a little. But the book is tedious, it has the smell of the grave about it; it has a certain cadaveric contraction about it, a serious fault, insignificant to boot because the main defect of this book is you, reader. You're in a hurry to grow old and the book moves slowly. You love direct and continuous narration, a regular and fluid style, and this book and my style are like drunkards, they stagger left and right, they walk and stop, mumble, yell, cackle, shake their fists at the sky, stumble, and fall. (III)

Brás Cubas's haughty claim that the book's primary defect resides in the reader is a double-edged sword: he is condescending both toward traditional, linear narratives as well as those readers who lead their lives as they read their romances, anxious to arrive at the conclusion.

As these examples illustrate, Brás Cubas's return does not signal the reestablishment of communal ties or the benevolent intervention of a spiritual benefactor. Instead he makes a parody of the intimacy, expectations, and trust generally reserved for the dead when acting as celestial advocates, and consequently, his provocations serve to systematically abuse the reciprocal and emotional ties that constitute the traditional relationship between the living and the dead in Brazilian society. The ambivalence created by such an untrustworthy specter contributes greatly to the irony of the novel. One notes in his chronicles and short stories that Machado cast a skeptical eye upon Spiritism and the Spiritist belief in reincarnation.[11] At best he considered them to be examples of Brazil's cultural dependency on European positivism and, at worst, a short step away from insanity. This is not to say, however, that Machado was unaware of the importance of the spirit world in Brazilian society. As Brazilian literary critic Raymundo Faoro proposes, the satire embedded in Brás Cubas's posthumous authorship was particularly effective because it was directed at a Brazilian readership that, "even if it didn't believe in Spiritism per se, knew that it was always a possibility" (465). Despite Machado's skepticism, his work is full of characters who, in one form or another, adhere to the supernatural and whose lives are swayed by the messages they receive from the spirit world.[12] Furthermore, late nineteenth-century Brazil's affinity for French positivism did not mean that people had stopped listening to the spirits, whether they be of the dead, Catholic saints, Afro-Brazilian *orixás,* or those conjured up by street fortune-tellers. The prevalence of the supernatural in Machado's work, even in the form of a parody, suggests that he was equally attentive to Brazil's "spirit idiom."

Although there exists an inherent carnivalesque quality, in the Bakhtin-ian sense, to Brás Cubas's death, resurrection, and subsequent "free-spirited" life narration, Brás Cubas's narration belongs to the more modern *roman-tic* version of the grotesque genre, in contrast to the collective nature of medieval folk culture and its popular carnivals. Like Laurence Sterne's *Tristram Shandy,* Brás Cubas's carnival is an individual one, celebrated in the "private chamber" of the character's fundamental sense of isolation.

Certainly, the afterlife enjoyed by Brás Cubas bears some resemblance to, if not a "joyful hell," a joyful purgatory. It was during the twelfth century that the idea of purgatory, as an intermediary place where the souls of the faithful were purged of their sins before ascending to heaven, took hold in Europe. Yet, throughout the Middle Ages (and later) the official geography of the afterlife sanctioned by the church was offset by the pop-ular belief that the dead remained with the living for some time follow-ing their death, haunting the places and people they had left behind. The unquiet dead were those souls who had suffered an unnatural or "bad death" (by drowning, suicide, murder, or the absence of a proper burial attended by loved ones) and, consequently, wandered the earth seeking redemption.

Despite the Christian funeral given on his behalf, Brás Cubas's demise by no means constitutes a "good death." Having neglected his health, he dies "possessed" by his quest for personal glory. Like his oppositional news-paper, the poultice never comes to fruition. Moreover, he dies single and his funeral is attended by only a handful of people. Perhaps the most vis-ible sign of his bad death, however, is his failure to produce offspring. With his death, the Cubas lineage comes to a halt, a misfortune that Brás Cubas seems to relish when, at the novel's conclusion, he takes measure of his life: "Putting one and another thing together, any person will prob-ably imagine that there was neither a lack nor a surfeit and, consequently, that I went off squared with life. And he imagines wrong. Because on arriving at this other side of the mystery I found myself with a small balance, which is the final negative in this chapter of negatives—I had no children, I haven't transmitted the legacy of our misery to any creature" (203). Brás Cubas cynical assessment, however, of his life and death and the absence of descendants may be read on a broader level. A good death, one recalls, ensures not only the possibility of personal salvation for the deceased but also the preservation of social coherence within the commu-nity. In this regard, "to die" is not a solitary activity. Rather, it involves the participation of the community at large in its rituals and symbolic gestures and lays the groundwork for reconciliation and solidarity among friends,

family, and neighbors. Moreover, these factors are essential for sustaining a sense of continuity among diverse groups and generations.

Along these lines, it is perhaps not incidental that Brás Cubas leaves no children to transmit his legacy, particularly when we consider the allegorical connotations of "Brás" in terms of nation: Brás—Brasil. Thus, Brás Cubas's bad death may also be read as the impending "bad death" of Brazil's empire, a system still haunted by the specter of its colonial past. As was mentioned before, one of the greatest political concerns for Machado de Assis at the time of *Posthumous Memoirs* was what he perceived to be the lack of continuity and clear vision surrounding Brazil's transition from a waning empire to a new republic in 1889. A national allegorical reading of this kind leads one to believe that, for Machado de Assis, Brás Cubas, with his restless narrative style and elusive sense of morality, represented the "wandering souls" of the Brazilian elite—a class that he viewed as lost in a kind of ideological purgatory.

The Revenant Returns

To be sure, if Brás Cubas represented the only example of a revenant with a carnivalesque disposition in Brazilian literature we might be able to write him off as some kind of remarkable but peculiar anomaly. However, one need not delve very deeply into twentieth-century Brazilian fiction to find strong evidence of the revenant's imminent return. The more internationally known, if less critically acclaimed, author Jorge Amado provides us with two novels that give forceful account to the recurring presence of a revenant unique to modern Brazilian literature. Moreover, Amado is probably the twentieth-century novelist most responsible for bringing the *topos* of the resurrected dead to the attention of modern Brazilian readers. The presence of a postmortem figure within the realm of the living assumes a different manifestation in each novel, namely, as protagonist who returns from the dead for a final night of revelry in *Death and the Death of Quincas Berro D'Água* (1961) and as a primary character and participant, albeit deceased, in a love triangle that takes place somewhere between *this* world and the next in *Dona Flor and Her Two Husbands* (1966). As with *Posthumous Memoirs* my focal question is twofold: What form does this *topos* take in each novel? And what specific function does it serve in the novel's construction?

The title *Death and the Death of Quincas Berro D'Água* suggests multiple deaths, which is precisely the case for Quincas Berro D'Água, the

protagonist in this novela. As the story opens, we learn of his physical death when his body is found in his apartment. Long before this, however, Joaquim Soares da Cunha, the mild public functionary, died a symbolic death when he left his oppressive family life and was resurrected as Quincas Berro D'Água, "King of the Vagabonds" and local hero for the common folk. On the night of his wake, and in the company of his closest "vagrant" friends, Quincas is physically roused from his deathly slumber by a few generous swigs of *cachaça* (rum made from sugarcane). A night of drunken revelry culminates in Quincas's final (and perhaps spiritual) death when he allegedly tosses himself off the bow of a boat during a storm, uttering these prophetic words: "Everyone take care of his own funeral. Nothing is impossible" (ix).

The narration begins on a speculative note: Which version of Quincas's death(s) should we believe? The ensuing narration chronicles not only conflicting reports surrounding his death but also the struggle over how Quincas (and the dead) should best be remembered. As the narrator tells us, "the memory of the dead is a sacred thing," and indeed, what constitutes a sacred burial lies at the heart of the question here (5). The situation of Quincas's "rebirth" during his wake is particularly illuminating because it reveals two conflicting approaches toward death at work in modern Brazilian society. Quincas's biological family, anxious to bury not only the body but also the memory of his bohemian life style, dresses the corpse in new clothing to give him an air of respectability. As soon as his relatives leave, however, his clothes are promptly removed and divided up amongst Quincas's four closest companions, his "adopted family" from the street. A resurrected Quincas then proceeds to carouse through the streets in his normal shorts and T-shirt. This act amounts to a symbolic disrobing of the hypocrisies and materialism of middle-class values, while, in turn, constituting an affirmation of the personalized treatment traditionally given to the dead.

The struggle over Quincas's posthumous identity may equally be explained in Bakhtinian terms, that is, both families are playing out the carnivalesque ritual of "crowning" and "decrowning" Quincas and his legacy on earth.[13] Indeed, during the course of the wake he is metamorphosed from "the King of Vagabonds" to "head of the family" and back again. Bobby Chamberlain, in his book *Jorge Amado*, makes a compelling case for reading *Quincas Berro D'Água* not only as social satire but also as biblical parody (55–60). He calls the reader's attention to the more obvious parallels between Quincas's resurrection and the resurrection of Jesus

Christ. Many of the events surrounding Quincas's death lend weight to this theory, such as his mysterious appearance before his four "disciples" at the wake, the symbolism of the *peixada* (fish stew) as Quincas's "last supper," his relatives' discovery of his empty coffin, and the parallels between the epithets used to describe Quincas ("King of the Vagabonds," "Grand Drunkard of Salvador," "Our Father") and those used to describe Christ in the Bible ("King of Kings," "Light of the World"). Although Chamberlain makes a strong case for the existence of these parallels he does not delve deeply into the implications of reading *Quincas Berro D'Água* as a biblical parody. The book's overriding message, according to Chamberlain, may be found in its "celebration of the freedom of the individual" (60). This is undoubtedly a conventional reading of Amado's *novela*, one that ignores how Quincas's resurrection and self-made burial represent not only the celebration of the individual's will, but also the affirmation of the community's collective will and its control over important rites of passage. To this degree, Quincas acts as a kind of savior because his life and death serve to reinstate important social ties. Because his resurrection is also a parody of the Gospels, he dies not for our sins, but for the very forms of popular culture that are perceived by the middle class as "sinful."

Jorge Amado brings another carnivalesque character back from the dead in his novel *Dona Flor and Her Two Husbands.* In fact, Vadinho's sudden death in the novel's opening pages occurs during carnival as he is dancing through the streets of Salvador dressed as a woman. The parallels between Vadinho and Quincas are numerous, although Vadinho is still quite young when he dies and very much in love with his wife Dona Flor, despite his infidelity to her. After an intense period of mourning during which Dona Flor separates herself from her family and friends, she re-emerges and eventually marries again, this time to a pharmacist who is as restrained as Vadinho was unrestrained. Over time, however, the emotional and physical connection between Dona Flor and her memory of her former husband elicits Vadinho's resurrection and subsequent presence, alongside the subdued Teodoro, in Flor's natural/supernatural love triangle. As in *Quincas Berro D'Água,* we do not know if the ghost has actually returned or if it is just a figment of Flor's imagination, a phantasm created by her need for companionship. To Amado's credit, this ambiguity is preserved throughout the novel, lending the reader's response to the narrative a kind of dramatic suspension of disbelief.

As Chamberlain points out, some critics have read *Dona Flor* as a political allegory of the ideological struggle waged in Brazil during the 1950s and 1960s between leftist populism (Vadinho, a man of the people) and the positivist, technocratic stance of the military government (Teodoro, a man who maintains order) (63). Considering that Amado, beginning with *Gabriela, Clove and Cinnamon* in 1958, had turned away from making overt political statements of the kind that marked the "social realism" of his earlier novels, one might be more inclined instead to accept Roberto DaMatta's reading of the novel as an example of Brazil's systematic depolarization of opposing ethical systems (house/street, personal/impersonal, heaven/hell) and the subsequent creation of a third relational element (83). Dona Flor is, according to DaMatta, the embodiment of this third element, and her decision to keep both Vadinho and Teodoro is emblematic of Brazilian society's tendency to build bridges between diametrically opposed ideological spaces. DaMatta's theoretical framework is useful for understanding the essential struggle taking place in *Dona Flor* (between personal relations and impersonal relations) and why the intervention of the dead is so important for bringing resolution to this particular social dilemma.

The currency of the carnivalesque *defunto* in modern Brazilian fiction is further exemplified by Érico Veríssimo's novel entitled *Incident in Antares*. Published in 1971, this was Veríssimo's last novel before his death in 1975. The novel is structured into two main parts. The first provides an historical backdrop of Antares (a frontier town in the southern state of Rio Grande do Sul) and traces the long-standing rivalry between two warring clans who, by the time of the "incident," represent the old power structure of *coroneis* (the local patriarchal chiefs) and their latifundiaries. It is in the second part of the novel that we learn of the "incident." A general strike in the city sets into motion a series of bizarre events culminating in the resurrection of seven corpses, which, during the confusion, are left in their coffins at the entrance of the municipal cemetery. Representing diverse socioeconomic and ideological positions, the cadavers find solidarity in their indignation for having been left unburied. They agree to stage their own demonstration in the town square and remain there until their grievances are heard and they are given a proper burial.

It is fitting that, as the corpses begin to make their way into the city, the first witnesses to the "incident" mistake the macabre bunch for a group of carnival revelers. Equipped with the unique vantage point of the living

dead, the corpses are able to see through the materialism and hypocrisies of those in power and, in typical carnivalesque fashion, expose the most corrupt to public denouncement. As Cícero, the spokesperson for the cadaveric group says: "From my perspective, that is from the viewpoint of the deceased, life more than ever strikes me as an elaborate masquerade" (341). It is the matriarch Quitéria's words, however, that strike at the heart of the matter. Embittered by her family's petty greed following her death she laments: "There can be no mutual understanding between the living and the dead" (356). Herein lies the underlying problem. Veríssimo seems to imply that before meaningful change can occur, Brazil must first exorcise the ghosts of its past, in other words, those social and political institutions that have outlived their usefulness. The unburied dead in Antares are a metaphor then for those moral doctrines, political structures, and deified figures that continue to haunt the living. By the same token, Veríssimo's political satire is directed most certainly at the Brazilian military dictatorship and, to borrow António Sérgio's expression, its own particular "tyranny of phantoms." Acting much like the military coup of 1964, the "Operação Borracha," or "Operation Erasure," that follows the incident in Antares is intended precisely to erase any evidence of this revolutionary moment from both the annals of history and the memory of the people.

"Our small thanatocracy"

The contrasting representations of the carnivalesque *defunto* in Brazilian literature discussed above illustrate significantly different, yet interrelated, cultural approaches toward death in modern Brazilian society. Literature's capacity to interact with and influence these cultural approaches makes it both an important source and protagonist in the history of Brazil's evolving relationship to death and the dead. In contrast to the extreme isolation of Brás Cubas's "individual carnival" and wandering soul, Amado's Vadinho and Quincas Berro D'Água return to eat, drink, and sleep with the living, and as a result their resurrections carry a sense of rebirth and community. In this respect they embody the collective carnival spirit of medieval folk culture described by Bakhtin.[14] The possibility of renewal through death suggested in Amado's novels stands in contrast to the perpetuation of social ills following in the wake of death, a theme explored by Érico Veríssimo's *Incident in Antares,* in which the tormented voices of the dead (as well as the living) speak to Brazil's need to come to terms with the social and political ghosts of its past.

It may also be said that these works present two distinct pathways into the afterlife: death followed by resolution and the possibility of renewal *or* death followed by irresolution and the haunting appearance of the unquiet dead. Rarely is this opposition clear-cut during the course of each narrative. Instead, each novel seeks to strike a balance between maintaining close proximity to the dead/the past, through memory and specific rituals, and keeping the dead/the past at a healthy distance. Thus, for the modern Brazilian reader the carnivalesque *defunto* is at the same time undeniably familiar and highly uncanny. Part Menippus and part *malandro,* the Brazilian postmortem reveler serves to expose underlying social fissures in Brazilian history and, by adopting a carnivalesque form, calls attention to the social order or institution responsible for the existing crisis. Like the dead in the Menippean satire, the carnivalesque *defunto* subverts and demystifies any and all forms of social, political, and aesthetic authority, including its own. As we have seen, these forms of authority are inevitably interpreted differently in each novel, depending on the particular sociohistorical or authorial circumstances at play in their respective time periods.

The carnivalesque *defunto* also serves as an analogy for what has proven to be perhaps modern Brazil's greatest dilemma: reconciling the past with the present. Itself belonging to neither the past nor the present entirely, the revenant gives corporal shape to those sociopolitical and cultural anachronisms so prevalent in contemporary Brazil. To be sure, these spectral traces of a colonial past (and of a premodern relationship to the dead) may be found in other parts of Latin America as well. The festivities marking the Day of the Dead in Mexico and Juan Rulfo's novel *Pedro Páramo* (1955) are two examples that spring to mind and that lend further weight to Cícero's comment in *Incidente em Antares* about the dead's unique position in Latin America: "Here in our small thanatocracy we enjoy absolute freedom to think and speak our mind, a rare thing indeed in today's so-called Latin America" (356). In other words, in Brazil and elsewhere in Latin America the *defunto* is very much alive.

NOTES

1. In his study *Spirits and Scientists: Ideology, Spiritism, and Brazilian Culture,* David Hess suggests that possessing a spirit idiom has become part of "Brazilianness," and that part of Spiritism's wide popularity in Brazil stems from the close relationship of other spirit medium religions, such as Candomblé, to Brazilian national identity (210). Spiritism took root in Brazil during the second half of the nineteenth century

following the Portuguese translation of Allan Kardec's *The Spirits' Book* (1857). Spiritist movements also spread throughout Europe and the United States during this same period. Whereas Spiritism has largely declined in these areas, it continues to flourish in Brazil, which, according to Hess, is "the home of the world's largest Spiritist movement" (201).

2. See, for example, Gilberto Freyre, *Casa Grande & Senzala* (*The Master and the Slaves: A Study in the Development of Brazilian Civilization*); and Sérgio Buarque de Holanda, *Raízes do Brasil*.

3. For a broader historical discussion of the dead in Iberian culture during the Middle Ages, see José Mattoso, ed., *O Reino dos Mortos na Idade Peninsular*. Legislation was passed in Portugal in the 1830s, with the support of church authorities and the medical establishment, calling for the construction of cemeteries far removed from the church grounds and forbidding the age-old practice of burying the dead in or near the local parish church. For a discussion of the intense popular reaction against this legislation, see João de Pina-Cabral and Rui Feijó, "Conflicting Attitudes to Death in Modern Portugal: The Question of Cemeteries," in *Death in Portugal*, ed. Rui Feijó, Herminio Martins, and João de Pina-Cabral, 17–43; and Fernando Catroga, "Morte Romántica e Religiosidade Cívica," *História de Portugal*, ed., José Mattoso, vol. 5, 595–607.

4. Gilberto Freyre in *The Masters and the Slaves* provides ample testimony to the spiritual autonomy of each plantation, where, in addition to the master's house and the *senzala* (slave quarters), there usually existed a small chapel, overseen by a resident priest who remained subordinate to the master (xxviii). As in Portugal, the dead were buried in close proximity to the living: "The custom of burying the dead underneath the house—beneath the chapel, which was an annex of the house—is quite characteristic of the patriarchal spirit of family cohesiveness. The dead thus remained under the same roof as the living, amid saints and the floral offerings of the devout. The saints and the dead were, indeed, a part of the family" (xxx).

5. David Hess's observation of a uniquely Brazilian spirit idiom formed by the confluence of Catholic, African, and indigenous religious elements finds its antecedent in Gilberto Freyre's somewhat generalized affirmation that "Brazilians are, *par excellence,* the people with a belief in the supernatural; in all that surrounds us we feel the touch of strange influences, and every so often our newspapers reveal cases of apparitions, ghosts, enchantments. Whence the success among us of spiritualism in both its higher and its lower forms" (155).

6. One fundamental difference between Protestant and Catholic doctrine lies in the former's affirmation that the individual is wholly responsible for his or her own salvation, while the latter views the soul's salvation as a collective effort. The doctrine of predestination during the Reformation effectively sounded the death knell in Protestant cultures for the concept of purgatory, the soul's temporary resting place before salvation, thus eliminating the imperative for ritual gestures aimed at influencing the destiny of the deceased's soul.

7. See João José Reis, 1991; Patricia Goldey, "The Good Death: Personal Salvation and Community Identity," *Death in Portugal*, 1983; and José de Souza Martins, ed., *A Morte e os Mortos na Sociedade Brasileira*.

8. See Jean Baptiste Debret, *Viagem Pitoresca e Histórica ao Brasil*, 175.

9. All references to *The Posthumous Memoirs of Brás Cubas* are from the Oxford edition, trans. Gregory Rabassa (Oxford: Oxford University Press, 1997).

10. See Roberto Schwarz, *Um Mestre na Periferia do Capitalismo:Machado de Assis*, 19.

11. See, for example, his short story, "A Segunda Vida" (*Obra Completa* 440–46), in which the central character is reincarnated only to later become insane, and newspaper columns contained in J. M. Machado de Assis, *Diálogos e Reflexões de um Relojoeiro* (Rio de Janeiro: Civilização Brasileira, 1956).

12. Two obvious examples of belief in the supernatural may be found in Machado's short story "A Cartomante" (The Fortune-teller) in *Obras Completas* (477–83) and his novel *Esau and Jacob*.

13. See Affonso Romano de Sant'Anna's symbolic reading of Quincas's transformation in his article, "De como e porque Jorge Amado em 'A Morte e a More de Quincas Berro D'Água' é um autor carnavalizador, mesmo sem nunca ter-se preocupado com isto," 45–65.

14. Bakhtin's notion of the carnivalesque is an adept one, particularly when discussing Brazilian cultural products. Arguably, the importance attributed to carnival in Brazil suggests that it remains a living, everyday force, in the medieval "folk" sense proposed by Bakhtin, rather than as merely a literary vestige.

WORKS CITED

Amado, Jorge. *Dona Flor e Seus Dois Maridos.* São Paulo: Livraria Martins Editora, 1966.

———. *A Morte e a Morte de Quincas Berro D'Água.* Rio de Janeiro: Editora Record, 1998.

Bakhtin, Mikhail. *Problems of Dostoevsky's Poetics.* Ed. and trans. Caryl Emerson. Minneapolis: University of Minnesota Press, 1984.

———. *Rabelais and His World.* Trans. Hélène Iswolsky. Bloomington: Indiana University Press, 1984.

Buse, Peter, and Andrew Stott, eds. *Ghosts: Deconstruction, Psychoanalysis, History.* New York: St. Martin's Press, 1999.

Caldwell, Helen. *Machado de Assis: The Brazilian Master and His Novels.* Berkeley: University of California Press, 1970.

Castro, Ruy. *O Anjo Pornográfico: A Vida de Nelson Rodrigues.* São Paulo: Companhia das Letras, 1992.

Catroga, Fernando. "Morte Romántica e Religiosidade Cívica." *História de Portugal.* Ed. José Mattoso. Vol. 5. Lisboa: Editorial Estampa, 1993. 595–607.

Chamberlain, Bobby J. *Jorge Amado.* Boston: Twayne Publishers, 1990.

DaMatta, Roberto. *A Casa e a Rua: Espaço, cidadania, mulher e morte no Brasil.* São Paulo: Editora Brasiliense, 1985.

Debret, Jean Baptiste. *Viagem Pitoresca e Histórica ao Brasil.* Vol. 3. São Paulo: Livraria Martins Editora, 1954.

Derrida, Jacques. *Specters of Marx: The State of the Debt, the Work of Mourning, and the New International.* Trans. Peggy Kamuf. New York: Routledge, 1994.

Faoro, Raymundo. *Machado de Assis: A Pirâmide e o Trapézio.* Rio de Janeiro: Globo, 1988.

Feijó, Rui, Herminio Martins, and João de Pina-Cabral, eds. *Death in Portugal.* Oxford: JASO, 1983.

Freyre, Gilberto. *The Master and the Slaves: A Study in the Development of Brazilian Civilization.* Trans. Samuel Putnam. New York: Alfred A. Knopf, 1946.

Goldey, Patricia. "The Good Death: Personal Salvation and Community Identity." *Death in Portugal.* Oxford: JASO, 1983: 1–16.

Hertz, Robert. *Death and the Right Hand.* Glencoe, N.Y.: Free Press, 1960.

Hess, David. *Spirits and Scientists: Ideology, Spiritism, and Brazilian Culture.* University Park: Pennsylvania State University, 1991.

Holanda, Sérgio Buarque de. *Raízes do Brasil.* Rio de Janeiro: José Olympio, 1993.

Kardec, Allan. *The Spirits' Book.* Trans. Anna Blackwell. Rio de Janeiro: Federação Espírita Brasileira, 1996.

Lucian. "Dialogues of the Dead." *The Selected Satires of Lucian.* Ed. and trans. Lionel Casson. New York: W.W. Norton & Co., 1968.

Machado de Assis, Joaquim Maria. *Diálogos e Reflexões de um Relojoeiro.* Rio de Janeiro: Civilização Brasileira, 1956.

———. *Obra Completa.* Ed. Afrânio Coutinho. Vol. 2. Rio de Janeiro: Editôra José Aguilar, 1962.

———. *The Posthumous Memoirs of Brás Cubas.* Trans. Gregory Rabassa. Oxford: Oxford University Press, 1997.

Martins, José de Souza, ed. *A Morte e os Mortos na Sociedade Brasileira.* São Paulo: Hucitec, 1983.

Mattoso, José, ed. *O Reino dos Mortos na Idade Peninsular.* Lisboa: Edições João Sá da Costa, 1995.

Reis, João José. *A Morte é uma Festa: Ritos fúnebres e revolta popular no Brasil do século xix.* São Paulo: Companhia das Letras, 1991.

Rodrigues, Nelson. *Memórias de Rodrigues, Nelson.* Rio de Janeiro: Edições Correio da Manhã, 1967.

Rulfo, Juan. *Pedro Páramo.* Madrid: Ediciones Cátedra, 1986.

Sant'Anna, Affonso Romano de. "De como e porque Jorge Amado em 'A Morte e a Morte de Quincas Berro D'Água' é um autor carnavalizador, mesmo sem nunca ter-se preocupado com isto." *Tempo Brasileiro* 74 (1983): 45–65.

Schwarz, Roberto. *Misplaced Ideas: Essays on Brazilian Culture.* London: Verso, 1992.

———. *Um Mestre na Periferia do Capitalismo: Machado de Assis.* São Paulo: Livraria Duas Cidades, 1990.

Sérgio, António. "Espectros." *Ensaios* (Tomo 1). Lisboa: Livraria Sá da Costa Editora, 1976.

Sontag, Susan. "A Critic at Large—Afterlives: the Case of Machado de Assis." *The New Yorker* 7 May 1990: 102–8.

Spivak, Gayatri. "Ghostwriting." *Diacritics* 25.2 (1995): 65–84.

Sterne, Laurence. *The Life and Opinions of Tristram Shandy, Gentleman.* New York: Random House, 1950.

Teixeira, Ivan. *Apresentação de Machado de Assis.* São Paulo: Livraria Martins Fontes, 1987.

Veríssimo, Érico. *Incidente em Antares.* Porto Alegre: Editora Globo, 1977.

Watching Over the Wounded Eyes of Georges Bataille and Andres Serrano

KYLIE RACHEL MESSAGE

By positioning Georges Bataille's 1928 *Story of the Eye* and Andres Serrano's 1992 photographs from *The Morgue (Cause of Death)* series within a masochistic framework, this essay attempts to recognize the ways in which this writer and artist problematize the gaze. Invocation of a masochistic narrative corrupts the privileged position of the controlling spectator as the one who looks. Engaging with the fascinating and irreal world of Bataille's text demands a loss or fragmentation of spectatorial self-identity. Similarly, the repulsed attraction experienced before Serrano's always disturbing—but nonetheless very beautiful—*Morgue* photographs incites an anxiety within the spectator, if not a partial wounding, or a proper blinding of the eye. The spectatorial (or reading) eye can no longer be sure that it is controlling the charge of the gaze or whether, indeed, the spectator is looking at what she will look like when she can no longer look. Using the voice of *Story of the Eye*'s nameless narrator, Bataille writes that "the contrary impulses overtaking us in this circumstance neutralized one another, leaving us blind and, as it were, very remote from anything we touched, in a world where gestures have no carrying power, like voices in a space that is absolutely silent" (44).

The hyperreal context of ever-quickening and self-propelling signifiers that infinitely proliferate offspring of a third-order simulacrum—signifiers without signified, signs void of meaning—would at first sight appear to be far removed from Bataille's *Story of the Eye*. However, Bataille's conception of impulses that do not generate ardor, but only distanced and neutralized bodies, would concur with Jean Baudrillard's dystopian position (*Selected Writings* 186). In the presence of the sight of death, spectators become

inert. In Bataille's *Story of the Eye,* this inertia may be reconfigured within a masochistic and continuous relationship with the desired object. In the sight of death, the spectator, too, is blinded. Unable to communicate, the individual that gazes becomes "like" the dead body. A sign that can refer only to its own death, or death absolute, the corpse is its own punctum. It is its own evidence that it once had being (Barthes, *Camera Lucida* 85–87). The corpse's unblinking eyes stare through us, and it is incorporated into the hyperreal and excessive spiraling of signs that compete for our distracted attention. It is removed from that which it was, and yet it superficially remains the same. The sign of death that the corpse represents is "more real than real, more true than true." It has become "obscene" (Baudrillard, *Selected Writings* 188).

In this context, bodily sensation can have no shadow and thus no reality (Baudrillard, *Selected Writings* 155). Corporeality is overwhelmed by obscene signs where gestures flail through a spiraling void, and the cognitive real is annihilated (Baudrillard, *Selected Writings* 156). The body is no longer itself. It does not resemble itself. It is assimilated into that third order of simulacrum where it no longer references any object (other than perhaps a memory). It should signify or "mean," but its meaning is beyond our line of vision, beyond our knowledge. As such, we may perceive our identity as reflecting, or being or reflected within, the unblinking eyes of the "unreal immobility" (Bataille, *Story* 41) of that corpse we gaze upon. As discontinuous but human bodies, we are oriented toward the teleological point of death. However, in identifying with, or in entering into, an optical exchange with the transparent gaze of death, our individual existence and discontinuous identity is ruptured. We become continuous with the energies and excesses of death itself.

Without bound finalities, Baudrillard claims that this death is "a useless luxury, and the only alternative" to life, as regulated by "production and accumulation" (*Symbolic Exchange* 155–56). According to his argument, death thus becomes a transgressive anti-economy, a means of escape. Our cognitive fear of death is, therefore, to be understood as expression of our desire for it. Bataille states that "to will that there be life only is to make sure that there is only death" (qtd. in Baudrillard, *Symbolic Exchange* 155). Thus, the "responsive" spectator is not inert or stagnant, but continuous with the impassioned and erotic excesses of death. Bataille contends that: "We are discontinuous beings, individuals who perish in isolation in the midst of an incomprehensible adventure, but we yearn for our lost continuity" (*Erotism* 15).

This process renders the corpse strangely compelling. In Andres Serrano's *The Morgue (Pneumonia Due to Drowning 2)*, 1992, the pursed lips and the vaguely unreal green skin of the cadaver evoke a glow. This iridescent corpse is the boundary of my own being, and I recognize it as that which "show[s] me what I permanently thrust aside in order to live" (Kristeva 3). This body, itself poised upon the boundary between cohesion and decomposition, is only a sight for my discontinuous being, a removed spectacle. However, its appearance remains intriguing and seductive. Yet, the significance promised by the superficial appearance of this body-become-simulacra disseminates upon interaction or touch. It cannot respond, and its coldness sends shudders through my detached body. This hyperreal sign seduces its spectator through promising a meaning that is infinitely deferred, or always already absent, unless the spectator enters into an optical exchange and continuous relationship with the corpse as desired object.

This engagement demands a transgression from the bounds of the real, and from one's own coherent subjective status (Baudrillard, *Selected Writings* 185). Regardless of the seductive pull of death, this cadaverous spectacle is fascinating because we perceive it in the knowledge that we will also be perceived in this manner of spectacle when we can no longer see. This cognitive attraction expunges the horror of recognition that, even now, our bodies and gestures float endlessly in a void that reverberates only with the silence of nonreferential signs. Although at maximum distance from this corpse, we are, in fact, in a similar situation.

We can communicate only through the borders and limitations constructed discursively for our body, and if we become unbound, we are exiled into the void of presence that the corpse shows. As such, our choice is bound inertia within the system of signs and taboos, or unbound and meaningless floating beyond these life systems. Accepting that we will, likewise, become this spectacle of death, the only pleasurable option is to take succor at the pain of this sight and to take (the) death (of our own body) itself as our desired object (Silverman 54). Bataille comments that: "Two things are inevitable; we cannot avoid dying nor can we avoid bursting through our barriers; they are one and the same" (*Erotism* 140). To do this, we must invert Baudrillard's strategy of inertia and enter into a masochistic relationship; desiring (to become) that exquisite corpse presently before our eyes. We must become continuous with death. Consequently, and paradoxically thus, the corpse watches us; it holds us in its penetrating gaze: "The eye, instead of being the source of structured space, is

merely the internal point of flight for the convergence of objects. Another universe whirls forward, an opaque mirror placed before the eye, with nothing behind it—no horizon, no horizontality. This is specifically the realm of appearances where there is nothing to see, where things see you" (Baudrillard, *Selected Writings* 157).

The corpse stares through us, disseminating the substance of our corporeal existence. The mirror, similarly, is unable to reflect identity as singular, unified, or cohesive. The corpse reflects our gaze only by asserting our invisibility in its eyes, whilst the mirror splinters our reflection, launching the shards to proliferate amongst a spaceless and groundless void. To gaze into the mirror, is to see that we are paradoxically bound only by the depthless vacuum within the mirror's frame. Unable to perceive affirmation of our own gaze in the eyes of the corpse, we are rendered indiscernible, void. This fractured reflection is simultaneously disseminated and multiple. Our boundaries of self-identity are contained within the mirror's frame, but due to the lack of substance of this frame itself, we recognize that these boundaries are also mere illusions that have been discursively fabricated.

Like Serrano's *The Morgue* series, the postmortem photography of Jeffrey Silverthorne's *Letters from the Dead House* series (1972–74) manipulates the insubstantiality of these borders. The discomfort presented by the subject of Silverthorne's *Listen . . . Beating Victim,* is primarily due to the strained position of the head, which is turned and askew, roughly escaping its shroud. The spectator recognizes this body as a sign of death. It has been contained twice over, initially by the cloth surrounding the body and then by the photograph's formal structure and edges. This multiple framing exposes the fact that this cadaver has transgressed the boundaries regulating mortality. Indeed it is proof that mortality can only be organized through such fabricated, disjunctive, and illusionary boundaries.

Serrano's *The Morgue (Pneumonia Due to Drowning 2)* is harshly cropped and is restrained even more tightly than Silverthorne's *Listen . . . Beating Victim.* This photograph presents only a portion of the cadaver's face. However, this rigorous binding seems insufficient. The portion is threatening because it looks as if it could begin to leak out from the picture frame at any moment. In close proximity, this image is suffocating to perceive, not simply due to its partially bloated mouth and moist teeth but because we cannot see enough. The extreme formal shackles binding this image of death obstruct our view and thus call into question our own unified being. We are disturbed or repulsed by this face fragment, and yet, we

maintain the desire to perceive the eyes of this corpse, which have been excluded from the scenario. This fragment cannot confirm our living status, it cannot even appear to consolidate our gaze. Desire to see the eyes girds the spectator to *The Morgue (Pneumonia Due to Drowning 2)*, and this impossibility renders the spectator partially blind. Despite knowledge that the eyes will not be revealed, no matter how persistently we look, their absence indicates that there is more to this photograph than our own wounded eyes can see. Wanting to narrativize this image, we express our need to normalize it in the hope that it will, then, return our gaze. It is only through this normalization process of rebinding that we may dispel the fear that we experience before it.

This endeavor is retarded not by the exclusive cropping but by the fact that we recognize that there are eyes beyond the frame. This beyond is unsettling and inarticulable. This corpse has been blinded by the photographer, and we are bound to this image by our desire to restore its sight as well as our own. The absence of this corpse's eyes makes us aware that we desire to see the eyes of death, as if death itself resides not in the limp muscles and pallid skin, but in the eyes that have become transparent, and in the case of *The Morgue (Pneumonia Due to Drowning 2)*, invisible. By gripping the eyes of Silverthorne's *Listen . . . Beating Victim* to our own gaze, we may comfort ourselves with the illusion that the corpse is within the constraint or possession of our gaze. In the absence of the eyes of the corpse, in *The Morgue (Pneumonia Due to Drowning 2)* we become aware of that unspeakable beyond as that which binds us to this sign of death. This binding effects the spectatorial inability to divert our gaze from this object, and this evokes the fear of rupture in our mind and body. In positioning these dead eyes beyond the scope of the image, Serrano equivocates this absence of life with the multiplicity of eyes that the mirror proffers. As such, we recognize that we can only see our gaze via this illusion presented by a mirror or the nonresponsive but present eyes of a corpse. This recognition is unnerving because it renders our boundaries unstable, wavy (Barthes, "Metaphor" 125).

Rather than objectifying this subject as sight and attempting to dominate it in order to assert our own living status, this fear may only be superseded by identifying with the corpse. This does not bring us closer to this object that we desire but supplants fear with excitement and arousal. We thereby become excited at the prospect of death by becoming continuous with it. And yet we cannot simply commit suicide in order to embrace death. We must enjoy the anguish associated with being dominated by the

corpse (as the sign of death as that which we desire) and the pain of pro-
longing life so that death will be the ultimate erotic climax. In this sce-
nario, where corpses are assimilated into the unbound realm of enhanced,
seductive appearances, free-floating signifiers and manifold gazes, we can
only be ambivalent about our positionality. This uncertainty evokes anxi-
ety within the desiring subject and reiteration of Lacan's formulation that
"[y]ou never look at me from the place from which I see you" (103). Even
in the mirror, "I" am not where I am standing to look. This inversion
explains the apprehension and fear of the hyperreal (and yet actual) body
that is without (formative) limitations or place. Claiming "I know where I
am, but I do not feel as though I'm at the spot where I find myself," Roger
Callois explains further: "Then the body separates itself from thought, the
individual breaks the boundary of his skin and occupies the other side of
his senses. He tries to look at himself from any point whatever in space.
He feels himself becoming space, dark space where things cannot be put.
He is similar, not similar to something, but just similar. And he invents
spaces of which he is 'the convulsive possession'" (qtd. in Foss 27).

 I am a like signifier in hyperreal terms. Or, in Callois's terms, I have
become "similar." Our boundaries are superficially delimited, and our self
is contained only by our own gaze, which is itself devoid of manifestation.
In the case where I am the object of another's gaze, I cannot help but
wonder whether my boundaries disappear altogether. Indeed, being gazed
upon by another does not reassert our limitations but shatters them. In
gazing at another, we perceive the illusion of that which we are not (and
indeed, when gazing in the mirror, "they" also are not what we see). We
see in the negative. Lacan explains that "the relation between gaze and
what one wishes to see involves a lure. The subject is presented as other
than he is, and what one shows him is not what he wishes to see. It is this
way that the eye may function as *objet a,* that is to say, at the level of the
lack" (104).

 The act of looking upon another is not necessarily an act whereby a
subject asserts his stability of identity over that fragmented identity of
she who becomes objectified in his gaze. Apart from the fact that it is
not necessarily easy to ascertain which eye is controlling the exchange of
the gaze, the act of looking hides the gazing body. Not simply neutralized,
the looking body becomes invisible (Studlar 61). And Lacan claims that
every gaze "designates the person who is looking as that which is con-
cealed, no longer viewer but viewed, one spot in a totally exteriorized
space" (qtd. in Foss 33). The gaze returned by another can only be one

of equivalent uncertainty, . . . similar . . . and perhaps even continuous. Unsurprisingly then, it is with some discomfort, if not horror, that we interlock gazes with, or meet, the gaze of another.

This optical exchange, particularly with a desired body or object, threatens the boundaries of self in much the same way that death encroaches upon existence or that the mirror reflection denounces our subjectivity. Bataille writes that "there is always some limit which the individual accepts. He identifies this limit with himself. Horror seizes him at the thought that this limit may cease to be" (*Erotism* 144). As signs that demonstrate our own otherness, the corpse, the mirror, and the desired body/object reflect not the love that we express in our eyes but the limits of our bound self (Baudrillard, *Symbolic Exchange* 157). We are reflected not as a subject but as a formal system of delineations. Reflection of this truth by nuanced glances threatens to destroy that which they have exposed. Our limits, and our identity that is forged through these, are thrown into anguished flux. This other gains authority, and caught within their dominating gaze, we are contracted into waiting for them to break their gaze or for us to be subsumed within this.[1]

In *Story of the Eye,* Bataille manipulates the sight of a corpse to explain the gaze passing between the narrator and Simone. Unable to speak the narrator's desire, he can gesture toward it only through an expression of horror. Accordingly, it is only through relating the sight of an anonymous corpse that the narrator is able to articulate his experience of Simone: "The horror and despair at so much bloody flesh, nauseating in part, and in part very beautiful, was fairly equivalent to our usual impression upon seeing one another" (*Story* 11). Barthes claims that *Story of the Eye* is the narrative of an object's travels through the possession of various individuals. However, in privileging this elusive and singular One Eye, Barthes is obliged to present all the other eyes and gazes active within the story as simply the One Eye reconstituted. In this case, the One Eye is never itself a bound entity, it has no actual presence or optical function. To gain substance it must infuse or pervade these other eyes, masquerading as another eye, gaze, or substitute object ("Metaphor" 120). As such, and despite its lack of absolute containment, the One Eye is disembodied and, hence, is everywhere.

For Barthes, this single central Eye is the object signifying desire within this text. The other eyes seek out consummation of their gaze with this One, become icon. Both Simone and the narrator fantasize about Marcelle's eye, and Sir Edmund turns purple in his voyeuristic activity of

observing the One Eye in its various manifestations. Despite Barthes's contention that "the Eye thus both varies and endures" ("Metaphor" 121), it would seem that the Eye in question is, in fact, a simulation of itself. This One, authentic Eye is that hyperreal or obscene object that seduces those eyes that desire it. As Barthes notes, the Eye is simulated throughout the text by various metaphoric illusions, versions, or reembodiments. As such, the One desired Eye, in all its multiple transformations, is itself a sign with no origin or referent. It is desired by the other eyes, and it seduces the other eyes, yet it cannot be contained by or within their gazes. Evasive of itself being seduced, it threatens the death or blinding of those who pursue it. Its illusion may be only fleetingly possessed. The fickle and erratic precariousness of the Eye is suggested by the ambivalence of Simone on gaining the eye of Don Aminado. She "gazed at the absurdity and finally took it in her hand, completely distraught; yet she had no qualms, and instantly amused herself by fondling the depth of her thighs and inserting this apparently fluid object. The caress of the eye over the skin is so bizarre that it has something of a rooster's horrible crowing" (Bataille, *Story* 66).

The irony is that seduction "is an endless strophe" (Baudrillard, *Selected Writings* 160). Just as Lacan's *objet petit a* cannot be attained, "there is no active or passive in seduction, no subject or object, or even interior or exterior: it plays on both sides of the border with no border separating the sides. No one can seduce another if they have not already been seduced themselves" (Baudrillard, *Selected Writings* 160). The Eye thus entertains the games of the narrator and Simone because it has, in fact, already been seduced. Knowing that it is the sign of death as seduction consummated, Simone and the narrator desire to become continuous with the Eye's position. The seduction of these two characters is scintillating precisely due to its tortured slowness.

It is this hyperreal-become-obscene Eye that challenges the bounds of the self. In conflating the dialectic of inside and outside, it also conflates object relations. It seduces the gaze of Simone, yet in its transparent and infinite state, it also becomes her own eye. However, incorporated within her body, she is unable to perceive the object she desires. With the shuddering of her body, her objective distance is shattered. Desire functions through the maintenance of distance, the differentiation of self from the desired other. Yet possession of this simulated eye transcends distance (Baudrillard, *Selected Writings* 163). Regardless of the object's position between Simone's thighs, it is beyond her realm of vision. This absolute

proximity and negation of vision results in the culmination and obliteration of Simone's desire. The similarity of Simone's own eye and the absolute, continuous proximity of her body as a "like" signifier become transfigured as an equivalence. Not simply similar to this other Eye that is always already multiple, she becomes (as)simulated by its form(lessness) and compelling violence. The narrator relates the change in Simone following Marcelle's death: "As for Simone, she would first open uncertain eyes, at some lewd and dismal sight" (Bataille, *Story* 47). Her fear at the violence that this Eye may inflict on her could only be counteracted by her heightened desire for this incumbent assault. The fear that we experience in considering our own demise is, likewise, a heightened sensation. Bataille contends that this may even be exhilarating: "Fear of dying makes us catch our breath and in the same way we suffocate at the moment of crisis" (*Erotism* 105).

The violence of the gaze is centered on its ability to immobilize, silence, and suffocate the other that is arrested within its protracted vision. The subject of Silverthorne's *Listen . . . Beating Victim* declares its own object status through this title. Despite its position as desired object, it is the corpse that silences the spectator through its demands that we listen. This stills us, ensuring that we are captivated within its rupturing gaze. Barbara Kruger explicates the seizure that occurs within this contracted viewing through her contention that "I can't look at you and breathe at the same time."[2] The dominating gaze disseminates spatial relations and seduces through the false promise of absolute proximity. However, rather than incorporating or accumulating this spectatorial other, the dominating gaze devours or kills it. The activities of looking and breathing are both annulled by death, and yet it is a gaze fascinated with the sight of death that draws the spectator into proximity with the corpse, into the breathless and unseeing death that is represented by the photographs of Silverthorne and Serrano. Context is rendered devoid of substance, and the seduced eye becomes invisible to the systems regulating the real. Despite the fact that it is now distinguished by its unseeing nature, the gaze maintains an effective role in its seduction of spectators to the photographic images, who can choose either to identify with the displacement and de-subjectification of this Eye, or with the vision of the corpse that they will become. The subject desires to touch the surface of the object and to become blind and breathless. Yet in the context of the masochistic relationship, proximity is prohibited until the moment of absolute consummation: death.

The paradox propelling desire for this One Eye is that it is the violence feared by the subject, which also functions as the agent of seduction. This violence is the cognitively feared annihilation of the self. Interlocking the gaze with this One Eye transcends the dispossession experienced when looking in the mirror. Decorporealized, this Eye is not simply its own death, it is erotic continuity, which is, in a certain sense, immortality. It determines and disciplines the mortality of the desiring spectator. "To find oneself missing," Karen Piper contends, "is precisely the attraction of the signifying corpse" (171). As it is with the disembodied One Eye. From this dominated position, my knowledge of my self, and my reflection itself, is shattered. My own eyes maintain direct focus, but the unified body that I attribute as proof of my existence is thrown into a state of flux. In fact, it appears to be sliding away, out of and beyond my control. Despite my groundlessness, I remain frozen before the image of the One Eye (Bataille, *Visions* 238). The comforting sameness that I expect to see in the mirror is eclipsed. Indeed, I am reduced to no more than a dirty spot on its glass. "A tactile vertigo recounts the subject's insane desire to grasp its own image, and then vanish. For reality is gripping only when we have lost our identity, or when it reappears as our hallucinated death" (Baudrillard, *Writings* 156).[3]

However, if I am to reassert my bound self as a knowing and articulating subjectivity (that doesn't hallucinate), I must resist being seduced by the fear that attracts me to the nothingness of the corpse. I must shudder and then withdraw. I must reassert my discontinuity from this sight that I am not. When this other gaze is that of Silverthorne's *Listen . . . Beating Victim,* this withdrawal is problematic. The spectator responds by becoming quite static. Her gaze cannot unproblematically break from the unblinking eyes of the corpse represented here, a corpse that does not see and that will never avert its eyes to break the exchange of vision.

In this situation, the spectator cannot dominate this optical exchange; she is rendered inert before it. The spectator's own eye is disembodied. The spectator shudders in her propulsion toward, yet repulsion from, these images that draw her into the masochistic fantasy of pleasure, pain, and the ecstatic terror of the convulsive moment of death. *Story of the Eye*'s narrator recounts this exalted experience: "And it struck me that death was the sole outcome of my erection, and if Simone and I were killed, then the universe of our unbearable personal vision was certain to be replaced by the pure stars, fully unrelated to any external gazes and realizing in a cold state, without human delays or detours, something that strikes me as the

goal of my sexual licentiousness: a geometric incandescence (among other things, the coinciding point of life and death, being and nothingness), perfectly fulgurating" (Bataille, *Story* 30). As he notes, it is not simply death itself that attracts, but the knowledge of the sight that is experienced in that final moment of life, the transgression of that final boundary of existence. This perfect beyond is the culminating point of the narrator's sexual debauchery, and he knows that this is a beyond that will be reached only after he has been held in sufficient suspense. Implicated within this conception of seduction is the masochist aesthetic. The masochist's torturer must already have been seduced in order to effect punishment on her/his victim. Suspense, detours, distance, all these forms of waiting must ward off death as the ultimately anticipated but necessarily delayed masochistic pleasure. What the Eye is for Simone, Simone is to the narrator.

Story of the Eye is masochistic because its fantasy is such that the ideal and the real are absorbed within the narrative (Bataille, *Story* 29; Deleuze 114). The masochist "expects pain as the condition that will finally ensure (both physically and morally) the advent of pleasure" (Deleuze 71). As in Leopold von Sacher-Masoch's novels, the suicide hanging of Marcelle in *Story of the Eye* indicates the "physical suspension" of the masochist. The masochist is caught in this process of awaiting pleasure as an indefinitely deferred action, whilst the intense expectation of pain is always already immediate. The masochistic subject, victim or hero, loses the right to his name (Deleuze 75), and the narrator of *Story of the Eye* is, similarly, deprived this acknowledgment. No central characters have proper names.

In order to prolong the delay and incite further stimulation to the concluding moment of absolute joy, *Story of the Eye* centralizes themes of suspense and waiting within the text. Don Aminado's eye, as that which has seen the narrator's perfectly fulgurating moment, must be removed from his dead body. It is vital that the object of Simone's desire not perish, for that would signify her death also. Therefore, it may be that the various mutations, *petit morts* and rebirths, of the One Eye is necessary to ensure the prolonged, greater seduction of Simone and the narrator (Bataille, *Accursed* 103). Similarly, the specific eye of Don Aminado must be removed so that the broader significance of the One Eye as object of desire may perpetuate and proliferate further. Disposal of Don Aminado's eye as insignificant simulation—substitute object—of the One Eye ensures that Simone's masochistic searching will remain unsatisfied. Her activities and insatiable hunger will be repeated, and the One Eye will be reconstituted so that its simulacra can be sacrificed over and over. Deleuze quotes

Robert Musil's cry: "What fearful power, what awesome divinity is repetition! It is the pull of the void that drags us deeper and deeper down like the ever widening gullet of a whirlpool. . . . For we knew it well all along: it was none other than the deep and sinful fall into a world where repetition drags one down lower and lower at each step" (qtd. in Deleuze 114).

In this way, Simone will never possess that Eye which she desires, and her masochistic search for that Eye will be sustained. Her absolute death will be delayed indefinitely. The Eye must not be destroyed, but must be transformed into yet another gaze or substitute object. The suspense at potentially apprehending the gaze of this Eye remains to be its seduction. If the gaze is seized or interlocked, one party must perish (by blinding or averting their gaze) or both will die. Indeed, this may be the significance of the metaphoric blinding, or destruction, of Don Aminado's disembodied eyeball, now between Simone's thighs: "Now I stood up and, while Simone lay on her side, I drew her thighs apart, and found myself facing something that I imagine I had been waiting for in the same way that a guillotine waits for a neck to slice. I even felt as if my eyes were bulging from my head, erectile with horror; in Simone's hairy vagina, I saw the wan blue eye of Marcelle, gazing at me through tears of urine" (Bataille, *Story* 67).

The threatening violence of the disembodied eye is connoted by the fact that in Don Aminado's eye, the narrator saw the wan blue eye of Marcelle. Earlier, the sight of Marcelle's corpse had seduced Simone into "creating death itself" (Piper 167). Similarly, the narrator, who had been "waiting in the same way that a guillotine waits," had been pushed beyond the bounds of self by the sight of Marcelle's death. He explains that "as of then, no doubt existed for me: I did not care for what is known as "pleasures of the flesh" because they really are insipid; I cared only for what is classified as "dirty." On the other hand, I was not even satisfied with the usual debauchery, because the only thing it dirties is debauchery itself, while, in some way or other, anything sublime and perfectly pure is left intact by it. My kind of debauchery soils not only my body and my thoughts, but also anything I may conceive in its course, that is to say, the vast starry universe, which merely serves as a backdrop" (Bataille, *Story* 42).

The narrator was seduced and excited by the creation of death; and as such, he desired to conquer that Eye that seduced him through threatening his own destruction. Yet he knows that he cannot kill that which wills his own destruction because without the challenge presented by this Eye, he would perish regardless. This echoes that choice we must all make

in the face of death; between inhabiting an inert but secure position, or transgressing our boundaries of self through embracing a desiring and masochistic role. The narrator recognizes with despondence that in death, he would—like Marcelle—be rendered a "total stranger" (Bataille, *Story* 43). He would be subsumed by the floating and inert masses whose pleasures are restricted to the "insipid" (Bataille, *Story* 42). Despite the fact that "Marcelle was closer to me dead" (Bataille, *Story* 44), the narrator describes that desired absolute proximity that comes with death as "hopeless" and "boring" (Bataille, *Story* 43–44). Although he had excitedly imagined Marcelle's death previously (Bataille, *Story* 23), in the event of it, Simone was irritated and furious, while he was calm and wearied. He could not share Marcelle's moment of death, except in moments of "certain catastrophe" (Bataille, *Story* 43). Hence the narrator's propensity toward the latter, masochistic proposition.

Each simulation of the One Eye carries with it traces of its previous embodiments. In this way, the simulation is simultaneously the One desired Eye and the multiple, fragmented eyes that are sacrificed in its name. And with this accumulative disintegration of the self and incorporative multiplicity of the One Eye, desire is intensified. The more that this Eye acquires meaning for those that pursue it, the more seductive it is. For Simone and the narrator of *Story of the Eye,* the Eye came to signify the creation of death itself. Each death they witnessed was infused as energy into the One Eye, and the nonconstant distance between this Eye and their own drooling eyes was the distance between themselves and their own deaths.

The horror at coming face-to-face with this Eye further reinvokes the masochistic relationship. The narrator had been waiting for this moment to slice the Eye, and despite his impulse to blind or silence the vision that this Eye reflected, he must evade the confrontation and continue the suspenseful waiting in order to live. In Don Aminado's eye, the narrator saw Marcelle's eye, but more terrifying, he saw his own eye: "When the other that is expelled is recognized as myself, I lose my boundaries" (Piper 166). As with the mirror's reflection, by gazing into the eye of another, one sees the boundless image of one's own eye, or self, reflected.

This is terrifying because it allows the narrator to see what he looks like at the moment of Don Aminado's death. He is seeing what he can only imagine that he will look like when he, too, has experienced this moment of expiration. His coherent image of self is fissured, or dissimulated. The shattering of self that this reflection exhibits is such that the narrator must

recognize that his own eye is, similarly, merely a simulation of, or sub-stitute object for, the One Eye. The unblinking and disembodied eye will not avert its gaze, just as "The Open Eyes of the Dead Woman" (Bataille, *Story* 41–44)—that is Marcelle—will continue to seduce the narrator toward his own point of absolute, uninhibited pleasure. The narrator is experienc-ing "joy before death," and he must look away, or endure his own blind-ing (Bataille, *Accursed* 109). As such, the pain the narrator experiences in seeing Marcelle's eye in Don Aminado's eye forms the masochistic pre-occupation with arrested movement. He desires proximity and yet must suspend this impulse.

Serrano has been quoted as stating that "my work does more than just shock, it also pleases. And that really fucks with their heads" (qtd. in Hill 44). This is the attraction-repulsion paradox that seduces the spectatorial eye within the gaze of a corpse. As in the narrator's necessary severing of his gaze from his desired object in *Story of the Eye,* the self-spiraling vortex of two gazes caught together must be shattered for subjectivity to be reconstructed. Yet this optical bondage (as transgressive of taboos regu-lating that I be a discontinuous, Cartesian subject) is pleasurable. I am absorbed and reflected in the eye of the other. This causes a continuity between myself and the corpse, which is erotic. In acknowledgment, Bataille claims that: "Ecstasy begins where horror is sloughed off. More than any other state of mind, consciousness of the void about us throws us into exaltation. This does not mean that we feel an emptiness in our-selves, far from it; but we pass beyond that into an awareness of the act of transgression" (*Erotism* 69).

Just as Don Aminado's eye pleasured Simone's body, I desire the physi-cal touch of she whose optical scope I am within. Yet that moment of ecstatic "touch" will also be the moment of my momentary or actual death, the moment when I am returned to the objectified status of being looked at. My fantasy is disseminated after this *petit mort* (Bataille, *Erotism* 170). If this is the moment of my actual death, as it is for Don Aminado, I move beyond fantasy into that noncognitive void beyond life. If this is a spec-tatorial *petit mort,* my eye will be returned to the site of my body and distance will be reconstituted between myself and my desired object. My body will be re-bound, and my desire intensified rather than satisfied (Studlar 267).

The spectator participates in the image or text through internalizing the humiliation or terror presented. This internalization guarantees that access to the image is direct and that it is imbricated throughout by Bataille's

conception of the attracting horror of the dead eye. Michael Halley explains that the symbolic function of Bataille's Eye is to "direct consciousness beyond re-presentation, semantic perpetration, to its end-point, its telos, a culminating (and initiary) absence" (293). This means moving away from the charted realm of signifier and signified, into that beyond which Bataille speaks of as both inherently violent (Bataille, *Visions* 238) and erotic: "To retrieve the erotic requires at once unspeakable self-violation and unthinkable societal transgression. One must be willing to entertain the fascinating, vertiginous conjunction of sex and death; to admit their singular, specularly interchangeable nature" (Halley 286).

Whether with body, or without, the blinded, transparent eye of the cadaver evokes a fear in the spectator due to the fact that this object, which once had a gaze equivalent to theirs, is now reduced to an absence. The corpse threatens the boundaries of the spectator's "clean and proper" body (Kristeva 102). The indeterminate and undifferentiated status of the unburied corpse, as with Serrano's bodies positioned midway in *The Morgue,* increasingly heightens spectatorial unease and even nausea (Bataille, *Story* 11). The corpse is an absence, yet it remains visible as a very present and disturbing absence. Indeed, Serrano contends that the individuals he photographed "became more powerful as symbols than they actually were as human beings" (qtd. in Hill 44). This is the fascination of the corpse that is still there before our eyes, but devoid of being or existence. Bataille states that: "A dead body cannot be called nothing at all, but that object, that corpse, is stamped straight off with the sign 'nothing at all'; . . . [the corpse] is the answer to a fear. This object, then, is less than nothing and worse than nothing" (Bataille, *Erotism* 57).

Don Aminado's transparent vision of death is aligned with a certain visionary transcendence. Through the loss of identity that death entails, the corpse becomes multiple and excessive, through its hyperreal movement beyond the boundaries of corporeal existence and identity (Bataille, *Erotism* 173). The eye that was momentarily possessed by Don Aminado implicates Bataille's conception of the productivity of death, described by Halley as being the "unseen scene of life in death, that which is beyond mere vision, not bereft of it" (292). Similarly, this experience has been described by Hegel as a "holding close to death, watching it appear in a consciousness which it eliminates" (qtd. in Halley 291). This certainly concurs with Serrano's *Morgue* images, whereby the subjects photographed have "seen what will never again be seen with the eye. The eye which maintains the experience of death, [is] dead itself in representation" (Halley 292).

Perhaps inevitably, Barthes's structuralist account of the linguistic pro-
cesses and form of *Story of the Eye* is problematic. This uncertainty may
be considered to be an appropriate fallibility for any attempt made to
explain the process of desire or seduction, because this process is neces-
sarily inarticulable. Through his reconstructions of the Eye as various and
dissimilar objects, Bataille's intention may be regarded as highlighting this
indiscernability of desire. He is exploring the notion that objects them-
selves have an ambivalent existence or presence and that the process and
satisfaction of desiring such an object is beyond the realm of cognitive
thought and language (Baudrillard, *Selected Writings* 159). Indeed, this un-
speakable process cannot be satisfied without a certain, equally ambivalent
and unknowable, "joy before death." Bataille recognizes that it is better to
devote oneself to the protracted and masochistic process of unresolved
desiring rather than to conquest of its object:

> How sweet it is to gaze long upon the object of our desire, to live on in our
> desire, instead of dying by going the whole way, by yielding to the excessive
> violence of desire! We know that possession of the object we are afire for is
> out of the question. It is one thing or another: either desire will consume us
> entirely, or its object will cease to fire us with longing. We can possess it on
> one condition only, that gradually the desire it arouses will fade. Better for
> desire to die than for us to die, though! We can make do with an illusion.
> If we possess its object we shall seem to achieve our desire without dying.
> Not only do we denounce death, but also we let our desire, really the desire
> to die, lay hold of its object and we keep it while we live on. We enrich our
> life instead of losing it. (Bataille, *Erotism* 142)

Desire to blind the all-seeing Eye may be based on a superstitious con-
struction whereby this ritual will allow the action of the story to begin and
continue unfettered by the visionary constraints of the Cartesian subject
(Foss 29). Certainly Bataille contends that death is a form of beginning.
And yet the discontinuous spectator standing before Serrano's *The Morgue
(Jane Doe Killed by Police)*, 1992, sees this image as a point of punctuation.
A finality that cannot be reversed. The profile image that Serrano presents
of an unseeing woman, bloodily blinded and dirtied by the gunshot wound
to her head highlights the disembodied aspect of the gaze. Her eye sock-
ets are hollowed out and void. As if stunned, she stares ahead blankly. We
can never meet her gaze front on, only her gunshot wound. In obscuring
Jane Doe's line of vision, Serrano seems to highlight the fact of her violent

death over her sharply arrested subjectivity. To encounter death too eagerly may result, as it does in this photograph, in an acute loss of identity.

As Bataille cautions, we must prolong our desire through enriching our life rather than focusing on an incumbent death. This increases desire for the moment of death that will be decided for us, and will enhance life as elemental to the desiring process. We cannot attain our desired object in life, and yet, if our life is ended too soon, the joy of death cannot be so sweet. Suspenseful waiting for that unknowable and desired moment may be a process of pain, yet it ensures an ultimately joyful climax or satisfaction in death. Not simply dead and unseeing, this woman is identified or named exclusively by her death. She is called not simply Jane Doe but *The Morgue (Jane Doe Killed by Police)*. The brutality of her death encroaches upon, and indeed encompasses, any subjectivity she may have had whilst living. This violent death is what we must avert in order to live, not simply as continuous desiring bodies but so that our final moment of death is ecstatic.

Story of the Eye's characters, Simone and the narrator, only appear to be liberated through the metaphoric deaths of the dominating One Eye. Rather than being fatally wounded, this Eye is repeatedly partially blinded. In being fractured, it permeates the multiplicity of other active gazes circulating within the text's scenario. Similarly, the obscured vision of *The Morgue (Jane Doe Killed by Police)* does not signify her death per se but rather the anxious animation of desiring spectatorial gazes. Despite the wound testifying to her cadaverous state, her unaffected stare does not make her look closer to death than the spectator. As such, this image, like the authoritative Eye of *Story of the Eye,* does not primarily attest to its own death but to the multiplicity and mobility of gazes that take this body or disembodied gaze to be their desired object.

Desire to blind the autonomous eye, as it occurs by the spectator standing before Serrano's *The Morgue* series and through the characters in *Story of the Eye,* may be read as a moment in which the text is ruptured from within or disturbed from its own coded and situated construction. Rather than attempting to engage with this image or text in order to decode or disseminate meaning, it may be more plausible to recognize that these texts are, in fact, expressing "an atrophy of meaning" (Popowski 305). This would concur with Baudrillard's position that the One Eye, and those desiring the Eye, are in fact, nonreferential signifiers. Indeed, these texts may signify a crisis or catastrophe in meaning itself as a structured illusion.

Preoccupation with the eye as a meaningful signifier may simply be based on the fear that "illegibility corresponds to a blinding" (Popowski 304). In this way, *Story of the Eye* undermines notions based on seeing and comprehension. In disembodying the eye, thereby annulling the active function of this organ, in addition to its position as an object to be gazed upon, both the production and avoidance of understanding is encouraged. Appropriate to both Bataille and Baudrillard's notions of excess, Mikhal Popowski maintains that *Story of the Eye* is affective in and through the repetition of minor points of rupture or transgression (308). If, indeed, *Story of the Eye* and Serrano's *The Morgue* images are rupturing their own status as unified texts through their hyperrealizing of the Eye as a nuanced and meaningless sign within the spiraling system of other like signs, then the eye engaged with the text is also implicated within this scenario of multiple eyes that rupture rather than see: "The eye referring to itself is the eye of equivalence. 'The eye within the eye' is not only the eye that goes from the same to the same (equivalence) but is also that which, at this precise moment, ceases to see, arresting the function of 'seeing' in the fixidity of its open glance" (Popowski 299).

The analogy between illegibility and blindness throws the spectatorial or reading position into confusion. If this analogy is correct, then "the eye is simultaneously the organ of 'seeing' and of 'knowing' and that of their impossibility" (Popowski 300). This reading of the text's illegibility reinstates the dominating eye. It represses all the various possibilities for looking that are offered within the text, in order to resituate the privilege of the One encompassing Eye that, blind and therefore illegible, ruptures the text's connections with meaning. This presents this One Eye as possessing Medusan capacities, whereby "when the eye looks at the eye, it triggers fixidity. The staring eye paralyses the stared-at-eye and immobilizing (itself), it arrests at once everything that falls into its field" (Popowski 300).

Apart from the difficulty in ascertaining which eye is looking and which eye is looked at, this potentially sadistic account of *Story of the Eye* seems to overlook the various and multiple—indeed animating—dynamics of the gaze itself. In subsuming the many to the One, Popowski seems to be averting his own gaze from the fact that while the "various eye substitutions finally congeal in one multiple eye" (Foss 24), this Eye remains multiple, and its gaze is continually fractured, pursued, and pierced by that of others. Rather than this One Eye signifying the illegible excesses of *Story of the Eye,* perhaps the aggregated substitutions do not indicate individual, directional, and penetrating gazes per se but the excessive presence of

many individual gazes and eyes. In reducing the individual subject to the typology of the universal corpse as sign of death, Serrano's *The Morgue* series does not condense or universalize the gaze into the One authentic Eye. *The Morgue* series seems to contend that the various presences (of those that have, and of those that had, being) may be expressing that in-articulable and ambivalent desire that resides beneath active looking: the desire to see beyond the optical scope.

Recognition of the multiple dead eyes of Serrano's subjects contributes to the realization that "what is seen is not so much the horror enacted, but rather the horror of looking itself" (Foss 25). Popowski's position diverts attention from the dynamics of looking—the gaze itself. Without signi-fied, the Eye as signifier can only be effective within—and imply rupture within—dominant modes of comprehension. However, this overlooks the function of the eyes themselves, in a literal, figurative, and erotic sense. Reading *Story of the Eye* alongside *The Morgue* allows the multiple gaze of the bodies presented by Serrano to puncture discursive readings of Bataille's text. Of course, the many eyes do not need to be decoded or understood, because they simply mean looking itself. The reader and spectator desire subjection to these active gazes, and in interlocking our own gaze with that of a corpse, we become immobilized. Like the corpse, our stillness is not motivated by inertia or horror, but by our masochistic desire to become this death that is presented before us.

NOTES

1. For an example of a masochist's contract, consider that held between Mrs. Fanny von Pister and Leopold von Sacher-Masoch. See appendix 2, "Two Contracts of von Sacher-Masoch," in Deleuze 277–78.

2. Barbara Kruger, *Untitled (I can't look at you and breathe at the same time)*, Photograph on T-shirt, 1987, in Linker 30.

3. See also Lacan 103.

WORKS CITED

Barthes, Roland. *Camera Lucida: Reflections on Photography*. 1980. Trans. R. Howard. London: Vintage Press, 1993.

———. "The Metaphor of the Eye." Trans. J. A. Underwood. *Story of the Eye*. 1928. By Georges Bataille. Trans. J. Neugroschel. Harmondsworth: Penguin Books, 1982. 119–27.

Bataille, Georges. *Story of the Eye*. 1928. Trans. J. Neugroschel, Harmondsworth: Penguin Books, 1982.

————. *Erotism: Death and Sensuality*. 1957. Trans. M. Dalwood. San Francisco: City Lights Books, 1986.

————. *Visions of Excess: Selected Writings, 1927–1939*. Trans. A. Stoekl, et al. Theory and History of Literature 13. Minneapolis: University of Minnesota Press, 1985.

————. *The Accursed Share: Volumes 2 & 3*. Trans. R. Hurley. New York: Zone Books, 1991.

Baudrillard, Jean. *Symbolic Exchange and Death*. Trans. I. Hamilton Grant. London: Sage Publications, 1993.

————. *Selected Writings*. Ed. M. Poster. Trans. J. Mourrain. Stanford, Calif.: Stanford University Press, 1988.

Deleuze, Gilles. *Masochism: Coldness and Cruelty*. New York: Zone Books, 1994.

Foss, Paul. "Eyes, Fetishism, and the Gaze." *Art and Text* 20: 24–41.

Halley, Michael. "And a Truth For a Truth: Barthes on Bataille." *On Bataille: Critical Essays*. Ed. and Trans. L. A. Boldt-Irons. Albany: State University of New York Press, 1995. 285–94.

Hill, Peter. "Andres Serrano: Pissing on the Klan." *Art and Text* 42 (1992): 44.

Kristeva, Julia. *Powers of Horror: An Essay on Abjection*. Trans. L. S. Roudiez. New York: Columbia University Press, 1982.

Lacan, Jacques. *The Four Fundamental Concepts of Psycho-analysis*. Trans. A. Sheridan. London: Penguin Books, 1994.

Linker, Kate. *Love for Sale: The Words and Pictures of Barbara Kruger*. New York: Harry N. Abrams, 1990.

Piper, Karen. "The Signifying Corpse: Re-reading Kristeva on Marguerite Duras." *Cultural Critique* 31 (1995): 159–77.

Popowski, Mikhal H. "On the Eye of Legibility: Illegibility in Georges Bataille's *Story of the Eye*." *On Bataille: Critical Essays*. Ed. and Trans. L. A. Boldt-Irons. Albany: State University of New York Press, 1995. 295–312.

Serrano, Andres. *The Morgue (Cause of Death)* series, Paula Cooper Gallery, New York, 1992.

Silverman, Kaja. "Masochism and Male Subjectivity." *Camera Obscura* 17 (1988): 30–67.

Silverthorne, Jeffry. *Letters from the Dead House* series. Artist's Collection, 1972–74.

Studlar, Gaylyn. "Masochism and the Perverse Pleasures of the Cinema." *Quarterly Review of Film Studies* 9.1 (1984): 267–82.

Optative Death

Gerhard Richter in the Wake of the Vanguard

ANDREW MCNAMARA

The deceased lies in profile, visible from the shoulders up, clearly displaying the welt marks around her neck. These marks graphically attest to her death by hanging. Rather than being depicted in clinical detail though, the figure hovers in a hazy, colorless register—as though in a transit zone of embodiment. Though not exactly clinical, the representation is nonetheless very deadpan, inert, even cool. It seems that Gerhard Richter's sequence of paintings, *Tote (Dead Woman)*, 1988, gestures toward nothing, saying nothing (figure 6). Yet we are confronted with this highly emotive, unsettling subject matter: it depicts the corpse of Ulrike Meinhof, whose name became enshrined with left-wing terrorism, the "Baader-Meinhof gang," here painted in close proximity to the picture plane, as if the figure were pressed up against an imaginary viewing screen like an item of forensic analysis.

Figure 6. *Tote (Dead Woman) 2*, from the series *18 Oktober 1977*, 1988, Gerhard Richter.

This is the transit zone to which the corpse testifies—the corpse as that trace between life and death. Here, in Richter's suite of paintings, *18. Oktober 1977* of 1988, art would appear to fulfill a traditional role insofar as it commemorates and preserves that physical transience that haunts biological life. But this is complicated; there is hesitation before the inert weight that this commemorative function imposes. It is possible to imagine decay and transience in art. As Richter puts it in regard to this much-discussed series, which includes *Tote (Dead Woman)*, he sought to stage another funeral for the Baader-Meinhof gang—the colloquial, media title for the Red Army Faction (RAF)—but one that does not bury their memory alive.

The question might be: can art memorialize without completely burying its subject matter? We are never allowed to imagine the corpse of art. Art is indestructible; this is its saving grace. Yet everywhere, always, transgressive art has perished and this is what haunts Richter in these images of death. Artists are compelled to consider the role of transgressive art when it is hounded by an "interminable discourse of termination"—hounded, that is, by a machinery of recuperation that appears so effective that the vanguard is swallowed whole and its death by recuperation appears seamless (Mann 115). Except that the artist does not command such a formidable perspective from which to make these devastating assessments. The avant-garde legacy renders the commemorative impulse unstable, and this is troubling for artists: how does one follow in the wake of the vanguard while at the same time adhering to its tenets in the aftermath of its heroic intentions. This commitment to the living dead of vanguard tradition can be understood simultaneously in terms of mourning—mourning in the sense described by Freud, insofar as there is a return of what has not been fully dealt with, but lingers unincorporated and unresolved.[1] For Richter, the terroristic violence of the Baader-Meinhof episode is a particular example of this unsettling irresolution, and not just because he personally cannot shake its haunting memory. It unsettles because it is a "complex" (to use Richter's term) that taints all heroic consideration of the transgressive act, thus suspending any redemptive sense of its memorialization. What is intriguing here is the way that this disjuncture resounds like a call from nowhere, it is difficult to coordinate because it has no clear redemptive anchors. Yet it has the potential to unsettle one's very fabric, for that call of redemption was thought to be dead and buried. In Richter's RAF series, we find another tripartite sequence of images, this time of Gudrun Ensslin that, while not depicting her corpse, engages with this

haunting summons quite provocatively. This call, always singular, and disruptive because it is disjunctive, haunts one to the core in demanding a response. How is it possible, though, to find oneself in its grip, as if one's response has been well and truly rehearsed beforehand, already beckoned, yet nonetheless startling all the same because it lacks all reliable cues?

Think of a very familiar situation: when we hear a new sound, whether we turn or not, we feel compelled to divert our attention to it. It is a common reflex to a new auditory stimulus no matter what the context. It can be frequently observed in the still formality of the conference room or seminar—it even happens while listening attentively to the most stimulating and engrossing of presentations. There is simply a phylogenetically old reflex mediated via the brain stem that diverts our attention to the new stimulus. Like many such reflexes it no doubt derives from a fundamental survival principle. Imagine being in a cave, huddled around a fire, and not bothering to look when a large bear stumbles upon the scene. Developed functions of the human cerebral cortex allow one to consciously override these impulses and, for the sake of decorum, appear oblivious to the intrusion.[2] Yet when a major brain trauma occurs—such as a stroke—the basic reflexes reemerge and reassert themselves over all learned responses and over all the social imperatives of decorum. In medicine, this is reputedly one of the first ways of assessing damage: one looks to see if the primitive reflexes have reasserted themselves, such as upturned toes when scratched on the sole of the foot rather than the usual down-turned response (what is called the Babinsky reflex).

Turning to the source of a loud sound or a new arrival upon a scene is not necessarily a primitive reflex. It is an involuntary response to a new auditory stimulus, but one that possesses significant social dimensions and implications, for it takes the form of an unprovoked engagement prompted by an interruption. Like most interruptions, it beckons—in one way or another—for a response, even if it is coerced. One must respond before one can fully decipher what one is responding to. The significance of this abrupt occurrence is that it is akin to being taken, almost seized, as much as it is to participating in an active form of response. One is beckoned by interruption that imposes itself beyond our immediate parameters of engagement and thus elicits a glimpse of all that has the potential to become unsettled or uncertain before accounts can be resettled again. This exposure occurs in the blink of an eye; it is a process of exposure that grasps one as much as one grasps it.

We witness such a response depicted in the crucial sequence of works within Richter's *18 Oktober 1977* corpus that features Gudrun Ensslin, the relatively anonymous but key figure of the RAF. Anonymous, that is, unless one knows anything about the RAF, for Ensslin was a strident militant, who strove to maintain the white-hot ideological intensity of the RAF and was described early on as the backbone of the then-unnamed terrorist group.[3] This time Richter's portrait is a snapshot sequence of images titled, "*Confrontation* (Gegenüberstellung) 1, 2 and 3." These "photo-paintings" depict Ensslin as she negotiates the straitened passage of incarceration after her arrest in 1972. She is caught briefly responding to a call of recognition from amidst a throng of people that presumably included the paramilitary, police and court officials, a gallery of journalists, photographers, and assorted public onlookers.[4] Her engagement is brief and fleeting. Captured in this snapshot sequence, she appears hesitant, more subdued than strident—much more like a tentative ghost startled at being summoned back from the grave. This grainy depiction—as if sliding between registers, as though on the path to recognition and slipping away from it—echoes the doubt Ensslin exhibits as she is drawn to one short instant of recognition amidst a sea of unfamiliar faces. Then she looks away again.

In this frozen sequence, we are prompted to ask to what does Ensslin now respond in this arrested gesture, captured and duplicated in Richter's paintings? Ensslin is caught in the act of looking, but she no longer sees; her image is like a shadow event. The work is a memorial: the snapshot

Figure 7. Gerhard Richter, *Confrontation (Gegenüberstellung)* 1, 2 and 3, 1998, The Museum of Modern Art, New York.

cliché of this momentary, fragmentary incident that may have barely reg-
istered to Ensslin herself and is here enlarged to monumental significance.
Ensslin's image is recruited again in order for Richter to present a grim
elegy reflecting upon the wastelands of a frenetic political activism. Ensslin's
image is more deathly than the figure of the inert corpse of Meinhof
because the chasm of recognition haunts their retrieval. The figure of
Ensslin in this sequence appears once again to address some call or greet-
ing within a desolate landscape of forensic debris: Baader's record player,
the prison cells, a funeral, the various corpses (hung and shot) of the RAF
terrorists (including that of Ensslin herself) who died on the night of
October 18, 1977 (and, in Meinhof's case, earlier). Unlike the before and
after shots of Meinhof, this sequence is not simply one of a passage from
a once bright future to a grim death, or from problem to resolution. It is
genuinely a confrontation in which Ensslin appears again, as if from the
ruins of a lost messianic logic, from which Richter confronts the ruinous
potential of art at the end of the twentieth century. So what monument is
Richter erecting with this series?

Variously translated in English as "Confrontation" or "Line Up," these
variations convey a range of possible meanings suggested by "Gegenüber-
stellung." Literally, it suggests a placing before or against in juxtaposition,
vis-à-vis one another in a one-on-one engagement, or an act of recogni-
tion. It also implies (perhaps more coercively) a public parading or pres-
entation, such as one finds precisely in a lineup and, thus, presenting a
moment, mode, or point of comparison. The source photographs do, in
fact, depict Ensslin on her way to a police line-up after her arrest in 1972.[5]
In Richter's hands, the sequence suggests then a very apprehensive grasp-
ing on Ensslin's part. This is perhaps evident in the way she responds in
this timid and reticent—yet still inviting—fashion, as though she is asked
to respond to something that opens up to her as both welcomed and wel-
coming, yet at the same time is almost unfathomable in its transient, un-
expected offering. She responds to a greeting, but in this work it is no
longer evident what greets her.

Because the complex of events surrounding the violent agenda of the
RAF as well as the deaths in Stammheim have left such a scar, Richter
endeavors to restage their funeral. Why—to end the haunting? As it turns
out, Richter's response is contradictory: on the one hand, he wants to
revive what has been buried and disposed of all too readily. He mounts
another funeral in order to counteract "the feeling that we forgot, or that
we are forgetting—throwing the entire thing away from us like garbage

(173). On the other hand, though, Richter wants to dispose of something that haunts him personally. And yet there is a suspicion that what might ultimately spook him is his inability to put it all to rest. There is a horror here of distressing events that haunt as "unfinished business," a business that just will not be suppressed.[6]

Clearly this "unfinished business" refers, as the artist makes clear, to specifically German events and perhaps even to the ever-present sociopolitical assumption that to survive is to forget. Richter, of course, does not want to dispose of it all like garbage, because the idea of vanguard action is what is haunted here, and this involves all art practices in the wake of the modernist tradition as much as it does political contestation. Turning to the subject matter of the Baader-Meinhof group in order to rehearse these recriminations means wading through the refuse heap of public controversy for, as Richter concedes, "too much spectacle (is) invested" in this "complex" of events (qtd. in Magnani 95).

But Richter, who once postulated that the proper destination of this suite of paintings was a German museum, only entangled himself further in the notoriety of this spectacle and its attendant controversy when he sold the works to the Museum of Modern Art (MOMA) in New York. The artist—whose students, he admits, protested from the outset that he was too bourgeois for such subject matter—leaves himself open to charges of mock piousness not only because of his confused sense of destination but also due to the quasi-religious reverence in which he unveiled these works that barred any of the festivity of a normal opening.[7] Furthermore, in the new destination of America, he stood accused of glorifying terrorism. Richter would like to mark this work off as a special event, a significant pause in the proceedings of visual art, but he finds himself further enmeshed in the grip of the controversies and entanglements that he had set out to dispel. Richter then continues to be haunted, but equally as much by the prospect that he, the artist, has no magic powers to lay to rest what has been uncovered. He himself is caught in the grips of circumstances just like the image of Ensslin he depicts in *Gegenüberstellung*—warmly welcoming the call for a response, yet contorted in the grip of events that multiply rather than find any resolution.

What still spooks this scene is the fact that the more one delves into the "unfinished business," the more it becomes murky and the less it relates entirely to the specific events from the late 1960s and 1970s. Other specters haunt this scene; they are at once riven and intertwined. In the guise of the RAF, of course, there hovers that specter directly reminiscent of the

one Marx declared haunted Europe—the trajectory of messianic deliverance, of hope and the struggle against exploitation and suffering. At the same time, in the aftermath of the violent implosion of the extraparliamentary opposition in the 1970s, the "unfinished" matters also allude to, and cast a shadow over, a whole voluntarist economy of action that became essential to modern thinking about art and culture. This trajectory registers whenever we speak of cultural acts as offering deliverance—some sheer elevation from the grip of events—and yet, while suggesting this movement up and beyond, the trajectory also registers when prizing something autonomous, unsullied, and self-contained, something almost sacred. With Baader-Meinhof, Richter seems to suggest that, taken in the form of this unmitigated and thoroughly heroic ardor befitting the genuine authors of revolution, the struggle against exploitation can readily become exploitative—the cause of the violently "just" giving way to indiscriminate violence all round. It is, however, a vocabulary difficult to dislodge, even for an artist most avid in expressing his ambivalence about such rhetoric. Richter may debunk the rhetoric, but he is still drawn to it: as he testifies, the RAF challenge still holds an appeal due to "their uncompromising determination and their absolute bravery" (Richter, *Daily Practice of Painting* 173).

Identification is a central theme for the *18. Oktober 1977* series, but it is fraught: having experienced two forms of dictatorship, Richter sees things differently from Ensslin. Living in the former German Democratic Republic did not exactly instill a desire for the communist utopia; he keeps his distance from the ideological zeal of the RAF. Terror knows no bounds; it wreaks havoc and appears indiscriminate, thus the sense of unease and dread terrorism provokes, as Richter observes, reinforces rather compromises the state. "Now we are more pragmatic, we may not like the government, but we see its necessity. We are at the opposite end of terrorism, we want this order so that we can be a bit anarchist in our homes" (qtd. in Magnani 95).

The prospect that art cannot really countenance is that it may extend damage; art engages political spectacle in order to escape unscathed and prove itself pristine. Thus Richter argues that he embarked upon this fraught subject matter because he was drawn into an "entire complex of events" that was never "dispatched," but the reason for this return, he states quite unequivocally, is to try "to dispatch that complex" (qtd. in Magnani 95). Simple as that, but why proffer this wholly unambiguous resolution?

The answer might be that Richter seeks mastery where he rebukes it. He wants to be the master that can articulate our lack of mastery—to

articulate that lack and still come up trumps. But in order to do so, he must partake of the very thing that he dismisses. Art, he postulates, is "the pure realization of religiosity, of the ability to believe, longing for 'God.'" Then, virtually in the same breath (though more accurately it is in fact simply ten days later in his diary of the same year as the *18 Oktober 1977* series), art is said to be "wretched, cynical, stupid, helpless, perplexing (*verwirrend*)."[8] The whole complex is, of course, not dispatched at all—the revival of its memory further contributes to the mire of spectacle, intrigue, and controversy. Nothing in Richter's own pronouncements would verify this sheer and spontaneous elevation of art and the artist from the context of events. Richter then lingers in limbo between registers like the figure of Ensslin he depicts—half-resolute, half-dissolving, heading in both directions simultaneously. Art does not dispatch, instead it is perplexing and bewildering (*verwirrend*). Yet, although Richter decries the limitations of utopian thinking, he invests in its anticipatory potential—at least, as a vestige of a proposition. These are the two main planks of his rhetoric: "I have always been resigned to the fact that we can do nothing, that Utopianism is meaningless, not to say criminal. This is the underlying 'structure' of the Photo Pictures, the Colour Charts, the Grey Pictures. All the time, at the back of my mind lurked the belief that Utopia, Meaning, Futurity, Hope might materialise in my hands, unawares, as it were; because Nature, which is ourselves, is infinitely better, cleverer, richer than we with our short, limited, narrow reason can ever conceive" (Richter, *Daily Practice of Painting* 103).

Art might retain all the complexity that such considerations urge upon it, but it remains important for Richter that art retain this anticipatory appeal—even in its wretchedness.[9] It thus remains important for him to hold out the promise of not being wholly consumed by the trauma of the event and even to risk exploring its frayed remnants.[10] Richter, in effect, can only conjure the specter of Ensslin and the whole "complex" of the RAF event by marking a chasm between them. He wants to invest in their messianism, so much so that he can postulate a realm that is "infinitely better" or, alternatively, a lurking capacity to discharge us from the complex of events. But what does he invest in? Can he obtain a good return for his investment and make it truly calculable? Benjamin Buchloh almost asks as much when he presses Richter into conceding that his work renounces "every possibility of producing transcendental meaning, beyond the pure materiality of the picture as a picture," but this will not do for the artist. "Then why do I trouble to make it so complicated?" he responds

(qtd. in Buchloh "Interview" 25). Why bother? Why bother at all, we could ask, with all this "unfinished business"? But Buchloh has the right to be puzzled, too, because Richter disparages utopian transcendentalism and yet adheres to it simultaneously. Richter has dealt with an "extreme utopia" in the Baader-Meinhof terrorist group, yet disparages their political transcendentalism, which derives from their extreme political voluntarism. Richter even goes so far as to say that he understands the state's response to their terrorist campaign.[11]

The points of recognition are disjunctive, though nonetheless compelling. There is, after all, the blazing appeal of that radiant energy to which Richter responds despite himself—energy so heedless of personal consequence, so blindly ambitious, and so unwilling to compromise with half-measures. The appeal of this uncompromising energy harkens back to that incendiary violence beckoning in Futurist rhetoric: the call to take hold of any implement that could wreak havoc upon the "venerable cities," that would incinerate the august libraries and flood inert edifices like the Uffizi. It recalls, too, André Breton's vehement outburst to "Nadja" that he was appalled by the servitude of the working masses. Only the "vigor" of their protest against that servitude retains any significance to him because only then does the "spirit of revolt" fuel their energies.[12] It is this animating spirit of revolt that has inspired avant-garde rhetoric and conjoins it to the historical force of vanguard political struggle. Yet, conjoined as it is, it is nonetheless conjoined in empathy as well as in resentment, in recognition as well as rejection—as Breton testifies to that contradictory force of appeal to the agents of political struggle, "You see them and they don't see you."

Endurance fails to ignite any animating flame; the fire is sparked only by a revolt against servitude. Without such a protest, and no coincidence of recognition, Breton can only envisage loitering in its glow: "For myself, I admit such steps are everything. Where do they lead, that is the real question. Ultimately, they all indicate a road, and on this road, who knows if we will not find the means of unfettering or of helping those unable to follow it to unfetter themselves? It is only then that we may loiter a little, though without turning back" (Breton, *Nadja* 69). For Breton in the 1920s, there is as much skepticism about a coincidence of recognition as there is for Richter at the close of the twentieth century. Such profound asymmetry is an essential component of Richter's portrait of Ensslin. It derives from the appeal of these people who "tried to change the stupid things in the world" and were willing to die for it. Of course, there is a voyeuristic

fascination with death that confuses our sense of what is actually exem-
plary, Richter grants this: "Looking reminds us that we are the survivors,
and at the same time, we see our own end, in front of us, and somehow
we like seeing it." Still if this were all there were to it, it would amount to
a mis-recognition" "I hope it's not the same as seeing an accident on the
motorway and driving slowly because one is fascinated by it. I hope there's
a difference and people get a sense that there is a purpose in looking at
those deaths" (qtd. in Magnani 97). But grasping this difference of pur-
pose is difficult because there is no one exemplary memory within this
complex entanglement of competing destinations, media spectacle and
memorialization. Richter contributes to this difficulty because his stand-
point is that utopia is meaningless, even criminal (Richter 103). As he
characterizes it, he depicts victims, not heroes (Magnani 97). Anything
exemplary that the artist can retrieve from this situation stems from this
fundamental discrepancy that divides Richter from Ensslin, and Baader and
Meinhof. This stance is more complex than even Richter allows for art too
is caught in these entanglements. Yet what is at stake here though is not the
familiar complaint that dismisses art because, despite all its vanguard pos-
turing, it continually proves itself incapable of achieving anything tangible
politically. Far more unsettling, Richter flounders in the wake of a heritage
in which aesthetic analogies did, in fact, prove highly conductive to polit-
ical programs, primarily, though not exclusively, for totalitarian politics.[13]

This trauma has also scarred that safe haven, that home, called "art" and
this proves to be deeply unsettling. There is, for Richter, something exem-
plary in this "complex" of contorted events. It manifests in that golden
appeal of plenitude and the rush of action, an action fulfilled and made
supreme, that the utopian zenith promises. It is not simply, as Richter
states, that authority has become more acceptable or that we have become
more pragmatic. It is more that this radically voluntarist espousal of defi-
ance and spontaneity—so nourishing to the rhetorical spirit of the avant-
garde—has revealed its Janus-faced potential as well as its fatal complicities.
Today we witness this rhetoric everywhere. Once vehement avant-garde
rhetoric exalting the unaffiliated creativity of the sovereign individual has
become the "catch cry," as Raymond Williams points out, of the neolib-
eral economic orthodoxy that has emerged since 1945. To quote Williams:
"The politics of this New Right, with its version of libertarianism in a dis-
solution or deregulation of all bonds and all national and cultural forma-
tions, in the interest of what is represented as the ideal open market and
the truly open society, look very familiar in retrospect."[14]

Another fatal complicity has been pinpointed by Boris Groys in his critique of the Russian avant-garde between avant-garde aesthetic rhetoric and political dictatorship. Although overstated, Groys's argument presents a sharp historical example of complicity. Avant-gardist zeal, of course, always expressed itself as a kind of death—that is, in an "aesthetic of rupture," in a form of perpetual "eventness," that quintessential modernist "permanent play of the present moment" that will always be superseded. Accordingly, we accommodate, even expect, the outlandish rhetorical jolts espoused in Breton's *Nadja* or in the Futurist manifesto and we treat them precisely as aesthetic jolts. But what happens when such rhetoric becomes the guiding wisdom for the praxis advocated by the likes of the Baader-Meinhof? The aesthetic proves challenging precisely because it never is supposed to transform into praxis. The virtue of Groys's critique is that it reminds us that such rhetoric—espousing both the virtue of the sovereign creator and the ultimate fulfillment of its work as a new social order of pristine accord—proves a magnet for the worst kind of political excess. This is especially true as this rhetoric dovetailed into the aesthetic-organicist view of the state prominent in the political rhetoric of the two totalitarianisms Richter experienced, Hitler the "architect" of Third Reich and Stalin the "sculptor" of soviet Marxism. For Groys, the issue of such violent rhetoric can no longer be compartmentalized as an aesthetic consideration, but becomes instead an ethical issue when, in the extreme case, this rhetoric is acted upon. Such praxis is the province of a politics that aims to be brutally efficient and utilitarian at the level of avant-garde rhetoric; its messianic destiny dictates that it be as rigorous as possible in pursuing its road to fulfillment. The daunting realization then is that the messianic state may be happy to act on the exuberant advice of a poet like Vladimir Mayakovsky when he advocates using "brass knuckles to bash in the world's skull," albeit taken up as a challenge to smash in the "skull of its citizens." Richter renounces the similarly violent ramifications of the RAF, but would like to compartmentalize the aesthetic component in general. Groys, by contrast, proffers an aesthetico-political complicity—vanguard rhetoric redolent with the bright spell of utopian inspiration, the zeal of action and the smell of blood, and ultimately, death. Unlike Brenton, Richter no longer envisages a road that directs the path. Richter's stance recalls Rudi Dutschke's comments after visiting Jan-Carl Raspe in prison: "A subjective feeling that one is an anti-imperialist revolutionary does not make it impossible for one to play a disastrous part." And then, perhaps touching on what makes this theme and Richter's treatment of it so movingly

melancholic, Dutschke adds that the outcome of "a wrong idea and solitary confinement in jail, is to accelerate a process of self-destruction."[15]

Groys asks adroitly, in the aftermath of the Russian avant-garde's horrendous lesson, whether we can believe today that the artist has any more access to transhistorical truth—that is, to "address eternal truths, moral imperatives and 'quality'"—"than anyone else?" (111, 113). It is this mortifying question, more than any other I would argue, that most unsettles Richter. In broaching the idea that he could dispatch this entire complex, it is almost as though he still subscribes to that "truly priestly function" that Saint-Simon foresaw for the vanguard actors so long ago. Richter wants to disparage utopianism, but he wishes to preserve—or, at least, shelter some vestige of—art's anticipatory appeal.

Art is a realm of this bewildered anticipatory potential, and Richter wants to be master of that realm. Yet, contrary to his own stated intentions, he shows that art does not dispel or dispatch "complexes." What it does do instead, to paraphrase him, is strive to keep things open in an "effortless" way that nonetheless keeps all complexity alive. Art does not return to itself to discover itself again. Art must contend with its particular bewilderment, which derives from acceding to so many deaths in the wake of the avant-gardes and thus attending to so many haunting returns. Richter's optative appeal can only be understood in terms of a commitment to an avant-gardism, to the vestige of an idea of transgression in the wake of the avant-garde. The conceit of this appeal derives from his assumption that only art could offer the call of anticipatory hope, and that, by implication, he may be the master of our contemporary lack of mastery.

But this is an unstable conceit, and this may explain Richter's extraordinary diffidence. Still, though he seeks to preserve the frameworks of vanguard action for art, he also ventures to explore contemporary art's limit condition: to recall him once more, art is wretched, bewildered, and that is because we do not know what it is or why it matters. This is the nature of the haunting that plagues Richter. So why indeed does he go to this trouble: is it to finish it off and bury it once and for all? Or is it precisely to recall what is "unfinished"?

Richter's series *18 Oktober 1977,* and the portrait of Ensslin in particular, amounts to a self-portrait by proxy. It is an inquiry about what is possible for an artist in the aftermath of all this wreckage of critical ambition. The portrait of Ensslin does, however, differ from that of the artist's

daughter painted in the same year, *Betty* (1988), in a way that is quite revealing. In this latter painting, the foreground figure—in a resplendent ensemble of red, pink, and creamy white with radiant blonde hair—turns her back to the prospective viewer and faces an opaque dark gray void that seems to be one of Richter's own abstract monochrome paintings. With the back of the figure facing the viewer, it seems a disconcerting portrait, but it can be viewed as a "portrait" of the polar possibilities of artistic endeavor. In this sense, the work provides a testimony to the artist's own virtuosity in displaying the formidable range of his repertoire, from photo-realist to abstract, and thus his capacity to span the divide. A subtle circuit is set up within which Richter exhibits his technical mastery as the main subject matter.

Except that, contrary to this circuit of fulfillment, the gray monochrome does not simply denote a void or an incidental backdrop, which is evident by the retinue of painterly markings that are on display in each work, differentiating each despite their apparent uniformity. Those discrete technical demarcations aside, Richter invests great significance in this dull, opaque tone of gray: "Now when I see the grey monochrome paintings I realise that, perhaps, and surely not entirely consciously, that was the only way for me to paint concentration camps. It is impossible to paint the misery of life, except maybe in grey, to cover it." And this leads him directly back to that anticipatory appeal that lingers in the aftermath of the Baader-Meinhof, an appeal still to be reckoned with: "The concentration camps were simply terrible, without any hope, and that is something I can't paint. Baader-Meinhof is different: I tried to have some of their hope come out in the paintings" (qtd. in Magnani 97). Hence the gray haze from which the figure of Ensslin appears cannot be likened to a blanket cover that buries the unspeakable. Instead the gray film allows her image to emerge. Ensslin continues to peer, and Richter concedes he is haunted by that now mute, but still powerful, call for a response. Richter reopens the case, but does not do so in the spirit of a detective because he simply does not attempt to solve anything.

What is it then that surprises and disrupts Richter in his restaging of Ensslin's confrontation? Is it the fact that when he peers into the face of Ensslin he does not come full circle? Nothing there redeems him. In the wake of the haunting "complex" unearthed by the Baader-Meinhof episode, Richter faces up to what cannot be answered; that is, he faces up to the question of what it is that greets him now in what is unfinished. In this way, the opening up of the question is no longer wholly self-involved

and self-revealing. A trauma is unleashed, but Richter's virtue is that he does not dissolve into its abyss, nor does he attempt to smooth it over or encapsulate it. He remains, like Ensslin, blind to what will greet him in the aftermath of this episode, but nonetheless he remains willing to respond.

The question is, though, how far does willingness extend if not accompanied by the aesthetic-critical redemption of mastery?

Ensslin's image could be said to be a portrait of interruption. What kind of response is urged when it is elicited by an interruption? What is it that is being interrupted? And to what does one return after the interruption? Walter Benjamin once wrote that the photograph is "the corpse of an experience." Eduardo Cadava, extrapolating from Benjamin, suggests that "history happens when something becomes present in passing away, when something lives in its death. 'Living means leaving traces.' History happens with photography. After life" (128). Ensslin reappears like a haunting ghost from the past. She summons as much as she has been summoned herself, even though Richter fails to respond to her particular messianic appeal. For the painter, this is not a criminality to be redeemed, nor a criminality that is justified by some greater vantage point in history, which is idyllic, a nodal point tying every struggle together and absolving all violence and every death. If this is a portrait of interruption, then it is interruption as an incision and this is the difference in picturing these particular deaths that Richter so earnestly wishes to conjure and to effect. It is not mere voyeurism, not a spectacle of death, but of being exposed; exposed by an affinity for Ensslin and Meinhof despite everything, and of being captivated by the representation of ghost figures that nonetheless remain incongruously contiguous. The image is not one of disappearance or of fading, not of a trauma solved and dissolved by the artist. It is an incision, hardly on the level of, as Richter puts it, any natural accord, nor anything that reveals the sphere of a higher, richer, cleverer nature, but an incision, not a devouring trauma, not a trauma to be dispensed with like garbage. As an incision, it incises Richter too. The dead don't speak; they cannot be represented. Richter would like to span this chasm, to put things to rest, but he cannot.

How, do we remain open to what we cannot know and cannot adequately grasp? How does one grasp anything beyond the grip of events in which we are grasped? Richter does not want to repeat himself; he wants

to produce something exemplary. He would seek to evoke the memory of this exemplary spirit in the wake of his own success, in which he has become a legacy himself. Richter returns to a traumatic episode to rehearse fears of being consumed and to uncover an exemplary memory that lingers like a ghost. If such memories were to be dispatched as he first hinted they could be, then they would simply be eradicated, so the artist desires rather to conjure exemplary memory, by means of formulations and responses that will not be readily disposed of but instead linger in an ambiguous, seemingly irresolute state. "What I'm attempting in each picture," he informs Buchloh, "is nothing other than this: to bring together, in a living and viable way, the most different and most contradictory elements in the greatest possible freedom. Not paradise" (Buchloh, "Interview" 29). This is perhaps as good a statement as one can make about contemporary aesthetic possibilities. Yet it is still fraught: the appeal to "the greatest possible freedom" often spells the kind of self-assertion that has little compunction in overriding "the most different and most contradictory elements."

Politically Richter does not identify with the Baader-Meinhof group at all, but there is the specter of their hope. Utopianism may be criminal, as Richter continually remarks, but it haunts his practice, which articulates its possibilities amidst the wreckage of avant-garde utopian formulations. Art may not dispatch "complexes"; although today it remains alive to that task of recalling—that is, resisting the urge to dispose of everything like garbage—only by recalling that its sovereignty is impinged. As a portrait by proxy, Richter's identification with Ensslin (and with Meinhof) lies elsewhere than with political identification. He admits, "I never had the feeling that I was a modern artist" (qtd. in Storr, "The Day Is Long" 71). So he practices as a modern artist by confronting certain "emergencies"— either technical or conceptual—that are then raised to aesthetic significance. These emergencies are dealt with by means of an assault at the level of the image: "The blurring is always a kind of emergency butchering" (qtd. in Storr, "The Day Is Long" 73). Through such violent butchering, Richter is able to forge a career as a modern artist, even while not quite feeling like one, because he achieves an aesthetic vitality in mistakes and errors as well as by means of a certain anachronistic disposition. Yet the incising portrait of Ensslin that reappears in his RAF series suggests that the commemorative function of art has changed; Richter identifies with a certain level of violence that operates across the surface of paintings and imagery, and these acts made for his career. In short, and to recall an earlier point, Richter seeks to preserve some of the frameworks of vanguard

action for art; this is the source of his identification with the RAF, even though, like the Russian avant-garde, it is meant to be contained as an aesthetic challenge. Thus, he would like to wrap this challenge up in a "genuine" (that is, a well recognized) aesthetic appeal. But what is exemplary in representing these images of death and terrorism is not exactly what the artist sometimes declares it to be.

Richter would like to wrap his work up in a circuit of fulfillment and of accomplishment despite the odds, to be ahead of the game. Richter opens up old wounds, but he cannot dispatch this complex without annihilating the very thing that was not dispatched, the hope that things could be otherwise, sometimes even better. Optative residues remain, in the visage of Ensslin, recruited once more to recall other possibilities. It mounts to a blurred portrait, not "simply a case of imprecision," as Gertrud Koch remarks of the blur in general, but the "capture of a sliding glance" (Koch 136). The exemplary move is perhaps to forge something between "the most different and most contradictory elements," and thus in the case of these images of dead terrorists—who we are not asked to identify with—another encounter is fashioned within another limbo realm the "in-between" space, as Richter describes it, of "art and documentation" (qtd. in Magnani 97).

Richter's blurring across this in-between realm produces a rather uncanny resolve: it allows him to treat the most poignant of subject matter (death, decay, and mourning) as well as the richest of aesthetic material (portraiture, figuration, the sublime, and the abstract) as if they are stretched wafer thin. Blurring amounts to a scrapping and obscuring, a pressure applied to dissolve the solidity of the surface form, so that its tension derives from its capacity to wear thin to the degree that it appears contrived and schematic as any bearer of illumination or of serious discourse. There is something of a cliché here, as though the film surface of the photograph traverses the paintings and spreads everything thin. Richter risks this enfeeblement in order to continue being serious as a painter. The arts, however, lack a firm vocabulary for such moves, except for an exemplary domination and a circuit of fulfillment.

The thinness of the cliché is telling: there are clichés about salvation, art, and the vanguard that have become frail in their overestimation of history as a continuously unfolding success story (which, despite our cynicism or heightened suspicion, still feature endlessly in the most likely and unlikely of quarters). Yet the cliché also signals the assault of the seized moment, the image of the historical snapshot. It constitutes a snapshot

cliché in the sense of a slice or cut, somewhat focused and yet indiscriminate as to where it picks up its focus. It spells an extraordinary thinness because the risk is stark in grasping what position to adhere to when seized unexpectedly.

The emergency move, in turn, is the apt mistake, the active confrontation without adequate knowledge, the exemplary interruption. An emergency butchering testifies to what makes retrieval possible, within highly choreographed steps, and always at the risk of blurred memory. One makes a future possible by dealing with the impingement of memory, which urges both responsibility for a legacy and an awareness that it often threatens to engulf us. To keep complexity alive, effortlessly, requires endurance, even to prosper without forgetting, which requires attentiveness to what becomes available within the garbage heap of our memorial complexes, so as to make it happen as if it had never happened before.

So what does the portrait of Ensslin testify to? Is it a look into a future for which this call has not yet received its response—an infinite call to a future that is as yet unknown, because it remains as yet without injustice and suffering? The brief respite of recognition is now captured for all to see, but for who knows what purpose other than to respond to this arrested gesture: Remember me. Remember me for I failed. Remember me for this failure. My hope may well reside in this failure.

NOTES

1. On these themes, see Jean-Michel Rabaté, *The Ghosts of Modernity* 1996.

2. With the development of the cerebral cortex, new, highly sophisticated reflexes emerge. For example, background noise, once established as nonthreatening or unimportant, is monitored unconsciously until there is an additional, new sound. It is then that the brain decides to arouse one's awareness, so that this new component can be consciously evaluated. Thus, the humming of air-conditioning fades out of one's awareness until it is interrupted by, say, rattling or squeaking. In effect, the brain filters what a person might need to be aware of and what not.

3. Cited in Becker, *Hitler's Children* 70. Becker is summing up the assessment of a court psychiatrist, Dr. Reinhard Redhardt, appointed for the Frankfurt arson trial of 1968: Ensslin, according to him, was "capable of hating in a very elementary fashion." She would also "involve herself with her neighbours against their will, and so put into practice those ideas which she had learned, in the last analysis, at home in her parsonage."

Becker's heavy editorializing tone in her account of the RAF manages to replicate the very thing she cannot abide in the RAF: their capacity to see everything in resolute oppositions that guarantee the virtue of one's position automatically and in advance. While politically, Richter might sympathize with the reasons for this, his

ambivalence toward these events is far more intriguing because it is this attempted suspension of certainty that compels his fascination (as I hope to show).

4. To give some indication of such scenes, on April 28, 1977, the verdict at the Stammheim trial of Andreas Baader, Gudrun Ensslin, and Jan-Carl Raspe was delivered. They were each sentenced to "three times life," plus fifteen years. Those listed as in attendance that day were 178 members of the public, 49 journalists, 5 state-appointed lawyers for the defense and 3 state prosecutors. Becker, *Hitler's Children* 227.

5. Richter chose these three images of Ensslin from among five photographs. The first more or less merges the first two photos, and the last is excluded altogether. Apart from showing the figure moving in the opposite direction (presumably after the line-up), this omitted photo shows a far more guarded, even wary Ensslin with her head drawn back and chin raised to the assorted gathering that witnesses her parading. Compared to Richter's paintings, Ruch's photographs delineate both the figure and the passage more distinctly. Richter also crops the image to center around Ensslin's upper torso and face. Storr makes the observation that "the three canvases suggest a first meeting with someone we have heard about but never seen close up before, but what Richter has really staged is her parting," See Storr, *Gerhard Richter: October 18, 1977 (18. Oktober 1977)* 107. Though this suggestion is intriguing—and I have no difficulty with it, except to say that given that this is an "engagement," no matter how fleeting and unprovoked—I would suggest that the austere complexity of this sequence relates to the fact that the parting is never fully departed. We are dealing with returns and engagements that are unexpected, sometimes unwarranted, often unwelcome. In short, the artist never fully parts with this episode.

6. "The deaths of the terrorists, and the related events both before and after, stand for a horror that distressed me and has haunted me as unfinished business ever since, despite all my efforts to suppress it." Richter, *The Daily Practice of Painting* 173.

7. For all these details, see Gregorio Magnani, "Gerhard Richter" (interview) 97.

8. Richter, *The Daily Practice of Painting* 170–71; S. Rainbird and J. Severne, eds., *Gerhard Richter* 120.

> *3 January 1988:* Art is the pure realization of religiosity, of the ability to believe, longing for "God."
>
> All other realizations of this most considerable quality of man are an abuse to the extent that they exploit this quality, in other words make it serve an ideology. . . .
>
> The ability to believe is our most considerable quality, and it is only appropriately realized through art. If, on the other hand, we use an ideology to quench our need for belief, we can only do damage.
>
> *13 January 1988:* Art is wretched, cynical, stupid, bewildered—a mirror of our spiritual poverty, our abandonment, loss. We have lost the grand ideas, the utopias, any sense of faith, everything that endows meaning.
>
> Incapable of faith, hopeless to the utmost degree, we are wandering around a poisonous rubbish tip, extremely endangered.

9. See Richter's comments in Benjamin H. D. Buchloh, "Interview with Gerhard Richter," *Gerhard Richter: Paintings* 25. He states that he wants to produce a picture "that represents our situation more accurately, more truthfully; that has something

anticipatory; something also that can be understood as a proposal, yet more than that; not didactic, not logical, but very free, and effortless in its appearance, despite all the complexity."

10. See, in this regard, Derrida's comments: "When one repeats a traumatism, Freud teaches us, one is trying to get control of it—it repeats it as such, without letting itself be annihilated by the traumatism, while keeping speech 'alive,' without forgetting the traumatism totally and without letting itself be totally annihilated by it. It is between these two perils that the philosophical experience advances." Jacques Derrida, "Passages—from Traumatism to Promise" 382.

11. "I could not find it in my heart to condemn the State for its harsh response. That is what States are like; and I had known other more ruthless ones." Richter, *The Daily Practice of Painting* 173. Again Richter differs from Buchloh here. Richter writes that he doesn't know "whether the pictures 'ask' anything." (Richter, *The Daily Practice of Painting* 175). There is certainly no explicit adherence to the left conspiracy theory that the members of the RAF were *murdered* in Stammheim Prison, which Benjamin Buchloh asserts very directly and in a rather matter-of-fact fashion. See Benjamin Buchloh, "A Note on Gerhard Richter's *October 18, 1977*" 89.

12. "People cannot be interesting insofar as they endure their work, with or without all their other troubles. How can that raise them up if the spirit of revolt is not uppermost within them? Besides, at such moments you see them and they don't see you. How I loathe the servitude people try to hold up to me as being so valuable. I pity the man who is condemned to it, who cannot generally escape it, but it is not the burden of his labour that disposes me in his favour, it is—it can only be—the vigour of his protest against it."

"For myself, I admit such steps are everything. Where do they lead, that is the real question. Ultimately, they all indicate a road, and on this road, who knows if we will not find the means of unfettering or of helping those unable to follow it to unfetter themselves? It is only then that we may loiter a little, though without turning back." Breton, *Nadja* 68, 69.

13. Richter tends to isolate the madness of belief to religious and political ideologies: "I know it is part of us to build a world of ideas. I grew up with Nazi ideology and then, overnight, we had Marxism. For years Marxism told us that the capitalist system was about to collapse. . . . Still, when I had to read Marxist political and economic theory, I could really see their power. They were not simple, but they made everything so clear, you could actually see the future as a logical development of the present," ibid., 95. Storr argues that Richter judges ideology unacceptable "because it is, in its overcompensation for uncertainty, all too human," Storr, *Gerhard Richter: October 18, 1977*, 98. This is no doubt accurate, but is a commitment to art, such as Richter's, beyond belief and ideology?

14. Raymond Williams, "The Politics of the Avant-Garde" 14. Williams continues: "For the sovereign individual is offered as the dominant political and cultural form, even in a world more evidently controlled by concentrated economic and military power. That it can be offered as such a form, in such conditions, depends partly on that emphasis which was once, within settled empires and conservative institutions, so challenging and so marginal."

15. Stefan Aust, *The Baader-Meinhof Group* 272–73. Dutschke knew Raspe from

the Berlin student movement, but clearly didn't share the belief in terrorism. He died, however, not long after Raspe, from the side-effects of an assassination attempt in 1968.

WORKS CITED

Aust, Stefan. *The Baader-Meinhof Group: The Inside Story of a Phenomenon,* trans. Anthea Bell. London: Hodley Head, 1987.

Becker, Jillian. *Hitler's Children: The Story of the Baader-Meinhof Terrorist Gang.* London: Pickwick Books, 1989.

Breton, André. *Nadja.* 1928. Trans. Richard Howard. London: Penguin, 1999.

Buchloh, Benjamin H. D. "A Note on Gerhard Richter's *October 18, 1977.*" *October* 48 (Spring 1989): 88–109.

———. "Interview with Gerhard Richter." *Gerhard Richter: Paintings.* Trans. Stephen P. Duffy. Ed. Terry A. Neff. New York: Thames & Hudson, 1988.

Cadava, Eduardo. *Words of Light: Theses on the Photography of History.* New Jersey: Princeton University Press, 1997.

Crow, Thomas. *The Rise of the Sixties: American and European Art in the Era of Dissent.* New York: Harry N. Abrams, 1996.

Derrida, Jacques. "Passages—from Traumatism to Promise." *Points: Interviews, 1974–1994.* Ed. Elisabeth Weber. Stanford, Calif.: Stanford University Press, 1995. 372–95.

Foster, Hal. *The Return of the Real: The Avant-Garde at the End of the Century.* Cambridge, Mass.: October Books/ MIT Press, 1996.

Groys, Boris. "On the Ethics of the Avant-Garde." *Art in America,* May 1993.

Koch, Gertrud. "The Richter-Scale of Blur," *October* 62 (Fall 1992): 133–42.

Magnani, Gregorio. "Gerhard Richter" (interview). *Flash Art* (May/June 1989): 94–97.

Mann, Paul. *The Theory-Death of the Avant-Garde.* Bloomington: Indiana University Press, 1991.

Rabaté, Jean-Michel. *The Ghosts of Modernity,* Gainesville: University of Florida, 1996.

Rainbird, S., and J. Severne, eds. *Gerhard Richter.* London: Tate Gallery, 1991.

Richter, Gerhard. *The Daily Practice of Painting: Writings and Interviews 1962–1993.* Trans. David Britt. Ed. Hans-Ulrich Obrist. London: Thames and Hudson, 1995.

Storr, Robert. *Gerhard Richter: October 18, 1977 (18. Oktober 1997),* New York: Museum of Modern Art, 2000.

Storr, Robert. "Gerhard Richter: The Day Is Long" (interview), *Art in America* (January 2002): 67–74, 121.

Williams, Raymond. "The Politics of the Avant-Garde." *Visions and Blueprints.* Ed. E. Timms and P. Collier. Manchester: Manchester University Press, 1988.

You Can't Keep a Dead Woman Down

The Female Corpse and Textual Disruption
in Contemporary Hollywood

DEBORAH JERMYN

You see we so-called creative artists have a great respect for cadavers. We treat them with the utmost reverence. We put them in soft beds, lay them out on fur rugs, leave them lying at the foot of a long staircase.

—Humphrey Bogart as Hollywood screenwriter Dixon Steele, *In a Lonely Place*
(United States, Nick Ray, 1950)

Bogart's words may have been astute back in 1950 but they seem far removed from contemporary cinema and its grim fascination with the dead body. This essay looks specifically at representations of the female murder victim in contemporary Hollywood, a subject I have been drawn to in the context of a number of interests, which I should briefly point to. First, the films and images I consider here must be situated within the context of a mainstream cinema that has become increasingly explicit in its representations of the murder victim and the work of forensics, a process that has led to ever more grisly images becoming ever more commonplace. Second, for feminist film criticism, images specifically of violence against women provide contradictory and problematic material. Are they evidence of the misogyny of a mainstream cinema that revels in the subjugation of women? Or are they graphic and honest depictions of the reality of violence against women? Finally, I must situate this interest in the context of my own responses to the films I discuss here, responses that again point to the contradictory nature of these texts, particularly for a female audience. While I found them disturbing, I also found them enjoyable, something that led me to a certain amount of confusion, even self-recrimination;

though I do not mean to suggest that the only textual pleasures for femi-
nists lie in feminist readings, nevertheless as a feminist, is it "wrong" to
enjoy a film that lingers over images of women's violated bodies? Is it pos-
sible to reconcile the two? This essay will demonstrate that the films dis-
cussed here do indeed offer the opportunity for such a reconciliation,
since the female corpse becomes such a disruptive presence in the text that
any accusations of mere salaciousness are made redundant.

From Shakespeare's Ophelia to Edgar Allan Poe,[1] the history of West-
ern culture's fascination with death and femininity is a long one, but
recent cinematic manifestations undo the once-popular vision of beauti-
ful repose. The sight of the female murder victim's body has become one
of cinema's most disturbing figures, with a resonance arguably not shared
by the male victim.[2] In Julia Kristeva's terms one might say she is doubly
abject, not just a woman but a dead woman. Kristeva uses the term abject
to describe those things that threaten society's established boundaries (but
that are nevertheless fascinating), particularly our fears of disorder, decay,
and the female body. The female corpse, then, brings together two strands
of the abject—femininity and mortality. In another sense, her power to
disturb lies in the ever-present threat of sexual motive or violence that
haunts the female murder victim's body. She is also resonant as an image
that seems to stand, at a wider level, for the misogyny of our culture, a cul-
ture where women seem to be routinely made to feel threatened, vulnera-
ble, or victimized in some way. As Elizabeth Young has said of the act
of serial murder of women, "Its very repeatability suggests that there is no
end to misogynist murder, but rather an endless stream of such crimes
spilling not only from film to film but beyond the borders of all film, to
the non-film 'real world' itself"(5–6). The female murder victim's corpse,
then, comes to testify for the ultimate violent act against women in our
culture, she resonates as the final outcome of everyday misogyny.

In many ways the female corpses I am looking at here are the descen-
dants of the "female foil" from the film noirs and women's films of clas-
sical Hollywood. Like the dead (or presumed dead) women who haunt
such films as *Rebecca* (United States, Alfred Hitchcock, 1940), *Phantom
Lady* (United States, Robert Siodmak, 1944), *Laura* (United States, Otto
Preminger, 1944) and *Gaslight* (United States, George Cukor, 1944), the
female corpse in these recent films perpetuates the Gothic traditions of
a woman who figures as an uncanny absence/presence. Similarly, my
approach can be seen as an extension of feminist analysis of these genres,
work that sought to explore their ruptured repression of the absent woman,

the multiperspectivity and, by extension, the polysemy of popular cinema.[3]
Clearly what has changed, and the implications of which I wish to explore,
is that the inflection of the female murder victim in contemporary cinema
is much more explicit; the absent woman here is no longer resonant
through anecdotes and artifacts (portraits, possessions) but through recur-
rent, often graphic, returns to her body and the forensic details of her
demise. The shift toward greater explicitness surrounding the corpse,
generally, was of course made possible by the relaxation of censorship
that accompanied the demise of the classical era, so that by the time of,
for example, *Frenzy* (Great Britain, Alfred Hitchcock, 1960) there is a
far more graphic representation of the dead body. As Pam Cook notes,
"One of the characteristics that quite clearly differentiates post-classical
from classical cinema is the move towards greater visibility of sex and vio-
lence" (230). But we must also acknowledge the impact of changes in gen-
der roles and relations in the latter half of the twentieth century as crucial
here; shifts in the representations of the female corpse, and women gener-
ally, cannot be removed from the wider context of the growth of feminism
and the backlash(es) against it.

I want to focus on Hollywood and three films here—*Reversal of Fortune*
(United States, Barbet Schroeder, 1990), *The Silence of the Lambs* (United
States, Jonathan Demme, 1991) and *Copycat* (United States, John Amiel,
1995), all of which were popular, mainstream successes and share the trope
of the female murder victim (or more precisely in *Reversal of Fortune,* an
attempted murder victim).[4] Though the serial killer narratives and female
detectives of *The Silence of the Lambs* and *Copycat* mean they invite obvi-
ous comparisons on a number of levels and share a far more conspicuous
similarity to each other than to *Reversal of Fortune,* all three are linked
by the way the body is returned to, photographed, scrutinized, invaded.
The first and most obvious reaction to such an impulse, which explores
the explicit, disturbing details of violated women, might be to accuse
the filmmakers of misogyny. What we are offered by these films is surely a
disturbing four-way process of dissection and invasion, first by her killer,
second by the authorities, third by the camera, and finally by us, the
audience. Indeed Giuliana Bruno has argued that there is a link between
the development of film and the concurrent development of forensics to
be found in the camera's "dissecting quality," a drive that suggests that
"cinema's analytic genealogically descends, in a way, from a distinct ana-
tomic fascination for the woman's body" (243). To explore this "interaction
of scientific and filmic language" (248) she considers a range of formative

influences in early cinema and their spectacular fascination with the body, including the "anatomy lesson" performances of Menotti Cattaneo in Naples at the start of the century[5] and the short film experiments of Georges Melies and Eadweard Muybridge, concluding that, "'analytic' desire is present in the very language of film. It is inscribed in the semiotic construction of film, its decoupage (as the word connotes, a "dissection" of narration in shots and sequences), its techniques of framing and its process of editing literally called "cutting," a process of (de)construction of bodies in space" (241). The fascination with the corpse here also recalls Foucault's analysis of surveillance and the body and in particular his exam-ination of cultural shifts at the end of the eighteenth century, a period that saw the decline of public torture and its preoccupation with decimating the body. Foucault charted the "decline of the spectacle" of punishment, an analysis that invites provoking questions in the light of these texts' re-current contemplation of the abused body; do these films and their like demonstrate a rejuvenation of fascination with these processes or rather the enduring nature of what Foucault would characterize as a kind of pre-nineteenth-century imagination? (7–16).

In this essay, however, I want to argue that despite its beginnings in this sphere of victimization and vulnerability, the site/sight of the female victim's body can become a troubling and disruptive presence in the text via a number of different mechanisms that I will explore here. Rather than remaining at the level of absence or being merely the ultimate passive female, the female victim's corpse paradoxically can become a powerful figure, by creating an uncomfortable and critical *subtext,* which under-mines or suggests different concerns to that of the *dominant* text, terms I use to suggest a tension between the apparently peripheral (subtext) and the principal narrative concerns (dominant text). Similarly Elizabeth Bronfen, in her study of representations of the female corpse in art and literature since the eighteenth century argues, "Femininity and death cause a disorder to stability, mark moments of ambivalence, disruption or duplic-ity" (xii). She goes on to argue that, "The threat that death and feminin-ity pose is recuperated by representation, staging absence as a form of re-presence." Ultimately however this attempt at regaining order cannot work: "The recuperation is imperfect, the regained stability not safe, the urge for order inhabited by a fascination with disruption and split" (xii). This description perfectly mirrors Kristeva's description of the abject; that whilst the abject must be seen to be defeated, this defeat is illusory since, once experienced, the attraction it poses lingers on, ready to reemerge.

Rather than merely evidencing objectification or victimization, then, the constant return to images of the victim means she is not merely elided. Instead she freezes the narrative momentarily, in a kind of gross parody of the spectacle usually offered by women in film. The existence of this ambivalence and the diversity it implies foster the sense that "popular cinema is more ideologically open and processes of identification more fluid than has previously been imagined" (Cook 234). The female murder victim, though voiceless and inanimate, can refuse to remain absent. The gap she typically represents in the dominant text—the mystery of her demise, the point of view that can never be shared—is ruptured and undermined by the subtext she creates. Like the madwoman in the attic[6] she is another story trying to be told, lingering, should we look there, beneath the surface of the dominant text.

Reversal of Fortune

Reversal of Fortune is an account of the true life story of the fabulously wealthy Sunny von Bulow, who in 1981 went into a coma from which she never awoke. It was later alleged that this coma was the result of an attempt on her life carried out by her husband Claus von Bulow, who had allegedly administered insulin to her. While Sunny is not literally a corpse, then, her inanimate body laid out on the bed for inspection and the recurrent return to it parallels the vision of the corpse seen in the other texts here, while her hospital room mimics the environment of the morgue or funeral home. The film received considerable acclaim, most notably perhaps in Jeremy Irons's Oscar for Best Actor. Already this points to how this is Claus von Bulow's story—it is overwhelmingly constructed not as the story of Sunny's life and the alleged attempt on it, but as her husband's fight for justice in clearing his name. Admittedly the film is based on the book written by Claus von Bulow's defence lawyer Alan Dershowitz; to ask the film to tell Sunny's story is perhaps beyond the scope of these origins. However I want to argue that despite the dominant text's marginalization of Sunny, her story is nevertheless there, making itself felt, in curious and perplexing fashion, in the intermittent voiceover of a comatose woman.

How can a woman lying in a coma narrate an account of the attempt on her life? There are precedents for such a device of course, most notably Joe Gillis (William Holden) in *Sunset Boulevard* (United States, Billy Wilder, 1950) who narrates the film despite his dead body being found in

a swimming pool in the opening sequence. More recently *American Beauty*
(United States, Sam Mendes 1999) also endows Lester Burnham (Kevin
Spacey) with a posthumous voiceover. The key difference between these
narrations is that Gillis and Burnham's voiceovers are marked as domi-
nant and masterful whereas Sunny's is transgressive. This contradiction,
the comatose yet vocal woman, creates a parallel but critical subtext that
develops alongside the dominant concerns of the film. Sunny's voice-
over is a conundrum the text does not explicitly deal with. Instead she is
bestowed with almost mystical qualities, an omnipotent and sage narrator.
As the film develops she comments on the events surrounding her inani-
mate body and disturbed family with a sense of serenity and perceptive-
ness that is very much at odds with the paranoid and hysterical depiction
of her appearing in her husband's flashbacks. In the opening scenes of
the film we move from sweeping aerial shots of the grounds and mansion
where she lived to the hospital where she now lies. A camera roams down
corridors like an unseen intruder. As we approach her hospital room, the
door magically swings open for us as if by its own accord. We enter and
see a still room bathed in an ethereal blue light till finally we turn and
see the body of Sunny von Bulow. The first dialogue in the film is hers as
she comments wryly in the voice over, "This was my body."

Why the past tense? Where is Sunny now? Her voiceover is in no way
limited to the events of her life. Indeed she is a sphinxlike creature, whose
knowledge seems limitless, yet tantalizingly she never reveals what actually
happened to her. After initiating a flashback of the day she went into her
coma she cues the change of scene to the legal wrangles that followed, say-
ing "Enter Robert Brillhoffer, former Manhattan D.A." Therefore she has
access to knowledge, scenes, and events that she could not possibly have
had access to in her life. Not only can her voiceover initiate the change
of scene, she also seems to be present and watching scenes where she
lies comatose, apparently oblivious to what is going on around her, and
indeed scenes where she is entirely absent. For example, at one point her
daughter is seen sitting at her bedside as Sunny's voiceover says critically
"It's easy to forget all this is about me, lying here." She then commands
us, "Look at Cosima," thus very much situating her voiceover in the here
and now of the image. She has become a kind of free-roaming spirit able
to watch the bedroom of her apartment and look at Claus lying there with
his new lover. When we cut to the empty bed where her body was found,
we discover she is still fully sentient when she visits these scenes, as she
says, "It all looks the same, feels the same, smells the same. If you could

just go back in time and take a peek you'd know." She can even instigate her own flashbacks, such as her account of first meeting and falling in love with Claus, which show her as an elegant and desirable woman (quite at odds with his vision of her) in a series of romantic images that *his* recollections never imply.[7] Despite her victimization in, and relegation to, the body of a comatose woman, then, Sunny undoes the restraints of this role. We might say that, despite the film's concern with Claus and his lawyer's efforts to overturn the guilty verdict and the apparent preoccupation with this as the subject of the film, it is *Sunny* who controls the narrative. She unfolds or withholds events and the shifts in setting. She decides that, as she puts it in her final voiceover, "This is all you can know, all you can be told."

Claus's flashbacks typically show her as shrill and dependent, lying in bed whimpering, smoking too much, drug addicted, paranoid, weak, irritable. By contrast the Sunny who speaks in voiceover is confident, philosophical, shrewd, an assertive and calm presence. Thus while the bulk of the text undermines her, constantly suggests her instability, and shows Claus as a slave to her whims, her voiceover, in conflict with that account, gives her a more powerful voice. The obvious concerns of the film are the legal system and the question of Claus's guilt or innocence. But by extension, this concern creates a depiction of Sunny von Bulow as a paranoid and unstable woman—the film must suggest that she was indeed capable of overdosing on insulin *herself* in order to create the dramatic tension and ambiguity surrounding Claus. But her voiceover casts doubts on this representation of her as hysterical woman.[8]

Given the complex relationship between women and language looked at by feminist critics such as Luce Irigaray this film throws up intriguing possibilities. According to Irigaray, women are excluded from and disempowered by language since it is mediated by men. The female murder victim's corpse is the ultimate symbol of this female voicelessness—but in these films this voicelessness is problematized. Bronfen has argued, "Death and femininity are excessively tropic; they point to a reality beyond and indeed disruptive of all systems of language" (xii). *Reversal of Fortune* is the most explicit example from the films I am looking at of the victim being given a voice, in that it very literally enables her to speak despite her comatose state, a voice that creates a discourse that lies in conflict with the dominant male discourse. But in all these films we might say that despite their voiceless status, on a symbolic level at least and in a different kind of language to that of conventional speech, the victim speaks. She speaks,

in that if she is listened to, the female corpse is a source of knowledge, she can enlighten, she can be learned from. She can tell us things about herself, but also about those around her. To explore this I want to draw here on John Hartley's concept of "forensic analysis."

Forensic Analysis

In *The Politics of Pictures* Hartley considers the status of pictures as "aesthetic, textual works, capable of personal appreciation and individual interpretation, but at the same time. . . . Institutionally produced, circulated within an economy and used both socially and culturally, . . . pictures are neither scientific data nor historical documents, but they are literally, *forensic evidence*" (28–29, italics mine). Hartley borrows from the approach of forensic science, which is to search for truth based on clues, to turn objects into subjects, to transform the facts of physics and chemistry into the language of discourse and argument, and argues that such an approach can be used to understand or listen to photos. In forensic analysis objects are "caused to talk as mute witnesses, . . . coaxed into telling a story" (30). In much the same way, photos can speak to us. This concept of forensic analysis seems particularly useful here when we are, after all, considering the representation of the female corpse, the very subject of "real" forensic analysis. But Hartley's context, the place where he puts forensic analysis to work (in other words, the interrogation of pictures) is also highly apposite here, since the circulation and dissemination of pictures of the female victim is one of the most recurrent and central motifs of films where such a corpse features. Our fascination with photographic evidence of the corpse and the increasing prominence of this as a characteristic trope in the detective or crime genre reminds one of Sontag's words: "All photographs are *memento mori*. To take a photograph is to participate in another person's (or thing's) mortality, vulnerability, mutability" (15).

Furthermore, as Hartley notes, all pictures are "talking pictures" (28). In *The Silence of the Lambs* and *Copycat,* to be able to "read" or listen to such photos is a highly sought after skill. They are material evidence, they point to the psychology of the killer. If one can read his work, then perhaps one can read his mind. But in these films, photos of the female corpse signify more than the handiwork of the killer. Again they are part of a critical subtext around the victim that is on the fringes of the dominant text and its overriding drive to catch the killer. To look at such photos is inscribed in the texts as a test, a test for the investigator *and* a test for the

audience. Can they and we face these disturbing images? In both *The Silence of the Lambs* and *Copycat,* the central investigators are women, the FBI agent Clarice Starling in the former and Detective M. J. Monahan and criminal psychologist Dr. Helen Hudson in the latter. Of course this meeting of women as investigators and victim sets up a fascinating dynamic. They are not just looking at bodies, but bodies of other women. For them part of the "test" of looking at the photos and the actual corpse itself is to deal with looking at their own like. This is not to say that the male, too, is not capable of seeing himself in the victim's place, but it is a boundary that, with their recurrent use of close-ups, pauses, and reaction shots, the films present in a much more dramatically loaded way than is typically the case when a male investigator looks at the corpse of a male victim. As Judith Halberstam notes of the autopsy sequence in *The Silence of the Lambs,* "The corpse laid out on the table, of course, is a double for Starling, the image of what she might have become had she not left home" (42).

Copycat

A short sequence from *Copycat* very powerfully demonstrates the disturbing resonances that such photos can hold in these texts. In this sequence both Helen Hudson and M. J. Monahan examine photos from the crime scenes of a serial killer on the loose, a man whose method is to recreate the crime scenes of the twentieth century's "greatest" serial killers. Monahan has approached Hudson in the hope of enlisting her help to catch the killer; Hudson had once been a leading authority on serial killers, a "pop serialkillerologist" (Hoberman 67), but after being stalked and almost killed by a serial killer herself in a particularly vicious opening scene, she has become agoraphobic and retreated from academic and public life. In this sequence she reluctantly begins to examine the scene-of-crime photos that Monahan has left for her. A montage of explicit images of partially clothed women who have been viciously murdered follows, intercut with close-ups of Hudson's perplexed face and crosscutting with images of Monahan in her office, also looking at the same pictures.

Copycat is a film that foregrounds the use and manipulation of images in the age of the Internet, a film that offers a vision of the contemporary murderer as "semiotically informed bricoleur" (Tietchen 99), and indeed it was often referenced in reviews as a kind of postmodern *Silence of the Lambs.*[9] It is also a film that, no doubt largely because of this manipulation,

met with a distinctly divided critical response over its feminist credentials. Whereas Lizzie Franke felt able to call it "an instant post-feminist classic" (51–52), elsewhere it was described as having "a great deal of women-stalking cliches" (Malcolm 8) and as being "nastily done, masquerading as a feminist statement" (Walker 26). These responses point again to the contradictions these films pose for a feminist reading; are the images here merely prurient or might one find a critical subtext among them?

The sequence referred to above is a particularly fascinating one for a number of reasons. It stands out in the text as a peculiarly suspended moment. It does not seem to flow particularly naturally or usefully within the development of events or the aesthetic of the bulk of the film. Our entry into the scene has a kind of jarring effect; it is not a classically seamless shift, which is the aesthetic that the film adopts elsewhere. There is an overt signalling of a new sequence. We go from a bright, daytime kitchen to a close-up of a CD player starting. This allows for the use of the sequence's distinctive diegetic music, a classical choral piece that bridges the cuts, the use of such music here is arguably one of the most disturbing features of the sequence. J. Hoberman in his review of the film, for example, seems distinctly perplexed when he notes that the film "gooses a succession of lurid colour corpse photos with a pseudo-religious chorale." This sequence, then, points to the significance of *aural pleasure* in film (a notion Laura Mulvey might usefully have explored), a pleasure that is all the more striking here in its juxtaposition with the subversion of visual pleasure. As the scene begins, Hudson walks into her living room taking her seat as if taking her place on stage. She is alone, contemplative, somber. It is now dark, the lighting is low-key, all amounting to a very clearly demarcated shift from the previous scene.

She sits, pauses, drinks, puts on her glasses before looking at the pictures. Her face is deep in concentration as she looks through a magnifier. We see the image of a horribly blemished face, a woman who has been strangled, enlarged through the magnifier. In a series of three facial close-ups we move from Hudson's face, to the face of the victim, to M.J.'s face, who is also seen looking at pictures of the victims. This crosscutting, then, unites the women; it forges links between them across time and space. The consistent style of the camera work here further underlines this connecting of the women in its repeated use of a slow pan across their faces. Hudson and Moynihan seem to mirror each other, both of them reaching up to touch their temples in a gesture that suggests tension, concentration, and deliberation.

This montage forms a symphony of images, a lyricism enhanced by the music, and its mellow, harmonious tones form a disturbing contrast with the horror of the images. The female body here is fragmented, but in a *corruption* of the expectations that the cinematic fragmentation of an attractive young woman usually entails. Where we see exposed female flesh, it is in the context of bruised and battered corpses. Where we see white panties, it is on the torso of a hideously bludgeoned body. Where we see a close-up of a woman's eyes, it is destabilized by the bloody cuts revealed on her cheek. Another victims's breasts appear momentarily under the magnifier—but as the camera shifts across, it reveals a body grotesquely splayed out on the floor. Hudson reaches out to touch one of the pictures, tracing her finger across a victim's outstretched leg, but there is no warm inviting flesh here, just the cold touch of a glossy picture.

In this sequence, then, the traditions of female spectacle and the fragmentation of the female body are undermined, subverted by their uncomfortable repositioning in the context of blood, violence, and death. Maintaining the traditions of female spectacle, the narrative has been frozen; there is no dialogue, no progression of the story. But to look at the female body here is to feel uncomfortable, to be perplexed, to want to look away. The corpse becomes a disturbing presence, a critical subtext, a commentary on the use of women's images. The form adopted—in other words, the use of dissolves, montage, and classical chorale music—in the context of such content is unsettling. The female victim is not tastefully passed over or elided but virtually glorified. Though I don't wish to revisit the well-trodden ground of Mulvey's "Visual Pleasure" essay at any length, if the image of woman in mainstream film typically connotes "to-be-looked-at-ness" (27), then the image of the female corpse, in the multiple inversions of this structure of looking I have described, connotes "*to-be-looked-away-from-ness.*"

The Silence of the Lambs

Or does she? In fact there is another source of tension at work here, one that could be said to both lend itself to and undermine Mulvey's analysis of the male gaze. As I indicated above, to look at the female corpse is to undergo a kind of necessary ritual, a test of boundaries. This of course suggests that despite, or even because of, their disturbing nature there is a compelling aspect to these images, an urge that would seem to support Mulvey's early view of mainstream cinema as pivoting on a sadistic,

voyeuristic gaze on the female form. The compulsion to look is seen in *The Silence of the Lambs* where Starling is repeatedly confronted with, and handed photos of, victims. When she first stands waiting to meet Jack Crawford, who is leading the hunt for Buffalo Bill, she is alone in his office looking around her. Then her eyes lock onto something, the camera zooms into her face, emphasizing the dramatic revelation that is about to follow—what has she seen? The camera then surveys an array of gruesome pictures of flayed women and newspaper headlines on the wall, moving in closer to scan them. Starling remains cool—she has passed the first test. Later in the asylum, Jack Chilton passes her a picture of the mutilated nurse who tried to help Lecter. However, Elizabeth Young has argued that these scenes constitute a "variety of complicated spectatorial moments" that serve to "complicate the idea of a monolithic cinematic male gaze," thus problematizing any straightforward application one might attempt of Mulvey's concept of popular cinema's sadistic, voyeuristic gaze. Starling is endowed with an "evaluative and critical" gaze that makes her not just object of the gaze herself but also a female spectator upon it (Young 23). Furthermore, the series of confrontations between Starling and images of the victims goes beyond what Young describes; as she travels to the site of a newly discovered corpse, she is handed photos of another victim, Frederica Bimmell, a handful of images that feature her as both skinned corpse and smiling teenager. In the autopsy she is handed polaroids of the victim, and later when she visits Frederica Bimmell's home, Frederica's image is everywhere.

Perhaps the most intriguing photos though are the ones Starling finds when she visits Frederica's room. As she wanders around, her instinct guides her intuitively to the music box, (the trope of the box being a psychoanalytically loaded object). Hidden inside the lid she finds photos of Frederica posing playfully in her underwear. Here is "material evidence" overlooked, undiscovered, by the investigators who had searched this room before her. It is a scene that serves no notable purpose, quiet and contemplative at a time when the film is heading toward dramatic climax. But it gives new subjectivity to Frederica Bimmell. *The Silence of the Lambs* was widely received, in Amy Taubin's words, as "a profoundly feminist movie" (129). Yet the critical work on the film that has popularized such a reading has done so almost entirely in relation to the character of Starling as active hero; what then of the victims? How do they figure in the film's apparently feminist discourse? Any reading of the film that argues for a feminist conception of it must surely consider Clarice's relationships with,

and the representation of, these other women (including Catherine Martin but also, and particularly, Frederica Bimmel), for as David Sundelson notes, "except for Starling herself and Buffalo Bill's victims, women scarcely exist in the film" (16).

Who was this girl Frederica who, like Clarice, apparently lived alone with her father and dreamed of escaping her existence there; what was her life like in this ramshackle home and small town; who took these photos of her? It is Clarice's attempts to reconstruct Frederica's life, to let her things and pictures tell a story, to go on to find Frederica's friend and interview her, that lead Starling to the real home of the real killer whilst the men in the investigation stumble into a false lead. These scenes suggest, however fleetingly, that there is another story here that is never told, that perhaps can never be told, only momentarily engaged with by Starling. Frederica's picture remains one that haunts the text, making her a presence felt and returned to despite her absence, and though her death is solved, she, ultimately, is not. Like Sunny von Bulow, she leaves behind more questions than she answers.

This attempt to personalize or bring subjectivity to the victim in some sense through Starling's "relationship" with her is also felt during the autopsy scene. As the body of the latest victim lies on a slab it is Starling who takes command of the roomful of policemen, chatting and drinking coffee and generally making a show out of the discovery of another corpse, by asking them to leave. Her language here very deliberately and ironically appeals to their sense of chivalrous masculinity—"her folks would thank you if they could for your kindness and sensitivity." But it also transforms, or at least shifts, the objective of the autopsy. It is not merely about Buffalo Bill, about finding out about him through the clues her body could yield; it is about treating her as she deserves to be treated. She tells the men in the room, "There's things we need to do for her. . . . Go on now and let us take care of her." Halberstam argues that in this sequence "the corpse finally becomes object, thing, post-human" (42) and indeed it seems pertinent that Starling's first comment when she turns to face the body is "Bill," as if the marks of his "authorship" on her body have superseded who she was. But her words that precede the examination (and indeed her strangely poignant observation that the corpse is wearing "glitter nail polish") do much to alleviate this sense of indignity and anonymity. As Starling describes it, the examination of the body becomes an act of service, it is about helping the victim, a concept that emphasizes that the victim is a subject and not merely object. *The Silence of the Lambs* highlights

the fear of anonymity surrounding the female murder victim—to die and become a nameless body. Starling's "relationship" with Frederica and the constant return to her photo in life as well as death, seek to undo this anonymity and show Frederica as a woman, a friend, a daughter, and not just a corpse.

Naturally there are other ways of understanding these texts. In particular I have not begun to tackle the place of class, sexuality, or race (and particularly the fusion of whiteness with death) in these representations, all of which would open up other kinds of tensions at work in these films. But I hope that I have demonstrated that to condemn these films on the basis of their perceived violence against women is a negligent and rather cursory reading. Such a reaction neglects the capacity for popular culture to be both complex and contradictory and, in the texts examined here, overlooks the troubling and disruptive resonance of these female murder victims. It fails to acknowledge the implications of this discomfort, a tension that demands we look closely at the complex ways these texts use the figure of the female corpse to play with representation, gender, knowledge, and power. The sense of unease when watching these films that I described at the start of this essay, then, both attests to this complexity and mirrors the tensions that are at work within them. In Bronfen's words, to look at the image of the female corpse and "to attribute only a sadomasochistic vogue, a necrophilic misogyny . . . is a semantic reduction which ignores the multiplicity of themes that are condensed and displaced in this image. . . . [It] means ignoring the instability and indeterminacy so fundamentally inscribed into the narrative and representational process" (60).

NOTES

A shorter version of this paper was originally presented at the 1999 Society for Cinema Studies Conference at Florida Atlantic University. Thanks to friends and colleagues including Will Brooker, Peter Kramer, Mike Hammond, Su Holmes, Nova Matthias, Sean Redmond, and Roberta Pearson for their insights during the writing of this paper.

1. Poe famously asserted, "the death of a beautiful woman is unquestionably, the most poetical topic in the world." (*The Philosophy of Composition,* 1846). Contemporary cinema's fascination with the details of forensics, scene-of-crime photos, and autopsies provide a rather less idealized and more pragmatic approach to this figure, suggesting a shift away from the melancholy and sublime representations of the female corpse in eighteenth- and nineteenth-century art and literature.

2. The continuing fascination with, and unknowability of, the female corpse seems also to stem from their relative absence in war photography. Since the American Civil

War, images of dead men on the battlefield have been in common circulation. The battlefield remains an arena women are still predominantly absent from, the result being that the image of the female corpse somehow retains a greater sense of elusiveness. I am grateful to both Roberta Pearson and Mike Hammond for their comments, respectively, on how images from the American Civil War and the First World War impacted on the cultural ramifications of images of corpses.

3. See, for example, Tania Modleski's account of the murdered wife in Hitchcock's *Rebecca,* in *The Women Who Knew Too Much.* As Modleski notes in her introduction, Hitchcock's films recurrently figure women who exert an influence from beyond the grave, "females whose power is both fascinating and seemingly limitless" (1), and her subsequent analysis, like the approach that I draw on here, "is dedicated to tracing the resistances that disturb the text" (45). In the case of *Rebecca* this involves identifying the many strategies the film takes to evoke Rebecca's presence in the text so that despite her material absence and the text's "brutal devaluation and punishment of her" (53) she ultimately manages to subvert and resist patriarchal containment and closure.

4. Clearly many other films, such as *River's Edge* (United States, Tim Hunter, 1986) and *Short Cuts* (United States, Robert Altman, 1993) from the American independent filmmaking scene and beyond, would lend themselves to similar analysis. While it would be intriguing to open the analysis up beyond mainstream American cinema and undertake the necessary analysis of national and industrial contexts this would demand, such a remit would result in a much larger and longer project than the scope of this essay allows.

5. Cattaneo performed a show where, dressed as a surgeon, he would take apart and then reconstruct a wax model of a human body complete with organs. From this he moved into film exhibition, a smooth transition since "both forms of popular spectacle shared a fantasmatic ground. Their common terrain is a discourse of investigation and the fragmentation of the body." See Bruno, 241.

6. Susan Gilbert and Sandra Gubar, *The Madwoman in the Attic.* Their study of nineteenth-century literature demonstrates how the predominantly absent figure of the madwoman nevertheless impacts on the sensibility of the whole text (see for example, Charlotte Brontë's *Jane Eyre*).

7. There is an ambiguity inscribed here, however; arguably the rose-tinted, soft-focus quality of this sequence connote it as fantasy.

8. For a discussion of the history and implications of the figure of the hysterical woman see Elaine Showalter, *The Female Malady.*

9. Though of course *Silence of the Lambs* was itself understood as a "postmodern horror movie." See Halberstam, 38.

WORKS CITED

Bronfen, Elizabeth. *Over Her Dead Body: Death, Femininity and the Aesthetic.* Manchester: Manchester University Press, 1992.
Bruno, Giuliana. "Spectatorial Embodiments: Anatomies of the Visible and the Female Bodyscape." *Camera Obscura* 28 (1992): 238–61.

Cook, Pam. "No Fixed Address: The Women's Picture from *Outrage* to *Blue Steel.*" Ed. Steve Neale and Murray Smith. *Contemporary Hollywood Cinema*. London: Routledge, 1998. 229–46.

Foucault, Michel. *Discipline and Punish*. London: Penguin, 1991.

Franke, Lizzie. Review of *Copycat*. *Sight and Sound* 5.6 (1996): 51–52.

Gilbert, Sandra M. and Susan Gubar. *The Madwoman in the Attic: the Woman Writer and the Nineteenth-Century Literary Imagination*. New Haven: Yale University Press, 1980.

Halberstam, Judith. "Skinflick: Posthuman Gender in Jonathan Demme's *The Silence of the Lambs.*" *Camera Obscura* 27 (1991): 36–53.

Hoberman, J. Review of *Copycat*. *Village Voice* 7 Nov. 1995: 67.

Hartley, John. *The Politics of Pictures*. London: Routledge, 1992.

Kristeva, Julia. *Powers of Horror*. New York: Columbia University Press, 1982.

Malcolm, Derek. Review of *Copycat*. *The Guardian* 2 May 1996: 8.

Modleski, Tamia. *The Women Who Knew Too Much: Hitchcock and Feminist Theory*. New York: Routledge, 1989.

Mulvey, Laura. "Visual Pleasure and Narrative Cinema." *Screen Reader in Sexuality*. London: Routledge, 1994. 22–33.

Showalter, Elaine. *The Female Malady: Women, Madness, and Culture in England, 1830–1980*. New York: Pantheon, 1986.

Sontag, Susan. *On Photography*. London: Penguin, 1978.

Sundelson, David. "The Demon Therapist and Other Dangers." *Journal of Popular Film and Television* 1.21 (1993): 12–18.

Taubin, Amy. "Grabbing the Knife; *The Silence of the Lambs* and the History of the Serial Killer Movie." Ed. Pam Cook and Philip Dodd. *Women and Film*. London: Scarlet Press, 1994. 123–31.

Tietchen, Todd F. "Samplers and Copycats: The Cultural Implications of the Postmodern Slasher in Contemporary American Film." *Journal of Popular Film and Television* 26.3 (1998): 98–107

Walker, Alexander. Review of *Copycat*. *Evening Standard* 2 May 1996: 26.

Young, Elizabeth. "*The Silence of the Lambs* and the Flaying of Feminist Theory." *Camera Obscura* 27 (1991): 4–35.

Database/Body

Digital Anatomy and the Precession of
Medical Simulation

EUGENE THACKER

The Visible Human is one of the cornerstones of a one million percent
revolution in medicine. . . . If everyone develops their simulators from the
Visible Human, then these things will be inter-operable. All you do is replace
the Visible Human with your patient's own data. . . . It is no longer blood
and guts; it is bits and bytes. It's like sending a letter or e-mail.

—Dr. Richard Satava

The real future of medical education is not in the Visible Human Dataset
itself but rather in the manipulation, distortion, and modification of the
data to produce whole populations of virtual humans of every age, race,
and pathology.

—Drs. Victor Spitzer and David Whitlock, "The Visible Human Dataset"

The Visible Human Project

In the early 1990s, the National Library of Medicine, along with the
National Institutes of Health, initiated the Visible Human Project (VHP),
a $1.4 million research endeavor whose primary objective would be to
create the computerized equivalent of the anatomical atlas.[1] To appreciate
the significance of this project, one needs to consider the exhaustive pro-
cess whereby the anatomical databases of the "Visible Man" (completed
in 1994) and "Visible Woman" (completed in 1995) were produced. Once
healthy, intact cadavers were located (from individuals who had donated
their bodies to science), the bodies were preserved, volumetrically scanned
using MRI and CT scanning technologies, and then frozen. From there,

researchers, using a special cryosectioning saw, proceeded to slice the cadavers into transverse cross sections, totaling close to two thousand individual cross sections for the Visible Male (sliced at 1 mm intervals) and close to five thousand cross sections for the Visible Female (sliced at 0.33 mm intervals). As the cadavers were methodically sheared away by the cryomactotome saw, each cross section was scanned and encoded using digital photography and a computer graphics workstation. These various images (X-ray, MRI, CT, and "raw" cross sections) were then transferred into a digital file format and organized into a computer database. The database was made available over the Internet so that, using a basic file transfer application, interested parties may download cross sections or indeed entire segments of the Visible Human dataset. Using computer graphics and animation applications, users and/or institutions can produce a wide range of images, from extrapolated sagittal and coronal cross sections to volume-rendered limbs and organs and interactive simulations of anatomical and physiological properties.

VHP researchers Victor Spitzer and David Whitlock have stated that "the final goal [of the VHP], however, is to simulate living human anatomy, not cadaver anatomy" (49). The projected applications of the VHP material include educational uses (for example, to use virtual cadavers to replace the need for cadaver dissection in medical schools), medical uses (for example, with presurgery visualizations and telemedicine), military uses (for example, in research done by the U.S. military on the physiological effects of combat injuries), and entertainment uses (for example, the production of CD-ROMs and other products for a nonspecialist audience and even uses in industrial design and video-game animation).[2]

The researchers working on the VHP at the University of Colorado Health Sciences Center called the process of producing these Visible Humans "reverse engineering." As they state in a textbook derived from the VHP, "We now have a renewable cadaver, a standardized patient, and a basis for digital populations of the future. Not only can we dissect it, we can put it back together again and start all over" (Spitzer and Whitlock xix).

Posing Questions of Corporeality

Clearly what is at issue with such a project as the VHP is the complex relationship between the body and technology, here framed within the field of anatomical and biological science. But what is also at issue is the role that sciences such as anatomy and projects such as the VHP have in

articulating what will officially come to be understood as "the body." Here the discourse of anatomical science, and the range of techniques and technologies that constitute that discourse, enter into a complex relationship with a range of social and cultural assumptions about how a body may be recognized or misrecognized in medical and scientific contexts.

The Visible Human Project brings with it many questions. Is the cadaver a body? Is the body a cadaver? The VHP shows us a cadaver that never decays, a body that is lifeless but animated, and a visual morphology of the body that is also, in some important way, the body itself, mediated by anatomical science. How will embodied difference be understood in this future of digital anatomy? More importantly, how will such bodies, constituted by information, touch the bodies of individual subjects and patients in medical practice and health care?

In this essay I would like to critically analyze the ways in which technoscientific projects like the VHP attempt to establish anatomical/medical and technical norms. The first part of the essay will consider the computer database as a contemporary paradigm for ordering data objects—that is, for creating infrastructures that produce particular types of knowledge. The second part will then consider the VHP in light of such a "database logic" and the tensions that result when the "thick" inertness of the cadaver meets the abstract malleability of a computer-generated virtual body.

The Biovalue of the Dead

The VHP is a project that is part of a much larger cultural tendency toward a fascination with virtual technologies. While advertisements for CD-ROMs derived from the VHP promote these new media as the "digital equivalent of the anatomical theater," how might we begin to critically assess the kinds of assumptions incorporated by the VHP in the spaces between cadavers and virtual bodies?

On the one hand, it would seem reductive to simply assume that a supposedly natural, prediscursive body is passively inscribed by the text of anatomical science; these apparently isolated objects of science are too saturated with cultural histories and social contexts to be purely natural. But on the other, it would be equally reductive to adopt the obsessive textualizing of certain strains of postmodernism, suggesting that, in this case, discourse totally produces and precedes materiality and the body.[3]

As a way of understanding this complex zone between bodies and data, we might look to Catherine Waldby's work on the VHP, which she

specifies as a technoscientific project whose primary aim is to enable (dead) bodies to generate "biovalue" (33–37). Waldby's primary concern is to think through the theoretical and political implications of the current intersections between information technology and biomedicine. Using the VHP as her main model, she argues that contemporary biomedical research demonstrates a certain kind of instrumental relationship between technologies and the body. Such practices call upon the body "to account" for itself, to impel its participation in nonnatural contexts in the form of an "instrumental address." In doing so they produce "biovalue," or the surplus of knowledge and data for use in medicine. This biovalue is created through practices of at once opening up the boundary between bodies and technologies while also reiterating the desire for a stable, predictable, and homogeneous biomedical body (as sets of what Waldby calls "operable images"). This can only be accomplished through the extraction of biovalue from the corpse and its transferal to the animated computer model. As Waldby explains: "Rather it [biovalue] specifies ways in which technics can intensify and multiply force and forms of vitality by ordering it as an economy, a calculable and hierarchical system of value. Biovalue is generated where the generative and transformative productivity of living entities can be instrumentalized along lines that make them useful for human projects—science, industry, medicine, agriculture or other arenas of technical culture" (33). In this sense the VHP follows a very familiar concern with anatomical and medical science: the overcoming of the "opacity" of the body by approaching it on the level of information and maximizing the body's visibility and vitality.

What Is a Database?

In his essay "Database as a Symbolic Form," Lev Manovich discusses the increasing ubiquity and standardizing potential of the database in late-twentieth-century cultures: "Indeed, if after the death of God (Nietzsche), the end of grand Narratives of Enlightenment (Lyotard) and the arrival of the Web (Tim Berners-Lee) the world appears to us as an endless and unstructured collection of images, texts, and other data records, it is only appropriate that we will be moved to model it as a database. But it is also appropriate that we would want to develop a poetics, aesthetics, and ethics of this database." While it is certainly possible to overgeneralize the actual impacts of computer technologies across different cultures, the new generation of digital storage media—of which the computer database is a

prime example—are nevertheless proliferating collections of information at an unprecedented density.

However, as Manovich also points out, what is at issue here is not necessarily a deterministic and exhaustive encoding of culture; what is needed are modes of analysis, critique, and practice that embody the database, both as a technical apparatus and as an organizational logic. In relation to the biological technosciences, this means focusing on the current intersections between the biomedical body and the computer database as well as their resultant tensions and aporias. In fields such as genomics, bioinformatics, telemedicine, and computational molecular biology, the database forms a central part of the kinds of research being done and also structures the kinds of propositions and questions that may be brought up. The VHP is no exception here, bringing the anatomical body and computer technology into an intimate relationship represented by an online FTP database (File Transfer Protocol, a type of automated file transfer procedure for transmitting digital files directly from a server, over the Internet, to a user's computer). However, while VHP promotional material is explicit in its presentation of "a real human body," the hybridization of anatomical and computational modes of organization reveals something more complicated.

Friedrich Kittler has provided an in-depth analysis of the "media revolution of the 1880s" in the mechanical inscription technologies of the gramophone, film, and the typewriter (1–20). While these storage technologies tended toward the isolation, separation, and autonomization of the senses (sight in film, sound in the phonograph, language in the typewriter), Kittler sees the current digital media revolution as providing a synthesizing phase, in which all media operate through binary code. This standardization of the language of storage media means an effective reassemblage of previously incompatible media formats and a greater homogenization of media themselves.

Such technologies were, of course, historical and cultural developments and were, and are, thus connected to a range of institutional sites, political uses, and technical regimes. It is in this sense that Kittler suggests that history is a mode of technical inscription, the incorporation of "writing" technologies into the privileged role of mediating culture and the simultaneous falling away of those other modes that are situated outside the technical requirements of hegemonic media. Thus Western history can be regarded as a technically inscribing process, a "discourse network," from the "monopoly" of print technology to that of computer code. What does

not thus inscribe in this way—oral traditions, modes of communicative graphism, hybrid models, primitive technologies—falls through the technical filter of history-as-media.

According to contemporary textbooks and technical manuals, "a database is a collection of related data that contains information about an enterprise such as a university or an airline. Data includes facts and figures that can be represented as numbers, text strings, images, or voices stored in files on disk or other media. A database management system (DBMS) is a set of programs (a software package) that allows accessing and/or modification of the database."[4] For a computer database, there are three properties that characterize its design. First, a database is not just a randomly generated grouping of information but also a collection of logically related elements grouped into a single structure for a specific reason (for example, the VHP database contains anatomical data). Second, the database is functional; more than a knowledge base or an archive, it is designed with a set of potential uses and applications in mind (for example, the VHP database is geared toward research in visualization, virtual medicine, and medical practice). Finally, the database always establishes, through its design and implementation, some direct connection to the "real world." This may occur simply through representation (for example, medical visualization images), bibliographic modes (for example, a health network database of medical doctors or a medical library database) or it may occur through more ambiguous means (for example, the direct encoding of cross-sectional slices of a cadaver, as in the VHP).

There are four main advantages to a database and a DBMS over more conventional file management systems (as in good old-fashioned file cabinets or the later file-based computer systems):

1. The DBMS makes possible what is called "data abstraction," whereby data modified on the "back end" (producer) does not modify the representation of data at the "front end" (user). This means that, for the computer user, the database can be black-boxed, such that the data representation (say, a CT scan image) will not be modified if a specific part of the data file is modified (say, a change in the file describing its location in a folder, or for data-compression in data transfers).

2. In data processing lingo, the DBMS can act as a "normalization" system, dynamically regulating the database as a whole, so as to prevent unnecessary procedures (duplication and redundancy, deletion and

insertion errors, and other computing anomalies). The general goal of database normalization is to enable the database to be as efficient as possible, which translates to greater performance for database users and for procedures.

3. The DBMS separates the data (or information) from the program applications that run the database. Earlier file management systems were composed of multiple systems, each of which managed their own share of data; thus data was inextricably connected to structure and could encounter system-incompatibility problems. With the DBMS several databases can act upon a single set of data, resulting in greater efficiency and data consistency.

4. The DBMS enables a greater degree of automatization of database management, as can be seen today by the various Web-based services (including online shopping, secure servers, automated listservs, "cookies" and CGI scripts, and so forth). This is especially convenient in terms of security and the automation of basic, repetitive procedures (from data entry to backups).

As a way of managing logically grouped sets of information, the database and the DBMS form an important link between the distribution and transmission of knowledge between computer users and storage systems. Many computer science and database management textbooks present this relationship as an interface: between the hardware and software of the database as a computer system and the sets of actions effected by human subjects there is the mediator of the database and DBMS, enabling or disabling access, addition, deletion, modification, transfer, and interactivity:

hardware >><< software >><< database/DBMS >><< actions >><< subject
(storage system) (mediation) (human user)

Each of the properties described above are techniques through which the DBMS interfaces computer users with storage systems. In data abstraction, an "object" (in computer science terminology a set that includes the "entity," or representation, the "attribute," or particular property, and the "relationship," or links between attributes) is transformed into a certain linear depth of data, between a source code (which can be modified) and an output modality (which is not affected); inscription can thus signify without producing any meaning. In normalization, data is streamlined, pared down, and optimized specifically for functional efficiency; data

becomes aphoristically inscribed as data packets. In the separation of data from programs, information becomes a quantity that is not only universal (it can be used by several programs) but also polyvalent (it can be put to several uses); data becomes morphological, capable of being instituted in multiple ways. And with greater automization, the database becomes a stronger "actant," to use Bruno Latour's term, a stronger object-participant in the mediation between human computer user and computer storage media.

With the advent of a standardized digitization of media languages, the archive (the form of mechanical storage) becomes the database (the form of digital storage and computer-based memory). While the archive is often unable to be modified—as with printed records, gramophone discs, filmic and photographic plates, typeset pages—the database is defined by its flexibility in the handling of information (and thus the supplementary need for "backup storage," data encryption, and security). This proliferative character of digital media means not only that computer media can write themselves (automated processes, expert systems, and agents) but also that through this recombinative logic, information comes to be seen in new, morphological terms. The implication here is that information, as in the mechanical archive, is no longer simply a concrete materiality of fact; rather, information, with the database, becomes the highly technical and automatized reservoir for the proliferation and production of other media and other mediated sensory experiences. The database is not only the foundation from which totally connected media systems emerge; it is also the very interstices and linkages that constitute the possibility of connected media.

Such a situation applies directly to the VHP and the digitization of the cadaver. In cultures where storage media play a central role in the relationships between power, history, and the dead, storage media fulfill a function of accountability. Individual identities and related information, health and medical data, demographic and criminological records, all these and more inscribe the subject upon death. The cadaver does not slip away, to be replaced by personal memory, oral narrativizing, or informal anecdotes; rather, the cadaver is accounted for on all of its surfaces, through the material practices of medicine, science, the state, and the links between a cadaver and a case file. Thus "the realm of the dead has the same dimensions as the storage and emission capacities of its culture" (Kittler 42). Once a cadaver, recognized as having had life extracted from it, recognized as no longer being a living subject, is thus encoded and stored in a database,

then the dead are no longer simply the not living. Informational accountability also means informational integrity, morphology, reproducibility, and a unique type of "immortality" specific to digital storage media.

The VHP dataset as a whole is dependent upon a real world object (the cadaver) that does not exist; the VHP dataset, in its production process, has destroyed the real world object (the cadaver) from which it is extrapolated, through a process of "destructive scanning." As VHP researchers point out, the meticulous shearing and slicing of the cadaver meant, of course, that the cadaver was destroyed; any remains were given a formal burial, but otherwise the entire body—bones, muscle, tendon, organs, et cetera—became a residual pile of shavings. However, because the "source material"—the actual cadaver—that generated the VHP has been destroyed, this doesn't mean that anatomical discourse has also disappeared in the translation into the database. While the first phase of the VHP was the technological production of the dataset (the scanning, slicing, and encoding of individual slices), phase two includes the segmentation and documentation of each of the slices, what VHP director Michael Ackerman refers to as "a librarian's nightmare." It is here that anatomical discourse will reinscribe itself upon the digital anatomy of the VHP body and within the VHP database (another example of data abstraction).

The current challenge for the VHP researchers lies in the correlation of discursively distinct data structures: that of anatomical-medical science and that of computer science. The VHP slices are, representationally speaking, radically different from the standard modes of axial-anthropomorphic representation seen in anatomy textbooks, and thus the "uncanny" familiarity with a given cross section. Researchers must correlate anatomical organizations of the body (most often mediated through representation that oscillates between realism and diagrammism) with their digital correlatives (organized into a basic hierarchical database). The trick here is to incorporate standard anatomical discourse into the database structure, while also enabling the unique morphological capacities that digitization makes possible (sophisticated imaging, volume rendering, animating and simulation, et cetera). The VHP dataset is thus doubly constrained (by the parameters of standard anatomical knowledge and by the parameters of current computer technologies) and also technically mobilized (through the potentials in the use of the VHP database for medical practice, virtual medicine, and so forth). The overt goal here is to separate the data files as self-descriptive and tautological objects from the data files as elements, with a technical functionality within the database. That is, the challenge

for the VHP researchers, in the databasing of a "real human body," is to preserve the immediacy that anatomical science has traditionally held (revealing the "truth" of the body) while also incorporating new computer technologies (such as database management) and their abilities to radically transform the ways in which the anatomical body is known and "operated" upon.

As Manovich states:

> What we encounter here is an example of the general principle of new media: the projection of the ontology of a computer onto culture itself. If in physics the world is made of atoms and in genetics it is made of genes, computer programming encapsulates the world according to its own logic. The world is reduced to two kinds of software objects which are complementary to each other: data structures and algorithms. . . . [A]ny object in the world—be it the population of a city, or the weather over the course of a century, a chair, a human brain—is modeled as a data structure, i.e., data organized in a particular way for efficient search and retrieval.

Thus the DBMS is more than a technical tool; it is a combined epistemology, technical apparatus, mode of regulation, standardization, and "normalization" and a type of interface between the virtual and real, between information and materiality, between computers and humans. The DBMS not only manages these boundaries but it also constitutes them; in the very design, creation, and implementation of the database such boundaries are formed. The degree to which the DMBS allows or disallows mobility, morphology, and hybridity will dictate to what degree the "posthuman" or forms of "postorganic life" will be possible.

Digital Anatomy

The Visible Man and Visible Woman are digital anatomies that can only exist in virtual space. The Java applets or virtual surgery simulations are manifestations of bodies whose physiology is simultaneously medical and computational. In this sense the VHP not only makes available new modes of producing knowledge about the anatomical body (still universal, still abstracted, still grounded in sexual difference), but it also creates digital anatomies with unique properties (the ability to view an animated simulation of a working digestive system, as in current Visible Woman research). So these are bodies that both produce new knowledges about

the anatomical body and are endowed with unique capabilities (such as morphing) that are impossible for "real" bodies.

VHP anatomies are not simply neutral, archival information; they are produced with the intention of being used in medical and surgical application. At the very least, they are bodies of information to be used as analytical and diagnostic tools, reflecting back upon the "real" bodies of patients. But, as may be the case with medical technologies, the VHP bodies are not an example of Baudrillard's "hyperreality," or rather not exactly so (*Simulations* 138–52). While they do certainly function as optimized bodies, they are not merely models (Baudrillard's discussion of the model as a simulation node conditions the disappearance of the "real" and of real bodies). The primary value of the VHP research is the fact that computer technology has literally and physically combined with anatomical data from actual cadavers ("a real human body" as the advertisements for CD-ROMs state). The VHP is therefore a constant reminder that the virtual body is never totally virtual, and that "real" bodies are never completely different from the technologies that touch them at multiple points.

The primary element that differentiates the Visible Human Project from traditional dissection or from the use of diagnostic technologies in medicine is in the range of applications of the Visible Human data. For instance, a number of medical schools and computer science centers have created complex interfaces with which to study and analyze human anatomy. These include CD-ROMs, applications for the Web, and the development of "haptic feedback interfaces," which simulate the texture and resistance of flesh, muscle, and tendon in a virtual dissection. In addition, the overall goal of the Visible Human Project is not just reproduction or simulation, but the development of the capacity to create the conditions for what VHP researchers have called a "living anatomy." For instance, researchers working on the VHP have expressed the desire to be able to model digital anatomies of standardized bodies according to differences in age, sex, race, and pathological ratios, creating an anatomical morphology between bodies that are at once particularized and universal.

Such morphological capacities are a direct result of the incorporation of new computer and networking technologies into anatomical science. With the range and the limitations afforded by such technologies, the Visible Human Project has been able to produce visualizations, models, and simulations of the anatomical body never before seen. An example is the basic "fly-through" animation, where each of the Visible Man slices are put into an animating program to give the effect of literally taking the

computer user straight through the body. Other examples include real-time, interactive simulations of physiological systems and research done in pathology to see how a given pathogen affects the anatomical body (which, presumably, can be reset at any time). But aside from such high-tech examples, we might even take a literalization of the VHP dataset: in this case what we have are a distributed and networked set of digitized cross-sectional slices from a cadaver, something akin to what Kroker calls the "hyper-texted body with its dedicated flesh" (16–19). In other words, the very technical possibility of databasing and networking a cadaver suggests that the horizon of the impossible with respect to the body is being reconfigured by contemporary anatomical and medical science. Anatomies such as these are quite simply not possible in dissection or through medical technologies; they are produced by, and depend upon, the morphological capacities of computer-based technology applied to a science of the body.

Thus, for the Visible Human Project digital anatomies are bodies that are not simply free-floating avatars, nor are they a new version of the "body itself." Digital anatomies are, above all, technically constituted and corporeally interstitial; they make possible anatomies that are dead but animated, inert but morphological, nonsubjective but interactive, and composed of tissues that are also data.

"Nakedness is death," or the Politics of Data Transmission

Projects such as the VHP do not simply reiterate the anatomical knowledge of early or even midcentury textbooks; rather, they serve a productive, proliferative function. New technological developments and technical knowledges have enabled the production of new (technically assisted and enframed) anatomies. These anatomies (be they volumetric reconstructions or cross-sectional animations) are in every sense normative: they are at once a model and a minimum threshold of acceptability, and, we may assume, they ultimately refer back to a more familiar anatomical body—that found in textbooks and in gross anatomy labs. But as normative models, these anatomies are also in excess of a certain ontology that defines modern anatomical practice. That practice has historically been grounded in, first, the evidence of direct observation (through the intermediary technology of dissection), and second, the authority of textual exegesis (facilitated by techniques in representation, tables, taxonomies, diagrams, et cetera). While digital anatomy gives up neither of these practices, its primary focus—the digital encoding and manipulation of anatomical

files—lies outside of the rhetoric of direct, involved intervention that characterizes early modern anatomy.

In fact, the entire field of debate between textual authority and direct observation that characterized the early modern period in anatomical science has been displaced in digital anatomy, with a concern for the most effective, thorough, and technologically sophisticated means for analyzing the anatomical body. The issue within digital anatomy is not text versus dissection, simply because the terms of this debate during the early modern period have to do with the articulation of the recognizable outlines of the body. By contrast, digital anatomy is less concerned with identifying and exploring the body itself than it is with the technical formation of an optimized, technologically assisted anatomy. This body is, certainly, objectified as a source from which different types of knowledge may be extracted, but in its digital incarnation this body also operates as a kind of tactic through which a body of information may be produced. Digital anatomy does not, in a postmodernist vein, forego the body as a material, biological reality, but neither does it obsess over the verification of the body, or in locating some quality that might be identified with the "body itself."

Digital anatomy is primarily concerned with the development of a technical mode in which information can operate independently of verification; verification in this case is made possible by information—readout translates or mediates reality. In such a scenario, verification (the explicit concern with the placement of the real) is effectively separated from information (the set of data units that can comprise a group of interrelational units contributing to a certain type of knowledge). In its current state, what will come to count for digital anatomy and its potential biomedical applications will not be the "real" body of the patient, but neither will it simply be a monolithic, universal model of the anatomical body, this time computer generated. Instead, what will be of importance will be something connecting the individual patient-body and the universal anatomical body, and their connective tissues will be fully technological. The complexity of the proposed intersections between the patient-body, medical technologies (X-ray, CT, MRI), and new computer technologies moves toward approaching the biomedical body as a field of informational diagnostics, where what is to be trusted is not, as in the early modern period, one's own eyes (within a rhetorical and performative setting) but rather an informational, calculative dimension to the body and materiality.

For example, results from the VHP have already been used in selected surgical procedures to provide physicians with computer-generated models

of target areas and to "rehearse" and experiment on these virtual bodies different surgical techniques. An associated use has also been the application of high-end computer visualization software for the development of new analytical and diagnostic techniques in a variety of disorders (from forms of cancer to the implantation of artificial joints). These applications of VHP-related material are primarily diagnostic; their main function is to thoroughly analyze and extract data from a model generated from a target biological site (the patient-body). As a diagnostic model, as an analytic model, the possible knowledge that such technologies make possible also implies a whole set of constraints and biological norms (which are really bioinformatic norms). That a particular disease or its manifestation as an anatomical irregularity can be diagnosed in new ways means that there have been added new sets of standards with which to analyze and produce knowledge about the biomedical body. Because these standards emerge from the capacities engendered by new computer and information technologies, they become, in some sense, in excess of the biological, "natural" body and its attendant modes of information and knowledge production.

Now, at no point in these examples do physicians or researchers express worry about "losing" the "real" body in the diagnostic process. At issue with digital anatomy is not, as we find in the early modern debates over dissection, how to discover the most real body possible (and what is more real, argue the early modern anatomists, than the demonstration of the literal opening of the body before one's eyes?). Instead, digital anatomy is concerned with how to technically procure the most analytically optimized body technology configuration possible, to maximize the potential of the anatomical body to make itself manifest, while also maximizing the potential of diagnostic technologies to conduce the anatomical body to reveal its signs.

What these goals and these digital anatomies imply is a technical reconfiguration of anatomical science along several lines. Digital anatomy will create virtual bodies that are animated but biologically dead; it will articulate an organizational logic of information and databases, such that anatomizing will also come to mean the distribution of digitized body parts according to informatic values (file size, database structure, downloading time); and it will isolate, at its base, a cadaver that will function not as a referent (as the real to the virtual), but as what Latour calls an "intermediary," from the normal and natural body of biology and anatomy to the installment and programming of the normal and natural into the virtual (visualization and modeling) (56–57). Point for point, digital anatomy is in the process of renegotiating the ways in which anatomical discourse and

practice will integrate itself into normative, culturally dominant modes of approaching "the body":

- Instead of privileging direct observation from dissection of human cadavers, digital anatomy will emphasize the capacity to informatically model and "cut" the virtual body; a combination of technical-informatic knowledge and anatomical craft (the virtualization of dissection and surgery) will comprise the field of expertise for the digital anatomist. The emphasis is not so much what one can see as what one can translate into informatic terms, how much the body can be approached as an informational system—what is "real" is no longer the demonstration of the body itself in the anatomy theater but rather the efficacy of the technical modes of extracting and producing knowledge about the anatomical body.
- Instead of the reliance on the authority of textual exegesis, which was, despite the debates during the early modern period, still very much in effect up through the nineteenth century (continuing with *Gray's Anatomy*), digital anatomy will displace text with the polygonal model as its basic unit and point of reference. This model can incorporate both textual and dissection-based demonstration, fusing them into the polyvalent function of the mouse and pointer as simultaneously diagram, label, and scalpel.
- Instead of a unique collaboration between a certain realism of representation (for example, the anatomical works of da Vinci, Dürer, Rembrandt) and modes of anatomical pedagogy (for example, tables, diagrams, charts, taxonomies), digital anatomy will focus on the informatic organization of body parts and all digital elements within the structure of the database. What matters is not accuracy of reproduction but rather how much one can exceed the representation of the real, how much one can proliferate data on the body and move beyond the quotidianism of realism into openings made possible by increased technological capacity.
- And instead of a universal (and male-centered) body, digital anatomy, in its applications within surgery (for example, presurgery visualization and telemedicine), proposes the possibility of an individualized anatomy within medicine. This individualization, however, is not of the patient-body itself but of the capacity to successfully generate a model of the particularities of the patient-body based on an informational morphology (location of tumor, target site of surgery, differentiations in race, sex, et cetera).

The Visible Human Project is a unique endeavor within medical science to test the limits of the continuities and discontinuities that exist been virtual/computer technologies and the medical body. In its production of "impossible anatomies," the Visible Human Project transforms early modern anatomy's tension between text and body into an anatomical morphology made possible by an understanding of the body as constituted through information. Reverse engineering is the technical negotiation of the virtual and the real, couched in the specificity of the network joining the cadaver, the anatomical body, discourse, and practices, medical technologies, computer modeling and rendering, and network technologies and database management. On the one hand, it is reductive to state that the VHP is another example of the virtualization or disappearance of the body; the techniques and methods of the VHP make it clear that the link between the cadaver and the digital file is never severed. On the other, the bodies produced from the VHP are neither the "body itself," the anatomical body of early modern anatomy, or the virtual body of so many video games. The point here is not that an assumed, prediscursive, "real" body is dematerialized into abstract data nor that the virtual body is somehow constructed while the body prior to encoding is not. Rather, what is happening is that the anatomical body is being technically aligned with the capacities and languages of information, so that the material practices of anatomical science may be integrated into the digital domain. Curiously, the VHP—for all its gothic dealings with the "messiness" of cadavers—appears to smuggle in a desire for a body that is a body and that is yet totally amenable to the malleability of computerization and modeling, a kind of techno-transcendence of the body that claims to convert (as in "file conversion") corporeal materiality into pure data. As Nietzsche states in *The Will to Power,* commenting on the desire for transcendence in the sciences, "perhaps the entire evolution of the spirit is a question of the body; it is the history of development of a higher body. . . . The organic is rising to yet higher levels. Our lust for knowledge of nature is a means through which the body desires to perfect itself" (358).

NOTES

1. For more information on the Visible Human Project visit their Web site, http://www.nlm.nih.gov/research/visible.

2. For medical education uses see Ackerman's "Build for Future," 300–301. For uses in telemedicine, see the Web sites for Medicine Meets Virtual Reality conferences. For

uses by the military, visit the NASA–Ames Center for Bioinformatics Web site. For a list of products and CD-ROMs, see the links at the VHP Web site.

3. For postmodernist claims for the "disappearance" of the body see Baudrillard, *Ecstacy*, 11–28, and *Seduction*, 27–49.

4. For manuals and textbooks on databases see Bitter; Connolly and Begg; and Rob and Coronel.

WORKS CITED

Ackerman, Michael. "Accessing the Visible Human Project." *D-Lib Magazine* (October 1995): http://www.dlib.org/dlib/october95/10ackerman.html.

———. "Build for Future Technology When Building for the Future: A Lesson from the Visible Human Project." *Journal of the American Medical Association* 3.4 (1996): 300–301.

Baudrillard, Jean. *The Ecstacy of Communication.* New York: Semiotext(e), 1988.

———. *Seduction.* New York: St. Marks, 1990.

———. *Simulations.* New York: Semiotext(e), 1988.

Bitter, Gary, ed. *Macmillan Encyclopedia of Computers.* New York: Macmillan Publishing Co., 1992.

Connolly, Thomas and Carolyn Begg. *Database Systems: A Practical Approach to Design, Implementation, and Management.* New York: Addison-Wesley, 1999.

Kittler, Friedrich. *Gramophone, Film, Typewriter.* Palo Alto, Calif.: Stanford University Press, 1999.

Kroker, Arthur, and Michael Weinstein. *Data Trash: The Theory of the Virtual Class.* New York: St. Marks, 1994.

Latour, Bruno. *Pandora's Hope.* Cambridge, Mass.: Harvard, 1999.

Manovich, Lev. "Database as a Symbolic Form." Posted through Nettime (1998): http://www.nettime.org.

Medicine Meets Virtual Reality conferences, http://www.amainc.com/MMVR/MMVR.html.

NASA–Ames Center for Bioinformatics, http://biocomp.arc.nasa.gov/home.html.

Nietzsche, Friedrich. *The Will to Power.* New York: Vintage, 1968.

Rob, Peter, and Carlos Coronel. *Database Systems: Design, Implementation, and Management.* Belmont: Wadsworth, 1993.

Rowe, Paul. "Visible Human Project Pays Back Investment." *The Lancet* 353.9146 (2 January 1999): 46.

Spitzer, Victor and David Whitlock. *Atlas of the Visible Human Male: Reverse Engineering of the Human Body.* Boston: Jones and Bartlett, 1997.

———. "The Visible Human Dataset: The Anatomical Platform for Human Simulation." *The Anatomical Record/The New Anatomist* 253.2 (1998): 49–57.

Visible Human Project, http://www.nlm.nih.gov/research/visible.

Waldby, Catherine. *The Visible Human Project: Informatic Bodies and Posthuman Medicine.* New York: Routledge, 2000.

The Body in the Next Room

Death as Differend

MICHAEL MENDELSON

That which is there to be spoken and thought of must be. For it is possible
for it to be, but it is not possible for nothing to be.

For the same thing is for thinking and for being. . . . Thinking and the
thought that it is are the same.

—Parmenides of Elea

As distinguished from a litigation, a differend would be a case, between
(at least) two parties, that cannot be equitably resolved for lack of a rule of
judgement applicable to both arguments. . . . [A] universal rule of judgement
between heterogeneous genres is lacking in general.

What is at stake in a literature, in a philosophy, in a politics perhaps, is to
bear witness to differends by finding idioms for them.

—Jean Francois Lyotard, *The Differend*

Silent Relics

It is a curious and perhaps telling point: we do not need to know who,
nor do we even need to know how. We need only be told that there is a
body in the next room and suddenly all is transfigured.[1] It is almost as if
such circumstances were governed by a strange physics all their own. Dead
bodies, we know, cannot move, at least not in the customary ways.[2] And
yet, having been told of its proximity, it is as if we instantly felt a presence
of sorts intrude itself among us. It is, we are inclined to say, "eerie" and
"macabre." And it *is* an intrusion, invariably disruptive and unwelcome.
We want to leave, moving away from the unease of this nameless presence.

We know of this "presence" not because we know of some "thing," but
because, ironically, we know of a certain void, and because we know of

this void, we feel the need to name it. "Death" we call it, and the more the loss it portends is a loss that is our own, the more we speak of it and the more we believe we know of this void that we have named. And having named it, we would give it a place whence it comes, a place that is other than here, a place where it belongs. We have come to know that we cannot dispel it in any of the usual ways by which the unwelcome is banished from among us, so we would do the best we can and give it a sphere of its own. And having gone this far, we are sorely tempted to go one step farther: to have it *be* the place that is its own, the place whence all must "go" in the due course of time. The void that we have come to know too well, that disruptive intrusion from the outside, now has a name and a location of sorts, and it is now a part of that which it once seemed to destroy: it is "natural," we sometimes say, and it is a part of "life" that all should at some point "depart" from "here."

But then: there is that body in the next room. We can feel the unease that seems, as it were, to creep around us.

And sometimes, in a somewhat different setting, we await the arrival of well-mannered proprietors, studied in tone and gesture, who will come to tell us that we may now see the body that is in the next room. And out of the corner of our eye, we see the young couple still uncertain whether the children should be allowed in that room, still wondering between themselves whether the children are "ready" to learn the lesson that the body in the next room has to offer. And it is hard not to wonder just what that lesson might be—that dead bodies, when properly tended to, can look rather lifelike, in their own wooden sort of way? That they do not move? That Uncle John will not—cannot—come over to see them anymore? Or better: that Death is not quite so bad once you see it close up; it is rather like "sleep," and though they will feel the sadness of Uncle John's parting, he is "at peace" now and, no doubt, in a "better place," released from the suffering of his final days "here" with us.[3] But of course, if the body in the next room so readily offers such lessons, why this last minute hesitation, why this uncertainty whether the children are "ready"? What *is* it for which they may or may not yet be ready?

And then we find ourselves wanting to say: "Yes, there is a corpse in the next room. And you can stare and point at it all day, but you will *still* not find what you are looking for. *It* is not Death." "Corpses," we want to tell them, "are the vestiges of Death, relics of Death, but hardly something to which you can point and say, '*There* is Death; study it well and learn its lesson.'" But then, we imagine being asked: "Well, if *this* is not the place

to learn of Death, then *where* would that place be? Where would you have us take the children? To an emergency room or an accident site?" But of course, all know better than to say such things aloud.

Nonetheless, their question would be well put: "*Where would* that place be?" In such moments and at such places as these, it is hard not to think what we may well have suspected all along—that there is an evasive cheapness that constantly haunts our discourse on Death, a clichéd inelegance where every utterance seems one utterance too late. Predictable are the words; predictable are the pauses between the words; even the long stretches of silence often have a spiritless air about them. And so one thinks: surely we've done this often enough, and so surely we ought to do it better. By now, surely, we ought to be fluent and adept in the face of Death, filled with the sentiments and phrases appropriate to the moment. Surely, after all, the occasions have not been lacking.

But perhaps, one begins to think, the fault is not all our own. Perhaps it is not all due to lack of imagination or insufficient depth of feeling—perhaps there is something in the moral landscape of Death that defies and undermines all our attempts to capture and express what we think we perceive there. There may well be a reason why we are moved the way we are when we are told that there is a body in the next room, some corpse on the other side of the door, but this reason may have nothing to do with anything we discern or say; it may, instead, have everything to do with something we cannot discern or say. Maybe the landscape that stretches out before us is governed by a moral geometry that thwarts our attempts at representation at precisely the moment we most want to succeed. This dark possibility seems, at any rate, one well worth taking seriously as we consider the all-too-conventional unease with which we encounter the void before us, as we ponder the presence of the corpse on the other side of the door, that visible yet silent relic of the void we name Death.

Pondering all this is itself enough to prompt one to attempt charting the moral landscape that stretches out before us so that we might pose to it the questions that the presence of our silent relic poses to us: Why does all we say sound so hollow? What is it that our representations of Death fail to capture?

Moral Topography

This much surely we know: in the center, we see the Light, bright and polychromatic, teeming with variety and detail, a realm of richly textured,

myriad boundaries marking all manner of inclusion and exclusion, a place where one finds all the finely woven complexity that identity requires.[4] Here in the center, the Necessity of Identity—the ostensible necessity of having some sort of identity or other—is always accompanied by the Comfort of Identity, that comfort offered by the inclusions that accompany those exclusions that identity necessarily requires. This is the place of confidence—confidence in the moral reliability of the landscape in which we find ourselves; confidence in our ability to represent that landscape in a manner that accurately captures the actual details of the terrain; the confidence that there is, in principle, some sort of resolution to any problem that confronts us, that the terrain we are crossing is always traversable in a manner that preserves the most crucial boundaries that our identity requires. Let us call this the City of Luck, for this is the place where circumstantial fortune and moral desert manage, for the most part, to ever-so-reassuringly coincide.[5]

Off in the furthest reaches of the peripheral distance there is a darkness on all sides that looms in what seems the very edge of an ever-ambient, if sometimes unnoticed, horizon. This is a darkness that forever surrounds the polychromatic, brightly lit confidence that one finds in the center, but the brightness of the center is often enough to temper the darkness in the peripheral distance, sometimes even almost concealing it from those closest to that center. From the vantage point of the City of Luck, this peripheral darkness can all too easily seem to *not be* all that the City *is*: one discerns no light, no polychromatic variety and detail, no richly textured boundaries demarcating patterns of inclusion and exclusion. Instead, one can see only what appears to be an all-consuming darkness wherein all distinctions and diversity are obliterated in an utterly nonchromatic void. In the City of Luck, however, this strong and possibly unsettling contrast is often attributed to the very distance that divides the center from the peripheral horizon, and one often encounters a confidence that, were the distance smaller, considerable detail would no doubt emerge, perhaps even detail somewhat similar to what one observes here in the center. Regardless, however, of the manner in which the darkness is construed, there is no denying it is a different place, a place other than, and removed from, the place that is the center. This darkness, this place that lurks ominously if ambiguously off on the peripheral horizon, is the place called Death, the place furthest removed from the place that is the City of Luck.

Between the City of Luck and the place called Death, between the

polychromatic, brightly lit center and the ominous darkness of the peripheral distance, there are indeed other places. Most notable are those we shall refer to as the Alleys of Loss and the Plain of Gray. The Alleys of Loss are the place of those who have begun to lose much of the circumstantial confidence of those in the center, the place where one begins to doubt the details and the patterns of inclusion and exclusion that one finds near the center. This is the place where one finds, among others, those who despair of ever mapping the terrain in a manner that captures its contours, and one also finds those who would map it so as to deliberately mock the confidence of those closer to the center, and sometimes one finds those who would map it in a way that would chart avenues of transcendence. They are intended to be the means whereby we would escape to a more reliable haven, one that is surer than the presumptuous confidence of the City and simultaneously less threatening than the darkness off in the peripheral distance. A sense of tenuousness and fragility are to the Alleys of Loss what circumstantial confidence is to the City of Luck.

Between these Alleys of Loss and the place called Death there is the Plain of Gray, a place of gently lapping, thick gray water. This is a landscape devoid of all the details that the confidence of the City of Luck would discern, a fluid terrain devoid of all the representations identity requires and confidence provides; this is a place both enticing and unlivable—enticing because it provides a place where the empathetic eye discerns no boundaries to thwart it; unlivable because it supports none of the boundaries that the discriminations of human agency necessarily impose and that identity itself requires.[6] Here is a landscape where the tidy distinctions of innocence and guilt and responsibility find no purchase; instead, there is the intertwined and unmappable complexity of a weblike causal contiguity that undermines all confidence in some carefully circumscribed sphere of moral culpability.[7] Here there is naught but a swirling gray mist and the whisperlike sadness that accompanies the gentle lapping of thick gray water.

As one moves away from the confidence of the brightly lit, polychromatic center of the City of Luck, and as one moves toward the subdued and transcendentally inclined Alleys of Loss, toward the whisperlike sadness of the monochromatic Plain of Gray, one encounters a landscape that becomes increasingly more ominous and unsettling. And surely, nothing can be more ominous and unsettling than the place called Death, the darkness that lurks in the outermost peripheral distance.

Mortal Avenues

And just how dark *is* that darkness lurking off in the peripheral distance? If Death is truly Death—in other words, Death is *Death,* not just some form of "life" that is in some respects very different from the one we now know—then the darkness must be *very* dark, and Death is indeed ominous and unsettling, so much so that one has to wonder how it could ever come to pass that beings such as ourselves would take seriously the notion that Death *could* be a Death of this unsettling, seemingly unimaginable sort. If Death is so utterly alien, as Death must be if Death is *truly* Death, then how could we ever come to entertain it as a possibility in the first place? The answer, our landscape suggests, is that our relation to Death is ultimately a matter of dialectical tension: We cannot actually *see* the place called Death, so all consuming is its darkness, yet we find it difficult to doubt its reality, so prevalent are its vestiges. We cannot conceive the actuality of a Death that is truly Death, so alien is the darkness of its prospect from the interior of the more confident regions where we now stand, yet it is a possibility we find difficult to deny, so enduring is the void to which those vestiges bear silent testimony. In this tension between our inability to either embrace or shun the place we call Death, we find not only the origin of our awareness of the possibility that Death might truly be Death, but correspondingly the origin of the urge that drives us toward the Domestication of Death. This is the recurrent concern to assuage the unease Death provokes by making it something less than Death, by depicting it as an accessible and manageable place within the landscape that stretches out before us, even if it is the outermost periphery of that landscape. The dialectical dance this tension involves presents us with the mortal avenues through which we must approach the place called Death.

We cannot see the place called Death: look where you will, point at whatever you will, but it is not and cannot be Death. A corpse, a flower-strewn plot, a newspaper clipping, an old photograph, a lock of hair, a chalk outline on the pavement; perhaps the memory of a face or a scent or even the darkness itself: at best, these are the vestiges of Death, always ominously less and more than what they portend, but Death itself, it seems, is nowhere to be found. Wherever we point, wherever we gaze, we are met with what is there, and what is there always is in a manner that Death, if Death is truly Death, cannot be.

But *we cannot doubt the reality of Death*: too many are the memories, too many are the vestiges that litter the terrain all around us. Ubiquitous

are the relics of those who have gone before but whom we cannot see, those who seem to have been so much like us and yet are nowhere to be found. And then, there are the ones we did see but can no longer find, those who have become absent in a painfully numbing sort of way. The relics, those memories, those eviscerating voids—they are not Death, but they are enough to make it impossible for us to permanently avert our gaze from the peripheral darkness where we think it might be found.

We cannot conceive the actuality of a Death that is truly Death: in a puzzle as old as Parmenides of Elea, there is the difficulty attending any attempt to think of that which truly "is not," for to think, it seems, is invariably to think of something, yet to think of Death seems precisely the attempt to think of *nothing*, to think of "*not* being," to think the thought that has no object or content.[8] On a more immediate level, to contemplate one's own death seems to invoke the attempt at denying the very condition necessary for such contemplation, to imagine oneself as incapable of all imagining, as incapable of anything at all—to confront the prospect of an annihilation that is existentially eviscerating in a way that no attempt at conceptual representation could ever begin to capture. It is precisely this point that makes it so amazing that we could even arrive at the notion of a Death that is truly Death.

But, of course, *we cannot deny the possibility of a Death that is truly Death*: however inconceivable, utter, and absolute "not –being" may be, the vestiges are always there to haunt us, the pain of the void always there to goad us, in a manner that obliges us to take seriously what we seem incapable of lucidly and coherently conceiving. In the vestiges of Death we begin to sense the disconcerting possibility of a gap between what we can clearly conceive and what might actually be the case, the possibility that the much-coveted isomorphism of thought and being might fail on precisely the frontier where we would most want it to hold. One might want to argue that the vestiges of Death are not enough to prove that Death is indeed Death, that there are other possibilities to account for those vestiges. The crucial point, however, is this: the vestiges of Death are enough to make us take seriously the possibility of that which it is so difficult to conceive, in other words, that Death *is* truly Death and that what can seem so conceptually unthinkable and psychologically unfathomable is a genuine possibility, even if of a rather nightmarish, soul-wrenching sort.

Were all this a matter more theoretical, a matter of something more removed and remote from the sphere of our deepest personal concern, all this confusion would be tolerable and easily accepted. But it is not. The

landscape we are charting, after all, is our moral landscape, one that is in places fraught with the discriminations and divides that human agency must of necessity impose, the boundaries that demarcate the sphere of that about which we most care, the boundaries that serve to constitute the identity upon which, for us, everything depends. And Death, that ominous darkness off in the peripheral distance, is the haunting threat of all this being swept away in a flood of impenetrable nothing, the loss of all that truly matters in a way that seems both unthinkable and devoid of any possible solace. It is little wonder, then, that we would want Death to be a name of a place; little wonder that our avenues of approach are so confusing, at once both so direct and oblique; little wonder that we would want to rule out the possibility of a Death that is truly Death by focusing as much as we do upon the Domestication of Death.

The Maxims of Death

The Domestication of Death is the means by which we would temper the ominous and unsettling darkness of Death by rendering it conceptually accessible while simultaneously holding it at bay. This, of course, is a formidable task, which is fraught with all the tension from which it emerges, in other words, our inability to either embrace or altogether shun the place we call Death. Somehow, it seems, we must make Death fall within the landscape without allowing it to creep further toward the center; we must acknowledge the peripheral darkness without allowing its presence either to obliterate the bold, circumstantially rooted confidence of the City of Luck or to begin undermining what forms of confidence remain in the Alleys of Loss. To allow the darkness of Death to extinguish all confidence would be to move precipitously toward the Plain of Gray, the enticing but unlivable melancholy place where there is naught but the gentle lapping of thick gray water, where the eye of empathy discerns the fluidity and intertwined contiguity that agency must always deny. For those possessed of identity, those who seem to *be* at all, this itself is already a place too much like the place called Death. It is a place where the boundaries upon which identity relies begin to fade away, and there one is obliged to concede the lie of that which goes by the name of "innocence," the subterfuge that goes by the name of "guilt," the hollowness of all such attempts at demarcating neat spheres of culpability that would protect the boundaries of identity, which, from the vantage point afforded by the Plain of Gray, seem to have no purchase on the terrain itself. For those in

the City or the Alleys, this is as unthinkable as Death itself, and the Plain of Gray is at all costs to be avoided. It is itself the minimal distance that must be preserved between the City and the Alleys on the one hand and the place called Death on the other.

To preserve the distance while somehow denying it, to discern and acknowledge the darkness while somehow not gazing upon it—this is the goal and the challenge that lies at the heart of the Domestication of Death. To do all this, we often invoke the Maxims of Death and the Mirror of Death, devices of existential cartography that serve as lenses and shields, as bridges and walls—means by which we would perform that conceptual and existential legerdemain of making the darkness a part of the landscape without allowing it to creep forward toward us. The Maxims of Death and the Mirror of Death are means whereby we can yield our attention to Death without really having seriously to confront the possibility that our landscape has brought before us, the possibility that Death truly *is* Death.

The Maxims of Death are those vestigial and episodic pieces of conventional wisdom that acknowledge much of the grimness of Death while maintaining much of its distance. Indeed, the distance of Death is crucial to the Maxims of Death, for underlying the Maxims is always the boundary of identity that distinguishes those who are living from those who are not, those who are dead and those who are alive. The Maxims of Death do not always provide comfort, but they do provide an accessible explanation of why Death seems so bothersome, while simultaneously offering and fostering an appreciation of all that falls on *this* side of the chasm that divides the living from the dead. Death is, after all, as one of the Maxims of Death would tell us, some kind of fact of life, but it is not the sort of fact that can usefully engage our attention, for we should focus our attention upon the living,[9] and if one must think of Death at all, one should think rather of the distance that divides us from it and the value of all we find on *this* side of that divide.

Another of the Maxims of Death: sometimes we are told that Death is, perhaps, to be construed as some very long, endless sleep, to be characterized in terms of a kind of rest and repose. It is left unexplained, of course, how anything endless could even remotely serve as a rest, repose, or sleep that we could even begin to understand or desire, but if the Maxims of Death are to serve their purpose, it is imperative that they not be pressed too close. And more: Death, we often find ourselves inclined to say, is frightening precisely because it is so final. Or, perhaps, because it is the unknown. Or, maybe again, because Death is the end of all our projects.

And, of course, Death seems so utterly irreversible. There is, the Maxims of Death incline us to believe, something in all this that is unique about Death, that singles it out from all the other events and conditions we might encounter. "No wonder," one thinks, "that it should be such a fearsome object." And finally, there is the ever-present, almost irresistible urge to reiterate the one Maxim of Death that more than all the others seems to serve as a kind of talisman for some deep-rooted, if unarticulated, purpose: Death is, when all is said and done, that paradigm case of the unknown. No surprise that the very mention of it so often affects us as it does. "We fear," we say, "the unknown."

But: the Maxims of Death are never more than circumspect evasions that fail to confront the very darkness they purport to acknowledge. After all, we do not, as a matter of course, fear finality unless, perhaps, the finality is itself of a certain sort. Nor, as a matter of course, do we fear the irreversible and the unique unless, perhaps, it is an irreversibility or uniqueness of a certain sort. Even the "end of all our projects" might come, in certain cases, as a welcome relief. And, of course, the unknown need not at all be an object of concern or fear—unless, perhaps, it is of a certain sort. A curiously concealing phrase is this "of a certain sort." And just what sort might that certain be? That is the question we must not ask. To begin to address it would be to move toward the darkness itself, and that would be to forsake not only the Maxims of Death but, more importantly, to undercut the Domestication of Death that they are intended to accomplish. It would take us back to the dark possibility from which the Domestication of Death is supposed to spare us, the possibility that Death truly *is* Death.

The Mirror of Death

The Maxims of Death do what they can to temper the darkness of Death while simultaneously keeping the darkness at bay by emphasizing our identity as those "not dead," as those who are living, as those for whom the darkness of Death is not and ought not be of existential consequence—except, perhaps, in terms of prudential avoidance. Sometimes, however, the darkness of Death seems such that these sorts of relatively confident dismissals do not work, so ominous and prominent is the darkness, and sometimes one seems to have no choice but to stare into the silent darkness, wondering as to just what it portends. The darkness of Death, however, is a repellent darkness, and the more one gazes into it, the

more likely it is that the darkness of Death will be transformed into the Mirror of Death.

The Mirror of Death is like all mirrors: within its field every place is double long in an intractably regressive sort of way. The harder we gaze forward into the darkness, the more our vision is pushed backwards, and the harder we attempt to discern where we are gazing, the more we in fact see where we have been, albeit in a manner in which left and right are reversed. And so, the Mirror of Death does precisely what one would expect such a mirror to do: it presents us with a transfigured landscape wherein the travail and pain of our lot are transformed into their opposites, where our initial finitude becomes the kind of endless projection that a mirror's reflection provides. And the Mirror of Death is again like all mirrors: it will reflect everything but itself. Here the more one attempts to discern what is reflected in the Mirror of Death, the more one pushes oneself back into what is being reflected, away from the darkness that is the Mirror itself.

In the reflection cast off by the Mirror of Death, there begin the tales we tell of the place called Death. These are tales that speak of some place that is in many respects like the places we know, yet different enough to explain the darkness that often obscures our vision of the supposed sameness. Some, for example, speak of a shadowy place where one finds spirits that are not quite bodies, a presence for whom we would reach and grasp while it vanishes like smoke, a shadowy vestige that is as real as our memories yet absent like the void that is the pain of our loss.[10] And sometimes, invoking a bit more confidence, there are tales of rewards and punishments, of a place like this place, only with one significant difference: in the place called Death there are works of compensation and completion, a redressing of imbalances and a settling of old scores.[11] In this other place that is so difficult for us to see, there is a Moral Justice at work that would redeem the appearances, somehow punishing those who have transgressed the boundaries of innocence and assumed the burden of guilt, somehow rewarding those who have suffered even though they themselves seemed to respect those ever-so-crucial boundaries of innocence, guilt, and responsibility.

This, of course, is a tale that can be told in many ways, for there are so many possible landscapes that can be sketched out, and there are so many avenues through which this Moral Justice can be channeled. One could, for example, see this place as one that is in fact divided into many places, each of these in turn capturing some of the terrain that is required by the

Moral Justice that is at work in this place, the place that is so difficult to see but which redeems all that we do.[12] Or: perhaps this unseen place is the antipode of some larger, moral cycle, a cycle of which we discern only one vestigial and, hence, fragmentary pole, a cycle that, understood in its entirety, will itself redeem the appearances by means of the Moral Justice it implements.[13] Or even: Death becomes a place that is actually a "not-place" of sorts, one that is immune to the ravages that seem to afflict all places, a not-place that is safe for us and all about which we care, a not-place that is, because it is a not-place, far better than any place could ever be, a place that is a not-place in a way that we might well wish that all places were.[14]

Because the Mirror of Death can only produce a transfigured picture of the landscape of those who gaze into it, it is easy and tempting to scoff derisively at the tales told by those who have done the gazing. This, however, would be a mistake. The deceptive nature of the Mirror of Death offers rare access to a level of candor seldom encountered in either the City or the Alleys. The Mirror of Death is forever disarming to those who would gaze hard enough into it, and as they strive to describe what they see represented there, they sketch a landscape consisting of a moral self-portrait every bit as revealing as it is, more often than not, unintended. Here, in a manner often veiled yet betraying uncanny precision, one finds laid out before one all the presumptions and doubts, the fears and anxieties, the confidence and hesitation, all the loves and hatreds that make up the lives of those gazing into the Mirror and telling the tale. When the darkness of Death becomes a mirror, and when one gazes into the Mirror of Death, one cannot help but draw a portrait of oneself. And: in one of the curious yet almost predictable ironies of moral topography, the attempt to plot the terrain of the darkness off in the peripheral distance becomes instead a transfigured portrait of something far closer to hand yet, at times, seemingly every bit as inaccessible. One sets out to draw a landscape far off in the distance, and in so doing, one is obliged to gaze deep into the Mirror of Death and to construct a portrait of what is close to hand in a manner that is more revealing than any deliberate act of portraiture ever could be.

The Mirror of Death is, then, a vehicle for moral self-portraiture, but here is what it *cannot* be: it cannot be a transparent lens through which we actually chart some landscape on the other side of that lens. For all the poetic power and insight about ourselves that one finds in the tales prompted by the Mirror of Death, we are still immersed in the Domestication of Death. The harder we gaze, the more we are pushed back, and

while the tales prompted by the Mirror of Death seem to chart the place called Death and to dispel some of its darkness, they do so in a manner that, when all is said and done, can only do what the Maxims of Death do, what all attempts at the Domestication of Death *must* do: they keep the darkness at arm's length and provide us with a means whereby we can avert our gaze while pretending to probe the darkness itself.

Nor is it of any use to wonder whether the tales succeed in charting what the darkness conceals—no more than it is reasonable to wonder whether *any* mirror can reflect what is on the other side of the wall behind it. Even if there were to be some glint of similitude, there would be no discernible evidential connection between the similitude and the mirror itself, no discernible evidential connection between the similitude and the yearning that the tale expresses, no discernible evidential connection between the darkness that confronts us and the light with which we would hope to replace it.

But if there are no discernible connections of these sorts, then we are obliged to concede the ultimate failure of our attempts at the Domestication of Death, for the darkness in the peripheral distance remains untouched and unaltered by our attempts at assimilation and reconciliation. The Maxims of Death and the Mirror of Death have only served to bear witness and give expression to our visceral unease; they have done nothing to dispel the source of that unease or to warrant any confidence regarding it. And so we are left to ponder the dark possibility from which the Domestication of Death would protect us: What *if* Death is truly Death?

An Interlude of Sinister Reverie

But even if there *were* some evidential connections of the sort that are so glaringly absent in the Domestication of Death, it is difficult to fathom how they could ever be quite enough.[15] Knowing as we do of the body in the next room, knowing as we do of the unease that it begets, we know too well that if the Domestication of Death is to succeed in its purpose, it must altogether rule out the possibility that Death is truly Death. As long as the latter possibility remains, there is a deep fissure in the confidence that the Domestication of Death is intended to promote. Nor is it enough to suggest that we have some kind of standoff such that the possibilities offered by the Domestication of Death can be regarded as canceling out or standing on equal ground with the possibility that Death is truly Death.

There is, one must bear in mind, an asymmetry here. There is, after all, the body in the next room, and the unease we would preempt precedes the confident move with which we seek to dispel it—our unease is *anterior* to our attempts at the Domestication of Death; it is, in fact, the very source of their existence. Thus, the logic of instrumentality poses a certain burden upon these attempts at the Domestication of Death: if Something is the means to Something Further, then the measure of that Something is its success at attaining that Something Further. But if it is still possible that Death is truly Death, then our means have fallen short of their end.

Needless to say, however, one cannot claim that the possibility that Death is truly Death has somehow become an accomplished fact and that we can claim with any certainty that Death *is* truly Death. There is indeed an uncertainty that attends all our speculations regarding that ominous darkness off in the peripheral distance. But if it is possible that Death is truly Death, then this uncertainty is not and cannot be the end of the matter. The attempt at the Domestication of Death would, of course, invite us to stop precisely here, note the uncertainty, and let it be. And then, it would have us turn back toward the Alleys and the City, using the uncertainty to lend credence to the Maxims of Death and the Mirror of Death, the uncertainty being the shield we could use to defend the Maxims and Mirror from any disproof. With the Maxims and Mirror at our side, we could tell ourselves and others that "none can say for sure what 'Death' is," and we would then use this lack of surety as a defense of the possibilities that our Domestication of Death offers up. Since no one knows for sure, we would tell ourselves, no one can say decisively that what we want to believe is not so, barring perhaps the odd and extreme case of self-contradiction. This, however, does not quite work: we have before us a dark possibility that stands fast, and it forever competes with any complacent confidence we might buttress with the possibilities we find in our attempts at the Domestication of Death. The modality that makes the possibility that Death is truly Death so eviscerating is precisely that it is possible, not that it is somehow certain.[16]

The Domestication of Death is meant to protect us from the possibility that Death is truly Death, but it cannot do so, for although it attempts to avert our gaze from this possibility, in the end it can do nothing to dispel it. Whether or not there are evidential connections in which to ground the possibilities held out by the Domestication of Death, the menacing darkness remains, and we are back to the same question that has been haunting us from the beginning: What *if* Death is truly Death?

The Not-Place That Cannot Be Named—
Mortal Avenues Revisited

And so, at last we move toward the terrible possibility from which we would be shielded were it not that the dialectical tension of our position within the landscape raises it up before us. If Death is truly Death—and not just another form of life very different from our own—then finally we must confront the possibility that Death is not a name and that it cannot in any sense be a place, for if Death is *truly* Death, then it must be the utter absence of all that ever *could* be named, and it must be devoid of all that ever could *be* in such a way as to *be* a "place" or even "in" or "of" a place.[17] If Death is truly Death, a possibility left all too open by our otherwise preemptive attempts at the Domestication of Death, then the very word itself begins to look like a vestige of those attempts at Domestication, for the word Death is a placeholder of sorts that would clear a space and provide a position upon our landscape. But if Death is truly Death, we are now finding ourselves obliged to take seriously what seems unutterable and inconceivable yet, paradoxically, somehow possible nonetheless.

Perhaps in a very deep sense Parmenides was right: perhaps in some sense thought does require an object and to think is in some sense to always be thinking of something; perhaps it is impossible for us to think clearly of the nothing that Death must be if Death is truly Death. But perhaps in an equally deep but more unsettling sense Parmenides was wrong: perhaps we can somehow fathom that which cannot be clearly thought, we can somehow fathom that for which there can be no representation, no conceptual or linguistic instantiation that does not distort considerably more than it could ever capture and convey. And, perhaps, sometimes the utterance that attempts to latch on to that which we have fathomed would, by the very nature of the utterance itself, push us away at the very instant we tried to bring the darkness into the light, into a place where we could share our fears and begin to assuage them. It would be no wonder, then, that all would sound so hollow and that every utterance would seem to come one utterance too late. As we talked and gestured amongst ourselves, we might indeed feel that we were beginning to assuage our fears, but by means of the almost imperceptible dialectic of our condition, the fears we assuaged would no longer be the fears that prompted our unease in the first place; the original fear would have slipped from our grasp with the very first utterance, and we would busy

ourselves with some substitute that, while ever-more-accessible, was none-theless ever-so-less threatening than the initial, unutterable unease with which we began.

And then there is the dream that would protect us from this night-mare, that very old dream that lingers with us still more than we would know, the dream that does much to assuage such fears—Parmenides' dream, though it neither begins nor ends with him. In this dream, which repeats itself to us like some kind of magic charm, there is that wondrous isomorphism between the realm of thought and the realm of being, and if we can discern the laws that govern the former, then we shall uncover the structure of the latter. Difficult and exacting though the task may be, it is one that rewards us with the insight and strength to go on, perhaps even with a sense of the Moral Justice that is often invisible to the naked eye but which our deepest existential yearnings relentlessly demand. In this dream, the isomorphism yields all the confidence it takes to contend with and repair the moral damage with which circumstance so often afflicts us—that confidence in the moral reliability of the landscape in which we find ourselves; that confidence in our ability to represent that land-scape in a manner that accurately captures the actual details of the terrain; the confidence that there is, in principle, some sort of resolution to any problem that confronts us, that the terrain we are crossing is always tra-versable in a manner that preserves the most crucial boundaries that our identity requires. Here we have the confidence that would maintain the momentum of those in the City of Luck; here we have the confidence that would enable those in the Alleys of Loss to somehow continue moving forwards, perhaps even to chart the avenues of transcendence whereby we could escape to a more reliable haven—the one that is surer than the pre-sumptuous confidence of the City and simultaneously less threatening than the darkness off in the peripheral distance.

But now we are forced to confront the dark possibility that ruptures the confidence this dream inspires, the possibility that poses before us pre-cisely what the dream would have us regard as unthinkable and hence not possible. If Death is truly Death and not just some form of life different from our own, then perhaps there is an unbridgeable gulf that divides the conceivable and utterable from the dark prospect of what faces us, and perhaps it is of no use protesting the lack of conceptual clarity that attends this prospect. The body in the next room, our silent relic of Death, be-queaths us an unease that leads us to begin sensing what this ever-unclear prospect portends—the possibility of there coming to be no possibilities

at all, of a not-place that cannot be but which cannot thereby be dismissed; a not-place that cannot be but which is all the more threatening for precisely that reason; a not-place where there is the "not-being" of all that we would call our own, all that falls within the sphere of the identity we would recognize as being that without which we would not and could not *be* at all.

And yes: it is impossible to put all this clearly into words, but that is no matter. The body in the next room helps us to fathom what we cannot quite say, and the very unutterability of it all only adds to the ambient unease; every one of the silent relics we encounter is testimony to what has vanished in ways that defy comprehension, and we seem to have before us that for which there can be no reconciliation or assimilation, that for which there is no idiom that would enable us to bridge the distance. Even the Plain of Gray, that curious portion of the landscape that is devoid of the discriminations and divides that agency imposes and identity requires, that sometimes enticing if unlivable region where the eye of empathy finds no boundaries to thwart it—even there, in that place that looks so much like Death, we still find so much more than this darkness would allow.

Ours indeed is a dialectical tension—we cannot actually see the place called Death, yet we find it difficult to doubt its presence; we cannot conceive the actuality of a Death that is truly Death, yet it is a possibility we find difficult to deny. In this tension, we find ourselves confronted by the darkest prospect of all: a heterogeneity for which there can be no representation and for which there can be no reconciling idiom.

And so, it is hardly surprising that we so often do as seemingly we must, that we speak amongst ourselves, assuaging our fears as we move in the other direction—away from the corpse on the other side of the door, away from the body in the next room, unconsciously trusting in a moral geometry that would allow each step to increase the distance between ourselves and that which we would flee by means of our attempts at the Domestication of Death. And, more often than not, we are confidently unaware of the actual nature of the bleak moral geometry that governs this grim place—unaware that spatial distance and moral distance are not quite the same, unaware that although we wish to move away from the body in the next room by dispelling all that it portends, this cannot possibly be. Too unyielding, it seems, are the contours of the moral landscape within which we find ourselves; too opaque, it seems, is the impenetrable darkness that always surrounds us.

Evening in the City

And then they come to us: well-mannered proprietors, studied in tone and gesture, telling us that we may now see the body in the next room. Later, the young couple will no doubt escort their children down well-lit avenues, taking with them all the supposed lessons that our silent relic has to offer.

NOTES

While this essay is intended to stand alone, it is also meant to accompany and complement an earlier essay of mine, "The City of Luck, the Alleys of Loss, and the Plain of Gray: A Meditation on the Moral Landscape." As with the earlier essay, some parts of the present essay (especially sections "The Maxims of Death" and "The Mirror of Death") are taken from a longer manuscript, "Moral Horror: Tableaux in Philosophical Gothic." As always, I owe a special and incalculable debt to my wife, Gale Vigliotti.

1. William K. Everson quotes the Danish director Carl Theodore Dreyer regarding the effect he wanted to create in his classic film *Vampyr* (Th. Dreyer Film Produktion, 1931): "Imagine that we are sitting in an ordinary room. Suddenly we are told that there is a corpse behind the door. In an instant, the room we are sitting in is completely altered; everything has taken on another look: the light, the atmosphere have changed, though they are physically the same. This is because *we* have changed, and the objects are as we conceive them. That is the effect I want to get in my film" (63). This is both the model for, and a good description of, the phenomenon in question here. It is worth noting that Dreyer does a remarkably good job of creating this atmosphere in the film.

2. Though unembalmed corpses do, as a matter of fact, undergo considerable and rather stunning sorts of changes given the right environmental conditions and the right span of time, so much so that they easily appear to still be in some sense "alive" and capable of an unsettling motion all their own. For a detailed and well-documented discussion of this and the role that it plays in the folklore of "vampirism," see Paul Barber, *Vampires, Burial, and Death: Folklore and Reality.*

3. It is a platitude almost too widespread to bear repeating: it is "healthy" to spend time with the corpse of the deceased, for it will help us to come to "terms" with the "passing" and to achieve some sense of "closure." It is itself curious how obsessive can be the concern to turn the occasion of death into an occasion of health for the living and how much attention is devoted to making death seem so much less troubling than it might otherwise be.

4. The landscape sketched here is discussed more fully in my essay, "The City of Luck, the Alleys of Loss, and the Plain of Gray: A Meditation on the Moral Landscape." Needless to say, the "regions" described as concentric circles in what follows in fact often overlap and intermingle, for such is the geometry that governs the contours of moral space. It should come as no surprise to find that there is often a disparity between spatial distance and moral distance.

5. The terminology here and in what follows is my own, taken over from the article cited in note 4.

6. A landscape where the eye of empathy discerns what agency must deny, where agency and empathy are irreconcilably at odds—*this* surely is Moral Horror, but that is another story. For any who might be interested in that grim tale, there is the essay cited in note 4.

7. This, at any rate, seems as close as the resources of language can come to conveying a sense of a landscape such as this, one in which there is an intertwined, omnidirectional complexity that is antecedent to all attempts at representing it, one in which the relations are, in a sense, anterior to that which these representations will portray as the *relata.*

8. Needless to say, this is not meant to be a scholarly exegesis of the enigmatic fragments of his controversial poem (for which, see Diels and Kranz, *Die Fragmente der Vorsokratiker* 28B6, 28B4, and 28B8, translations by Richard D. McKirhan in *A Presocratics Reader,* 46, 48). What *is* being claimed here is that Parmenides furnishes us with a powerful and influential example of an enduring intuition that is often at the heart of the "confidence of representation" and the "confidence of resolution," in other words, the intuition that the necessities that govern human thought also govern that about which we think and that the laws of thought can thus be reliable guides to the structure of "being."

9. So, for example, the famous argument that we find in Epicurus's *Letter to Menoeceus*: [D]eath, the most frightening of bad things, is nothing to us; since when we exist, death is not yet present, and when death is present, then we do not exist. Therefore, it is relevant neither to the living nor the dead, since it does not affect the former, and the latter do not exist. (Translated by Inwood and Gerison, 23)

10. See, for example, Achilles' dream in Homer's *Iliad* 23.70–73 and 107–9, in which he encounters the ghost of his beloved Patroclus.

11. See, for example, those paradigmatic punishments recounted in Homer's *Odyssey* 11, not to mention the considerably more detailed and notorious ones provided by Dante in the first part of *The Divine Comedy.*

12. So, to cite the obvious example, the amazingly detailed moral landscape that Dante provides in *The Divine Comedy.* For a somewhat less detailed but equally gripping account, see Augustine, *City of God,* books 21–22.

13. See, for example, the philosophical myths that Plato presents at *Republic* 10.614b ff and *Phaedo* 107c–115a as well as the "likely story" presented at *Timaeus* 90e–92c. See also Virgil's *Aeneid,* book 6. It goes without saying that what Homer, Plato, and Virgil provide are highly stylized and carefully crafted tales that are themselves no doubt vestiges of moral intuitions that we can often only dimly glimpse through the panoramas that these more prominent, surviving relics provide.

14. Here the landscape is transfigured by means of the philosopher's vision of what it would take to remove us from all the dangers with which circumstances beset us; here we find haunting examples of the tales of transcendence that emanate from the Alleys of Loss. See, for example, Diotima's speech and the ascent she describes in Plato's *Symposium* 201e–212b, especially 210e ff; Plotinus's account of the soul's ascent to "The One" at *Ennead* 6.9.[9].8–11; and Augustine's account of his strange experience with his mother while overlooking a garden in Ostia at *Confessions* 9.10.23–25 (see also 11.29.39)

15. This would be short, of course, of some deductive argument that would show that the possibilities held out by the Domestications of Death are somehow *necessarily* true.

16. Is this, one might wonder, an argument against hope? No, not necessarily. But it *is* this: an argument by which hope is obliged to remain nothing more than what it is and by which it should not be transformed into some kind of bold and largely complacent confidence. It is an argument that emphasizes the tenuousness of such hope and that emphasizes the unease that is so often confidently dismissed once hope enters into the picture.

17. This is not to deny that we can construct a sophisticated account of how words that do not straightforwardly "refer" to "objects" nonetheless manage to function in a meaningful manner. The point being made here is neither logical nor grammatical; it is a point about existential access.

WORKS CITED

Augustine. *The City of God.* Trans. Henry Bettenson. New York: Penguin, 1972.

———. *Confessions.* Trans. Henry Chadwick. Oxford: Oxford University Press, 1991.

Barber, Paul. *Vampires, Burial, and Death: Folklore and Reality.* New Haven: Yale University Press, 1988.

Dante. *The Divine Comedy.* 3 vols. Trans. Dorothy L. Sayers. Middlesex: Penguin, 1949.

Diels, Hermann and Walther Kranz. *Die Fragmente der Vorsokratiker.* 10th Edition. Berlin: n.p., 1952.

Everson, William K. *Classics of the Horror Film.* New York: Citadel Press, 1974.

Homer. *Iliad.* Trans. Stanley Lombardo. Indianapolis: Hackett, 1997.

———. *Odyssey.* Trans. Stanley Lombardo. Indianapolis: Hackett, 2000.

Inwood, Brad, and L. P. Gerison .*Hellenistic Philosophy.* Indianapolis: Hackett, 1988.

Lyotard, Jean François. *The Differend: Phrases in Dispute.* Trans. George Van Den Abbeele. Minneapolis: University of Minnesota Press, 1988.

McKirhan, Richard D. *A Presocratics Reader.* Ed. Patricia Curd. Indianapolis: Hackett, 1995.

Mendelson, Michael. "The City of Luck, the Alleys of Loss, and the Plain of Gray: Meditations on the Moral Landscape." *Soundings: An Interdisciplinary Journal* 83 (2000): 231–49.

Plato. *Phaedo.* Trans. G. M. A. Grube. *Plato: Complete Works.* Ed. John M. Cooper and D. S. Hutchinson. Indianapolis: Hackett, 1997.

———. *Republic.* Trans. G. M. A. Grube. Rev. C. D. C. Reeve. *Plato: Complete Works.* Ed. John M. Cooper and D. S. Hutchinson. Indianapolis: Hackett, 1997.

———. *Symposium.* Trans. Alexander Nehamas and Paul Woodruff. *Plato: Complete Works.* Ed. Cooper and Hutchinson. Indianapolis: Hackett, 1997.

———. *Timaeus.* Trans. Donald J. Zeyl. *Plato: Complete Works.* Ed. John M. Cooper and D. S. Hutchinson. Indianapolis: Hackett, 1997.

Plotinus. *Ennead.* Trans. A. H. Armstrong. 7 vols. Cambridge: Loeb Classical Library, 1966–1988.

Virgil. *Aeneid.* Trans. Robert Fitzgerald. New York: Vintage Books, 1985.

Dead or Alive

JENNIFER WEBB AND LORRAINE WEBB

Introduction

While the dead body is not a subject that necessarily springs immediately to mind for most artists, images of corpses, of human anatomy, and of death (physical or symbolic) appear and reappear throughout the history of cultural production. As creative practitioners ourselves (one a writer, one a painter) and finding like many of our peers that death and the dead make compelling subjects, we have contributed to this tradition in our work. What we intend to do in this paper is to investigate the attraction exercised upon us by death and the dead. We discuss this phenomenon in two separate but related sections. In the first section we explore the idea of death, taking as a starting point Michel de Certeau's notion that "Death is the problem of the subject" (192), to explore our curiosity about what death means to "the subject." We also look at the ways in which death touches and motivates artists, compelling them to draw it, by their attention, into the realm of the representable, and we develop this by exploring the relation of dead bodies to meaning and being. In the second section we focus on the corporeality of the artist and the artwork and examine the connections between making representations of dead bodies and managing our own lives and work. In this we will be drawing on the paintings and drawings produced by Lorraine during a period in which she was permitted to sketch the exhibits (dead and surgically dismembered bodies) in the collection of the Museum of Anatomy in Melbourne, Australia.

Unresting Death

. . . I see what's really always there:
Unresting death, a whole day nearer now,
Making all thought impossible but how
And where and when I shall myself die.

. .

And so it stays just on the edge of vision,
A small unfocused blur, a standing chill
That slows each impulse down to indecision

 —Philip Larkin, "Aubade," 1977

Death is, in everything, a paradox, at once the great inevitability and the great uncertainty. "No one is sure of dying," writes Maurice Blanchot. "No one doubts death, but no one can think of certain death except doubtfully" (95): it won't—it can't—happen to me. But even while we cling to this thought, we know that it is just a fantasy; "unresting death" will come for me because it has come for everyone else throughout history, because it is part of life (metonymically speaking), and because it is life's Other.

As Other, death constitutes the limit and the boundary of both life and meaning: the limit because it marks the end of self-awareness; the boundary because it removes the human subject from the symbolic order and returns it to the Real. Knowing that death is always a whole day nearer undermines our confidence in ourselves as subjects, because we know that despite our best efforts and all our strategies, we can't escape it; and we know that no matter how we try, it will reduce and return us to the asocial. We are born into the Real: inarticulate, not quite human, and certainly not social. With the acquisition and appreciation of language and its rules, and of discourse and its rules, we become truly human. And yet this human status is contingent and temporary, dependent on death's delay; that inarticulate infant is still lurking somewhere in our being or our subconscious as a continual reminder that we once were, and we will inevitably again be, neither human nor social. Death thus dissolves meaning because it is itself beyond language, beyond signification, and beyond the symbolic order. As such it always escapes knowledge and remains for us as the "uncanny," the thing "beyond our ken": in Certeau's words, "a wound on reason" (192).

Death constitutes this "wound" because it is in an anterior relationship with discourse: as signified, it is beyond meaning; as signifier, its meaning

is always in flux. Death thus draws attention to the tenuous connections between reality and representation. This is, of course, not a novel idea; the convention of a "natural" connection between referent and representation has been thoroughly laid to rest because, as is demonstrated by contemporary linguistics, language is a system of difference and not of absolute terms, and hence there is no necessary connection between signifier and signified and no final meaning. In fact, the signified itself has been laid to

Figure 8. *Out of My Head,* 1999, Lorraine Webb.

rest: rather than a signifier calling up the thing signified, we now under-
stand there to be only an endless sliding of signifiers over one another, a
juxtapositioning of decontextualized signs in which, since the signs can
mean anything, they in fact mean nothing. And these are now the terms
for meaning making and hence for representation—meaning is only pos-
sible because there is meaninglessness: "There is language, there is art,
because there is 'the other'" (Steiner 137).

Taken to its logical extreme, this meaninglessness would be unbearable;
we must be able to communicate, and so we must behave as though signs
have consistent and shared meanings and as though there were an episte-
mological basis for, and a teleological focus to, everyday practices. The
Real provides, or can be claimed as, the grounds for the meaning of these
otherwise free-floating, neutral, contextless signs, but calling on the Real
to guarantee meaning is a dubious act, because it opens a door onto the
inarticulable—that which is irreducibly beyond language. Consequently,
any attempt to use the Real as a guarantor of meaning ushers in the loss
of all meaning because this effort places meaning in, and dependant on,
the Outside.

This constitutes a "wound on reason" that cannot be sutured. If lan-
guage is predicated on difference, and not identity, and if meaning is reliant
on meaninglessness, then the assertion of an unbridgeable divide between
life and death, of absolute life, or certain death, can't be sustained either.
The dead, by being life's Other, provide for the living that difference that
names and confirms our being. But the slipperiness of signification means
that in the process of providing the guarantee of our life—our aliveness—
the dead simultaneously call us to, and recall to us, our own death; and the
various signifiers we hold up as talismans to keep death in exile simply call
it back into social life by naming it and focusing on it. Death as signifier
slides across life, infecting and problematizing it and vice versa. Similarly,
the attempt to bracket death off as the Other simply reminds us that self
and other, death and life, are always imbricated within one another and
depend on each other.

An effect of the paradoxical uncertainty/certainty of death is that for
most of us death is both there and not there, "a small unfocused blur." This
blur must be blotted out because it is a stain on consciousness, a remain-
der of the Real, and a reminder of our own disintegration and expulsion
from the world of meaning that spoils the present and makes it difficult
to concentrate on "being-in-the world." And despite our denials, we know
we will die; as Heidegger tells us, being human is "being-toward-death,"

and this we can't escape. In the interests of asserting our own being—not a "being-toward-death" but a visceral vitality—we avow life and disavow death, but we know in a certainly uncertain way that at the end we will fall back to the prelinguistic, asocial state and, further back, into the state that is no state, where we are unable to say or even think: "I am, and I am dead."

If we cannot contain death's negative energy within symbolic logic, we will find, like Larkin's poetic persona, that it makes "all thought impossible but how / And where and when I shall myself die." So, not surprisingly, the dominant contemporary response to *my own death* is to switch it off: not to think it, not to speak it, not to know it. If death intends to put me outside the world of meaning, well then, I will treat it in the same way—as that which can't be (spoken). We do this in various ways. One way of controlling death and focusing thought is to do, insistently, the thing that makes us human—we speak, or write, or paint; we make representations, and thus assert meaning. In this way—making noise that proves we're alive—we can insist on presence, a presence that takes its identity and value from its correlative: absence, the absence that death constitutes.

Another way of containing death is by focusing on its vast anonymity—for instance, as it strikes the unnamed, unknown thousands on flooded Indian plains; or by reducing it to entertainment, as presented in the *Die Hard* movie genre with all its gratuitously risible deaths. Or, when death can't be excluded from the present, we can contain it within the bodies of the dead and dying, whom we then consign to the Outside. Certeau writes, dreadfully, of how hospitals manage the dying: "The dying are outcasts because they are deviants in an institution organized by and for the conservation of life. An 'anticipated mourning,' a phenomenon of institutional rejection, puts them away in advance in 'the dead man's room'; it surrounds them with silence or, worse yet, with lives that protect the living against the voice that would break out of this enclosure to cry: 'I am going to die'" (190–91). And Zygmunt Bauman writes in similar terms of funerals, which are the machinery for the management of the dead:

> Funerals differ in their ritual, but they are always acts of exclusion. . . . They expel the dead from the company of the normal, innocuous, these to be associated with. But they do more than that. Through applying to the dead the same technique of separation as

they do to the carriers of infectious diseases or contagious malprac-
tices, they cast the dead in the category of threats that lose their
potency if kept at a distance. (2)

But while we may thus seek to contain and then exclude death in the
bodies of the dying and the dead, we never achieve success. Anything
repressed, Freud insists, will always return, and we see death's return in
the stories of the unquiet dead—vampires, zombies, ghosts—who haunt
every culture. We see it in the efforts expended to build cemetery walls and
gates, and in the memorials raised to the great dead or moments of great
death, all of which remind us that death is really always there, that we can't
keep the dead at bay, that death can't be finally exiled from life.

Not that we don't try, and with good reason. Death's presence in the
everyday world, with all it signifies of the loss of being and meaning,
potentially calls into question the value of all we can say and do, vitiating
our energies, aspirations, and anxieties: "In death the intractable con-
stancy of the other, of that on which we have no purchase, is given its most
evident concentration. It is the facticity of death, a facticity wholly resist-
ant to reason, to metaphor, to revelatory representation, which makes us
'guest-workers' in the boarding-houses of life" (Steiner 140). As "guest-
workers" we can never be at home. And this "problem of the subject," this
"wound on reason," makes social life impossible by upsetting the verities.
The guarantee of identity that is provided by the *entre nous,* the perma-
nency that is implied by the social contract, and the social structures that
paper over ruptures in meaning and being are all undone by the "always
there" of death. This is because the more we invest in disavowing and
repressing the experience of such ruptures and the certainty of our own
death, the more they color our consciousness: in our efforts to exile death,
we keep it in the forefront of our minds and give it form and presence.

Unsuccessful attempts to control or keep the dead at bay are not the
only viable approaches to death. For those cultures that articulate death as
an ontological adventure or privileged state (Vikings gloriously entering
Valhalla, Native Americans returning to their ancestors, Christians com-
ing face to face with God), death doesn't necessarily open, or draw atten-
tion to, an impossible void. "The irreversibility of biological death," Jean
Baudrillard writes, "is . . . specific to our culture. Every other culture says
that death begins before death, that life goes on after life, and that it is
impossible to distinguish life from death" (158–59). And in fact death
doesn't exist as such in the material world; individual organisms die, but

their component parts break down into other forms of being; genetic codes don't die—they pass from one individual and one generation to another. Death is in life, and life in death. Nor does it "really" exist socially: we are dying from our first breath, yet even after physical death we aren't properly exiled from the place of the living but retain a toehold there, as memories, or as revenants. And death lacks authority in the world of creative or symbolic production too—Hamlet dies every night on stage, for instance, and we speak of him always in the present tense. Death, therefore, only counts in the space of the individual conscious subject, and even then only as "a myth experienced in anticipation" (Baudrillard 159), a myth that knocks out the body but can't (for that moment which constitutes memory) touch the symbolic being.

In the post-Enlightenment and post-Christian world, we can't easily accommodate or countenance such plurality, instead drawing a solid line between life and death because death is our confirmation that "nothing is." All the same, if life is predicated on an irreconcilable set of necessities (death-in-life, life-in-death), then in the recognition and embrace of certain death and our inevitable expulsion from the symbolic order, we are set free to be alive, for the moment, to mean and to make meanings. Ronald Schleifer writes, "Such a revelation of the other in the same is the secret melody of death and materialisms. . . . It makes the accidents of existence, including the material accidental formation of codes of signification, and including contingency and death, resonate in art" (49–50). Although the "revelation of the other in the same" may be, as Schleifer continues, a "negative understanding," nonetheless language and other codes of signification (such as art) offer ways of addressing death, of acknowledging the other in the same, of bringing into focus Larkin's small unfocused blur—and in the process, making it possible to go on.

That Schleifer singles out art as the site in which death and contingency resonate should not come as a surprise. Art is a form of communication that is simultaneously privileged and outside the conventions of everyday language. This vexed relationship to discourse arguably allows it to articulate, or at least approach, death in a way that can't be sustained in everyday discourse. We noted above the impossibility of denying, or quarantining, or even embracing death-in-life, life-in-death, in everyday discourse or understanding. But nonetheless, we are constantly being called on to confront it and, George Steiner writes, "All aesthetics, all critical and hermeneutic discourse, is an attempt to clarify the paradox and opaqueness of that meeting as well as its felicities" (138). To the extent that we are

Figure 9. *Chromosome Choice,* 2000, Lorraine Webb.

prepared to meet death, or to clarify life's contingencies, art provides an ideal starting point because it already "understands" (identifies with) death. There are, for instance, several parallels between contemporary art and death: both are frequently opaque; both are frequently self-referential; both are frequently not quite respectable; both belong "elsewhere" and are frequently excluded or repressed; and both must be disguised in order to occupy a place in society. Death, as we suggested above, may be disguised in popular film as entertainment, or in news footage as something that happens only "over there." Art is popularly disguised in several modes: as that which presents us to ourselves and others, as a significant industry and contributor to the economy, or as a container for personal and collective memory. This effectively sanitizes artistic practice, and sends into exile its more contestatory manifestations—political art, avant-garde work, the obscene, or representations of dead and dismembered bodies. And yet the unsanitized forms that so often attract protest and funding cuts and other forms of censorship are the gestures that bring the silenced, the abject, and the meaningless into the social-symbolic order. In demonstrating Nietzsche's thesis that aesthetics is "applied physiology," and in representing the insides as well as the surfaces of dead individuals, "unsanitized art" undermines the hierarchical arrangement of inside and outside, or living and dead. This can restore an attitude to the dead that has little place in contemporary Western society, because in representing the dead as subjects, and hence insisting that they have a place among us, the law of exile is contradicted. The painting of dead and surgically dismembered bodies responds to their normalcy and points out that the dead body is a subject like any other subject. And further, painting the dead body retains or restores its vitality, because in the moment of representation it is seen as *being*, more verb than noun. Focusing on the relations of spaces, planes, and edges engages with the potentiality of the body, its movement and function, and exposes the relationship between self and self, and between the self and the world beyond the borders of the skin.

This is an important aspect of making representations of the dead, because what it suggests is that aesthetic attention can reclaim death from its condition of exile. And more than this, it also tests out the notion that death is necessarily a troubling of the symbolic, or necessarily and straightforwardly a return of the repressed. Because such works insist on the materiality of being—dead *or* alive—they give the inarticulable a form and draw attention to the corporeal state as an identity in itself. This again tests out the self-evident aspects of death's relation to the subject, and to

life, because it problematizes the intellectual tendency (dating from the Enlightenment) to privilege reason over the sensate. As Schleifer writes, what modernism articulates "is the materiality of signification, the materiality of the 'idea'" (57) and we would like to explore the concept of the "material idea" in the light of the social functions of death and representations of the dead. We suggest, in the first instance, that this reification of the abstract may be another way of keeping death at arm's length, because if ideas are really as material as the material world, then death can constitute no real threat to me: in these terms, "I" am simply an idea of "I," and not dependent on concrete existence.

In fact, of course, ideas do not have concrete being and people do: I may indeed be understood as a material idea, but my body is absolute and finite; it carries the record of decline and death and will in time reduce me to nothing more than the building blocks of matter and perhaps a temporary (postdeath) identity as the face in someone else's photograph. Consequently we argue (*pace* Schleifer) that being is more than material or materialized idea; it is also, and perhaps primarily, corporeality. Nietzsche puts this corporeal effect quite graphically, problematizing abstract existence because for him existence is: "an imperfect tense that never becomes a present; . . . 'being' is merely a continual 'has been,' a thing that lives by denying and destroying and contradicting itself" (6). This continual "has been" is that which is inscribed in the body, because it is the individual concrete body that has been—that dies. The abstract (the idea of me) and the general (the body's component parts) cannot—or at least need not—die. At least, the abstract will not die as long as we, the dead, are memorialized by the living; and the general does not die, providing we accept as a form of life its translation into other kinds of being: atoms and fluids and cellular matter breaking down into nature.

In short, we can identify in this modernist privileging of the abstract over the concrete a quasi-religious attempt to escape and/or repress the Real, because it posits the living body as merely the hostage of the abstract "I," a tent for existence rather than existence itself. A close look at the dead problematizes this notion because they, the dead, are manifestly no longer symbolic subjects and clearly not a set of ideas and desires and aspirations either. Rather, they are flesh, raw material—both like and unlike me. This serves as a reminder that self-identity cannot be tied simply to mental consciousness. It is inscribed in the body because we are, in the first instance, physically functional human animals, as much process as processor. Philip Mellor writes, "self-identity is . . . constructed within the biographical and

biological constraints of the body, which limit the extent to which reflexively applied knowledge and reflexively constructed identity can be sustained" (27). If we are not just abstract ideas but concrete material as well, and if identity is tied to the body rather than a "soul" or "mind" or even memory (Mellor's "biographical constraint"), then with the death and decay of the body comes, necessarily, the death and decay of self-identity. The body and its parts may indeed be dispersed into new forms of being, but my awareness of this is impossible—the *I* disappears into the Real.

Here we can identify some of the attraction exerted on artists by the dead; as present, concrete entities they offer a way of confronting and exploring the boundaries of meaning and being—not of stitching up the wound on reason that death constitutes but of acknowledging the interwoven nature

Figure 10. *Aorta*, 1999, Lorraine Webb.

of death and life. Being dead means being set free from the constraints of the symbolic order so that the body can become a thing in itself, not subject to the dream world of angels (all ideas and abstract form) but manifestly the constitutive elements—tissue, fluids, organs—of "real" being. Drawing living bodies and their pure surfaces can be a valuable exploration of identity. But drawing dead bodies, both surfaces and inner parts, affords a way of exploring both being and "has been" because it reinserts materiality into the abstract world of thought and ideas.

All the same, why choose to make representations of death, the dead, or the insides of the body? These are not obviously beautiful subjects (although the works may depend on the imagination and the material world, corpses do not generally meet the conventions of beauty), nor are they sublime subjects (insofar as they privilege tangible form over pure reason, and the material over the absolute). And as subjects they are hardly enlightening, since they demand that artists and audiences pay attention to that which most of us prefer to disavow: decline, decay, and death. We suggest above that artists in various media write (or paint, or film, or perform) dead bodies to assert the presence and legitimacy of material existence, but this simply begs the question of why corporeality should be either engrossing or consoling. One answer is that becoming literate with respect to the corporeal, and developing fluency in the articulation of the inarticulate (and inarticulable), allows us to face—or better, master—our own death. Studying death, exploring death, confronting death offer the possibility of understanding it; controlling the significatory act provides the illusion that we can resist death's significatory power over our identity and, perhaps most of all, that we can hold back death.

Painting Away My Death

This brings us back, full circle, to where we started—death as a "problem of the subject," death as a "wound on reason," death as that which must be disavowed because it poses an insurmountable threat to my self-identity and self-presence. Thinking about our own approaches to our aesthetic work, and reading the words of other artists, suggests that what artists often do in creatively representing dead and dissected bodies is explore not just the subject of the work but self-identity as well. Arguably, this is always the case in aesthetic work; but working with, say, still life objects or living subjects doesn't bring constantly to mind the necessary limits of my own existence as a thinking, viewing subject. Because of the

threat posed by death, and because it is practically taboo in contemporary Western societies (outside of synthetic Hollywood representations or cosmeticized morticians' caskets, at least), facing the dead means facing our own death and coming to terms with the fragile condition of identity.

This takes us into the territory of the psychoanalyst, particularly that view on identity that posits that the self emerges as already fractured at the point at which the infant first recognizes (identifies) itself in the mirror as

Figure 11. *Under the Skin,* 1998, Lorraine Webb.

a subject. The infant here sees itself as whole and ideal; but that moment of identification is also the moment that forces attention on the space between the physical and the reflected selves that constitutes the first split in identity—I am here, and I am there. . . . Which I is me?

The distance between the artist and the object of the work (the dead) can be understood as a metaphor for this space. As such, the act of making cultural representations of the dead foregrounds this primary rift in identity. However, if we approach the making of artwork as a physical act, then it can provide a way of "reaching down into biological potentiality" (Fuller 187), temporarily forgetting the problems of identity and the wounds on reason. Rather than being overwhelmed by the anxieties of death or being absorbed by the external world, such work offers an opportunity and a stage on which to explore this rift in being.

In taking the dead body as subject we position death as an object of the gaze and, at the same time, as something that produces its own self-presence by the act of framing and forming it as a thing in itself: the subject of the work. This defamiliarizes the understandings of being that are inscribed in everyday discourse and everyday performances of identity, because in the presence of two self-presences (the artist and the dead body), the differences between self and other are blurred. I am "I," the artist who brings to the object of the work a controlling and measured gaze; and at the same time I am "me," that which identifies with the object and is experienced as both gazing and gazed at. This act of simultaneous identification and objectification allows the artist to recognize life in death and death in life, with its vicarious chills (because I identify with the dead, the dead is me) and its consolatory gesture (because I can look at the body, the dead is not me).

This two-handed looking (being at once subject and object of the gaze) is a consistent feature of creative work because (to paraphrase Graham Greene) artists may empathize with human being but must retain some ice in the heart in order to maintain the objective distance necessary to overcome pity and fear, appropriate the raw stuff of human experience, break it down into component parts, and return it in the guise of art. The chill of this gaze provides a mediated space in which the artist can work more effectively, because too close an identification with the dead body would mean the risk that the work would become pathological, self-indulgent, or incoherent.

This is similar in a way to the story of Perseus carrying out the task of slaying Medusa. The legend tells us that, by looking at the gorgon's

reflection rather than directly at her, he was able to evade her fatal gaze and overcome her horror. So, too, can the artist who takes a viewing position that objectively frames the dead/death both confront and evade its pathological return. It also enables the artist to move beyond the conventional reaction: rather than seeing in the dead the Uncanny, we can identify the traces of both death and life, of me and not me. In the dead body can be seen, as in Perseus's mirror, the body objectified, the abject rendered safe—framed and legitimized.

So, like the coroner's work, the artist's involves gaining control over death in its guise as Larkin's "standing chill / That slows each impulse down to indecision." Through the application of knowledge, classification, and categorization, we can sidestep that anxious indecision and shift our perspective on the dead: rather than viewing them as remainders of the human that remind us of our own not-quite-human "thingliness," we see them as machinery or the building blocks of matter. The dead subject is transformed from corpse to form, to matter, to sculptural potentiality.

Figure 12. *Waterbody 2*, 1998, Lorraine Webb.

It is important for artists who engage with death and the dead to find this mediated space, this knowing gaze, because each practice of artistic production is a kind of death itself. In the act of making work, something of the artist is transferred out of the self and into the work. As Roland Barthes writes famously, creative production is "that neutral, composite, oblique space where our subject slips away, the negative where all identity is lost, starting with the very identity of the body writing" (142). That is to say, making aesthetic works involves confronting one's own contingent existence and confronting death itself, and we must establish the terms of engagement if we are to be able to function effectively. Maurice Blanchot gives considerable space to this issue in his critical writings. Particularly, he discusses Kafka's view that "you cannot write unless you remain your own master before death; you must have established with death a relation of sovereign equals. If you lose face before death, if death is the limit of your self-possession, then it slips the words out from under the pen, it cuts in and interrupts" (91).

If we are not death's equal, we become its captives, falling under its spell, and risking the loss of our aesthetic and intellectual potential because we now belong to the Real rather than the symbolic order. This does not mean, though, that we should deny death, or maintain a stoical attitude, refusing to give in to terror in the face of our own disintegration. Rather, Blanchot suggests, we must undertake to live death, to "be the figurers and the poets of our death" (126). And, most significantly, we must assert existence in the face of death. We can do this confidently because, if the artist's self-identity is in fact leached out into the work, then we know we can die without ceasing to be: the "I" remains present in the work, and the work remains as the trace and marker of self-identity—the guarantee of life in death and life after death.

This provides writers and artists with a drive to make work, to secure their own self-awareness and their own status as subjects and not just as matter. And, because looking at the dead necessarily brings to mind our own death, such practice also provides the impetus for expression. Certeau writes that there is "a first and last coincidence of dying, believing, and speaking. . . . There is nothing so 'other' as my death, the index of all alterity. But there is also nothing that makes clearer the place from which I can say my desire for the other; nothing that makes clearer my gratitude for being received—without having any guarantee or goods to offer—into the powerless language of my expectation of the other; nothing therefore defines more exactly than my death what speaking is" (193–94). We can

speak (or draw, or write, or dance) because we know that this expression is going to cease, finally and irrevocably; we can desire because we know that desire, too, is always and only of the moment and gives that moment its vitality. This makes death particularly significant for creative practitioners: without the assurance of death, we have no material being and, as a correlative, no symbolic being.

My own death, therefore, can become an alluring undercurrent to my life and by extension, my aesthetic and intellectual practice. But what of dead bodies? We are not supposed to be close to the dead; some forms of contact are utterly proscribed (necrophilia, for instance); others are sanctioned as morbid or unhygienic; and these limitations are codified in most societies to become not just norms and mores, but the object of judicial attention. And except for those people in Western societies who have embraced the tradition of the wake or *tangi*, we hide our dead away, and if we glimpse them at all, it is in the sanitized and cosmeticized environment of the satin-lined coffin in the silent chapel. They are, Baudrillard argues (127), "hounded and separated from the living," because in their unarguably other state (nothing there but flesh), they remind us that we are only flesh too. If, however, we are able to transform them into artistic work, then their necrogenic power is subdued because they are reidentified as simply matter, or as body. Then, too, they offer us a way of managing our own anxieties about death, because although they remind us in their unmediated state that as they are, so we will be too, once they are framed within a narrative or visual space they become materialized as objectified subject, as the cogs or machinery of matter—something that is stable and consistent, something that is not like thought and not within the symbolic order—and, as a corollary, they are not like me.

This notion of the material is important in this work because the corporeal body, whether dead or alive, has a central place in cultural production. In poems, for instance, the body manifests in the breath and rhythms of reading; in novels it appears in the form of the characters, without whom fiction is a sterile experience; in visual and plastic art it emerges in figurative work, or in the metaphorized figure. The body is also central to the experience of self-identity because it is, as William James writes, "the storm centre, the origin of co-ordinates, the constant place of stress in all that experience-train. Everything circles around it and is felt from its point of view" (284). Maurice Merleau-Ponty argues in similar terms that the body "can sense itself and this anonymous tacit cogito is the foundation for the explicit cogito, the emergent experience of selfhood and

subjectivity that set the body apart from objects" (148). This phenomeno-
logical view is in startling contrast to the contemporary standard where,
as we noted previously, virtuality takes precedence over materiality and
meaning slips into pure difference, pure contingence. But it also reminds
us that in this condition of uncertainty, the one remaining verity is the
body. Hold a stethoscope to it, and you'll hear the pumping and grind-
ing of the organs or the blood whooshing under the skin. Or if the body's
dead (as it will be, one day), then it'll certainly putrefy. Because of this
constancy the body is, as Nietzsche has said, the place where truth can be
found.

"Truth," of course, is a highly contested notion, and we are certainly
not making any claims here for transcendental or universal verities. How-
ever, the "truth" of the finitude of the body is one that can focus attention
on the relation between mind and body. This is resonant for artists,
because creative production is a way of bridging the mind/body divide
that continues to inform understandings of identity. We'll discuss the pro-
duction of visual art in this regard, because it is the creative form that
depends so much on the movement of the artist's body and that produces
a corporeal form as its outcome. In fact, visual art—as both practice and
product—metaphorizes the embodied self. The painting can be seen as
a metaphor for the body because the skin of the paint, the structure of
the canvas, the layering of color and texture, and the painting's edges
and frames all reflect aspects of physical being. As Richard Wollheim
writes, corporeality is invested in the "aura of physicality resettling around
the painting as a whole" (310). It is also a metaphor for the idea of self—
the abstract self; in James's terms, knower and doer—because artworks typ-
ically express and realize emotions, ideas, and expressions in the finished
work. This bridges the mind/body divide because affect may be concep-
tual, but emotional effects are felt in the body.

Figure 13. *Body Flow*, 1998, Lorraine Webb.

Painting as practice also directly addresses the embodied self because it is a physical act and because the actions of the body while painting comprise some of the physical material used when making a work. In fact, Peter Fuller contends that "all forms of effective expressive (artistic) practice are . . . intimately enmeshed with the body" (187). Lorraine's experience corroborates this; as she writes elsewhere:

> When starting a new body of work, I try to move through and across the surface of the work, by looking and touching. I work out dimensions and format and then block in the initial images with a large brush. At this stage, the marks I make are loose and gestural. I play over the surface, trying to find or see something. At a certain stage in every painting, my mind goes blank. This blankness is analogous to blindness—the work surface becomes a stranger and I am dissociated from it. . . . The feeling of loss that results is like a death—it seems irretrievable.
>
> From experience, I know that the only way I can get over this stage is to move back into my mind by moving my body quickly, and by applying the medium with large gestures that require my whole body to move. Such experience of elemental force, expressed by an artist using perceptive and descriptive abilities rigorously, can, I believe, lead to a transcendence of the self, because I become absorbed into the subject or the activity of paint-ing. For me, this sensation is generated by the gestures and movement of the body when painting. Temporarily I feel that I am no longer within the boundaries of my body and mind—that I have forgotten myself, and the way that something is made. Although this feeling may be engendered in different ways, for me it originates from the movement of my body, and my speed or corresponding slowness in painting. (125–26)

The act of making art is thus an amalgam of the physical and the con-ceptual: the self, embodied, expressing itself in the work. But the notion that artists can (temporarily) lose themselves in making creative work, as Lorraine describes, is of interest because in a way it metaphorizes the loss of self that death constitutes and so underlines the fragile nature of self-identity and the permeability of the borders between "I" and "me," "me" and "you," self and other, life and death. And this brings us back to the work of making representations of dead and dissected bodies, because here we are confronted with the human form, with all its marvelous capac-ities, reduced to the gross mechanisms and inevitable failure of the body. Particularly when what is exposed is the dismembered body or body part,

representations are often considered to be simply grotesque: the body laid open for view, its skin removed or cut, and orifices and protuberances visible: the person removed and only the meat remaining. But if we can't identify clean demarcation lines between I and me, self and other, life and death, then such painting of bodily remainders need not be seen as a spectacle of the Bakhtinian grotesque but as an engagement with being. Certainly it may be a pathological moment, because death is unavoidably both loss of self and the ultimate loss of inspiration, and the dead body stands as a visible reminder of the permeability of the boundaries between living subject and dead object. Still, what we can identify in representations of dead and dissected bodies is the force and flow of life: the building blocks of being, organized in a set of organic connections that, laid bare, allow us to trace the imprint of the original person and to follow and probe the flows of form and life in general.

This moves us well away from the territory of the morbid, the pathological, or the grotesque, especially when the corporeality invested in creative works is metaphorized. In Lorraine's work about death, for instance, the focus is not so much on literal representations of corpses or body parts, but on expressing the body through light, movement, and color. She uses air as a central metaphor because of the relationship, drawn particularly by Freudian theorists such as Heinz Kohut or Donald Winnicott, between breath and being, or inspiration and creation. And, of course, the loss of breath is death, but by focusing on the flow and patterns of air in paintings of the dead, she can explore ways of looking at death in a reflected or reflexive way, as an active dimension of the body. Here the dynamism and movement indicated in the works aim to explore loss and to deal with death in a way that seeks meaning and hope—acknowledging its very real effects on the knowing subject, while still identifying it as something of value in our lives.

Dead bodies make better subjects for such work than the living, because in the surgically dismembered body can be seen the relationship of the internal organs, arteries, and muscles to the outer form. Dissected bodies consist of orifices and incisions and of multifarious structures. Both inner and outer parts of the body are seen (and represented) at the same time, with the veils of skin and paint simultaneously covering and revealing: the bones are visible through the skin, the aorta can be seen through the stomach wall, the lungs pulse within their ribcage prison. In the delicacy of the exposed interiors, the harmony of the color (or absence of color), the balance of form and movement, and the soft blurring of light and

image, such works can recuperate the materiality of the body, feeling out its existence as a sensibility that is purely for itself. And because in these paintings the outer may both contain and reveal the inner, the body is represented as something that is within a space and that is itself space in flux. Traces of latent movement are evident within the veins and arteries and in all the major organs. Life, growth, and death are suggested in the structures of the dead body. The indistinct boundary between internal and external body forms reflects the internal and external movement that occurs in the process of painting, and the patterns of life flow as metaphorized by representations of water or air.

Making representations of the dead in this way, and following these metaphorical lines, means confidently asserting being and self-presence. This could be read as a subjective and narcissistic obsession with self and the loss of self. But painting the dead involves more than just self-presence. It also demands an engagement with other people's death, and other people's grief, pain, and fear. It forces us to address the deaths of those we love, our anticipatory grief and fear, and the sorrow we have experienced. This grief at the death of others is real, and has real effects, but at the same time it acts as a forewarning of the death of the self. And all these fears and griefs, which thread through our lives and color our sense of the present, can be answered by bringing the body, in its living, breathing, and dying self, back into the seines of consciousness, looking past the abstractions of reason and the infatuations with subjectivity to the calmly organic balance of flesh, vessels, and bones.

WORKS CITED

Bakhtin, Mikhail. *Rabelais and His World.* Trans. Hélène Iswolsky. Bloomington: Indiana University Press, 1984.

Barthes, Roland. "The Death of the Author." *Image-Music-Text.* Trans. Stephen Heath. Glasgow: Fontana, 1977. 142–48.

Baudrillard, Jean. *Symbolic Exchange and Death.* Trans. Iain Hamilton Grant. London: Sage, 1993.

Bauman, Zygmunt. "Survival as a Social Construct." *Theory, Culture and Society* 9 (1992): 1–36.

Blanchot, Maurice. *The Space of Literature.* Trans. Ann Smock. Lincoln: University of Nebraska Press, 1982.

Certeau, Michel de. *The Practice of Everyday Life.* Trans. Steven Rendall. Berkeley: University of California Press, 1984.

Fuller, Peter. *Art and Psychoanalysis.* London: Writers and Readers Publishing, 1981.

James, William. *The Writings of William James.* New York: Random House, 1967.

Kohut, Heinz. *The Search for the Self, Selected Writings: 1950–1978*. New York: International Universities Press, 1978.

Mellor, Philip A. "Death in High Modernity: The Contemporary Presence and Absence of Death." Ed. David Clark. *The Sociology of Death: Theory, Culture, Practice*. Oxford: Blackwell and the Sociological Review, 1993. 11–30.

Merleau-Ponty, Maurice. "Cézanne's doubt." *The Merleau-Ponty Aesthetics Reader*. Ed. G. A. Johnson. Illinois: Northwestern University Press, 1993. 59–75.

Nietzsche, Friedrich. *The Use and Abuse of History*. Trans. Adrian Collins. New York: Liberal Arts Press, 1957.

Schleifer, Ronald. *Rhetoric and Death: The Language of Modernism and Postmodern Discourse Theory*. Urbana: University of Illinois Press, 1990.

Steiner, George. *Real Presences*. Chicago: University of Illinois Press, 1989.

Webb, Lorraine. "Being in the Body: 'Transcendence' and the Creative Process." *Redoubt* 28 (1999): 124–28.

Winnicott, D. W. *Collected Papers*. London: Tavistock Publications, 1958.

Wollheim, R. *Painting as an Art*. Princeton, N.J.: Princeton University Press, 1987.

Contributors

MARIA ANGEL is lecturer at the School of Communication and Media, University of Western Sydney, Australia. She has published in *Cultural Studies, Canadian Journal of Comparative Literature, Jane Gallop Seminar Papers, UTS Review,* and *Southern Review,* among others.

ROBERT S. APRIL, M.D., is assistant clinical professor of neurology at the Mount Sinai School of Medicine. He has published widely in medical journals, including *Speech and Hearing Review* and *Neuropsychology of Language* and has recently presented on "La Maladie de Flaubert et Madame Bovary" in the French department, New York University.

Retired professor of pathology at the Johns Hopkins Medical Institutions, EUGENE A. ARNOLD, M.D., currently teaches review courses in pathology for the United States Medical Licensure Exam.

KATE CREGAN is research associate at the School of Political and Social Inquiry, Monash University, Australia. Her work includes publications on aboriginal art and mothering. Manuscripts on anatomy in seventeenth-century London and multiculturalism are under consideration at Cambridge University Press and SAGE.

DEBORAH JERMYN is senior lecturer in film studies at the Southampton Institute (United Kingdom). She has published work in *Screen* and the *Encyclopedia of Contemporary American Culture* and is coeditor of two forthcoming collections, *Kathryn Bigelow—Hollywood Transgressor* and *The Reader in Audience Studies.*

Associate professor of English at Southern Illinois University Carbondale, ELIZABETH KLAVER is author of *Performing Television: Contemporary Drama and the Media Culture* (2000). She has published widely on postmodern drama, media, and autopsy as performance.

ANDREW MCNAMARA teaches art history and theory at Queensland University of Technology, Brisbane, Australia. He has published on aesthetics, modernist avant-gardism between the wars, and contemporary art. In 1997, he edited *Ornamentalism* and curated an exhibition of contemporary art on the same theme

Assistant professor of philosophy at Lehigh University, MICHAEL MENDELSON has numerous articles in journals such as *Studia Leibnitiana, The British Journal of the History of Philosophy, Augustinian Studies, The Asian American Review,* among others. He has completed a book manuscript entitled "Moral Horror: Tableaux in Philosophical Gothic."

KYLIE RACHEL MESSAGE is convener of the Media Studies Program in the School of English, Film, and Theatre at Victoria University, Wellington, New Zealand. She has published articles in *Journal of Australian Studies, Images of the Urban, inSite,* and *Flash* and has delivered numerous conference papers.

ROBERT H. MOSER is assistant professor of Portuguese at the Department of Romance Languages at University of Georgia. His publications include articles in *Revista Leituras* and *Brasil/Brazil* as well as numerous translations.

EUGENE THACKER teaches technology and culture at the School of Literature, Communication, and Culture, Georgia Institute of Technology. He has contributed articles to *Culture Machine, Flesh-Eating Technologies* (Semiotext[e]), *Body Modification* (SAGE), and *LifeScience: Ars Electronica* as well as online journals such as *Thing Reviews, Switch,* and *Theory and Event.*

JENNIFER WEBB is director of professional writing at University of Canberra, Australia. She is editor of *Re-Siting Theatre* and has published widely in *Diacritics, Social Semiotics, SPAN, Journal of Australian Studies,*

and *Southern Review*. Her current work includes projects on Michel Foucault and Pierre Bourdieu.

LORRAINE WEBB is senior lecturer in painting and drawing at Wanganui Polytechnic, New Zealand. She has exhibited her work widely in New Zealand and Australia.

Index

A RAY AND PAT BROWNE BOOK

Murder on the Reservation: American Indian Crime Fiction
Ray B. Browne

Goddesses and Monsters: Women, Myth, Power, and Popular Culture
Jane Caputi

Mystery, Violence, and Popular Culture
John G. Cawelti

Baseball and Country Music
Don Cusic

The Essential Guide to Werewolf Literature
Brian J. Frost

Images of the Corpse: From the Renaissance to Cyberspace
Edited by Elizabeth Klaver

Walking Shadows: Orson Welles, William Randolph Hearst, and Citizen Kane
John Evangelist Walsh

Spectral America: Phantoms and the National Imagination
Edited by Jeffrey Andrew Weinstock